LANDSCAPE
AND
NATURE
PHOTOGRAPHY

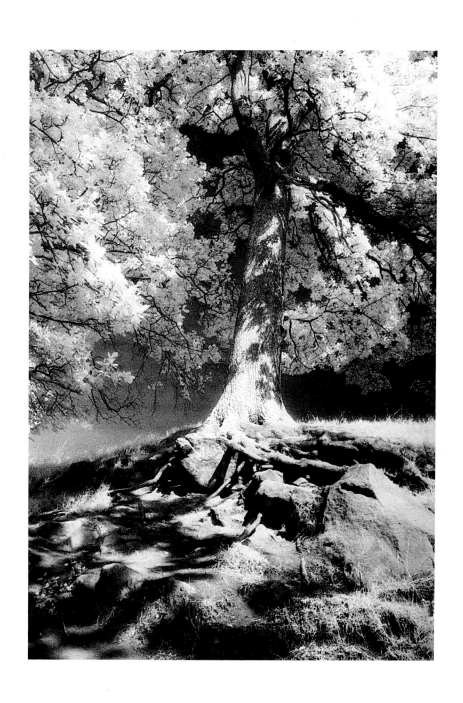

LANDSCAPE
AND
NATURE
PHOTOGRAPHY

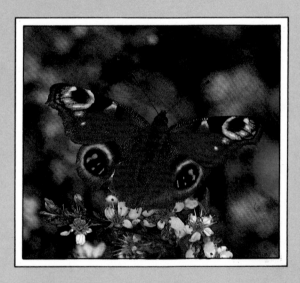

RICHARD MUIR

PHOTOGRAPHY BY RICHARD MUIR

GEORGE PHILIP

British Library Cataloguing in Publication Data
Muir, Richard, *1943–*
 Landscape and nature photography.
 1. Nature photography
 I. Title
 778.9'3 TR721
 ISBN 0-540-01100-2

First published by George Philip,
27A Floral Street, London WC2E 9DP

Printed in Italy

Dedication

Having spent a month indoors selecting the photographs for this book, I would like to have dedicated it to the sun. However, this would be an almost certain passport to 'Pseuds Corner', so instead it is dedicated to all the people who thought we were going for a nice country ramble and ended up carrying the tripod, particularly to Nina, Jack and Tom.

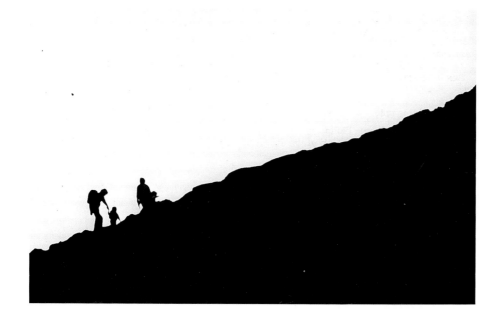

CONTENTS

Your Kind of Hobby? 9

Introduction: Overture and Beginners 11

1 The Right Stuff – Equipment for Landscape and Nature Photography 24

2 The Panorama 56

3 The Fieldscape 64

4 Beside the Seaside 72

5 The Spooky World of Infra-Red 81

6 Rivers, Lakes and Wetlands 85

7 Mountains and Caves 99

8 Woodlands 111

9 Villages 122

10 Air Photography 132

11 Wild Flowers and Fungi 136

12 Butterflies, Moths and other Insects 150

13 Amphibians and Reptiles 162

14 Fish 167

15 Birds 172

16 Mammals 189

17 In the Darkroom 198

18 Putting Something Back: the Nature Garden 206

19 Photography, Conservation and the Law 215

20 Weather and Seasons 219

21 Planning a Trip 227

Useful Sources and Addresses 233
Useful Books 234
Conservation Organizations 235

Index 237

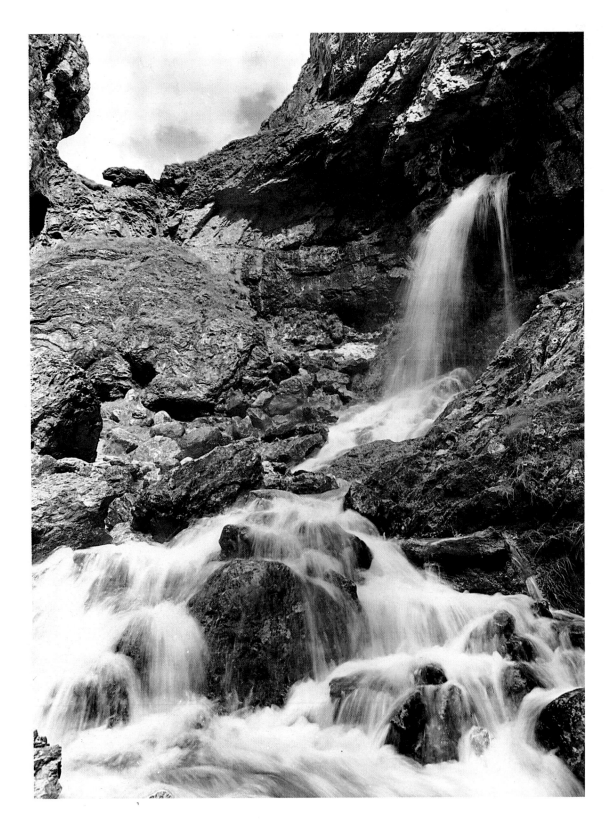

Your Kind of Hobby?

After parking on the outskirts of Malham village, you have hauled a heavy camera bag and tripod up the fell and then down into Gordale Scar. Just behind you is a gaping chasm and thunderous waterfall. Above is the focus of your attention, a cascade which bursts through a cleft in the limestone and then disintegrates in the chilly spring wind. You and your tripod stand calf-deep in the beck, this being the best vantage point from which to enjoy and capture the scenic drama. Here you have stood for half an hour, waiting for a shaft of sunlight to pierce the clouds and add its lustre to the scene. But each time that a break in the clouds seems imminent and you remove the hand which is covering the lens, windlashed spray spatters the filter with a distorting veil of droplets. If you feel the picture eventually achieved is worth the waiting, frustration and discomforts, you are, or will be, a good landscape photographer.

The next day finds you in search of early marsh orchids. After an evening spent researching locations, a morning's drive in the car and a long and squelchy walk through sodden pasture, the quarry is in sight. Your viewpoint must be no higher than the chosen plant so you lie down on the moist ground, taking care to avoid both cowpats and adjacent orchids. Using your elbows as a support you peer through the macro lens, checking composition and depth of field. It is now apparent that the orchid is twitching in the light breeze. If you are to use the lovely natural light and an exposure of $^1/_{60}$ sec at f/8, you will have to wait for an instant of stillness. Meanwhile the clammy dampness of the grass seeps through to your knees and elbows, and the breeze seems unrelenting. But if you persist, and then endure the same hardships to photograph the nearby cowslips and violets, you have the makings of a good nature photographer.

If just one superb frame is worth more to you than a whole spool of mediocre or 'adequate' shots, read on.

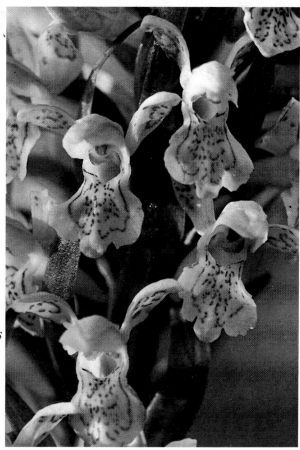

LEFT Gordale Beck in the Yorkshire Dales, photographed from a midstream position. BELOW Early marsh orchid, photographed using natural light from the setting sun.

Note on Measurements

The measurements relating to photography
and photographic equipment in this book
are given in the forms conventionally used,
which can be either imperial or metric (8
× 10 inch prints, 35 mm film).

INTRODUCTION
OVERTURE
AND BEGINNERS

Landscape and nature photography offer anybody with a love of the countryside and its wildlife the basis for a lifelong hobby. If you are not particularly ambitious or well-equipped, the hobby will still tempt you with an inexhaustible range of pictorial opportunities. If, in contrast, you seek to extend your technique and creative talent to their limits, these branches of photography will continue to pose new challenges. They remove all excuses for boredom and sluggishness, and I know that there have been many bleak winter days when I would have stayed by the fire and missed a refreshing ramble had not the lure of photography prised me outdoors, just as though the cameras were tugging like hopeful dogs on their leashes. Also, an interest in landscape and nature photography can lead one into other fascinating pursuits – the study of landscape history, the enjoyment of nature gardening or an involvement in vital conservational work.

There are several good books available on our subjects, but I have attempted to do something a little different. I take the view that equipment is a means to an end, not an end in itself. The subjects of photography are much more important –

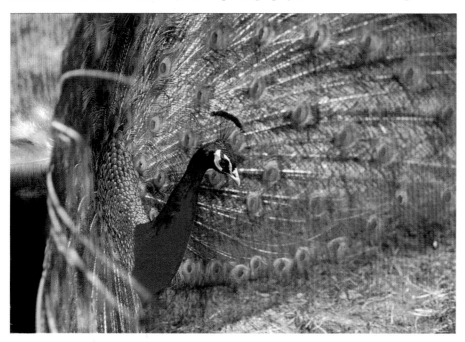

The use of a telephoto lens and wide aperture setting allows attention to centre on the sharply focused head and neck of this peacock, which stand out against the soft background of the bird's tail.

understand them and your pictures are sure to be more perceptive and inviting. The top nature photographers are invariably shrewd naturalists, though an intimacy with the processes of landscape creation seems to be a scarcer commodity amongst landscape photographers. This is surprising, since the best portraitists – whether with cameras or with brushes – have all appreciated the importance of developing a relationship of understanding with their human subjects.

I have dispensed with some of the hype and argot of popular photography. On the technical side, I have put a simplicity of explanation before scientific precision of meaning, thinking it better to offer a generalized understanding than potentially alienating technicalities. I have also banned words such as 'professional' and 'assignment' completely from the text. They are used far too widely, often in attempts to glamorize what may be an unglamorous job or to tempt one into buying expensive 'professional' equipment. If a picture is excellent, it matters not a jot whether the photographer concerned was paid for the work or what he or she paid for the equipment. Here, 'working photographer' is used, sparingly, as a synonym.

All manner of people are photographers, and the landscape and nature enthusiasts are likely to sense a greater kinship with botanists, fell-walkers or conservationists than, for example, with studio photographers working in advertising or with the producers of what is called 'glamour' photography (and what a misnomer this is!). Most, or at least, many working photographers come from art-school backgrounds, and while this may provide technical proficiency and a sound training in composition, I still believe that a love and awareness of the outdoor environment are more important attributes in the landscape and nature fields.

Photography is an important means of communication, and as such it raises moral and philosophical issues, some obvious, some less so but important none the less. For example, the natural tendency to seek out beauty and discard the scenic dross leads one to misrepresent what is really happening to our countryside. So long as the uncommitted reader receives his or her images of villages or landscape from the overabundance of glossy, sugary picture books, then the national awareness of the realities of the rural environment is bound to suffer and essential debate about its problems and fate is undermined. Similarly, I regard fox-hunting as a subhuman pastime for groups of extremely distasteful people, and so would never photograph a picturesque meet with the shining horses and pretty 'pink' outfits. Such pictures mask the fact that the essence of the hunt is the dismemberment of a terrified living creature.

I have included a strong conservational emphasis. This is partly to explain how nature photography is, in insensitive hands, a potentially destructive activity. More positively, I have tried to show how photography can be the springboard for useful work. It can not only heighten one's awareness of the details of the natural world, but also be the stimulus for ventures in habitat creation. Pictures of wildlife and unspoilt countryside can be used to remind others of the richness of some environments, just as pictures of the grubbing-up of hedgerows, the felling of broad-leaf woodland, a polluted river, or a pesticide-poisoned bird can be weapons in the fight against the devastation. I have not mentioned the price of equipment. In the nine months between the completion of the text and publication one simply cannot predict the inflation rate and the performance of the pound sterling against the yen, a crucial factor since the photographic market is now dominated by Japanese equipment.

RIGHT A 28 mm wide-angle lens, set here at f/11, produces a zone of apparent sharpness in this Lake District scene, extending from the foreground Scots pine roots to the fells beyond Derwent Water.

Success in photography is built upon success, and the confidence to tackle the more difficult subjects can be gained by personal triumphs in the less demanding fields. It is vital to realize that good pictures exist all around you, in their countless thousands – you just need a good eye and a few ideas to recognize the opportunities. Consequently I have included a selection of 'projects' – suggesting

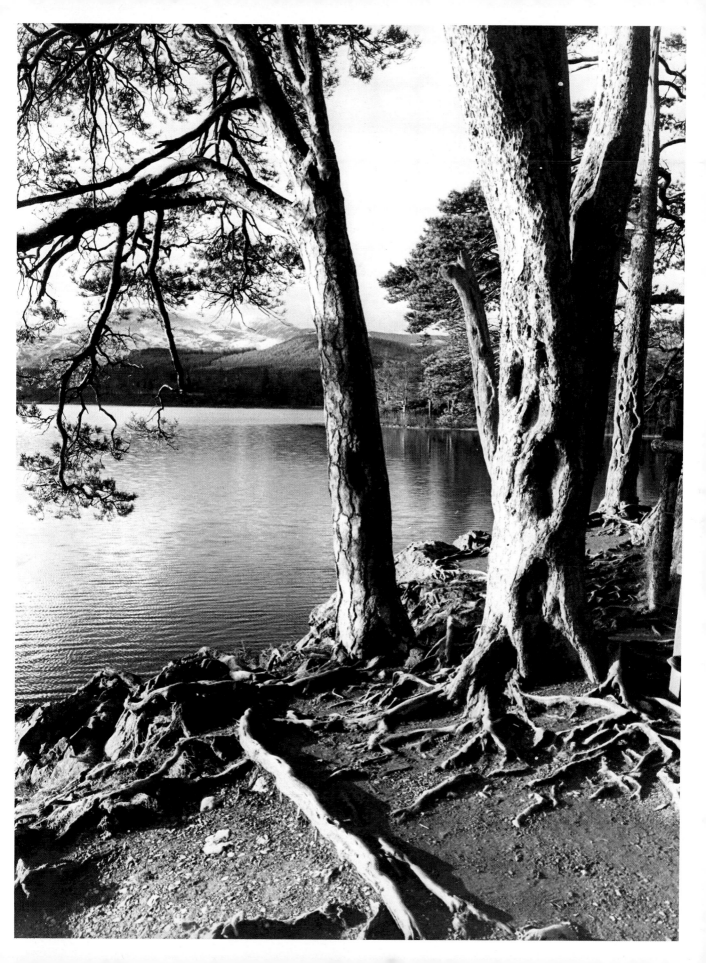

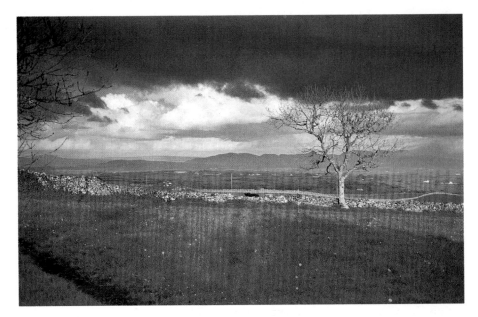

This landscape, in Co. Sligo, is photographed in the light from a low sun which is setting behind the photographer. When the air is very clear, the sun low, and the cloud tones are *darker* than those of the land, the most ordinary scenes take on a magical appeal.

ideas for pictures and explaining the 'nuts and bolts' side of how they can be captured. Paths into landscape and nature photography can come from different directions. One might, as it were, say: 'I am a well-trained and well-equipped photographer, now I want to find some fascinating subjects.' Alternatively, one might be thinking: 'Countryside and wildlife are enchanting and fascinating, so how can I capture and preserve this enchantment?' I approached photography from the latter standpoint, culling information from books or magazines, often learning the hard way by trial and error, asking questions but never actually taking lessons. Like many readers, I expect, I began taking photographs at the age of seven or eight, using an old box Brownie. By my teens I had a Halina 35, then an Agfa Silette and then a Zenith. Next came a Praktica LTL, a Zenith 80 and a set of Pentax Spotmatics. At the latest count there were ten cameras dotted around the house, Contax, Mamiya, MPP and Pentax all contributing to the jumble. At some stage in the accumulation of cameras I began writing and illustrating my own books and then illustrating books by other authors too. Now, as soon as time permits, the hundreds of prints and transparencies must be catalogued to form a picture library. But at no stage did the work ever become an unwelcome burden, and, were I to change my occupation tomorrow or never need to work again, I would carry on just as before, seeking any excuse to get out of doors and just take pictures. Whether photography is an art or a craft I know not and care less. Real living is about answering worthwhile challenges; landscape and nature photography offer such challenges in copious measure.

Some tips for the keen novice

Space will not allow the writing of a beginner's photographic course *and* the provision of moderately detailed notes on work in the branches of landscape and nature photography. Consequently I have decided to sacrifice the most basic information, secure in the knowledge that there are many good introductions which the outright beginner can explore. In addition, magazines such as *Amateur Photographer*, *Camera Weekly*, *SLR Photography*, *Practical Photography* and *35 mm Photography* are packed with useful articles, some elementary and some more advanced, which help the novice to top up his or her technical skills. There are, however, a number of points which tend to be undervalued or taken for granted by beginners and these are explored in the following paragraphs.

1 Depth of field

In technical terms there is no such thing as a *zone* of sharp focus, but in practical terms there is, and it is vital to master the simple concept of depth of field. The narrower the aperture that is set on a lens, the greater the apparent depth of field. Thus, with a 28 mm wide-angle lens focused at infinity and set at f/8, everything further than about 3 metres from the camera *seems* sharp. But if you stop down to f/16 the zone of apparent sharpness is increased, so that everything more than 1.5 metres from the camera appears to be in focus. By adjusting the lens controls, the depth of field can be increased. If you look at the indications on the barrel of your lens you will see numbers set out symmetrically on either side of the focusing mark. Set an aperture of f/8 and revolve the focusing ring so that the infinity symbol* is aligned with 8. Now look at the 8 on the other side of the focusing mark; on a 28 mm lens this will now be roughly aligned with the 1.5 metres mark, denoting a zone of apparent sharpness extending from infinity to only 1.5 metres from the camera. This is only a rough and ready indication of depth of field, but one which can be exploited to considerable effect.

In landscape photography you may want to have foreground boulders or foliage sharply focused or, alternatively, wish to isolate a branch or stump against a softly focused background or foreground. In nature photography depth of field is crucial, and one is often struggling to include a whole flower or complete insect within the tiny zone of apparent sharpness which can be exploited in high magnification work. The longer the focal length of a lens or the higher the magnification being used, the narrower the depth of field, so that precise focusing is essential when using telephoto and macro lenses (see Chapter 1, p. 28).

2 Lighting

Light is the essence of photography. When poorly lit the most beautiful landscape will seem unexciting, while under perfect conditions, which may occur for just a few minutes each year, the most prosaic scene will seem a fairyland. For most of its life a twig may exist as a rather boring bit of wood, but for a little time at a certain season the light may dance along the bark and convert it into a worthy

*It is a photographic convention that a lens set on its most distant focus is said to be set on 'infinity' – marked '∞'.

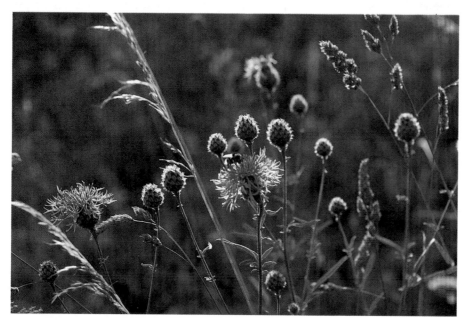

Backlighting is the essence of this picture of brown knapweed, which is redolent of the drowsy warmth of a summer meadow.

Sidelighting can produce quite dramatic effects, as with this ruined Irish castle overlooking the River Boyne, photographed in the light of a setting sun.

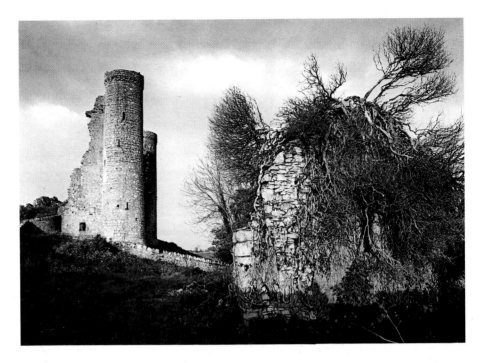

photographic subject. Novice photographers are often told (by other novices) that they should always work with the sun behind them. This is nonsense: *lighting is right if it looks right.* Although working directly into the sun, especially a low sun, may produce unattractive internal lens reflections or flare, aim to capture any scene that 'looks right', whether it be lit from the side, front or rear.

When using natural lighting or studio lighting, you have every chance to preview the result. Much nature photography is accomplished with flash and, unless a polaroid preview camera is employed, the exact nature of the final picture cannot be known. It can, however, be anticipated, and so one must practise using two or three flash guns of different powers until the results obtained by using various combinations of guns in different positions can be predicted.

In landscape photography the most intense colours and most finely sculptured landforms are perceived under conditions of extreme clarity with sidelighting by a low sun. Backlighting can also be very effective. Upright features, such as walls or trees, will be in shadow and stand darkly against the glow of the sun, while in nature photography a measure of backlighting can outline plants or animals in a most appealing way. Under overcast conditions one may seek to exploit the subtleties rather than the intensity of colour, and the pastel tones of mountain and moorland can be very attractive. Overcast or diffused lighting varies; it can be pleasant or flat and tedious, it can work for some subjects but not for others. Often sunlight is needed to inject a sparkle of colour and a strength of contrast into a scene, so that the serious landscape photographer should be prepared to sit out overcast periods in conditions which may be chilly and exposed in order to capture the instant when a shaft of sunlight bursts through the clouds, like a spotlight on Nature's stage.

3 Exposure

Correct exposure is achieved by obtaining the best relationship between shutter speed and aperture setting so that exactly the right amount of light reaches the film. Closing the lens down by one f-stop from f/2.8 to f/4, or f/8 to f/11 and so on, requires the shutter speed to be halved, say from $\frac{1}{125}$ to $\frac{1}{60}$ sec or whatever, to

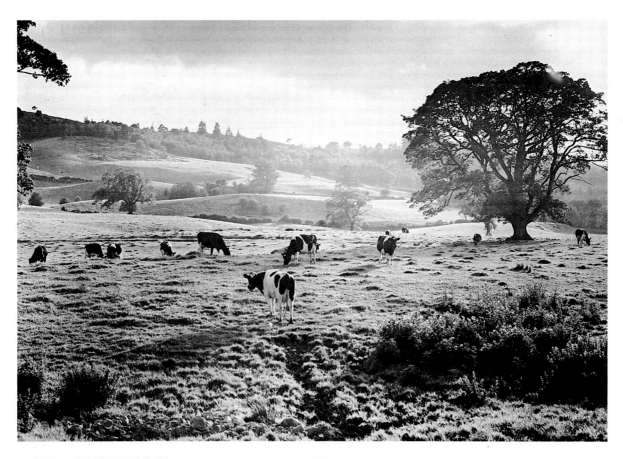

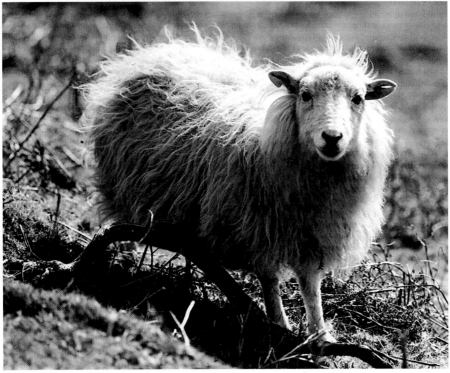

Backlighting can work well in both landscape and nature photography. By working into the sun (above), this picture of a Nidderdale cow pasture in the Yorkshire Dales has assumed a dreamy, idyllic quality, while the photograph of the sheep on a Shropshire hillside (left) shows the fleece outlined in a halo of light. Backlighting can work well with birds, animals, wild flowers and dark-coloured insects.

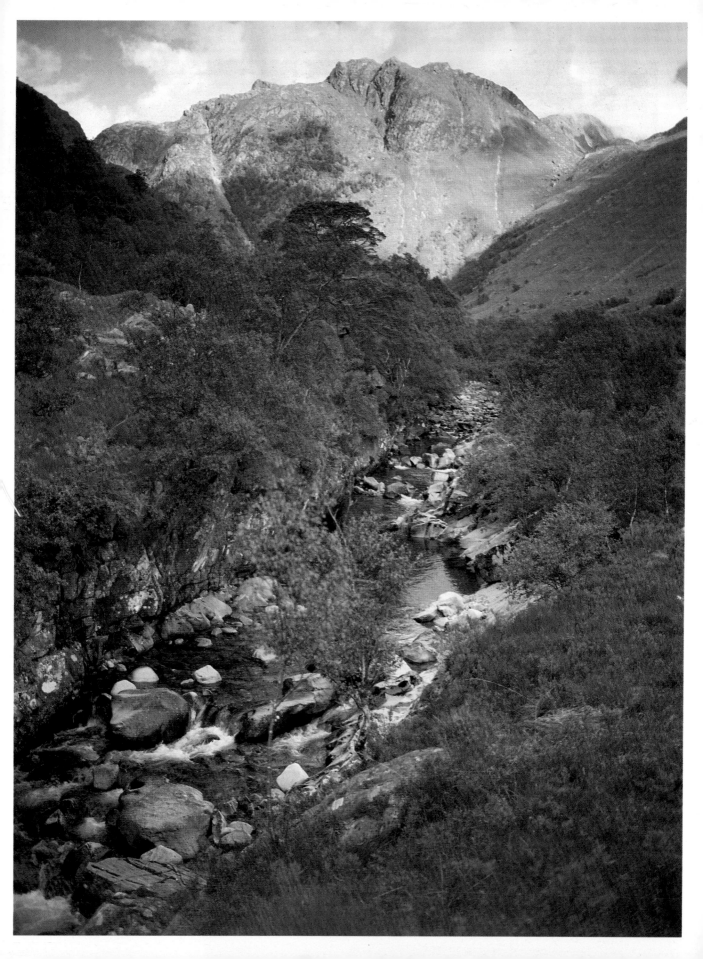

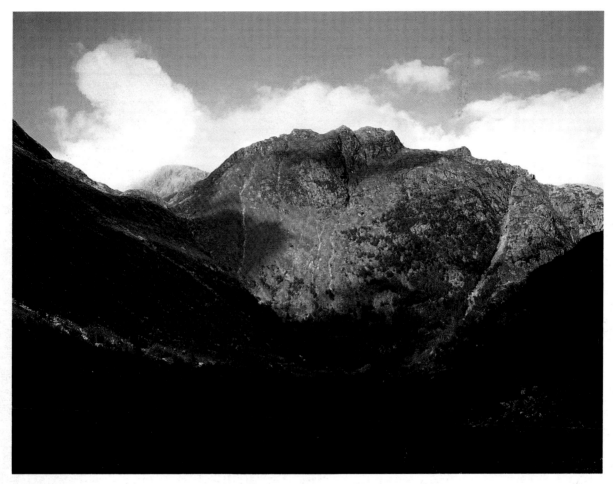

give the same overall exposure, that is, for the same total amount of light to reach the film. In other words, the smaller the aperture, the longer the time the film needs to be exposed to light in order to achieve the same effect. Opening the lens by one stop or halving the shutter speed without any other alteration doubles the total amount of light. In monochrome work the acceptable margin of error is around $^1/_2$–$^2/_3$ f-stop, but with colour transparency film it might be as small as $^1/_4$ f-stop. In any situation various combinations of speed and f-stop will offer correct exposure: $^1/_{60}$ at f/8 is the same as $^1/_{500}$ at f/2.8. At the same time, a lens is likely to perform better at f/8 than at f/2.8 and the depth of field will be much greater at the narrower aperture.

In any scene there are countless 'correct' exposures – at f/11 the sky might be metered at $^1/_{250}$ sec, a sunlit pasture at $^1/_{125}$ sec, a shaded tree trunk at $^1/_{15}$ sec, and so on, if they are all to be rendered at about the same tone. Quite complicated systems of such zone metering have been developed in attempts to calculate the best average camera setting. Most modern cameras offer an 'automatic' metering mode, and in simple situations more often than not this will provide the correct overall exposure. But one also needs to be able to override the automatic mode to cope with special conditions or effects, because all camera meters assume that all scenes average out to a mid-grey tone. Rather than becoming involved in elaborate sequences of spot metering and calculation, it is better for the beginner to decide on which key elements in a picture should be accurately exposed. Imagine, for example, a torrent with white foam which is flowing in a dark, wooded gorge. The meter reading for the trees might be $^1/_{30}$ sec at f/11, and for the

These two pictures of Glen Nevis and Meal Cumhann (left and above) were taken at virtually the same time and from almost the same vantage point. In the vertical format picture (left), I have exposed for the shady wooded glen, while in the horizontal format picture (above), I have exposed for the sunlit mountain. Both pictures 'work', but the effect and aura are completely different.

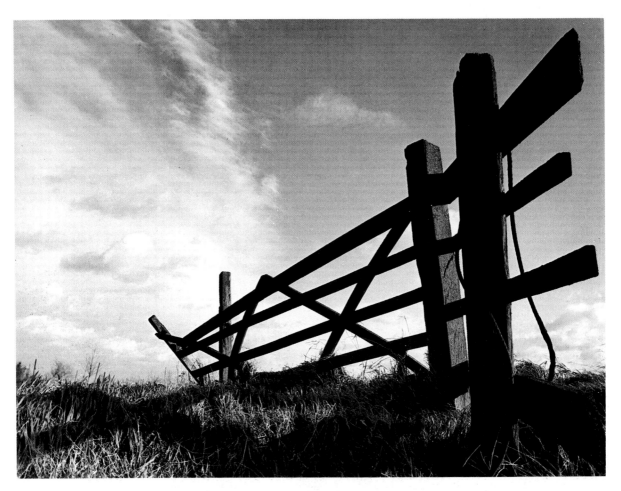

This picture was taken in the Fenland during a February gale. The starkness of the ruined gateway captures the bleak and chilly mood as well as any of the more obvious panoramas.

stream $^1/_{125}$ sec at f/11. If the stream is the focus of attention, then expose for it, and accept a dark and featureless wooded setting, while if the trees are the key features, expose for them and accept the rendition of the stream as a white streak. Alternatively, and at a rather more advanced level, one could choose an intermediate exposure of $^1/_{60}$ at f/11 and, at the printing stage, 'burn in' the stream detail and 'hold back' the woodland to preserve contrast (as described in Chapter 17).

There are still more questions to be considered: if you choose a shutter speed of $^1/_{30}$ sec you may not be able to hand-hold the camera steadily at this relatively slow shutter speed. You can mount the camera on a tripod, but the speed of $^1/_{30}$ sec will still be too slow to still the motion of the stream. Then you might decide deliberately to represent the rushing water as a soft white veil of motion, choosing a long exposure of something like $^1/_8$ sec at f/22.

To the beginner all such decisions will seem to amount to a difficult sequence of deliberation, but as you gain experience they will be made in seconds. It is best, if you are not sure, to make several exposures at different settings, particularly with colour slide film. You can then select the one that gives the effect you are seeking. Film is cheaper than a lifetime of regrets. The important thing is to be able to recognize what effect you want to achieve, and always to be in complete control of your camera, whether it be set in an 'auto', 'compensation', or 'manual' mode.

When photographing panoramas you must decide whether to expose for the land or the sky – usually, but not always, the sky is about 1 to $2^1/_2$ f-stops brighter than the land. Filters usually reduce the amount of light reaching the film by

between about $\frac{1}{8}$ and 3 f-stops, depending on the filter being used – although the modern camera's in-built through-the-lens system of setting exposure will make the necessary allowances. However, when using graduated filters to alter sky tones in colour work it is best to set the exposure before inserting the filter, otherwise the land may register in a slightly overexposed or wishy-washy manner.

Control over exposure is equally important in nature photography. It is not possible to photograph a black bumble bee on a pale pink dog-rose and select an exposure which will show both the delicate veining on the rose petal and the details on the body of the bee – the two subjects are around 3 f-stops apart. So, as in landscape photography, one must make decisions about which is the main subject of the picture and expose accordingly. In close-up photography the question of exposure is further complicated by the light-loss associated with lens extensions (as described in Chapter 1), and manual (as opposed to through-the-lens) metering becomes a time-consuming and complicated affair.

4 Seeing pictures

The acquired ability to see pictures in the countryside is absolutely essential to progress in landscape and nature photography. Anyone can stand on a summit and appreciate a panorama, but it is vital to realize that any patch of countryside is bursting with pictures, some vast, others just a few square centimetres in area, and

By *seeing* as well as looking you can recognize the pictures within the pictures – like foam at the foot of a waterfall, captured at close range with a 300 mm telephoto lens.

others still that are too small to see with the naked eye. Landscape and nature photography have many similarities, but they tend to occupy different areas on the spectrum of scale. In any panorama there are likely to be attractive field and hedgerow groupings which can be isolated from the scene to exist as pictures in their own right. Within these patches of countryside some trees are also pictures in their own right. Moving further in, the textures of bark can be very photogenic, while on many pieces of bark there are dramatic little landscapes of lichen, which are only revealed by the macro lens.

The still photograph has more in common with a framed painting or drawing than with some footage of movie film or video tape. In looking at landscapes it is useful to begin by imagining rectangular frames of all manner of different sizes. Sometimes the frame spans a waterfall or a group of cottages, at others it encapsulates a little growth of fungi, a flower head or a piece of moss. If a morsel from the environment *looks* well when isolated within an imaginary frame, it will also *photograph* well.

Being country bred I can go for a ramble with a 'townie' and point at distant rabbits or squirrels – and await the flattering comments about fantastic eyesight. In fact, though my eyesight is quite good, this has little to do with the ability to 'see' in the country. Countryfolk know that that little speck in the meadow is a rabbit because they are familiar with the hue, form and habits of the animals. There is nothing mystical about country lore, and acquired experience can greatly assist in the capture of telling pictures. For example, when walking along a not particularly photogenic country lane one might fit a 300 mm telephoto lens, knowing that one might stumble upon a crow or magpie picking at the corpse of a squashed rabbit, or else see a kestrel hunting above the hedgerows. Similarly, when rambling along cliffs to a seabird colony one could fit a macro lens and ring flash in the expectation that butterflies will be visiting the band of flowers which flourish in the narrow, herbicide-free cliff-top habitats.

The motor car is far more valuable than most photographic knick-knacks – at least it is when you have mastered the ability to drive safely and considerately while still appraising the landscape for tempting shots! The rear-view mirror tells you about the car behind, but also about the landscape behind. Often the car behind will prevent you from stopping, while a superb view may be poorly lit. Make a mental note of the location and aim to return when conditions are kinder.

Meanwhile, you should know your home area intimately, for here you have the opportunity to photograph vistas under the most perfect conditions. You will never exhaust the possibilities offered by a good local wood, meadow or wetland, and when I lived in dreary Cambridgeshire I would slip down the road with my cameras to Wandlebury Woods at least once a month.

If, so far, your pictures have been largely a source of disappointment then, more likely than not, you have been *looking without seeing*. It is not the expensive equipment which separates the master photographer from the throng, but determination, clarity of intent, and, above all, the ability to *see*. Cultivate this ability and eventually you will learn to 'see' in black and white as well as in colour – an important attribute in monochrome work. Then you can try to 'see' in infra-red!

5 Dedication, time and place

To capture a first-class picture you must be in the right place at the right time. How easy it is to dismiss this statement as a truism! Imagine two photographers, equally well equipped and able. Mary takes her cameras into the countryside once a week, Mark only once a month. Obviously, other factors being equal, Mary has four top-class pictures for every one that Mark can boast. Millions of people have spent around £200 on their camera and lenses, yet reel off just two or three films a year. If they ever take just one picture which does justice to their equipment it will

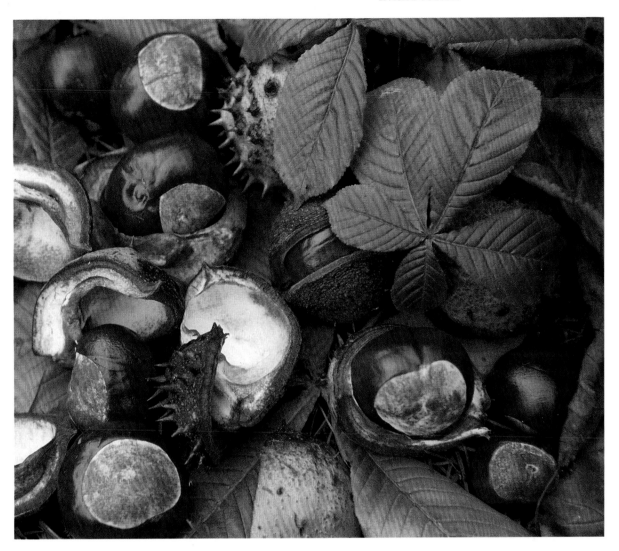

be a minor miracle, for nobody can take good pictures without gaining technique and experience by taking dozens of bad ones. If you regard each film as a very cheap lesson in photography, then you may be less miserly with film. A weekend photographic course can cost £100, a film costs between about £1.50 and £7, and at the end of the day the only person that can make you into a first-rate photographer is yourself. Mistakes are excellent, for by learning what will not work, you discover what will.

Most good pictures are the reward for a great deal of concentration. A really good photographer might take fifty very acceptable pictures in a day, and of these, as many as three or four could be superb. Watch such a photographer at work and the choice of vantage point, exposure, lens and composition might seem to be a smoothly automated process – but all the time you can be sure that he or she is expending a prodigious amount of concentration. (This is partly the reason why it is usually best to work alone.)

Determination is another vital attribute. If you only go out with a camera on settled sunny days, you will never capture the drama of a winter sunburst through lowering clouds. Go out in all seasons and conditions and you will be pleasantly surprised at the diversity and power of the images which accrue. Give your cameras a fair chance to show what they can do!

This cluster of fallen horse chestnuts captures the autumnal mood as well as any broad woodland vista (while Kodak Ektachrome 64 roll film does justice to the warm hues).

23

1
THE RIGHT STUFF
EQUIPMENT FOR LANDSCAPE AND NATURE PHOTOGRAPHY

Having the right equipment is as important in photography as in mountaineering. There are very clear distinctions between the demands of the two branches: successful landscape photography requires a modest collection of simple but good-quality gear, while success across the numerous branches of nature photography involves the purchase of a range of specialist items.

Types of camera for landscape photography

Most readers will know that the camera resembles the eye, with the film substituting for the retina and the diaphragm for the iris, while in both cases the image is focused by a lens. In essence the camera is a light-tight box – but these boxes come in all manner of shapes and sizes. Some we can reject without more ado. Apart from anything else, disc cameras and those of the 110 format produce images which are too small to be capable of worthwhile enlargement. The smallest format worthy of serious consideration is the very popular 35 mm size, producing 20, 24 or 36 negatives, each measuring 36 × 24 mm, on standard film. With the right sort of film and processing such negatives and transparencies should enlarge to produce crisp prints measuring at least the popular 8 × 10 inches (approx. 20 × 25 cm) format. The 35 mm cameras are of two basic types. Rangefinder cameras, like those in the old but renowned Leica range, have a viewfinder system which is separate from the 'taking' lens. A popular modern version of the rangefinder is the 'compact', the favourite of the holiday snapper. Top-of-the-range compacts may have very respectable lenses and sophistications such as automatic exposure and film winders. Even so they do not usually offer interchangeable lenses or the ability to accept various useful accessories. They are genuine pocket cameras and could be useful in specialist fields, like mountain photography and air photography from model aircraft. The old Leica and Contax rangefinder cameras can still produce superb results in landscape photography, but should not be considered by any readers wishing to use the more sophisticated accessories associated with nature work. Rangefinders offer the advantages of swift operation, bright viewfinder image and relatively vibration-free exposure without the momentary black-outs which occur with single lens reflex (SLR) cameras at the instant of exposure. They are excellent choices for sport and 'candid' photography, but lack the versatility of the more complicated SLRs, particularly in close-up work and with telephoto lenses.

By far the most popular camera for hobbyists and enthusiasts is the 35 mm SLR camera. Here the image 'seen' by the lens is reflected into the viewfinder prism by a mirror which swings up to expose the shutter and film at the instant that the

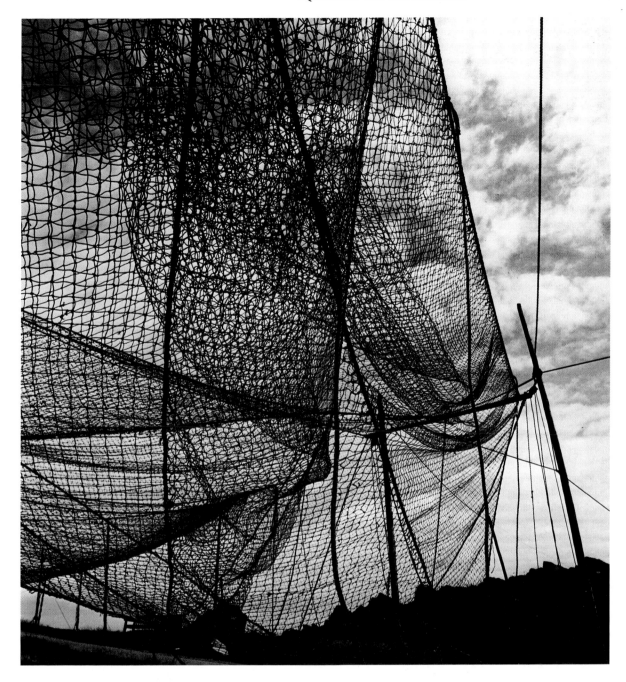

shutter release button is pressed. The better 35 mm SLRs (and in these days of refined development and intense competition most models are at least good) will accept a wide range of lenses and accessories. Any reader wishing to use a single camera for both landscape and nature work is strongly advised to adopt one of these cameras.

However, there will be others who will agree with me that the 35 mm format is too small for consistently excellent work in landscape photography, a field where the eye is drawn to any distant steeples, or twigs, or blades of grass which are not precisely defined. This brings us to the 'medium format' range of cameras, producing negatives of (nominally) 6 × 9 cm, 6 × 7 cm, 6 × 6 cm, or 6 × 4.5 cm

In photographs like this one, of fishing nets drying on a Grampian shore, where the resolution of very fine detail is vital, medium- or large-format cameras are preferred to the 35 mm format.

25

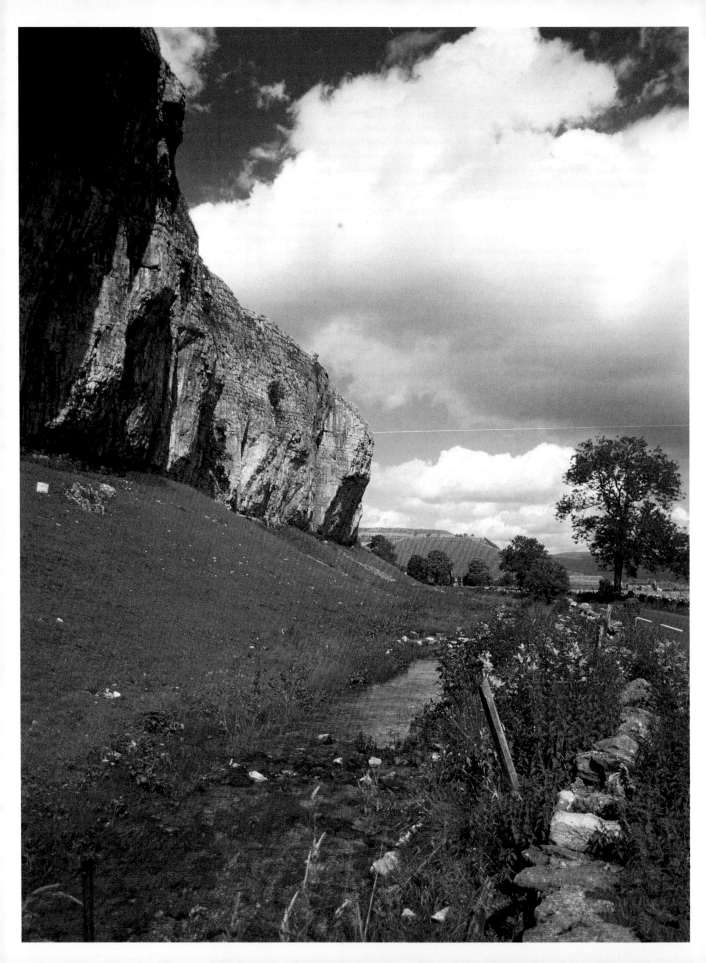

on 120 or 220 size film. One of the oldest chestnuts to emerge again and again in the camera press is the hoary debate about whether medium format beats the 35 mm format. As an unbiased user of both systems I can see no basis for such debates – with a negative size several times that of the 35 mm system, other things being equal, medium format is bound to allow larger, crisper enlargements.

Medium-format cameras are of various types. The Pentax 6 × 7 (i.e. 6 × 7 cm), with many devoted adherents, is a large and relatively unsophisticated version of the 35 mm SLR. Others, like the Mamiya 645s (shorthand for 6 × 4.5 cm), when fitted with pentaprism finders, and the Bronicas, are SLRs of a less familiar, box-like configuration. There are also the medium-format twin lens reflex (TLR) cameras, like the old Rolleiflex or the current Yashicamat, still a favourite with wedding photographers and formerly standard equipment for press photographers. Here a separate viewing lens is mounted above the 'taking' lens. As with the rangefinders, this separation renders the camera quite unsuitable for the close-up work associated with nature photography, while the waist-level viewing position will seem awkward to those who are not accustomed to it. A few TLRs accept interchangeable lenses, but while this system generally provides very sharp negatives and has often been used in landscape work, it is inflexible, limiting and not one that I would recommend.

The traditional medium-format negative size is 6 cm square. However, square-shaped pictures seldom work well in the landscape field and one can obtain better framing and three or four more exposures per film by adopting the 645 format. In recent years the range of camera choice has been expanded, with noted manufacturers, like Pentax, entering the 645 arena. Some medium-format cameras – like the Hasselblad and Bronicas – have interchangeable backs, allowing one to carry just a single camera body but several backs, each loaded with a different type of film. When forced by changing light conditions to work quickly this can lead to confusion, especially if you are tired – I prefer to use two cameras for landscape work, one loaded with ISO 125 monochrome film and one with ISO 64 colour film. There are persuasive arguments on each side.

There is no doubting the extra enlarging potential of work done in the medium format, but it is also necessary to consider the relatively high cost of the cameras, the slightly higher film costs and the extra weight and bulk associated with these outfits. Cameras available include the renowned and very expensive Hasselblads, the Pentax 645, the Bronicas and the Mamiyas. My pair of Mamiya 645s have survived years of the rough treatment which working cameras used in rugged landscapes must expect, and have never suffered a mechanical failure. In terms of the quality of images produced there is not a great deal of variation amongst different 645 models – all should produce excellent results, easily capable of 16 × 20 inches (approx. 40 × 50 cm) and bigger enlargements.

The final possibility is the large-format 'field' camera. These cameras, most commonly producing 4 × 5 inch (approx. 10 × 12 cm) negatives, are ideal for those who want to take small numbers of landscape photographs which are of exquisite quality and are capable of poster-sized enlargement. The (inverted) image is focused on a ground-glass screen at the back of the camera and the aperture is set according to readings from a separate exposure meter. Then a reversible film carrier containing two sheets of film is inserted, a protective slide removed and one sheet of film is then exposed. By working in this way one learns about the nuts and bolts of photography, and although the field camera may seem like a primeval monster in comparison to a modern SLR with its flashing LCDs and different programme modes, it does offer valuable sophistications. Different adustments of the lens panel and camera back, known as 'movements', allow one to change the angular relationships between the lens panel and film plane to control depth of field or modify perspective. There are other advantages too; a range of different film types can be carried in different holders while it is possible to process each sheet of film separately, giving it exactly the degree of

LEFT This picture of Kilnsey Crag, in Wharfedale, North Yorkshire, was taken with a 25 mm wide-angle lens, allowing the inclusion of the crest of the crag and the foreground wall and spring. Fujichrome 50 provides the fine detail and fresh green tones. Beginners should remember that wide-angle lenses can work well in the vertical as well as the horizontal format.

27

RIGHT An unconventional view of the ruined church on Burrow Mump, Somerset, showing the great depth of field available with a wide-angle lens. An orange filter helped to separate the (lightened) buff-coloured stump from the (darkened) grass and also intensified the sky tones.

development desired. Also, the large negative size reduces the need to carry a varied selection of lenses, a wide-angle and a standard lens or short telephoto generally sufficing. Rather than carrying longer telephoto-type lenses, you can simply enlarge the desired section of the negative. A field-camera kit is no more bulky than one for medium format, while a good second-hand camera – like my own rugged MPP MK7 – can be bought for the cost of a good new 35 mm SLR. You will, however, also need to carry a substantial tripod, for although field cameras were often used as press cameras, hand-holding for serious landscape work is quite impractical.

Lenses and accessories for landscape photography

The specification for a camera system for landscape photography is simple yet demanding. One may hardly ever need to use a shutter speed faster than $^1/_{250}$ sec, an expensive 'fast' lens, an autowinder or a flash gun, but whichever format is used the lenses should be of tip-top quality. (With regard to lenses, the appropriate focal lengths vary according to the format being used. Thus the 'standard' lens in 35 mm work has a focal length of around 50 mm; in medium-format work, one of around 80 mm, while in '4 × 5' work a 150 mm lens is about standard. Since the focal lengths of lenses used with 35 mm cameras now provide a universal language, these lengths are provided in this book, irrespective of the format concerned.)

A few photographers swear by the 50 or 55 mm 'standard' lens, the one that is sold with the camera, claiming that it has a 'natural' field of vision comparable to the human eye. Others regard it as an unhappy compromise between the landscape photographer's 35 mm wide-angle and the 90 mm lens favoured for undistorted portraiture. Not all landscape opportunities consist of panoramas with expansive foregrounds and sweeping cloudscapes, so it is worth carrying a standard lens for the more closely-cropped scenes.

In order to capture sweeping panoramas and scenes with sharpness apparently extending from foreground detail to the distant cloudscape, wide-angle lenses are needed. Traditionally the most popular wide-angle lens was the 35 mm medium wide-angle, but today improvements in lens-making technology have made the wider view of the 28 mm wide-angle the most popular choice. Both lenses have their uses. When working with two cameras, I carry them with a 28 mm lens fitted on the monochrome-loaded body and the 35 mm on the colour-loaded body. The underlying logic is that it is easier to crop monochrome negatives than colour transparencies, so that if there is a brief passage of exceptional lighting I am ready to capture the image with both cameras.

When properly regarded as a specialist lens for particular uses, the 135, 150 or 200 mm telephoto lens is very useful indeed. With its narrow angle of view it can pull in details like a distant church tower or tree silhouette and can be used to

Lens types

Short focal length (e.g. 24, 28, or 35 mm). Wide angle of view – gets more of the subject in but at a smaller scale.

'Normal' focal length (e.g. 45, 50, or 55 mm). Moderate angle of view – said to be about the same as that of the human eye.

Long focal length (e.g. 85 mm upwards). Progressively smaller angle of view as focal length increases – gets less of subject in but at a larger scale.

Telephoto Type of optical construction of lens which allows long focal length lenses to be made more compact.

Zoom Lens of variable focal length (e.g. 25–50 mm or 70–210 mm).

Mirror lens Type of optical construction used for some very long focal lengths (250 mm upwards), replacing most of the lens elements by two mirrors. This 'concertinas' the light path so that the lenses can be made very short. Aperture cannot usually be stopped down.

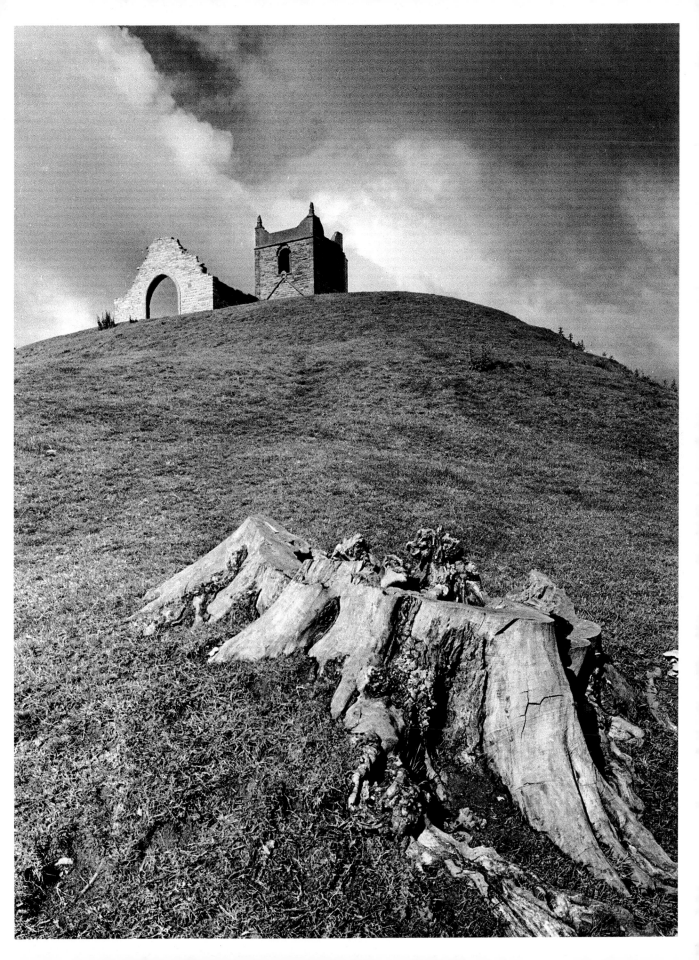

discover landscapes within landscapes – particularly when used from high vantage points. These features are available in a much more exaggerated form with a very powerful telephoto of 300–500 mm length – though the greater bulk and more limited usage of these lenses will often exclude them from the camera bag. Mirror lenses, resembling miniature reflector telescopes (usually with a focal length of 350, 500 or 1000 mm), are much more light and compact than comparable long optical telephotos and the best provide tolerably sharp images. They are delicate instruments and must be handled with care. A few models offer a choice of aperture, but most offer a fixed aperture – usually f/8 in the 500 mm length and f/11 or f/13.5 in the more powerful models. Some users complain about the doughnut-shaped out-of-focus highlights associated with mirror lenses, though these are only intrusive when the highlights are very bright.

Budding enthusiasts should build up a lens kit gradually, and those who are mainly interested in landscape work could find the following suggestions useful.

Suggested lens selections

Lens	Number of lenses carried					
	1	2	3	4	5	6
24, 25, 26 or 28 mm	×	×	×	×	×	×
35 mm			×	×	×	×
50 or 55 mm				×	×	×
90 mm						×
135, 150 or 200 mm		×	×	×	×	×
400 or 500 mm					×	×

By this time many readers will have remarked that the use of teleconverters or zoom lenses will reduce the number of lenses carried and provide a greater range of available focal lengths. Teleconverters are small lenses which fit to the mounts of the conventional photographic lenses and variously increase their focal lengths by × 1.5, × 2 or × 3. This convenience is bought at the cost of lens speed and image quality. The teleconverter effectively reduces the maximum aperture of the lens by about the same amount that it increases focal length, so that a × 2 converter will roughly reduce a lens setting of f/11 to f/22 – but without the increased depth of field normally associated with the smaller aperture (because focal length is increased). Loss of quality varies from converter to converter, with the more expensive examples with seven lens elements tending to perform better than those with four elements. A very good lens capable of resolving 110 lines per millimetre will generally become a mediocre performer resolving about 70–75 lines per millimetre with a good teleconverter attached, while lens contrast also suffers.★ In a few situations the economies of weight and space furnished by one of these lenses argue in their favour, though they are not generally to be recommended.

Zoom lenses enjoy a great deal more popularity. Some manufacturers claim that their zooms eliminate the need to carry any other lenses, and with models now available which zoom to cover a vast range of focal lengths from 35 to 200 mm and also offer a special close-up or 'macro' facility, there is at least something in this claim. Until fairly recently it could be argued that in terms of optical quality

★Note that lines per millimetre resolution figures are not entirely reliable as there are so many ways in which the figures can be inflated.

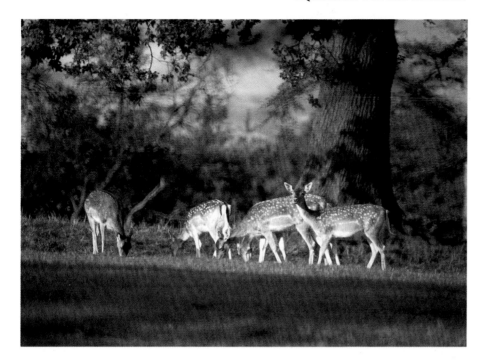

This group of fallow deer was photographed on Fujichrome 400 film (which has provided good colour saturation for such a fast film) with a 500 mm f/8 mirror lens. Note the shallowness of the depth of field provided by the extremely long focal length of the lens; although the deer were over 100 metres from the camera, the depth of apparent sharpness does not extend from the outer foliage to the trunk of the oak under which the deer are standing.

zooms bore no comparison with fixed-length lenses, though this is no longer so. Most popular are zooms covering the 70–210 mm telephoto lengths. Personally I prefer a compact wide-angle to standard zoom lens, covering the 25–50 mm range, which substitutes for three lenses, while using fixed-length telephotos. Wide-angle zooms and those in the 35–80 mm range used to turn in poor results, but modern advances in lens technology make them an interesting possibility. Quality apart, the zoom with an extended range and those in the 70–200 mm field tend to be unwieldy and zooming is an additional task to those of metering and focusing. At the same time, the zoom facility provides precise framing (most useful for colour slides) and so avoids the loss of quality which would be caused by cropping a negative during enlargement.

Whatever lens is used in landscape photography, it should be of the top quality. The most important features of a lens are the sharpness of the image produced, and the rendition of contrast and colour. Most lenses undergo tests which are published by the various photographic magazines, and most also deliver their best performance in the region of the f/5.6 to f/8 setting. Some features of lenses are difficult to quantify simply, but in terms of sharpness one should look seriously at lenses which resolve *at least* 100 lines per millimetre at f/8 and do not resolve less than 70 lines at the extreme settings.

Tripods

Most photographers who work outdoors have a love/hate relationship with their tripod. For close-up work using natural light the tripod is indispensable, and in landscape work it permits the use of long lenses and the small apertures needed to achieve a good depth of field. Large-format cameras are seldom used hand-held. The advantages which tripods provide are bought at the expense of carrying a burdensome and awkward piece of equipment. Tripods which are both light and compact will not provide the stability necessary for long exposures with long lenses. Two tripods have given me excellent service. The Benbo has a unique construction which allows it to be used in any conceivable situation and is sufficiently rigid to support a large-format camera. (A low-standing version, the

31

Despite what some critics have said, mirror lenses can produce sharp images, as the feather detail in this picture of a young kestrel shows; it was taken with a Tamron 500 mm f/8 mirror lens. Soft images will result if users do not appreciate the importance of precise focusing when using long lenses.

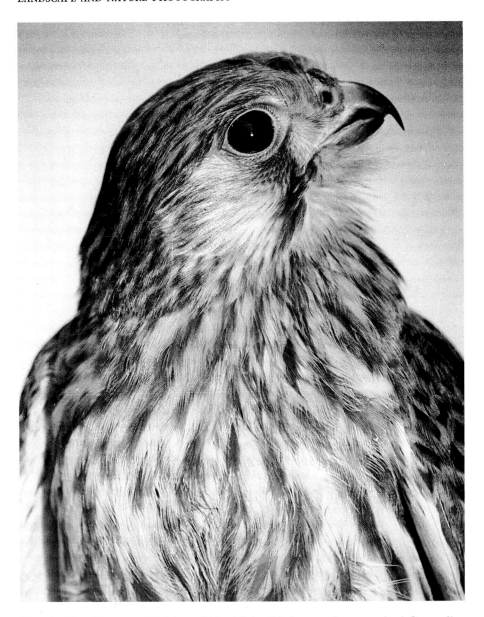

Baby Benbo, is more portable and ideal for wild-flower photography.) Secondly, the Posso is a relatively light tripod which will support a medium-format camera and has an ingenious and versatile construction which offers an unrivalled speed of operation. Detachable brackets allow its use in conjunction with a pair of flash guns. As insurance against being caught 'without visible means of support', I carry a miniature or 'table-top' tripod strapped to my camera bag. I have little faith in the genre, but with luck one could hope to take sharp close-up pictures with a 90 mm lens at $^{1}/_{15}$ sec using such a tripod.

It is wrong to assume that any tripod will result in sharp exposures at any shutter speed in outdoor conditions. One should always seek maximum stability by pressing down steadily and firmly on the tripod during exposures.

The monopod is a telescopic leg fitted with a camera mount. It can be a very useful aid in situations in nature photography when speed of operation and portability are important factors – as in bird stalking. No guarantees are given, but with a monopod support one should be able to use a 500 mm lens at $^{1}/_{250}$ sec and

might get away with using $^1/_{125}$ sec. Special hand grips and shoulder supports are available for use with heavier and more powerful telephoto lenses. Using a shoulder support, one might reasonably expect, for example, to use a 500 mm lens at $^1/_{250}$ sec, though, as with monopods, a measure of luck is involved.

Filters

A set of colour filters completes the basic kit for landscape photography. Orange, yellow-green and red filters are useful for monochrome work, with skylight, polarizing and graduated blue filters being used with the colour camera. The specific uses of different filters are shown in the following tables, and so we can proceed to the more complex outfits used by serious nature photographers.

Filters for use in colour photography

Filter	Kodak Wratten Number	Comments
Skylight	1A or 1B	Reduces excessive blueness in pictures taken under a clear blue sky, or in shaded areas within sunlit landscapes. Often kept in place for lens protection.
'Morning–evening'	82A	A very pale blue filter which reduces slight reddish cast in pictures taken around sunrise or sunset. But first decide whether you want to retain the 'golden' characteristics of such lighting. Can reduce unattractive pink rendering of blue flowers.
'Warming' or 'cloudy'	81A	A very slightly yellowish filter which can be used with discretion to reduce the excessively blue shadows in snow scenes, or to 'warm' other bluish scenes, like mountain scenery or seascapes.
Polarizing		When used at an angle of around 90° to the sun (see p. 97), this will control sky tone and sky reflections and can also be revolved in its holder to intensify colours like blue and green and modify water colours. A very useful filter.
80A	80A	Allows daylight film to be used in the studio with household lamps or studio lights. Filter needs to be used with a considerable increase in exposure – consult the leaflet packed with the film.
80B	80B	Allows daylight film to be used in the studio with photofloods. Filter needs to be used with a considerable increase in exposure – consult the leaflet packed with the film.
Graduated filters		These usually produce ugly, gimmicky effects. A graduated blue filter will strengthen a weak blue sky, while a graduated tobacco might be used, sparingly, to create brownish cloud tones.
Star-burst		Four-, six- or eight-point star-burst filters produce radiating rays of bright light from powerful sources. Can be used in some into-the-sun shots to produce effects which do not always seem too phoney. Similar effects are obtained by stopping the lens right down.

Filters for use in black-and-white landscape photography

Filter	Kodak Wratten number	Additional f-stops required in normal daylight	Comments
Yellow	8	1	Slight darkening of blue sky which accentuates cloud patterns, slight lightening of foliage and haze penetration.
Deep yellow	18	2	More pronounced effect than the normal yellow filter, which is often too weak to establish the desired effects.
Orange	21	$2\frac{1}{2}$	Significant darkening of blue and slight darkening of vegetation. Tends to produce punchy, contrasty images in sunlit conditions.
Red	25	3	A dramatic darkening of blue sky and water, good haze penetration and significant darkening of vegetation. Can intensify contrast in already contrasty situations – such as a sunlit harvest scene. Used sparingly and selectively can produce impressive, heavy, moody images. Essential in infra-red work.
Green	58	3	Lightens foliage and darkens blue sky. As with the similar but less intense yellow-green filter, this filter can underline contrasts in foliage on a dull day, and tends to give stone features an interestingly cold rendering.
Polarizing		Around $1\frac{1}{2}$	Darkens blue sky and controls reflections. Most useful used in colour work for intensification of colours and diminution of reflections.
Blue	47	$2\frac{1}{2}$	Little value in landscape photography, except for exaggeration of haze effects. Various pale blue filters are used in nature colour photography to re-establish blue in flowers and modify colour temperatures of some light sources.

Equipment for nature photography

Recent years have witnessed staggering innovations in the development of competitively-priced camera equipment. Some of them are gimmicks, some are of value only to holiday snappers who have no inclination to explore the technicalities of the craft but desire tolerably presentable sets of prints, while other innovations are so useful that they advance the frontiers of photography and are soon regarded as indispensable. Foremost in the last named category is the TTL or OTF ('through-the-lens' or 'off-the-film') flash facility, and anyone seriously considering a hobby in nature photography would be ill-advised to purchase a camera which did not offer this mode, which is described below. In

ABOVE An 8-point star filter was used to produce this sunburst effect. In general 'effects' filters are best avoided. A similar sunburst could have been produced by using a very small f-stop, but on this occasion a strong wind ruffling the autumn foliage necessitated a relatively fast shutter speed and a relatively wide f-stop. An exposure reading was taken from the sunlit foliage, avoiding the sun itself.

LEFT Beautiful wing detail on a (living) painted lady butterfly photographed with a standard lens reversed on extension tubes. Using TTL flash this was a relatively easy picture to accomplish – without flash such a picture of a live and free subject would have been much more difficult.

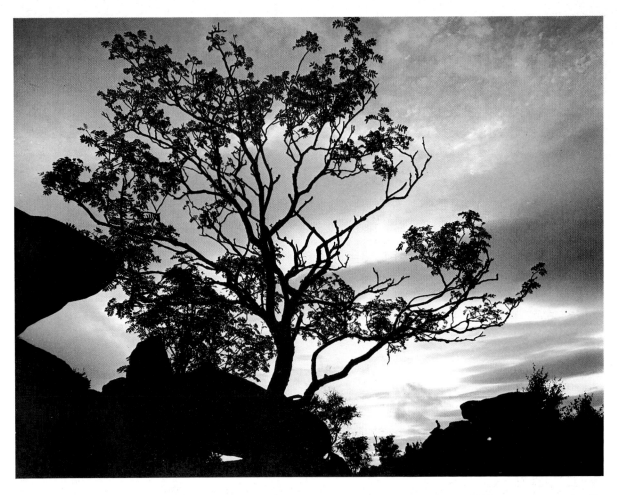

ABOVE AND RIGHT Both these pictures are silhouettes, but the metering and exposure techniques used were different. In the photograph above, of Brimham Rocks in North Yorkshire, the camera is pointing directly at the setting sun, which is so bright that an automatic exposure successfully renders the rowan tree growing on the crags as a silhouette. In the picture to the right, taken at midday during a thunderstorm at the edge of the Fens, the centre-weighted metering would have tried to compromise between the dark land and bright sky if used in the automatic mode. Since I wanted a silhouette effect, I locked in a reading from the bright sky.

contrast, automatic focusing is a sophistication which is likely to be more of a nuisance than an aid in nature photography, particularly when the subject which one wishes to be sharply focused is not centrally placed in the viewfinder. (However, it is a great boon to those with very poor eyesight.)

Many modern SLRs offer a range of programmed automatic exposure modes, some, like the 'TV mode' for photographing television images, being of no interest to the nature photographer. Automatic exposure is a distinct advantage, especially when one is obliged to work at speed. However, all that is needed is an 'aperture-priority' mode and a manual or a compensation mode. In the aperture-priority mode one sets the desired f-stop – normally with depth of field as the prime consideration – and the camera selects an appropriate shutter speed. LCDs in the viewfinder should allow one to decide whether the speed is sufficient for the lens being used. In 35 mm work this is normally a speed equal to or faster than the figure describing the focal length of the lens: $^1/_{50}$ sec for a 50 mm lens, $^1/_{125}$ sec for a 135 mm short telephoto, and so on, providing the photographer has reasonably steady hands. Shutter-priority modes work in the reverse manner, with the photographer selecting a shutter speed and the camera the aperture. However, so long as the shutter speed is indicated in the viewfinder display, an aperture-priority mode can be used to select a shutter speed simply by adjusting the aperture setting till the desired speed is marked.

The automatically determined setting will not always be ideal. For example, a brilliant white seagull with a dark rock background will require less exposure than the camera meter allows if its feather details are not to seem bleached out. So, in

36

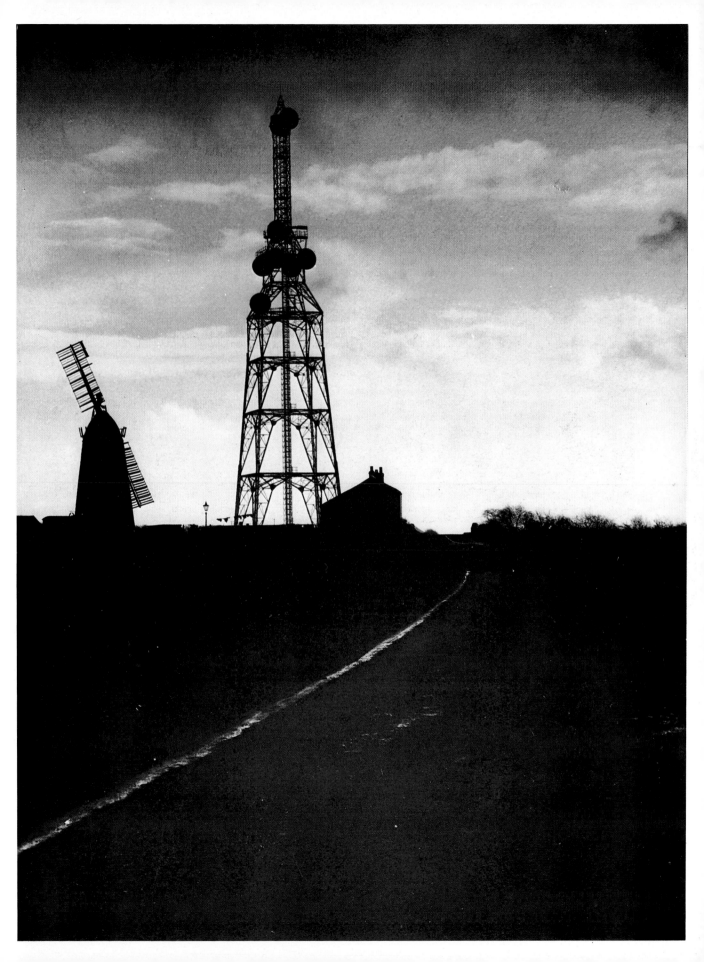

addition to the aperture-priority mode, you also must have either a full manual exposure mode, or a compensation dial which allows the setting to be overridden by 2 f-stops in either direction. Where such a mode is not provided a camera can be 'foxed' by adjusting the film ISO setting. There is nothing intrinsically wrong with the modern multi-mode camera, though when working under pressure it is easy to confuse the different modes offered and the two modes described are all that are needed.

Different types of metering systems are available and one should know which is being employed. The centre-weighted type, which is biased toward the central area of the image, is the most common. Spot metering enables one to take readings from smaller sections of a subject or area and allows the precise calculation of exposures, but it can cause problems if working rapidly, when the area metered may not be representative of the general scene.

Autowinders are devices which automatically advance the film, and the more sophisticated models offer single-shot and continuous-shooting settings. Motor drives provide a more rapid rate of advance, perhaps five frames per second, and a dozen or more in the case of expensive Canon and Nikon units. But a much cheaper good autowinder, providing three frames per second, should be adequate in most situations. An autowinder is virtually essential if a camera is used in conjunction with a remote trigger device, but is otherwise mainly useful for a rapid sequence of shots of fast action – like birds in flight or fighting stags – and it allows one to keep the eye to the camera in sequence shooting.

The uses of remote triggers are described in the chapters which follow. They come in various different forms and can be activated by sound, light, or infra-red beams, or by the breaking of such beams. The two most useful types are those which have a hand-held infra-red beam trigger and a receiver connected to the shutter release socket, and those which trigger the camera when a subject breaks an invisible infra-red beam running between a transmitter and a receiver. The former type allow a photographer standing well away from a subject to trigger a pre-focused camera at a chosen instant, while the latter type allow one to leave the equipment completely unattended. Where cameras lack electronic shutters, a solenoid device attached to the camera must be used in association with the remote trigger. A cheap but inferior substitute for the hand-held infra-red beam trigger is a long tube and air-bulb release, which will trigger the shutter when the air bulb is squeezed.

Cameras should be fitted with light nylon shoulder straps. Avoid the garish types and those fitted with metal clasps and swivels, which can jangle and frighten a shy subject.

Taking the various relevant factors into account we can write a demanding specification for the ideal camera for nature photography. Firstly, there is no doubt that the 35 mm SLR is the most versatile and convenient type of camera. It should offer TTL flash metering, and aperture-priority and manual or compensation metering. It should have an electronic shutter and a comprehensive display of viewfinder information, while an integral autowinder is an extra advantage available with the Canon T70, Pentax A3, Contax 137MA and MD, and the Nikon F-301. To this list of requirements we can add a stop-down button on the camera body or lens, allowing one to preview the depth of field provided by a selected f-stop setting. Finally, a black body devoid of chrome is preferable when camouflage and concealment are important factors. My own choice from the very limited range of fully qualifying candidates: the Contax 137 MA or, more economically, a second-hand Contax 137 MD.

Getting in close

Many of the most effective natural history photographs are close-ups or extreme close-ups. The typical 'standard' lens does not allow one to approach and focus a

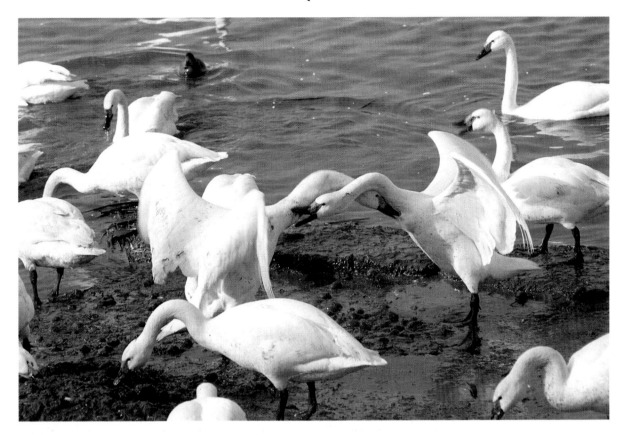

subject much closer than about half a metre (this varies from lens to lens) and does not perform very well at short distances. *Close-up attachment lenses or filters* can be mounted in front of the lens to allow shorter working distances. They are a cheap but poor alternative resulting in rather inflexible working conditions and mediocre images. Normal lenses are designed to produce their best results when focused at infinity and are likely to be poorer performers at short working distances. *Reversing rings* allow such lenses to be reverse mounted on the camera body, when they become extremely effective close-up lenses, although in this position the automatic diaphragm coupling is lost and the resultant 'stopped-down' mode produces viewfinder images which become increasingly murky as the aperture is reduced. *Extension tubes* are normally sold as sets of three hollow cylinders which can be mounted between a camera lens and body to produce variable extensions of the lens and consequently the facility to take close-up photographs at a high magnification. The better types retain the automatic diaphragm coupling but can do nothing to overcome the inherent problems of non-macro lens construction. When a standard lens is reversed and mounted on extension tubes high magnifications are achieved, and even higher ones are possible with reversed wide-angle lenses. *Bellows* are a more fragile but sophisticated form of extension tube and provide a full range of extensions. Used in the field they are unwieldy and the fabric of the bellows concertina is prone to damage. However, when used in the studio in conjunction with purpose-built bellows lenses they permit work of the highest quality. The more expensive models have automatic diaphragm couplings and an adjustable lens mounting board permitting effects comparable to the movements of the plate camera, allowing one to manipulate the depth of field, which is very limited at high magnifications.

Macro lenses are the best single choice of equipment for close-up photography

Fast reactions are much more valuable in nature than in landscape photography. If I had missed the instant when the necks of these squabbling Bewick's swans were intertwined, then the picture would be unremarkable. The whiteness of the swans and the clear March sunlight has allowed the use of a 300 mm lens and a fast shutter speed with relatively slow Kodachrome 64 colour film, giving good feather detail.

39

These pictures represent different stages in magnification. The spider's web (right) was taken using a modest extension on a macro lens with natural lighting. The moss (below) was photographed using bellows; a 100 mm bellows lens and studio lighting. The moth eggs (far right, above) are just visible to the naked eye and were photographed through a low-powered microscope eyepiece and objective lenses with sidelighting from a microscope lamp to produce the sculptured form. The diatoms (far right, below) are invisible to the naked eye and were photographed through a powerful microscope using conventional microscope sub-stage illumination.

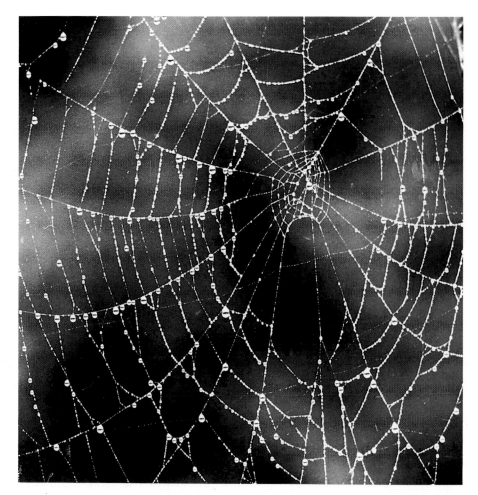

and are specially constructed for work of this type. They are mainly available in 50 or 55 mm and 90 or 100 mm focal lengths. The 90 or 100 mm length is generally preferable, as it allows one to work further from shy subjects, such as butterflies and other insects. The macro lens is an essential piece of equipment for the serious nature photographer, but like other systems which increase the distance between the lens and the film, it is associated with a loss of light which affects exposures. Many photographers are unaware that a small light-loss of around $^1/_4$ f-stop is incurred when a conventional lens is focused from infinity to its closest focusing distance, but when you wind out a macro lens like a 90 mm Elicar or a 105 mm Kiron the light-loss becomes quite severe. In technical terms the doubling of the distance of the lens from the film apparently reduces the aperture by 2 f-stops, so that f/8 becomes effectively f/16. TTL metering and TTL flash metering will automatically compensate for such light-losses, but external separate metering and manual or auto flash require the calculation of compensations. Fortunately some compensations are normally marked on the barrels of macro lenses, though work is smoother and swifter with TTL systems which allow one to concentrate on framing and focusing. The construction of most *zoom lenses* allows them to offer what is billed as a 'macro' facility. In fact this is usually a very modest close-up capability of around 0.25 life-size and the quality of the image bears little comparison to that provided by a true macro lens.

In photographic parlance an image scale of 1:1 relates to an image which is reproduced life-size *on the negative*. Some macro lenses are built to produce images up to half life-size and achieve 1:1 magnification with the addition of extenders. The Tamron 90 mm macro is an excellent performer of this type. A few will operate right up to a 1:1 magnification – like the superb Elicar 90 mm which I favour. The growing popularity of nature photography has encouraged other independent manufacturers, like Kiron, to enter the field. Magnifications beyond 1:1 are relatively easily achieved by mounting macro lenses on extension tubes, by mounting reversed lenses on extension tubes or bellows, and by mounting wide-angle lenses on reversing rings, as described, though with each increase in magnification the depth of field diminishes and the problems of camera shake increase.

When working close up – at image scales from about 1:4 and greater – it is not practical to focus on the subject by turning the lens's focusing ring with the camera to the eye, because you have to adjust the camera-to-subject distance at the same time, often in what seems to be the illogical direction. Instead, set the camera as closely as possible to the desired magnification and then, with the eye to the viewfinder, move the camera towards the subject until it is in focus.

Very high magnifications can be achieved by mounting a camera on a microscope. The most effective system is one which dispenses with the camera lens but retains the microscope eyepiece lens. A special tube links the camera body to the barrel of the microscope and, if not obtainable from the manufacturers, such camera mounts can be constructed to order by SRB Film Service Instruments (see p. 233). Special microscope lenses, like the Zeiss Luminar series, have built-in diaphragms allowing the use of small stops to maximize depth of field, and, like other microscope lenses, they can also be bellows-mounted on a special mounting board.

Unfortunately there is an awkward gap between the maximum magnifications which can be achieved without recourse to microscope optics and the lowest power available through combinations of weak microscope eyepieces and objective lenses. The table summarizes the equipment which can be used to obtain different magnifications.

Thanks to the development of 35 mm SLR cameras with TTL exposure and TTL flash metering systems, close-up work of a high quality is much less difficult than the beginner might imagine, though many challenges still remain. Perhaps the greatest of these concerns the shallow depth of field, which becomes shallower

Magnifications obtained with different equipment

System used	Degree of magnification		Comments
1 Standard lens at minimal focusing distance	Around 0.1.		Good lenses perform relatively poorly at shorter lens-to-subject distances.
2 Close-up attachment lenses	Around 0.2 or 0.3 depending on strength of lens used.		Sometimes loss of image quality with more glass between subject and film; results of quality comparable to those obtained with extension tubes possible if lens used at f/11.
3 Most macro lenses	Up to 0.5.		Good quality and ease of use, but extenders are needed to achieve 1:1 magnification.
4 Standard lens with extension tubes	Up to 1.0, or even beyond, depending on number of tubes used.		Lens performance going from mediocre to poor as extension increases. A cost- and quality-cutting substitute for a macro lens. Time is lost in adding or subtracting tubes.
5 A few macro lenses, like the 90 mm Elicar and 105 mm Kiron	Up to 1.0.		Good quality and ease of use, but tripods or ring flash usually needed at maximum extensions.
6 Standard lens reversed	Around 0.75.		Good quality at high magnifications, but inflexible. Loss of lens-camera coupling and a dim viewfinder image. Must use stopped-down metering but TTL flash still works.
7 Standard lens reversed on extension tubes	Around ×2 with three tubes.		Good quality, but intensifies the problems described under 6. Probably the most convenient system for high-magnification work in field conditions, especially when combined with TTL flash.
8 Wide-angle lens reversed on extension tubes	Around ×3 to ×4 with three tubes, depending on normal focal length of lens.		Good quality, but still further intensifies the operating difficulties described under 6.
9 Bellows with various lenses and reversed lenses	Depends on amount of bellows extension provided. Perhaps ×1.5 with 100 mm bellows lens to ×0.6 with a 25 mm wide-angle. With a 25 mm lens, reversed magnifications up to ×10 could be achieved.		Bellows are rather too fragile for use in the field, but excellent results at high magnifications can be achieved in the studio if reversed conventional lenses or special bellows lenses are used. Most expensive bellows retain lens-to-camera couplings and provide a range of movements. At high magnifications a very substantial tripod is essential.

Diminishing depth of field
Increasing problems of camera shake

System used	Degree of magnification	Comments
10 Microscope lenses mounted on bellows	Very high, depending on the strength of the microscope lens used.	Provides high magnification but very steady support is needed, even when flash provides illumination. Very shallow depth of field, though Luminar type lenses provide choice of apertures.
11 Microscope-mounted camera	From around ×15 upwards.	The only practical method for very high magnification photography. Requires a special microscope adaptor but relatively easy to use if camera has TTL exposure and TTL flash metering.

as magnification increases. This requires the use of the smallest possible f-stops and very precise focusing, which is particularly difficult with stopped-down reversed lenses or microscope lenses mounted on bellows. Since camera shake and subject movement are also magnified in the close-up mode, it is not easy, for example, to hand-hold a camera with a fully extended macro lens which is made front-heavy by a ring-flash attachment and produce a picture of, say, a wasp which is sharp in every dimension. Using a ring flash and a reversed standard lens on extension tubes the practical problems of focusing are considerable and one is always struggling to make the desired zone of sharp focus and actual zone of apparently sharp focus coincide. When working without a tripod always try to exploit any surface which will support your elbows.

Illumination in nature photography

The nature and quality of illumination play vital parts in determining the quality of the results. A variety of different types of illumination are appropriate in particular situations: natural light; natural light with fill-in flash; light from single, paired or multiple flash guns; ring flash, and studio spotlights. Under overcast conditions natural light has a soft, diffused quality which may be hard to beat. In practical terms, however, natural light is often too weak or too soft to be suitable for close-up work. Flash from a single source can be an effective fill-in for shaded areas, but a single flash source alone, whether mounted on or off the camera, will seldom prove attractive. It is common practice to use pairs of flash guns of different power mounted offset on either side of the lens. The more powerful gun is the main source of illumination, and the weaker gun provides a fill-in to lighten and soften the shadow areas. This is a versatile and effective form of illumination which emphasizes the moulded form of the subjects, be they fruits, flowers or fieldmice. The Kennett Macroflash is an ingenious mount which allows the guns to be held in a wide range of positions, while a third gun can be accommodated to provide backlighting in close-up work. This is a slightly unwieldy but very valuable accessory.

A ring flash consists of a power pack and a flash tube which completely encircles the camera lens. In close-up work the light, coming from all directions, is virtually shadowless and has a bright but soft quality which is usually pleasing and distinctive. Being designed for close-up work, ring flashes are not very powerful, and the rapid fall off in the intensity of the light produces dark backgrounds if subject and background are well separated. Sometimes this effect is attractive, but often it is not. Units come in various forms and degrees of sophistication. One of the cheapest is the Starblitz 1000, which can be recommended to beginners. The

Elicar Auto Macro 8 is a very useful and quite powerful unit in the middle price range, while the Sunpak Auto DX 8R is a powerful unit with the invaluable sophistication of dedicated TTL metering when mounted on appropriate cameras (i.e. metering dedicated to integrate with the particular system used by the camera manufacturer). An unusual type of flash gun for close-up work is the Canon Macrolite, somewhat intermediate between paired flash guns and ring flash. Two small flash guns are mounted on either side of the lens and the results seem rather more moulded than those achieved with conventional ring flash. Relatively shadowless lighting is achieved when both units are fired, more modelling when just one gun is fired.

Most flash guns offer an automatic exposure mode, though this is much less useful in nature photography than in general snapshot work. The flash gun has a light-sensor mounted on the gun which controls the amount of flash, normally so that you can work at a given f-stop over a range of distances. No allowance is made for the extra exposure needed to compensate for different macro lens, bellows or tube extensions, or for the higher magnification, and therefore significant loss of light, resulting from lens reversal. TTL flash allows for all such factors, but without the facility it is best to work in the manual mode, then compensate for the use of various types of close-up equipment, and then compensate further for the relative lightness or darkness of a subject – which by this time may well have wandered away. Manual exposures are calculated from the manufacturer's guide number, an index of the power of a flash gun (that is, the distance over which it is effective) in its maximum or manual mode. The well-equipped nature photographer will own a selection of flash guns in order to cover a variety of different options. Most useful is a reasonably powerful TTL dedicated gun with a guide number of at least 30 (metres) and a weak manual gun with a guide number of around 15 which can be used for fill-in illumination. Unfortunately the independent manufacturers often overstate the power of their units, and these guide numbers should always be checked against a reliable flash meter. The table overleaf will assist in the calculation of exposures, but any reader seriously considering a hobby in nature photography should evaluate the relative costs of buying TTL flash equipment, or buying non-TTL cameras and guns – and then selling them in order to obtain the far more effective system.

Readers lucky enough to have a spare room which can be used as a darkroom should consider using one half of the room as a studio. This would provide highly controlled conditions which are particularly suitable for close-up work involving insects, fungi and plants, while a vivarium and fish tank could also be included. Basic studio equipment could comprise a heavy tripod, bellows unit, 100 mm bellows lens, ring flash, two or three flash guns of different power and a couple of small studio lights: an expensive set-up I must admit! Costly corners can be cut by using table or Anglepoise lamps as light sources and a slide projector as a microscope or high-intensity lamp. However, for colour work it is necessary to discover the 'colour temperature' of the hi-jacked light sources and to fit the appropriate blue colour correction filter to the camera lens, otherwise the results will have an unacceptable orange cast.

Studio conditions allow the photographer to achieve exactly the type of illumination and depth of field desired. At the same time care is needed to ensure that living subjects are not scorched by the heat from the lamps.

Project: An inexpensive experiment with studio-lighting techniques

From time to time you may want to achieve a degree of control which is not possible under field conditions, and a system of illumination which is very effective for a wide range of natural history subjects can be created relatively cheaply in a corner of the living room. Obtain an attractive selection of hedgerow

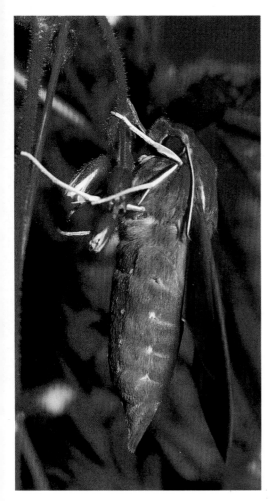

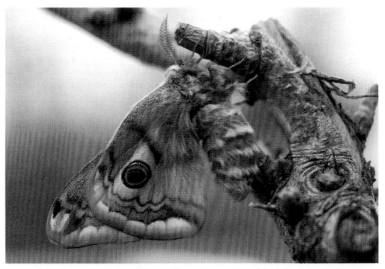

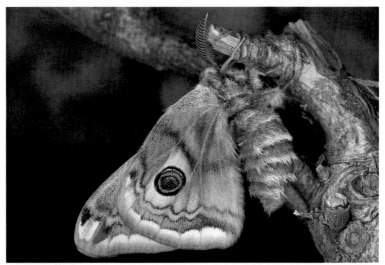

ABOVE An unusual form of illumination for serious nature photography: a single TTL linked flash gun set to one side of the subject. The elephant hawk-moth is our most colourful native moth.

RIGHT These photographs of a newly-emerged emperor moth epitomize the character of different types of illumination in nature photography. TOP Diffused daylight, giving a soft, natural effect. CENTRE Ring flash, giving a crisp, nearly shadowless result. BOTTOM Main and fill-in flash guns mounted right and left of the subject respectively on a macroflash unit to give a sculptured effect.

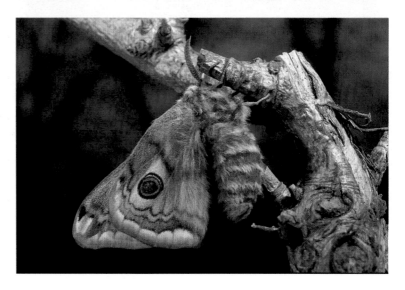

A guide to exposure compensations using flash manually

Methods and subjects	Approximate compensations
Standard lens reversed	$+1$ stop
Bellows: loss of light increases with extension	At 1:1 magnification, $+2$ stops over infinity setting with any lens
28 mm lens plus narrowest extension tube 28 mm lens plus widest extension tube 28 mm lens plus three extension tubes	$+\frac{1}{3}$ stop $+1\frac{1}{2}$ stops $+2\frac{1}{4}$ stops
50 mm lens plus narrowest extension tube 50 mm lens plus widest extension tube 50 mm lens plus three extension tubes	$+\frac{1}{3}$ stop $+1$ stop $+2$ stops
135 mm lens plus narrowest extension tube 135 mm lens plus widest extension tube 135 mm lens plus three extension tubes	$+\frac{1}{3}$ stop $+1$ stop $+1\frac{3}{4}$ stops
Dark subjects, such as moss, bees, beetles, blackbirds and some caterpillars	$+\frac{1}{2}$ to 1 stop
Light subjects, such as pale flowers, blossom, some butterflies, or ermine	$-\frac{1}{2}$ stop

Example: If photographing a white moth with a 28 mm lens and three extension tubes, one would add $2\frac{1}{4}$ stops to the general hand-held flash exposure meter reading to compensate for the light-loss factor caused by the extra extension, and subtract $\frac{1}{2}$ stop to allow for the lightness of the subject. This results in a $1\frac{3}{4}$ stop compensation, so that if the meter reading is f/8 one sets an aperture that is very slightly smaller than f/4. The table above can also be used in conjunction with a conventional hand-held light meter.

Note: With macro lenses, the appropriate compensation should be engraved on the barrel of the lens.

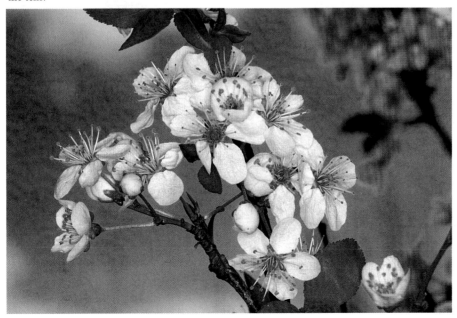

A complicated method of illumination was used for this portrait of blackthorn blossom. The f-stop was set from an exposure reading of the blue sky. Then ring flash was adjusted to expose the blossom at this same f-stop: a seemingly simple picture with a technically complex history.

materials, perhaps a spray of hawthorn berries or blossom, honeysuckle, a sprig of black bryony and so on. Support it in a 'natural' position in a simple clamp fixed to a stand of the type used to secure apparatus in laboratories. Arrange more hedgerow material loosely in a large vase and place this a few centimetres behind the specimen subject to form part of a background. Take a large sheet of cartridge paper and colour it evenly with a sky-blue pastel, rubbing the chalk with the thumb to obtain a streak-free finish. Then place the paper behind the vase of material to serve as an artificial sky. Form a square out of stiff wire and use another clamp and stand to support the square frame about half a metre above the hedgerow arrangement, and then cover this frame with two metres of white nylon material to produce an open-fronted box tent creation.

Position the camera on a tripod in a suitable position in front of the subject and a single small studio light – say a 500 watt photoflood in a 10-inch reflector – slightly above and to one side of the camera. Make sure that the lamp is able to shine directly into your 'light-tent', that none of the bits of paraphernalia intrude on your viewfinder image of the subject and background, and that the background paper is free of shadows. Make slight adjustments to the lamp position to achieve the best illumination and select an f-stop which will provide adequate depth of field: using ISO 125 film you could be working in the region of $^1/_{15}$ sec at f/16, hence the need for a steady tripod.

This inexpensive but effective lighting system will provide illumination somewhere between the diffused qualities of daylight on an overcast day, the shadowless lighting of ring flash and the sculptured effect associated with sidelighting by a single flash gun. Without the nylon tent the illumination would be unacceptably harsh, but with it one may achieve results in close-up photography which are comparable to or better than those associated with several expensive studio lights. Remember to fit an 80 B colour correction filter if using

RIGHT Studio lighting, involving a complicated combination of backlighting and reflectors, was used in this portrait of deak oak leaves.

BELOW Studio lighting (with a main source to the left and a reflector to the right) has been used to portray the details of this tiny fossil ammonite.

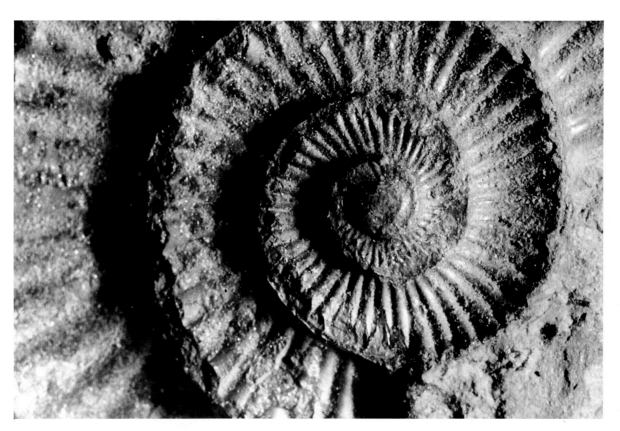

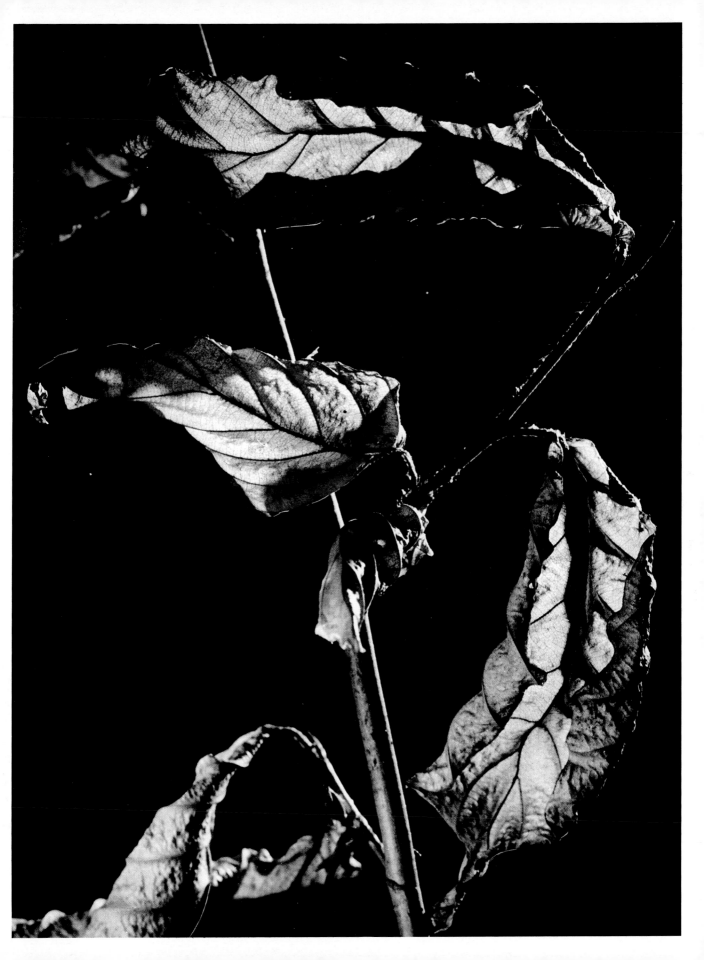

Kodachrome 64 has provided an excellent rendition of the red tones in the portrait of this cockerel. Had I been dealing with a green lovebird instead, then Fujichrome 50 would have been preferred.

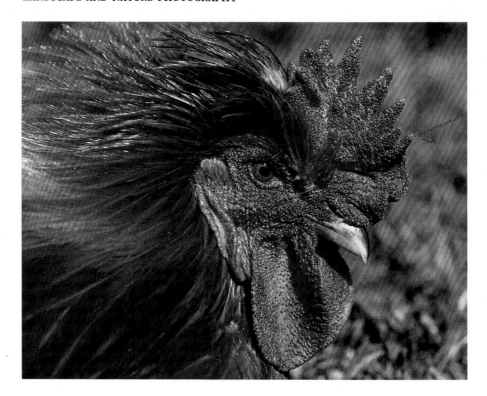

daylight colour film, while with monochrome film you could experiment with various filters – a green or yellow-green will work well with leaves, a red or orange will brighten berries.

When photographing through a microscope, one could use a purpose-built microscope lamp, a slide projector lamp or TTL flash mounted on an extension cord, the light being bounced up via the microscope mirror in the conventional way. Alternatively, at lower magnifications the subject could be sidelit by any of these sources to provide a strong relief effect. Dark field illumination, showing the subject brightly against a dark background, is more difficult to achieve. It involves arranging the lighting in such a way that no light reaches the lens directly when the stage is empty, but so that light is diffused according to a subject's structure and translucency when one is introduced. Dark field illumination can be achieved by obtaining a clear filter to fit the microscope filter holder and covering the centre area of it with a black disc of opaque material that is two thirds the diameter of the filter. Although light-levels will be low and any scratch on a slide or coverslip will be very obvious, some very striking results can be achieved.

The choice of film

Disregarding Polaroid films, mainly useful as preview material, the basic choice is between black and white film, in its conventional and infra-red forms, colour print film and colour slide or transparency film. The most popular material, used by millions of holiday snappers, is colour print film. If you want to accumulate piles of colour prints, often poorly reproduced and ever likely to become dog-eared, this is the material to use. In almost every respect colour slide film is a better option. The transparencies are small and easily stored; the quality of colour and detail is infinitely better; the transparencies can be projected or enjoyed via a hand viewer; they are used for virtually all book and magazine illustrations – and if you want to take a print from a transparency a good processing laboratory will produce superb results.

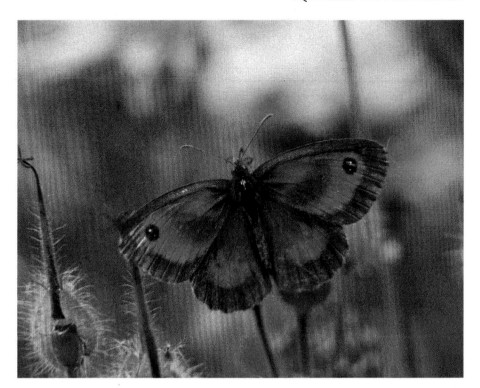

Ektachrome 400 is a fast film not renowned for the intensity of its colour or the fineness of its detail. Here it has been exploited for the soft pastel background tones in this picture of a gatekeeper butterfly.

Monochrome film is sadly neglected by most casual photographers. Where form, mood, simplicity and impact are concerned, it frequently produces punchier results than colour film, although of course it is impotent in situations where colour is the key component of a scene or is needed to separate out its different elements – as in most situations in wild-flower photography.

Films are available in different speeds – now denoted by an 'ISO' coding. Slow film, whether monochrome or colour, is associated with very fine detail and grain and strong contrast. Fast film allows one to use fast shutter speeds or to work in gloomy conditions, but these conveniences are bought at the cost of increased graininess, a poorer rendition of detail, lower contrast and, with colour film, less intensity of colour. Shortcomings in film rather than in the quality of the best lenses mainly explain why one cannot blow up a stamp-sized negative into a poster-sized print. The ideal film would be one with an ISO rating of about 800 and the quality of current ISO 25 material – but this sort of film, as yet, exists only in the sweeter dreams of the photographer.

Serious workers will choose the slowest possible material which is compatible with field conditions. One may be amazed to see, say, a beautiful bird portrait, taken at $^1/_{25}$ sec at f/8 on ISO 25 colour film with a tripod-mounted camera and 200 mm lens. Of course, one does not see the hatful of pictures which were discarded because the bird moved, or because its perch swayed in the wind. For general work it is sensible to compromise between the different factors and use ISO 50 or 64 colour film and ISO 125 monochrome film. Where fast shutter speeds and long lenses are needed in nature work, then ISO 400 monochrome film, like Ilford HP5, offers quite creditable results, though ISO 400 colour film is still distinctly less appealing than the slower types.

For medium-format work, Ektachrome 64 is a very popular and attractive film, while for decades Kodachrome ISO 25 and 64 films reigned supreme in the 35 mm field. However Fujichrome 50 has recently emerged as a very serious competitor to the Kodachromes. The colours, particularly the greens, have a delightful freshness and tests suggest that in some respects the quality compares

Monochrome film can be superior to colour film as a means of expressing texture. By examining the different qualities of texture represented in the following pictures you may discover ideas for your own pictures. RIGHT The soft, delicate texture of old man's beard seed heads. BELOW RIGHT The warty texture of these mating toads. BELOW The haystack-like texture of coypu fur (it is the soft underfur which furriers and silly ladies exploit). FAR RIGHT, CLOCKWISE FROM TOP The delicate, feathery texture of lichen, photographed at a high magnification; the gnarled texture of walnut bark; the somewhat repulsive brain-like texture of this fungi; the spiny texture of the hedgehog.

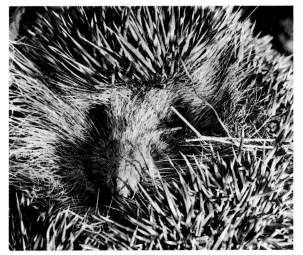

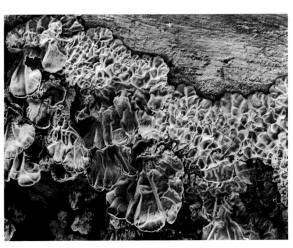

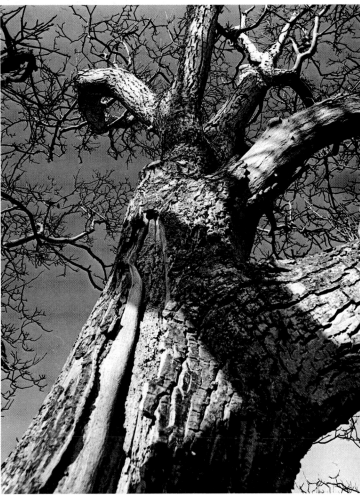

well with the slower Kodachrome 25. In addition, the Fuji material is available not only in a process-paid form, but also in cassettes which can be processed very rapidly by the local laboratory. In this book most of the monochrome pictures are derived from Ilford FP4 (ISO 125) film in its various formats, with a few infra-red and HP5 examples. The colour derives from Ektachrome 64 (most of the landscapes), Kodachrome 25 and 64 and Fujichrome 50.

The really fastidious photographer will exploit the characteristics of different films. While being no great admirer of Ektachrome ISO 400 film, I find that the soft characteristics of the material produce attractive, dreamy browns and greens as background to close-ups of subjects such as hedgerow plants. (Kodachrome 25 film will resolve 100 lines per millimetre, Ektachrome 400 only 63 lines – and the difference is very obvious.) Colour fidelity varies from film to film, most being designed to produce their best results with certain sections of the spectrum. The instruction leaflet supplied with the film generally gives valuable information on exposure and colour correction. Since assessments are somewhat subjective, experimentation is needed to discover the brand and speed which suits one best. Different camera lenses also affect the rendition of colour, and here Nikkor lenses have a very high reputation. Films can be 'pushed', as when one rates an ISO 400 film at ISO 1000 and compensates by developing for a longer period of time. Such techniques are best reserved as a last resort to be exploited in the most uncompromising conditions, for the poorer qualities of the material will be to some degree intensified.

Cutting costs

In the preceding sections I have described a range of equipment, some of it quite expensive. It is possible to cut costs without cutting too many corners. The photography enthusiast is the target of a great deal of persuasive advertising and must learn to steer a course between the temptation to buy equipment which is inessential and unnecessarily costly, and the habit of soldiering on with gear which is simply not up to the demands placed upon it. One answer is to think very carefully before one buys, choosing only essential items and then comparing costs and specifications very assiduously.

Some amateur snappers are sufficiently wealthy to be able to buy the most prestigious outfits, and may be more interested in the prestige of prominently-displayed brand labels than in actually using the equipment to its full potential. It is worth remembering that the top-price cameras used by working photographers may offer no more facilities than others sold at a third of their price. The high cost largely reflects the extra robustness of construction designed to allow daily use in very rough conditions. Any camera used for outdoor work should be robust, but need not be as rugged as one carried by a war photographer.

In purchasing new equipment there is no doubt that the big mail-order superstores offer the best prices. Even so, the beginner should give at least some of his or her trade to any local camera shop which includes a knowledgeable and helpful sales assistant on its staff. Most second-hand equipment sells at about two thirds the new retail price when bought through dealers, and rather less than this when bought privately, without guarantees, via the 'small ads' columns in magazines such as *Amateur Photographer*. On balance there is much to be said for buying quality equipment in this way.

The sale of used equipment is another matter, and the opportunities are much less inviting. And so it is vitally important to buy into a good system and stick with it – otherwise one may be left with a stock of lenses with mounts which are incompatible with the new camera. Factors such as this make the Tamron lenses, with their interchangeable mounts, an attractive possibility. Special mounts can be made by SRB of Luton which will allow one to fit almost any lens on any camera, but often without the ability to focus on infinity, though some custom-

built mounts will allow some lenses to become interchangeable – old M42 screw fit lenses can be fitted to several bayonet body mounts in this way.

Ambition and reality can be painfully different, but one can reduce or eliminate losses by securing a good foothold on the way to a summit. Thus those who have the Contax RTS II as the peak of their ambitions could begin by buying a Yashica FX 103 program. It costs less than half the price of the prestigious RTS II, but also offers TTL flash metering, while, if a lucky windfall should come one's way, the Contax will happily accept the Yashica lenses. Similarly, a Ricoh KR-10 super, a Miranda MS-1 super, or a Sigma SA1 could serve as a stepping stone on the road to owning an illustrious Pentax LX, as could the well-proven Pentax K 1000, since all share the Pentax PK lens mount. If you buy into a compatible system, then your old camera can soldier on as a second camera loaded with a second choice of film type. As lenses are compatible, the new camera can be bought as a body only, dispensing with the cost of its standard lens.

Most equipment tends to decline in value, though some 'classic' models do represent an investment. One such classic is the Pentax Spotmatic range of cameras. This range has the particular advantage that the cameras accept the screw thread lenses which can be found in quantities and at very competitive prices in the second-hand stores since the major manufacturers have moved on to bayonet mounts. Some of these lenses, like the Zeiss Pancolor standard and Flektagon 35 mm wide-angle, offer really excellent quality at very low prices.

When buying lenses one is strongly advised to check out the test reports published in the popular camera magazines (although these should be used with a certain amount of caution). Lenses produced by independent manufacturers tend to be considerably cheaper than equivalents from the camera companies; though their quality is variable, some are very good indeed. The Tokina 25-50 mm zoom that I favour sells at less than a third of the price of an equivalent from one of the top camera manufacturers – and delivers results which are marginally better. Other top-class but moderately-priced lenses include the Elicar 90 mm macro lens, the Tamron 200 mm telephoto, or the Ohnar 300 mm variable aperture mirror lens. At the same time, when one buys a lens from a top camera manufacturer like Nikon, Zeiss/Yashica, Pentax, Olympus, Canon or Minolta, one can be almost certain that the quality will match the price.

The bulk-buying of materials such as film, printing paper and chemicals offers considerable economies, while ensuring that good stocks are to hand at crucial times when the shops may be closed. Printing paper is a particularly expensive material, and it is worth checking the local press for announcements of photographic auctions. However, buying 'out-dated' colour materials – ones past the 'process before' date on the box – is very risky unless you are in a position to test a sample first.

To summarize, the prudent photographer will think very carefully before buying, and will then buy into a system which will be capable of satisfying all possible photographic ambitions without incurring any expensive changes of horses on the way. He or she will purchase only the gear which is known to be essential in meeting an important challenge, and will at least consider the possibilities offered by the second-hand market. In this way the popular photographic press can serve as a fund of ideas and information rather than as a temptation to spend without thinking.

2
THE PANORAMA

It is far easier for the untrained eye to recognize the exhilarating delights of a landscape panorama than to appreciate the pictorial potential of some tiny nook or facet of the scene. And so in landscape photography it is better to begin with the scenic symphonies than with brief passages in a minor key. The reasons behind this opinion are psychological as well as practical. To become a good photographer one needs some encouragement and rewards along the way. Panoramas are relatively safe and easy subjects, once you have discovered a suitable vantage point. The initial results may not be polished masterpieces, but at least they should be good enough to win some praise and boost your confidence – thus encouraging you to persevere with this demanding craft.

Possibilities

We can begin with what can be called – rather condescendingly – the 'picture postcard' view. In fact the phrase is not entirely apt, since picture postcards have become more varied and creative of late. But anyone leafing through the card racks in, say, the Lake District, will find that most of the pictures displayed are pretty, colourful and perfectly exposed. At the same time they may not tend to be very imaginative or particularly representative of an area which, away from the familiar lakeside places, consists of areas of rugged and uncompromising mountain scenery. Also, the Mediterranean skies, cotton wool clouds and clear primary colours of the cards scarcely epitomize the qualities of a region where the skies are more characteristically overcast or threatening and the colours are the subtle pastel tints of bracken, slate and mist.

Still, anyone who is undergoing a crisis of confidence in photography can head for Lakeland – or Skye, the west of Ireland or Snowdonia – and should expect to return with sufficiently attractive results to be encouraged to explore the next stages in the world of landscape photography. If Lakeland is the choice, then load the camera with a good, slowish transparency film, fit a wide-angle lens and, on a sunny day (preferably in May or September), follow the well-worn paths beside one of the lakes, perhaps Buttermere, Loweswater, Brotherswater or Wast Water. Only a broken leg or a camera failure should prevent you taking pictures to rival at least some of those on the postcard racks.

Success should always serve as encouragement to tackle something a little more difficult and demanding. Staying with our Lakeland example, successful work from the conventional lake-shore viewpoints could lead you to explore the interesting possibilities of, say, portraying Buttermere from the angular spur of Fleetwith Pike, or distant Wast Water from the flanks of Lingmell Crag or Great

Gable. Then you could re-explore such areas in weather which sends the tourists driving to the havens of Keswick and Ambleside and meet the Lake District that the fell-walkers know. Take the spirit of adventure a little further by loading monochrome film. Now is the time to experiment with filters. An orange filter will often help to boost the contrast levels on a moody day. With some practical experience you can cultivate the knack of 'seeing' in black and white, and so discover that many subjects which seem drab on a gloomy day will produce extremely effective images when photographed in monochrome. As in all fields of photography, there is no substitute for the experience which comes from taking lots of photographs under all sorts of conditions – and then analyzing the results in a discerning and critical way. The film miser may never gain the experience needed to become a good photographer, while each success should become the springboard for discovering a new challenge.

Equipment and techniques

Plainly, the basic requirement for this sort of work is the wide-angle lens – say a 28 mm or 25–50 mm zoom. However, initial attempts at capturing a panoramic view with a wide-angle lens can be disappointing. What seemed at the time to be a spectacular view is recorded as a narrow ribbon of interesting countryside sandwiched between a vast sky and an equally vast but uninteresting foreground.

The Vale of York from Sutton Bank. As the scarp faces westwards the picture was taken in the early morning, when the sun was still in the east. An orange filter has strengthened the contrast in the scene.

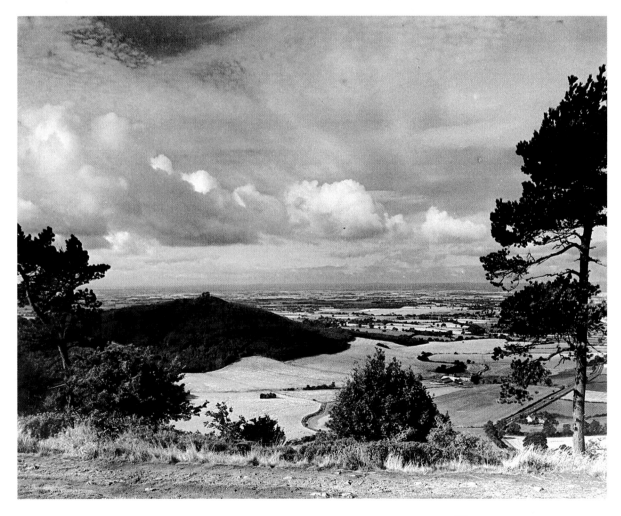

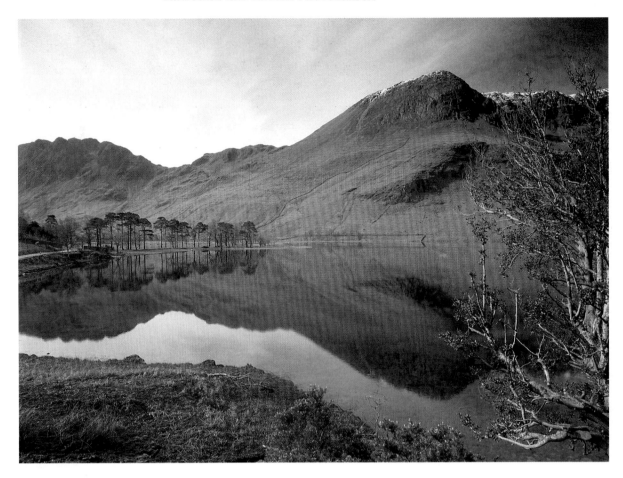

ABOVE Buttermere in the Lake District, seen from the lake shore. The unusual stillness of the weather allows the fells to be mirrored in the lake.

FAR RIGHT A more ambitious Lakeland panorama taken from an elevated position on Scale Knott; Crummock Water is to the left and Buttermere to the right.

Such pictures can be improved by ruthless trimming of the sky and foreground, but the best remedy is to study the area framed in the viewfinder very carefully, forgetting how splendid the scene may seem to the casual onlooker. Sometimes better results can be achieved by using a short telephoto lens and concentrating on the scenes within the panorama – which could be more expressive of the personality of the countryside than the much broader views obtained with the wide-angle.

To capture any panorama (but not a skyscape), you need a vantage point. The higher this vantage point, the closer the scene to be photographed, and the greater the altitude separating the lowest and highest ground, then the more that the panorama will fill the field of vision of a wide-angle lens. On modern Ordnance Survey maps, and also on many road maps, some of the more popular and accessible vantage points are marked by blue sunburst symbols of radiating lines – although only a minute fraction of possible vantage points are marked in this way. It is very disheartening to struggle up to a presumed vantage point and discover that in fact the view is obscured, but Ordnance Survey maps contain sufficient information to allow one to anticipate the configuration of a distant countryside and assess the potential of a vantage point. Place a clean sheet of paper on the map with one edge running between the viewpoint and the potential view. Then mark each point where a contour on the map intersects the paper and note the height of each contour. The annotated paper edge then forms the base-line for a graph-like topographical cross-section. The choice of a vertical scale can be varied according to the nature of the terrain, but $1/10$ inch to 50 metres of height can be adopted for mountainous areas. From the baseline each contour is plotted according to the

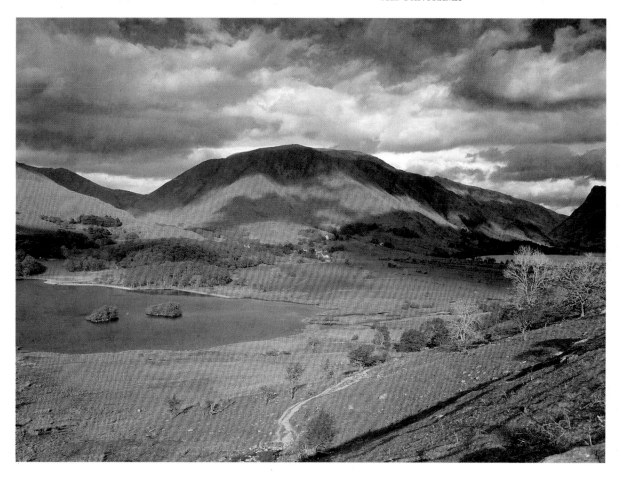

vertical scale and the plots are linked by a line which represents a topographical cross-section. If the view between the potential vantage point and the potential scene is uninterrupted, then a straight line drawn on the cross-section between these places will not be breached by intermediate hills. A word of caution, however. Where woodland is marked on the map, you should add an extra 15

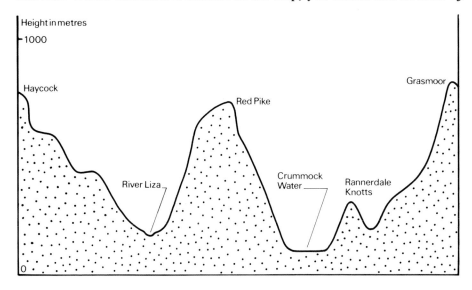

By drawing a geographical cross-section like this one, we know that the summit of Haycock is just visible from Grasmoor, but that the bulk of Red Pike obscures any view of Haycock from Rannerdale Knotts. Similarly, Rannerdale Knotts partly obscures the view of Crummock Water from the summit of Grasmoor. By drawing such cross-sections the photographer can assess the potential of different vantage points.

59

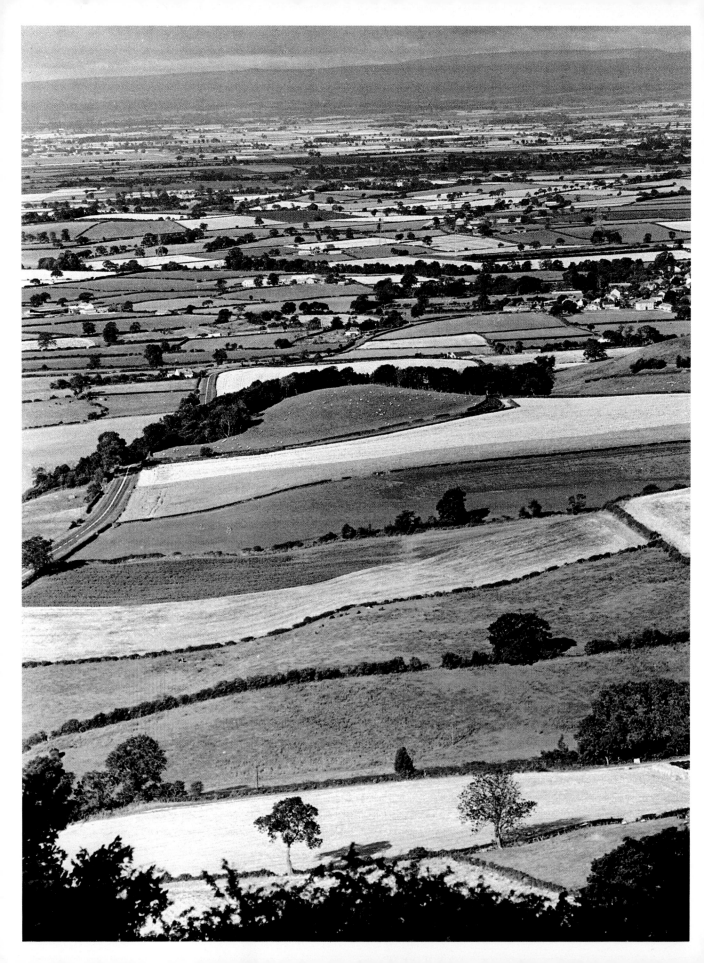

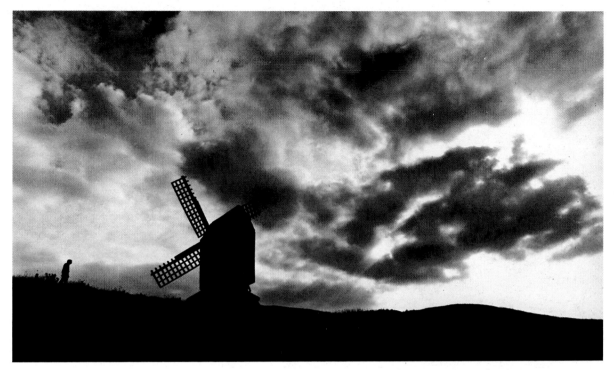

metres or so to allow for the height of the trees, while panoramic views are seldom obtainable from wooded hilltops.

The sky is a crucial component of any panorama, and a 'busy' or a heavy sky is usually far better than a clear blue one or a bland grey fuzz. A weak sky will fail to frame a scene, particularly in monochrome work, where it is normal to 'burn in' the upper part or all of the sky (as described in Chapter 17). However, you must make a distinct decision about the relative importance of skyscape and landscape. With exceptional aerial conditions the sky could be the main element in a panorama, filling two thirds or more of the frame. Otherwise it should complement rather than compete with the landscape.

Project: **To explore the potential of a panorama**

Given a superb panoramic view the novice photographer will fit a wide-angle, take just one picture and assume that the challenge has been met. The purpose of this project is to discover the true potential of such a scene. Firstly, choose a vantage point overlooking a first-rate panoramic view. This can be a familiar spot, one mentioned in guide books or one discovered using the methods dsescribed here. Work on a day when the air is exceptionally clear and when a fresh breeze is bustling a procession of stately clouds between the horizons. Pack wide-angle, telephoto and standard lenses and both monochrome and colour films. Use all the lenses to take broad and selective views in colour and monochrome and experiment to discover the effects produced by orange, red and yellow-green filters in monochrome work, and by skylight, polarizing and graduated blue filters in colour work. As well as the conventional panoramic view you should also achieve skyscapes, details of field, road and settlement patterns, pictures showing countryside dappled with cloud shadows, and others in which vegetation has been incorporated to provide a foreground. Make notes of each shot as it is taken and, in due course, assess the strength and weaknesses of each picture and technique. Given a good vantage point and favourable conditions you should be able to achieve not one good picture, but six fine and *distinctly different* photographs.

ABOVE A skyscape from Brill in Buckinghamshire. To create the silhouette effect an exposure reading was taken from the bright sky while an orange filter accentuated the cloud patterns. The small figure to the left of the windmill is a key element in the composition.

LEFT Never neglect the telephoto lens. This fieldscape is a detail pulled from the panorama shown on p. 57 and was taken from the same vantage point.

61

The Vale of Aylesbury,
Buckinghamshire, from
Coombe Hill. The
powerful sky and the
cloud shadows on the vale
are the main elements in
this very English
panorama. A polarizing
filter was used.

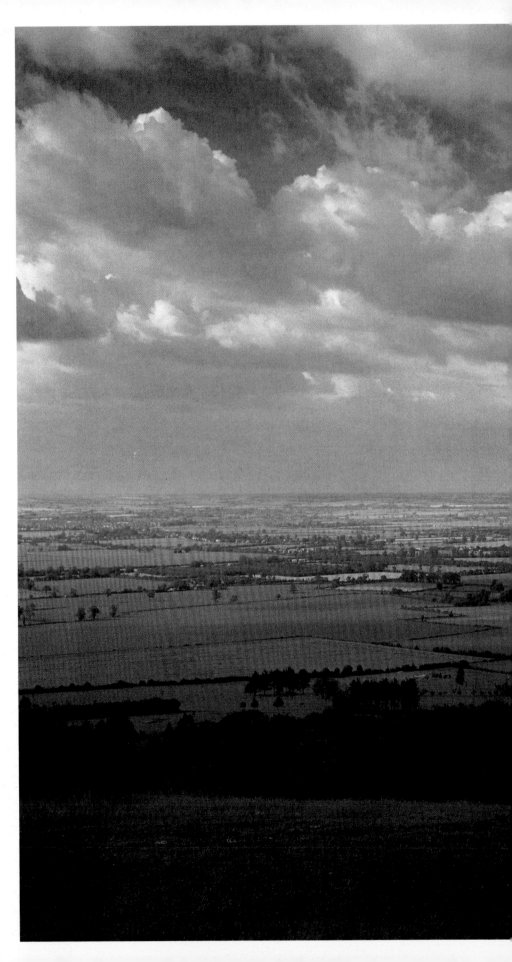

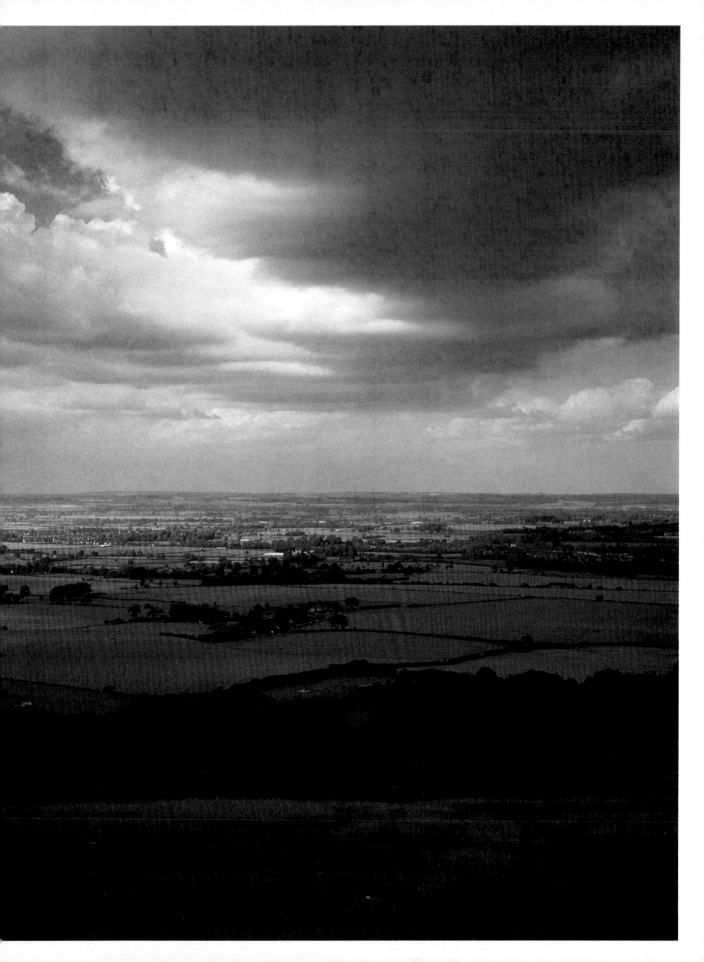

3
THE FIELDSCAPE

Though the photographers concerned are not always fully aware of the fact, many, perhaps most landscape photographs are pictures of fields. The traditional English scene is a mosaic of field shapes bound together by a tracery of walls or hedgerows. Wipe out the field boundaries and one is left with a featureless prairie – as readers in the eastern counties of England, where old countrysides have been blitzed by the agribusiness movement, will be only too well aware. Ironically, much of the best 'English' type of countryside now endures in parts of Wales

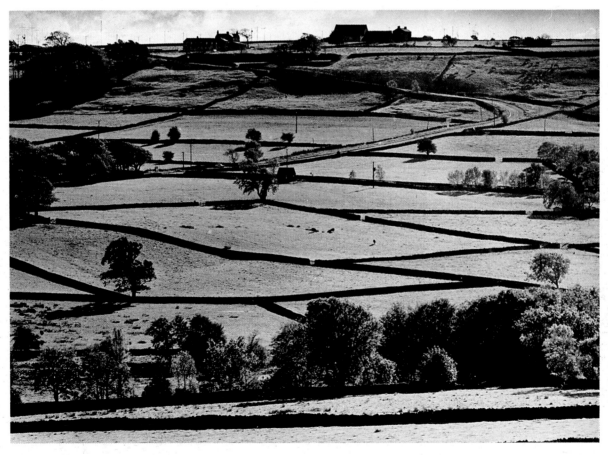

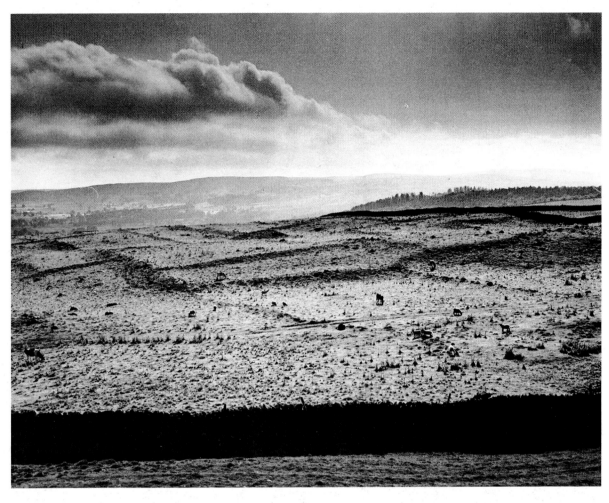

which have so far escaped the clutches of the barley barons and investment companies.

Field patterns are a vital, often a dominating feature of the countryside. They vary enormously and their different characters contribute significantly to the qualities of the scene. Fields come in all sizes and shapes and may be bounded by banks, walls, palings or hedgerows. They are also the legacies of different ages, and it is often possible to recognize countrysides or countryside components which can be ascribed to prehistoric times, the medieval period, the eighteenth century, and so on. The more that a photographer is able to appreciate the making of the rural landscape, the more perceptive will be his or her eye, and the better the pictures which result.

Understanding the fieldscape and its possibilities

Farming was introduced to Britain around 5000 BC, and in the course of the prehistoric period a succession of different field types developed. Some were destroyed and replaced before the long prehistoric era had run its course, while other ancient field systems – living hedged networks in Norfolk and fossilized patterns of 'lynchets' in Wessex – endured to be obliterated by the farmers of today. In some places the old field patterns can still be recognized, like the banks and crumbling walls on the flanks of Rough Tor in Cornwall, or the extensive networks of small, roughly rectangular fields seen amongst the rough grazings and

ABOVE Several visits and a three-hour wait were needed to capture this pattern of fossilized Romano-British fields which survives above Grassington, in Wharfedale, North Yorkshire. Earthworks are best photographed into a low sun, preferably from a high vantage point. The ancient field banks are revealed by the shadows.

LEFT The rigid straight-wall geometry of planned countryside, displayed here near Darley in Nidderdale, North Yorkshire, enclosed about 150 years ago. By photographing into the sun the patterns are emphasized by the black shadows on the shaded sides of the walls.

Modern prairie field patterns are quite unphotogenic and a special combination of snow and sunset was needed to produce an interesting picture. By noting the setting positions of the sun in this corner of Cambridgeshire, I was able to pre-plan this photograph, and the snow was an added bonus.

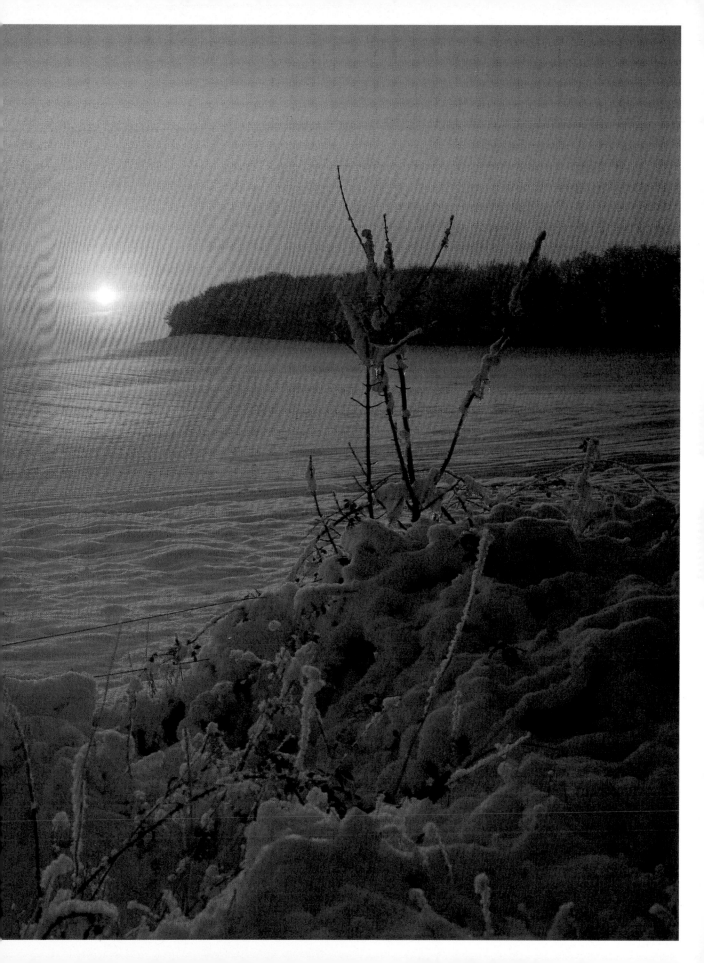

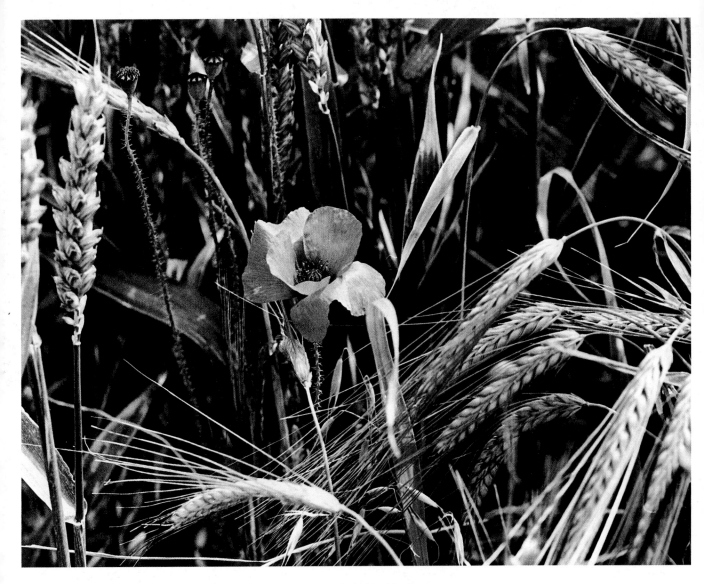

A cornfield cameo like this can be just as evocative as a sweeping panorama. Attractive weeds of cultivation sometimes escape the herbicides at the margins of the sown area. Annuals, such as poppy, corn marigold and cornflower, will rapidly colonize bare ploughland unless herbicides are used.

much later walls above places like Malham and Grassington in the Yorkshire Dales. Fossil fields (and other earthwork features) are best photographed looking *into* the sun, when it is quite low in the sky. Given such conditions the camera – which is often less discerning than the human eye – should be able to pick up the shadows cast by the shallow banks. Such photographs are challenging but the challenge is well worth pursuing by any photographer with an interest in the history of the landscape.

Hedged fields are of two basic types, though this generalization masks a wealth of special categories. Fields with curving hedgerows feature in countrysides which can be called variously 'ancient' or 'early enclosure'. The hedges could be inherited from prehistoric, Roman or Dark Age times, they could define new fields or 'assarts' cleared from the medieval woodland and 'waste', or they could preserve old field strip boundaries and reveal piecemeal enclosure of common field strips as arranged by a local agreement between the peasant tenants and yeomen of a village. Straight, geometrical hedge patterns (and the geometrical wall patterns of northern England) are components of 'planned' countryside and mainly date from the Parliamentary Enclosure movement of the eighteenth and

68

nineteenth centuries. At this time vast areas of open field ploughland and unenclosed common were parcelled out into private holdings, producing what was a surveyor's landscape of rectangles and straight boundaries. Lowland areas almost devoid of hedges are usually the product of the disastrous modern vogue for hedgerow removal. In very general terms a length of hedge will gather more tree species as the centuries roll by. Parliamentary Enclosure hedges tend to be rather uniform, dominated by hawthorn and with perhaps a couple of other species represented, while medieval and older hedges tend to be diverse, with six to a dozen or more tree species. In both types of hedge taller trees are often grown as standards, once a valuable source of structural timber.

Unspoilt ancient countryside is almost invariably photogenic. It tends to be a land of hamlets and small villages which are linked by winding, deeply-hollowed lanes, with small fields, mainly pastures, which are bounded by lush, rich hedgerows, and with plenty of small woods. In most such countrysides the deep old lanes and tall, thick hedges often mask the roadside view and you must seek an elevated vantage point – prehistoric hillforts are often the best choices. Well-preserved planned countryside is a landscape of plumper villages, whose extensive common fields were sliced up by the gridwork of Enclosure hedges. Many of the roads and lanes are straight, and were also the creations of surveyors. Here you can seek to portray the disciplined geometry of the scene – often a difficult proposition in flat countryside with few vantage points. Planned countryside is widespread and not without its visual attractions, but really effective photographs of such landscapes are uncommon. Again old hillforts are often the best vantage points – Bratton Castle, above the Westbury white horse in Wiltshire, for example, provides a wonderful panorama of Enclosure fields. In the hilly countrysides of the northern Dales there are innumerable fine views of Enclosure walls.

Project: **An unconventional fieldscape**

A successful fieldscape photograph does not have to be a broad panorama. It need not even include any sky, but can be a very tightly-framed picture showing just a section of winding hedgerow, a rustic stile, a juxtaposition of golden wheat and green pasture, or a portrayal of different colours and textures in a patch of barley and poppies. Often such a photograph will encapsulate the ethos of the working countryside more tellingly than the broader view. Here the aim is to achieve a very simple juxtaposition of colours such as might be seen in the most basic type of abstract painting, aiming for a picture which will derive its strength from its simplicity. Best results may be achieved in undulating arable country, using colour film and a short telephoto lens. Colours available on the photographic palette include the rich green of the pasture, the soft, shimmering green of growing cereals, the gold of ripening crops, the brown of ploughland – rough textured until levelled by the harrow – the lemon yellow of oil-seed rape and the red stipple of poppies. Once you have learned to discover the pictures which exist inside the sweeping panorama you can seek other cameo subjects. Find a field of barley and notice how the feathery heads of grain sway different ways in the breeze. With the great depth of field provided by a stopped-down wide-angle lens you can exploit a zone of apparent sharpness which extends from the well-defined seed heads, standing just a metre or so from the lens, outward to embrace the distant ripples in the grain field. Then you can look for tiny cameos at the margins of the ripening crop, where poppies or rye-grass have escaped the showers of herbicides. This project, like several others, amounts to an exercise in the study of scales: any tyro can recognize the pictorial appeal of the broad vista, but an experienced eye is needed to appreciate the countless scenes within the scene. The rural icons and miniatures are often more evocative than the giant frescoes of the landscape.

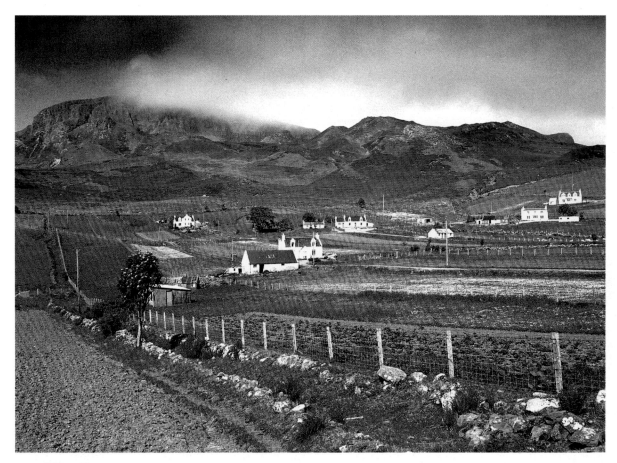

ABOVE Old crofting patterns survive at Digg on Skye, with loosely clustered crofts and ribbon-like holdings. The basalt mass of the Quiraing looms in the background. A polarizing filter has intensified the colours.

RIGHT Remains of a Bronze Age hut and field walls on the flanks of Rough Tor in Cornwall. Here I waited for a cloud shadow to darken the summit of the Tor.

FAR RIGHT Poppies and grasses at the margins of a Kent cornfield.

4
BESIDE THE SEASIDE

Fine still-lifes or portraits may fail to catch the public eye, but a good seascape will always rivet the gaze of the casual onlooker. There is something about the sea – even if it is not easy to articulate the emotions which lie behind this cliché.

At the core of most seascapes there is the horizontal junction between water and sky. This line is often muted by haze and need not be the centre of attention in a seascape, though the other elements in the picture – cliffs, rocks, clouds and crested waves – are usually all arranged around this datum (and, as a result, it is important to remember to keep the horizon exactly parallel to the upper edge of the viewfinder frame). While the horizon line will probably be a significant element, each successful seascape should present a main theme, which might be surf beating against a cliff base, dramatic cloud formations, a procession of rollers, or some other seashore feature. Almost invariably the vantage point will either be a cliff-top pathway or a stance on the beach below.

Equipment for working by the sea

The equipment needed is similar to that used for general landscape work. A wide-angle lens is, of course, essential for the exhilarating panoramic views which are the essence of this field. If you have a simple camera support with you, then you can exploit the great depth of field obtainable with this lens, so that in beach scenes shingle or boulders lying within arm's length of the camera can provide a pin-sharp foreground. Some very effective photographs have been taken in this way, though now one must struggle to avoid hackneyed repetition. The telephoto lens can be used to capture details, like the clouds of spray and streams of foam where waves assault the cliff base, or breakers pounding against a distant seashore. The peculiar ability of the telephoto seemingly to compress perspective can also be exploited. Looking seawards from a slight eminence towards a sequence of rollers you can obtain a remarkable impression of stacked breakers, the dramatic effect being heightened by the apparent compression of the space between each wave crest. Cliffs exist as refuges for a galaxy of interesting flowering plants, while unpolluted rock pools will harbour colourful sea anemones, crustaceans and shell-fish – so a macro lens and ring flash or light tripod are essential for the naturalist.

A number of filters should be included in the kit. In colour work a polarizing filter will both cool and intensify the colours of sea and sky, thus accentuating the white spray, breakers and cloud formations. With its ability to counteract reflections and intensify colour (see p. 34), this filter is also essential for any close-

RIGHT A section of coast close to that shown on p. 75, but approached in a completely different manner: photographed from the shore exploiting the great depth of field offered by a wide-angle lens.

72

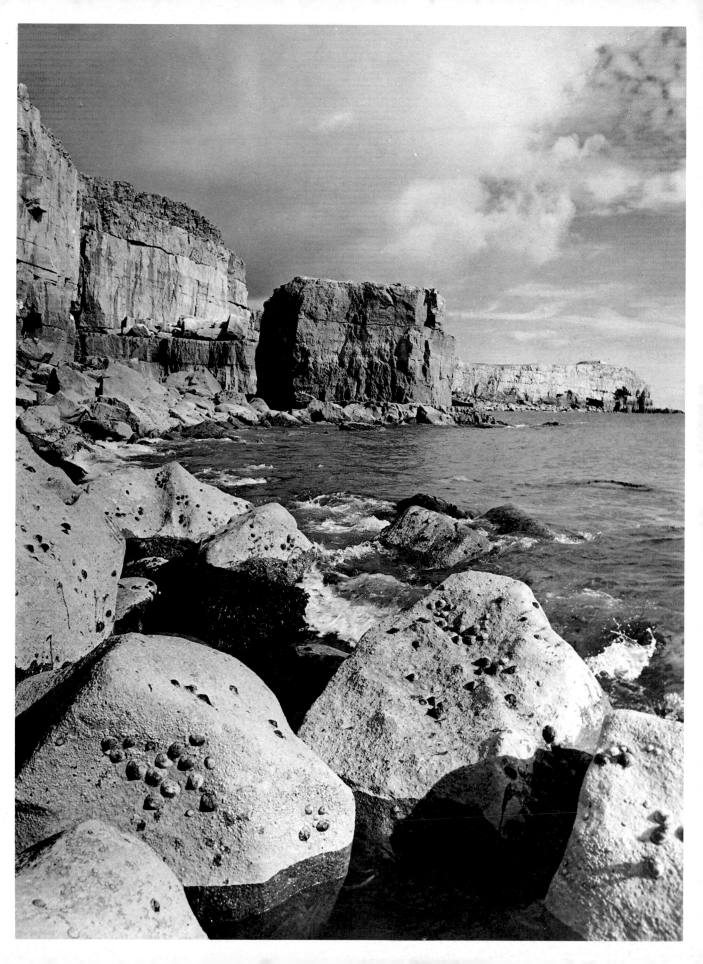

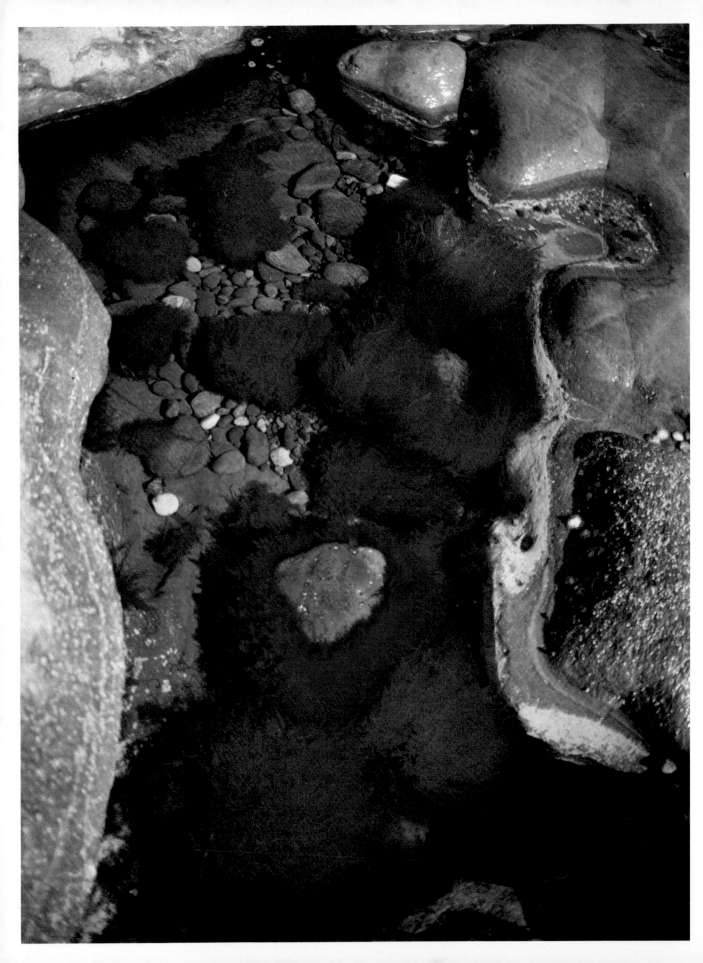

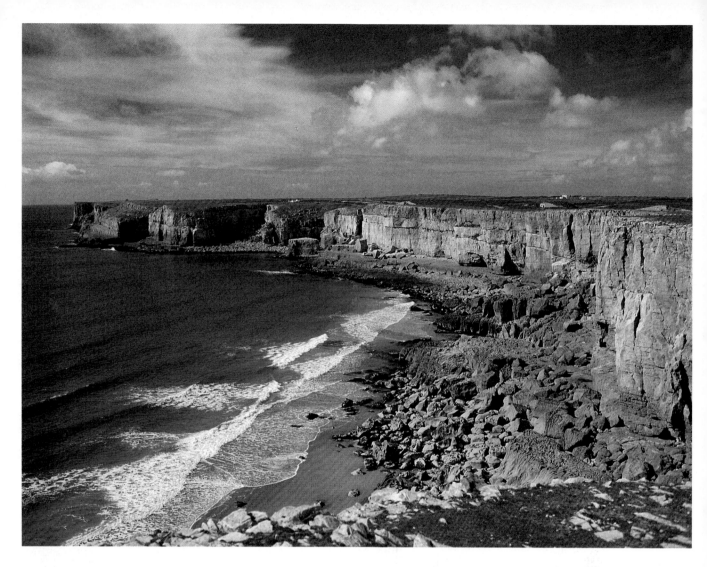

up work at rock pools. The colour of the sea could also be modified and strengthened by using graduated blue or green filters in an inverted position. For monochrome work a darkening of both sea and sky can be achieved by using yellow, orange or red filters, the strength of the effect increasing from the yellow to the red extremes. A red filter will exaggerate the contrast between the greatly darkened blue sky and sea on the one hand and reflections, bright clouds, cliffs or spray on the other. The results can be very striking, though unless there is an eye-catching, bright, non-blue element in the scene, the pictures may just be murky.

The coastal environment has two ingredients which are highly dangerous to delicate photographic mechanisms and circuits: fine grit and salt spray. Consequently you should take special care not to drop a camera or lens on a sandy beach or into a rock pool. Should a camera become contaminated by sea water, the remedy is a drastic one: immersion in fresh water and then a dash to the nearest repairer.

ABOVE Limestone cliffs on the glorious Pembrokeshire coast, photographed from the promontory of St Govan's Head. A polarizing filter has been used to darken the sea and underline the contrast between the turquoise waters and the white foam.

LEFT This picture of a Hebridean rock pool demanded the use of a polarizing filter to eliminate the reflections from the surface of the water.

Working from cliffs and photographic possibilities

Here, safety is the first thing to be borne in mind. Some cliffs, particularly those of sedimentary rocks like chalk, clay, shale and the younger sandstones, are unstable

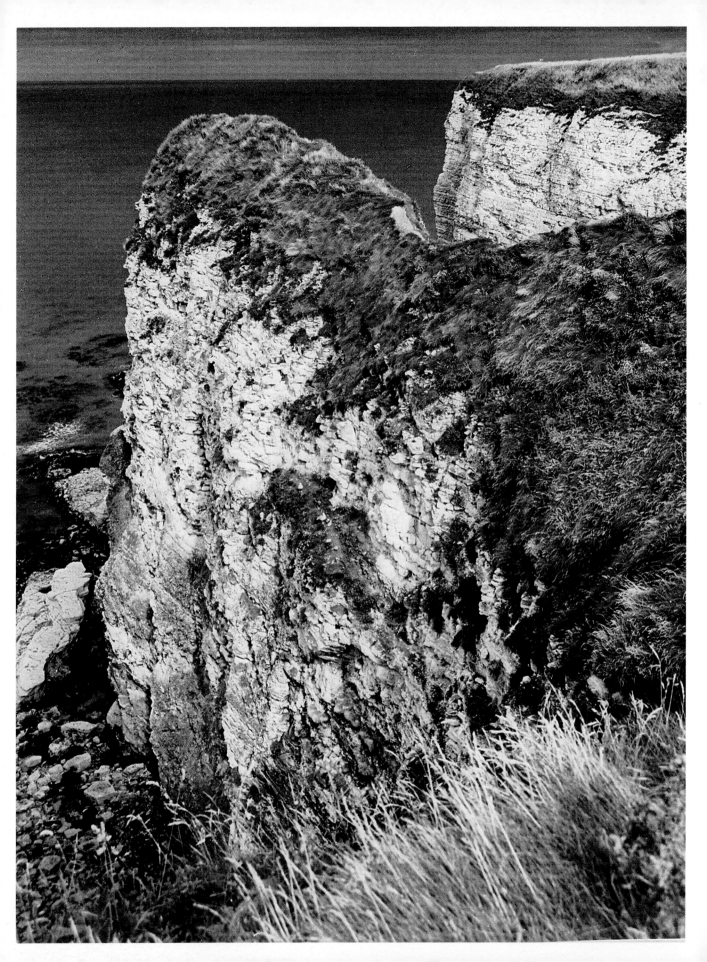

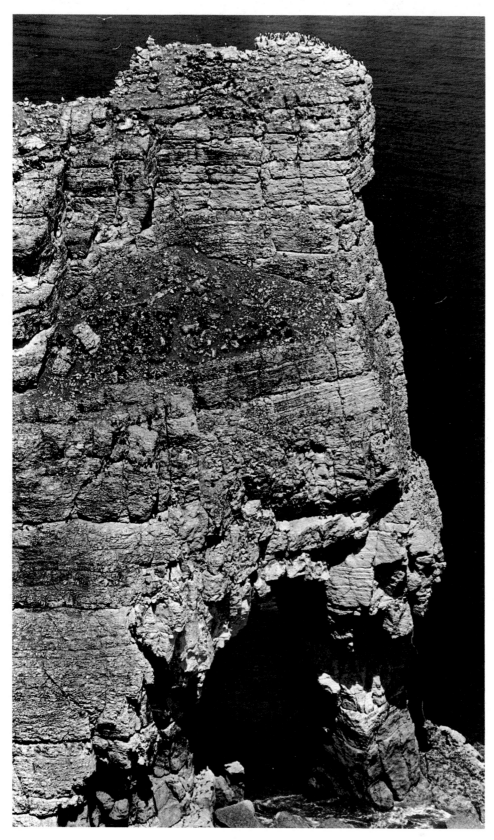

FAR LEFT A seemingly gnarled and windswept chalk promontory at Bempton, near Flamborough Head, Humberside. The direction of lighting is unusual in such photographs; it comes from a low angle *behind* the camera. Note the treacherous nature of the cliff-top terrain.

LEFT A wave-cut arch at Bempton, Humberside. In contrast to the photograph on the left taken with a 35 mm wide-angle lens, this picture was taken with a 200 mm telephoto. A colony of razorbills on the highest point of the promontory provides the scale.

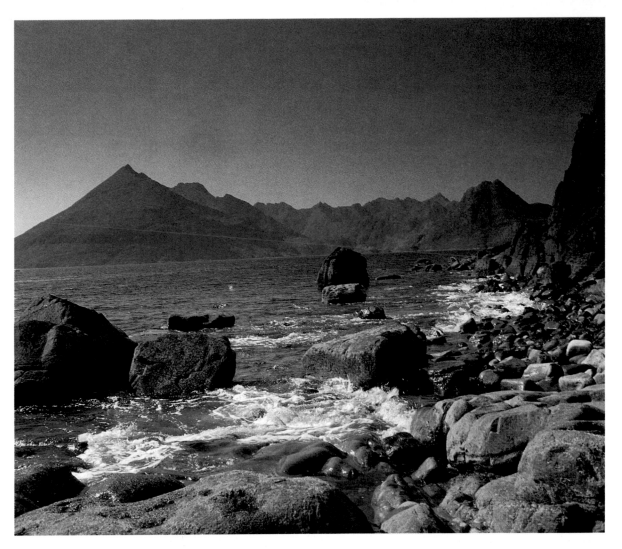

The Cuillins seen from the shore at Elgol on Skye. This is a celebrated vista, though the hopeful photographer might have to wait for weeks to see the summits of the Cuillins free from cloud.

and most cliffs are topped with a fragile or slippery layer of sand or boulder clay. Also, the cliff-top is likely to exist as a junction between the sheer rock face and a convex grassy slope. The convex nature of this slope can make it difficult to determine just where the sheer rock begins, while dew can make the grass extremely slippery. So any approach to the edge should be slow and deliberate.

Planning is important to success. On the Ordnance Survey map steep cliffs are marked by black hachures, while a notion of the height of the cliff formation can be gained by noting the height on any contour which intersects the top of the rock face. Orientation and time of day should also be considered, bearing in mind that the sun moves from east, through south, to west in the course of a day. Cliff formations may effectively be photographed when sunlit, so that one would work on east-facing cliffs in the morning, but west-facing cliffs in the afternoon, while the strongest reflections from the sea are seen when working into the sun. To capture a seascape at sunset you must plainly be on a west-facing shore, and the higher the vantage point, the broader will be the expanse of sea that is visible.

The sea is constantly reshaping the shoreline. Cliffs exist where erosive action predominates, and the erosion is accomplished both by the sand and shingle which the waves hurl against the cliff base and by the explosive effect of air which is suddenly compressed in rock crannies by the force of the breakers. Eroded material is swept away by the tides and currents and deposited elsewhere on the coastline, where the constructional rather than the destructive effects of the sea

78

are dominant. In such places one finds sandy beaches, dunes, sandbanks, spits and lagoons.

The bare geological bones of the landscape are exposed in our sea cliffs, and the nature of the rock plays a major role in determining the character of the scene. Readers will be familiar with the sheer, brilliant walls of the more imposing chalk cliffs, and since this rock tends to be relatively homogeneous, the details of buttress and inlet, which are produced by selective erosion exploiting the weaker strata, are normally not marked, though cliff-foot caves may be numerous. In contrast, the cliffs in the hard schist and gneiss rocks which form a spectacular stretch of coastline to the south of Aberdeen are breached by gorge-like inlets, formed where the sea has eroded the softer igneous 'dykes' which run in sheets through the rock. Granite cliffs usually produce spectacularly rugged, 'blocky' scenery, as at Land's End and many other places on the glorious Cornish coastline. The blocky character is caused by 'pressure release jointing', with the tough crystalline rock fracturing as erosion has removed the overburden of strata. The result is scenery which the cubist painter might enjoy. When exposed to salt spray the pink or grey granite takes on a black and brownish hue, giving a strong contrast to the white spray which surges and cascades around the cliff base. While granite cooled deep in the bowels of the earth, basalt is the product of surface lava flows. Successive basalt flows have produced the great grey cliff wall at Kilt Rock on Skye. The rapid cooling of a basalt flow could result in the formation of outlandish hexagonal columnar structures, best seen at the Giant's Causeway in Co. Antrim.

Ancient limestone formations produce rugged, silvery cliffs, such as many of those which form part of the wonderful coastal scenery of Pembrokeshire, while some of the finest exposures of geological folding are displayed in the limestone at Lulworth Cove in Dorset. Old Red Sandstone formations often produce rust-coloured cliffs, like the spectacular Cliffs of Moher in Co. Clare. In a few places, as with the cliffs in the vicinity of Peterhead and Fraserburgh in northeast Scotland, the Old Red Sandstone rocks are conglomerates, with large cobbles packed in a matrix of red desert sandstone, like plums in a pudding. The tough old rocks of northern and western Britain tend to produce the most spectacular cliff scenery, though the chalk of the south coast is impressive in places, for example the Needles, Isle of Wight, while dramatic chalk cliffs are also found at Flamborough Head on the northeastern coast of England, or at Hunstanton in Norfolk, where there is a peculiar juxtaposition of red and white chalk and khaki greensand, all in a delightful geological sandwich.

Occasionally the sea will cut across the neck of a headland to isolate a block of rock as a sea stack. A stage in this erosive process exists when a wave-cut tunnel breaches the headland to create an arch. Sea stacks and arches are very photogenic formations, the best examples usually being marked on Ordnance Survey maps. They include the spectacular example cut in Carboniferous limestone at Flimston Bay near Pembroke and the chalk arch seen by visitors to the seabird reserve at Bempton Cliffs, near Filey, North Yorkshire.

Clearly, then, it pays to do one's homework and mapwork in advance of any project in coastal photography. The Ordnance Survey maps provide an impression of the terrain and the orientation of a feature in relation to the sea. Geological maps provide information about the structure and composition of the rocks, so that you can deduce the likely colour and texture of the formations.

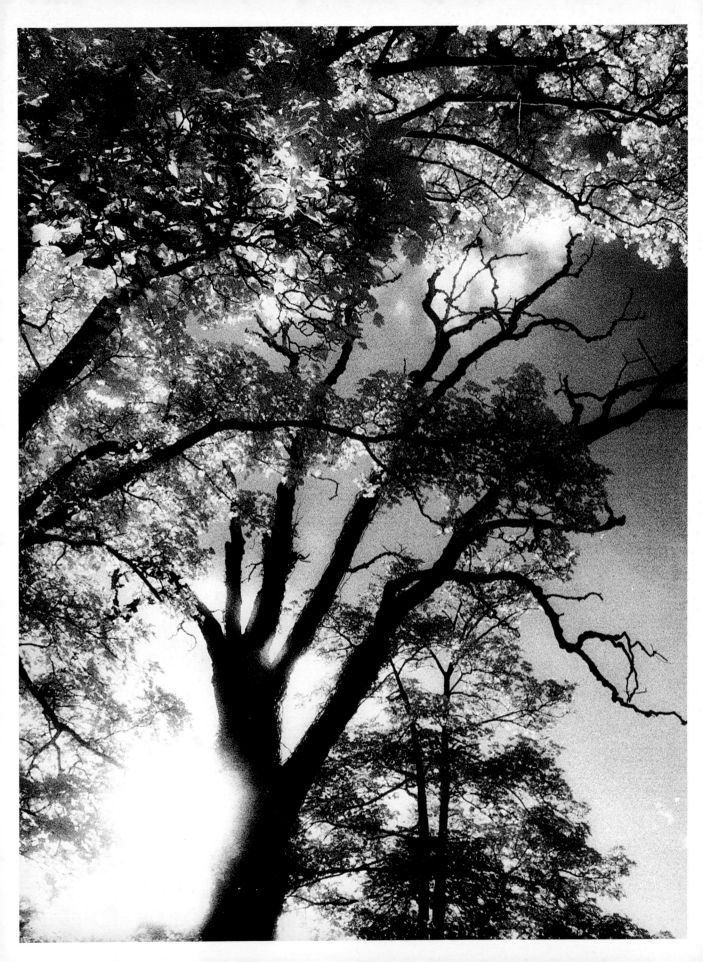

5
THE SPOOKY WORLD
OF INFRA-RED

Should the palate of the landscape photographer ever become jaded, a detour into the unfamiliar territory of infra-red will awaken interest in a whole new world of possibilities. While you might scorn results obtained with the aid of filters and slide sandwiches as being phoney and out of sympathy with the realm of Nature, the infra-red photographer creates striking effects, not by photographing anything that is not there, but by capturing qualities which are present, yet invisible to the unaided human eye.

LEFT This picture was taken into the sun, which is only partly obscured by the tree trunk, lower left. Note how the sunlit fronds of foliage appear snow white, while the dead elm is a silhouette.

Equipment and techniques

Kodak High Speed Infra-Red film is a monochrome film with a special type of sensitivity which extends beyond the deepest red that our eyes can see. It should be used in conjunction with a red filter, which blocks normal white light but is sensitive to reflected infra-red radiation from the sun. Different subjects reflect this radiation in different ways. In landscape photography the outstanding factor concerns the way that living objects appear to have a white luminescence. The effect is particularly attractive where living vegetation is concerned – but less so when, for example, ducks on a pond appear to be made of cotton wool, or sheep look like luminous tennis balls! Other significant effects of this film include the brightening of sunlit stone buildings, the darkening of skies and water and the virtual elimination of haze. Since some materials, like stone, reflect the radiation from slightly below their surface, a slight 'fuzziness' may be apparent, but this is a fairly minor feature in comparison to the marked graininess of the film. This graininess is a feature which can, of course, be reduced by working in a large format, though in 35 mm work it can be exploited as a distinctive quality of infra-red work.

Given the rather unsharp and grainy character of infra-red film, top-class equipment is (arguably) wasted on the material, but whenever possible it is as well to have a camera body loaded with infra-red to hand, ready to exploit the particular conditions in which it excells. I keep a battered old Praktica in service for infra-red work. Its metering is less than exact – but in practice metering for this film, with its peculiar sensitivity, is really a matter of guesswork. With the red filter fitted, $^1/_{60}$ sec at f/11–16 seems about right for the average sunlit scene, and you can add or reduce stops for seemingly lighter and darker subjects: fortunately the extent to which you can diverge from the 'correct' exposure and still get an acceptable result is quite wide, and you can only try to judge the infra-red qualities of any chosen scene.

The characteristic effect of prints from infra-red material centres on their

81

RIGHT The infra-red film seems to emphasize the vibrant motions of the willows tossing in the breeze and produces an image which is much more redolent of life in the plant world than those conveyed by conventional films.

BELOW RIGHT This Buckinghamshire churchyard (Lower Winchendon) would seem rather prosaic if photographed in the normal way, but the infra-red treatment (used on an overcast day) produces a feeling of mystery and unreality.

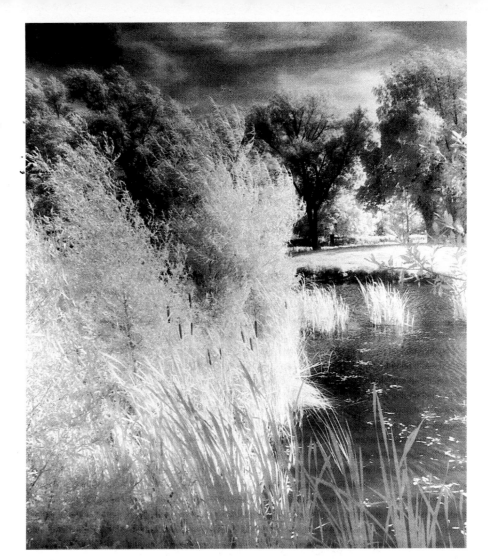

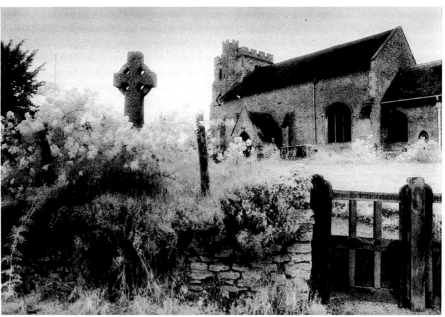

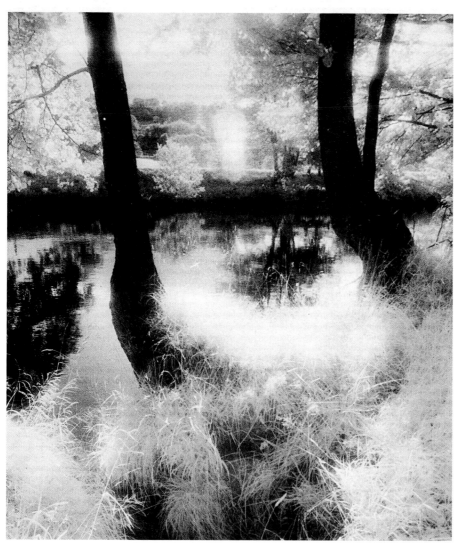

LEFT An unconventional riverside photograph, taken into the sun between two alder trunks. Note the delicate contrasts between the sunlit and shaded grasses in the foreground.

BELOW This infra-red picture of Grantchester Meadows, in Cambridgeshire, is strongly reminiscent of works by French Impressionist painters.

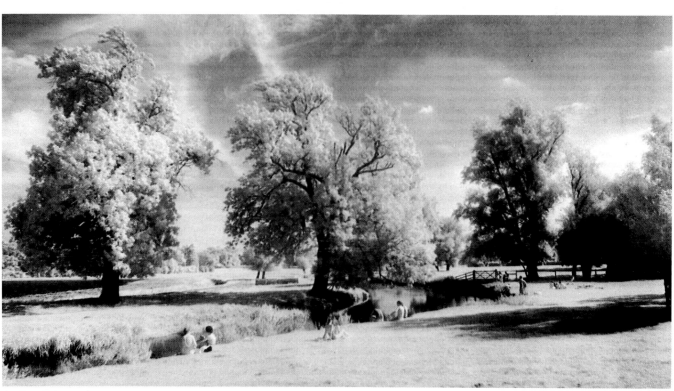

strangely unsettling and seemingly moonlit qualities, with the exaggerated cloud patterns and heavy, threatening skies juxtaposed with the glowing, vibrant vegetation: the black river is edged by writhing luminescent trees and rushes; white ivy encrusts the darker castle walls, or creates frosted patterns against an old gate-post. Simple combinations of stone, sky, vegetation and water produce the most striking effects. By recording the glow of life on film, infra-red materials express the vigour and exuberance of the plant world in a unique way, while landscapes assume a rather disturbing quality, reminiscent of the world as experienced in a feverish dream. Infra-red colour material can also be obtained, but it is mainly used for scientific surveys. For example, if a leafy wood is photographed from the air, all the healthy trees will appear bright red, while any dead individuals will be instantly identified, showing as a sickly grey.

Project: **Exploring the possibilities of infra-red film**

Imagine that you have been appointed to design the sets and posters for a dramatization of Tolkein's *Lord of the Rings*, or one of the more eerie fairy stories, to be produced as a period piece of the psychedelic sixties. Use the infra-red camera as a means of gaining ideas – it is safer than LSD but creates the similar interplay of exultation and insecurity.

Choose a sunny day during the leafy seasons of the year. Load the camera with Kodak High Speed Infra-Red film in conditions of total darkness. Any redundant camera body will do, particularly if you want to carry a 'best' camera with you for conventional work. Fit the infra-red body with a 28 mm wide-angle lens or a wide-angle zoom – and do not forget the red filter.

Move through the countryside looking for simple juxtapositions of objects and surfaces which will reflect infra-red radiations in different ways. The churchyard may include some promising associations of stone and plants; a walk along the river bank is bound to present possibilities – and do not forget the woods with their sunlit glades and dappled shade. Examine the infra-red illustrations in this book, so that you can seek to appraise potential subjects through 'infra-red eyes'. Strong dramatic forms, and powerful interactions of tone and suggestions of life and movement will be far more effective than more conventional subtleties of detail and texture.

Look at the markings on the barrel of your lens. Close to the normal infinity-focusing alignment mark there should be another, probably in red. This is the mark used for work in infra-red, where the focusing arrangements are slightly different from conventional film: remember to make the small compensation when exploiting the depth of field settings. Regard an intermediate aperture of $f/13.5$ at $1/60$ sec as standard for a view that is moderately well sunlit, and work around this norm. To avoid losing a particularly promising vista, bracket the exposure on either side of your guessed setting. This means making further pictures at exposures of $1/2$ and 1 f-stop more and less than the calculated one. In printing the film, use a soft-grade paper for lighter, dreamier subjects, but negatives will usually produce the most striking images when printed on a hard-grade paper. Persevere to discover the strengths as well as the difficulties of the technique: quite probably your old, neglected camera will be given a new lease of life, working in an unusual, rewarding byroad of photography.

6
RIVERS, LAKES AND WETLANDS

Usually in landscape photography one is seeking to record as much of the beauty and character of a countryside as possible. Occasionally the scene seems more attractive in the photograph than it did in real life. Whether one is working in colour or monochrome, water will prove to be highly, sometimes surprisingly, photogenic. There is a whole hatful of adjectives to describe the mood and motion of water – babbling, limpid, swirling, gliding, cascading and so on – and each of these modes can be captured on film. By thoughtful composition, technique, framing and printing one can both capture and intensify the qualities of the river or lakeside scene by excluding peripheral distractions, modifying the surface reflections and colour of the water, freezing or accentuating the motion of currents and cascades, while heightening the mood in monochrome work by contrast control and the 'burning in' or 'holding back' of portions of the print (see Chapter 17). These ideas go some of the way towards explaining why brook, river and lake subjects serve the landscape photographer so well, but a more complete explanation would have to include the peculiar sensual and spiritual appeal of

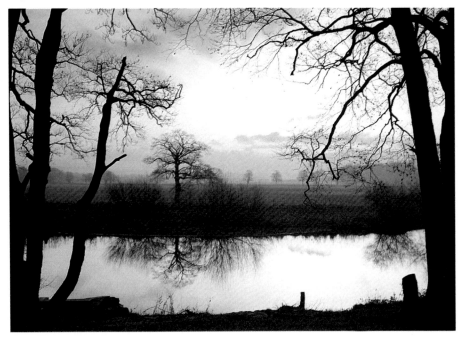

The River Ure at West Tanfield, North Yorkshire. To obtain this picture I needed leafless winter conditions and a day when the river was not in spate, and the surface quite smooth. It was eventually taken on a misty February evening, exposing for the sky and background rather than the foreground features.

85

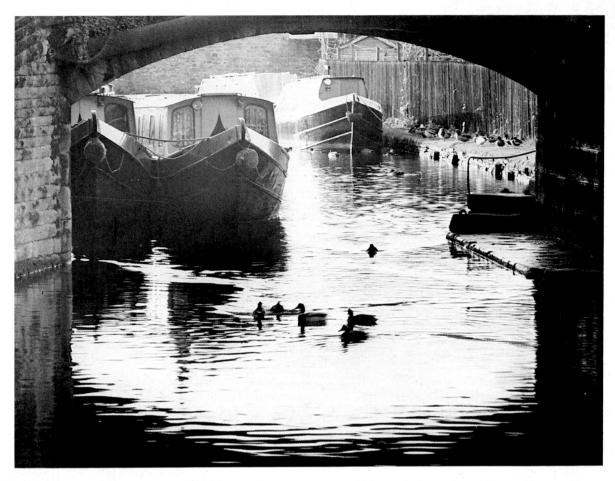

ABOVE Old industrial canals, like this one passing through Skipton, North Yorkshire, have their own tired and grubby aura. This photograph was taken on a Sunday morning in winter, using a tripod and telephoto lens with a longish exposure to permit the small f-stop needed to increase depth of field. (I can still remember the smells of Yorkshire pudding seeping from the terraces of houses, while the Salvation Army band was hard at work nearby.)

RIGHT Ranworth Broad in the Norfolk Broads, photographed into the sunset. The water-hen and its wake moving across the foreground form a small but crucial element in the composition.

water. Explore and enjoy a range of lake and riverside settings and you will not find it hard to understand the fact that the worship of water spirits featured prominently in the religion and ritual of British people throughout the first millennium BC!

Understanding the world of rivers, lakes and wetlands

Every body of water is a manifestation of an intricate interplay of factors, such as rainfall and snowfall ('precipitation'), underlying geology, catchment basins, slopes, water chemistry and human interference. Learn a little about the hydrological and ecological factors involved and you will not only increase your understanding and enjoyment of the watery worlds, but be far better able to select suitable locations for photography. Equally, an appreciation of the different water habitats allows the nature photographer to recognize the settings where kingfishers, mayflies, otters, pike and so on can be found. To give just a few examples, there is not a single really dramatic cascade to be found in the whole of 'Lowland Britain' (which lies to the south and east of the River Tees–River Exe line), while in contrast a vigorous Pennine river like the Ure is regularly punctuated with rapids and thundering falls. Similarly, the characteristic scenery of the chalk streams – with crystal-clear waters sliding and sparkling between banks which are fringed with a galaxy of plant life and embraced by flower-spangled water meadows – will only be found in parts of Lowland Britain where the underlying geology is chalk and where modern agriculture, with its ploughing,

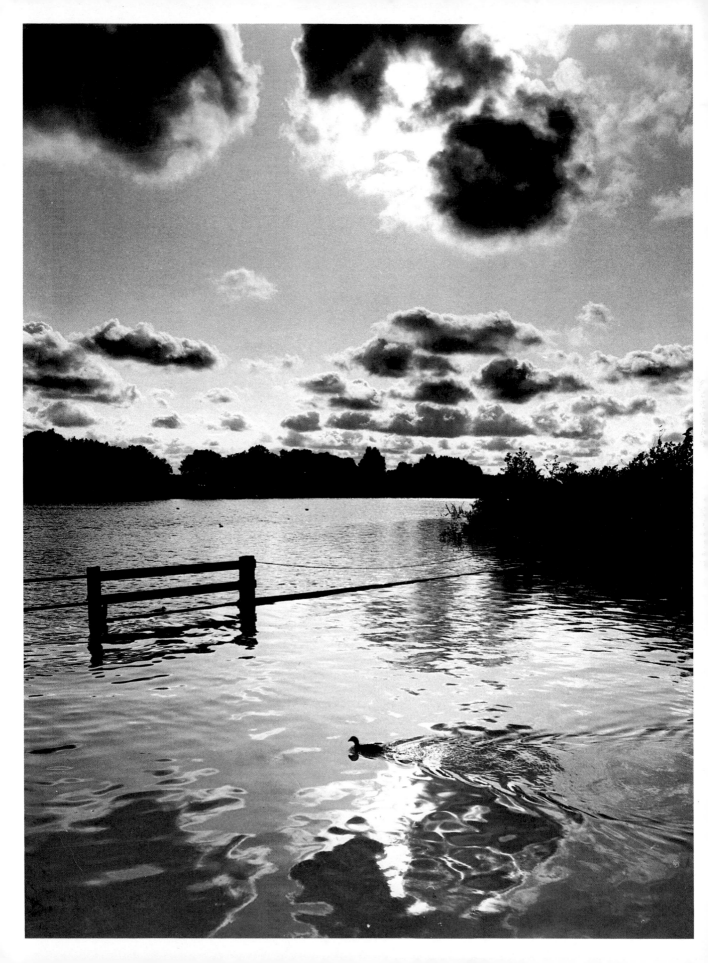

Loweswater, Lake District; the delicate foreground colours are a mixture of underwater features and cloud reflections.

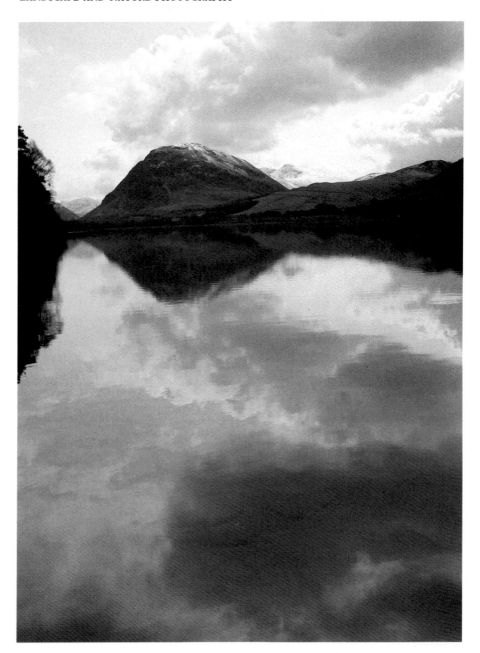

draining and pollution, has not yet extinguished the life and character of the scene.

In Upland Britain precipitation is quite high and the terrain may be composed of mountains, like those of the Lake District, Snowdonia or the Scottish Highlands, eroded granite domes, like the moors of Dartmoor and Cornwall, or stepped plateaus, like those of the Pennines or Brecon Beacons. Moisture tends to accumulate on the watershed plateaus, where expanses of upland blanket bog will often be found. As the water seeps out from the upland bog it may join runnels of rainwater, and soon these merge in turn to produce an upland stream. As the stream passes the break of slope between the high plateau and the valley side, its velocity increases rapidly – as do the pictorial possibilities presented by the rapids and cascades which now characterize the water course.

Now the stream is sliding across the faces of boulders, rearing over the rocks in

88

the stream bed and plummeting over cliffs, the torrents veiled in spray. As yet the waters are relatively free of the burden of eroded silt and debris, the current is too swift to allow water plants to be established in the bed, while exposure to the elements and the periodic sweeping of the margins when the stream is in spate also prevent the establishment of much marginal vegetation. Photographic images here could make use of the juxtaposition of black and white water, glistening rock exposures and angular boulders.

Another factor which reduces the presence of waterside and aquatic vegetation is the acidity of most upland streams. They are frequently fed by seepages from sour peat-bogs and flow over acidic rocks, like slate, granite, grit or shale. The situation is quite different in Carboniferous limestone country, where the alkaline or 'base-rich' conditions favour a richer diversity of plant life. Here, however, the soluble and fissured characteristics of the limestone usually ensure that streams soon adopt underground courses.

Waterfalls are the most spectacular features of the torrent and valley stages of a river. They may be formed by geological faulting, different juxtapositions of harder and softer rocks, or by glaciation which has over-deepened a main valley, leaving the tributary valleys 'hanging'. In all cases river erosion causes a waterfall to retreat upstream until, eventually, it vanishes, while a gorge will mark the former position of the falls. Cascades are invariably excellent photographic subjects, and in unfamiliar country they may be detected on maps, with the term 'force' being common in the north of England, while in Scotland falls are often revealed by the Gaelic word *eas*. (Advice on the pictorial treatment of waterfalls is given in the section which follows.)

In the case of the 'model' river, the torrent tract, where the river hurtles down steep slopes, is succeeded by a section of the course where, enhanced by the union of waters from several tributaries, it flows quite vigorously along the valley bottom. As it leaves the barren uplands for the valley pastures its banks become lined by alders and oaks. This scene, with its stone bridges, overhanging branches, bright water and lively currents, might be made for the photographer.

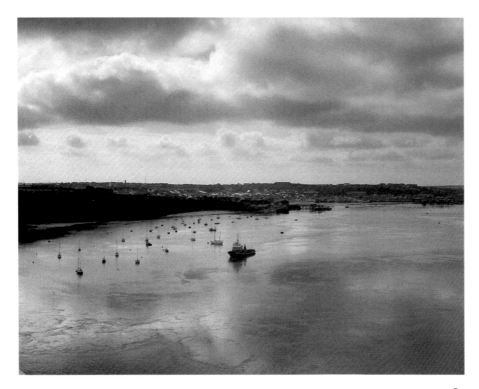

An unusual estuary photograph, taken by exploiting a high road bridge near Milford Haven in the southwest of Wales.

However, having recently illustrated a book on rivers with almost 200 photographs, I soon became aware of the need to try to avoid unnecessary repetition of the 'standard' river view – taken with a medium wide-angle lens from one bank diagonally across the water in the general direction of upstream or downstream. Some diversity can be achieved by using different vantage points, either exploiting bridges for the elevated mid-stream view or, where practical, wading into the water. A superbly evocative but unconventional view of the river is provided in the photographs which illustrate the book *River*, a poem by Ted Hughes with photographs by Peter Keen (Faber with James & James, 1983). Here precise detail, sharp definition and conventional panoramas are sacrificed in favour of texture and motion, with the soft impressionistic renditions capturing the mystery and ethos of the river in an exceptionally telling manner.

Some of the rivers of the English Lowlands lack an upland section and many originate in chalk springs. Various vistas are found: the lushness and sparkle of the base-rich chalk stream, already described; the sluggish waters green with algae in the rivers now over-enriched by farm chemicals and sewage, but also 'classic' scenes, like those at Grantchester Meadows near Cambridge, with banks graced by the silver-green lollipop shapes of pollarded willows.

The mood of the 'typical' river changes as one wanders down its course. In the torrent section the emphasis is on vigour and violent motion, but further downstream the photographer seeks to capture the soft tranquillity of the scene. Whether originating in an upland torrent or lowland spring, the penultimate stage of a river is commonly across a plain, where the sluggish waters wind drunkenly towards the sea, lacking the gradients needed to flow with force and deliberation. The serpentine meanders could beckon the photographer with their graceful repetition of curves – and air photographs of meandering rivers like the Cuckmere are striking. Usually, however, the flatness and lowness of the setting reserve such views for the airman, and, in the absence of adjacent high ground or tall bridges, the landsman is deprived of vantage points and unable to capture the twists and turns. You can still seek to capture the luminosity of the sheet-like waters and there are innumerable opportunities to portray combinations of the three basic elements of lowland river scenery: tranquil water, bankside vegetation and sky. There are added bonuses when grazing cows or strong cloud patterns are reflected in the silvered waters.

The 'model' river mingles with the sea at an estuary. This may be a stark and polluted place of foul creeks, oil-slicks, garbage and other trappings of industrialization. But it may also be a setting which rewards the photographer and water colourist with vast expanses of bright sky which are mirrored in the tidal sheets, and with the low lines of successive sandbanks to strengthen the horizontal emphasis of the scene. Panoramic views, filters to heighten contrast and strengthen cloud patterns and the sparkling reflections produced by shooting into the sun are the prime ingredients of landscape photography here. The rippled sand and dendritic patterns of tidal creeks provide a more intimate dimension, while the wildlife photographer is drawn to the colonies of wildfowl and waders flourishing in estuaries such as those of the Exe or Parrett. High vantage points are few and far between, but sometimes a long bridge or tall buildings will provide a valuable platform.

With the exceptions of artificial lowland reservoirs or some of the glacial meres of the Welsh Marches, lakes are features of the more heavily glaciated areas of Upland Britain. They are found in valleys where the glaciers were so vigorous that they could gouge down into the valley floors to form over-deepened basins, and where the outlets of post-glacial rivers were barred by morainic mounds of rock debris dumped as glaciers ran out of energy and began to recede. The lochs of Scotland fill over-deepened glacial valleys, sea lochs or 'fjords' existing where the sea has invaded an ice-gouged valley. With their dramatic settings, these lakes are seen against a powerful backdrop of hills and mountains. Most lake photographs

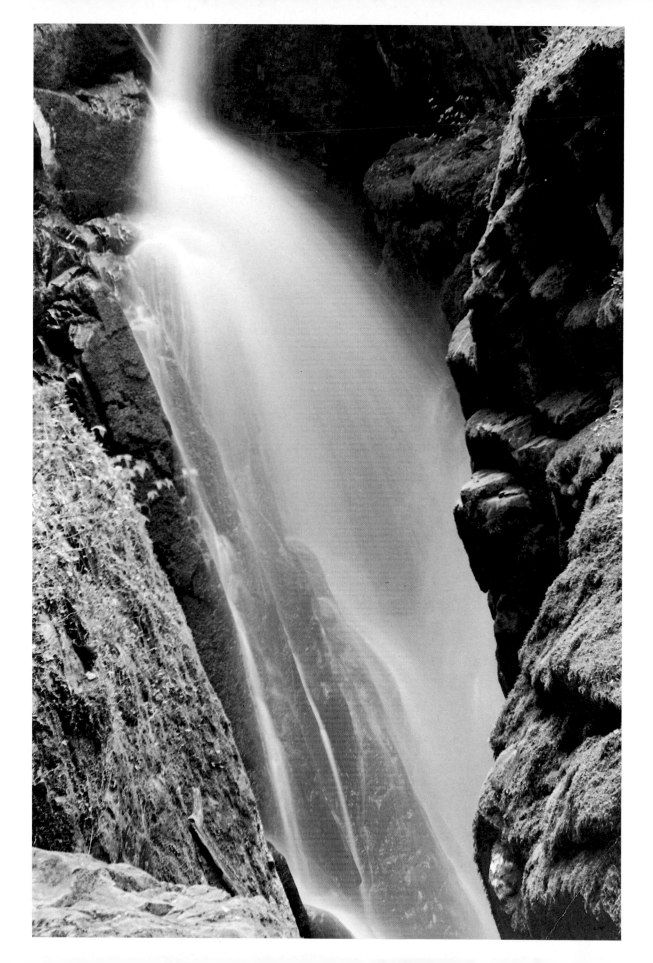

Crummock Water, Lake District, from Low Bank. The modest ridge overlooking House Point provided an ideal vantage point. Under such conditions, with fine views from the lakeside road, it would have been easy to neglect to search for an elevated stance providing even better views. The dark fell on the left helps to strengthen the image.

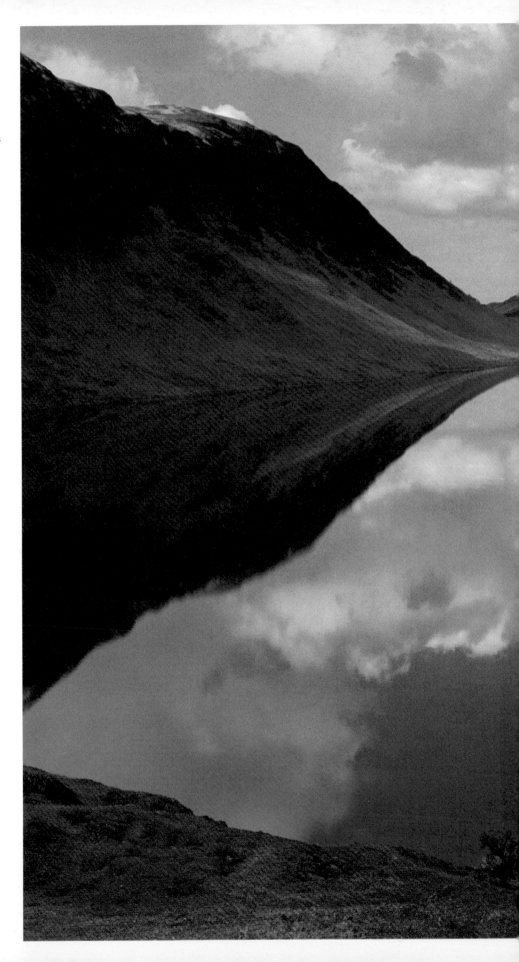

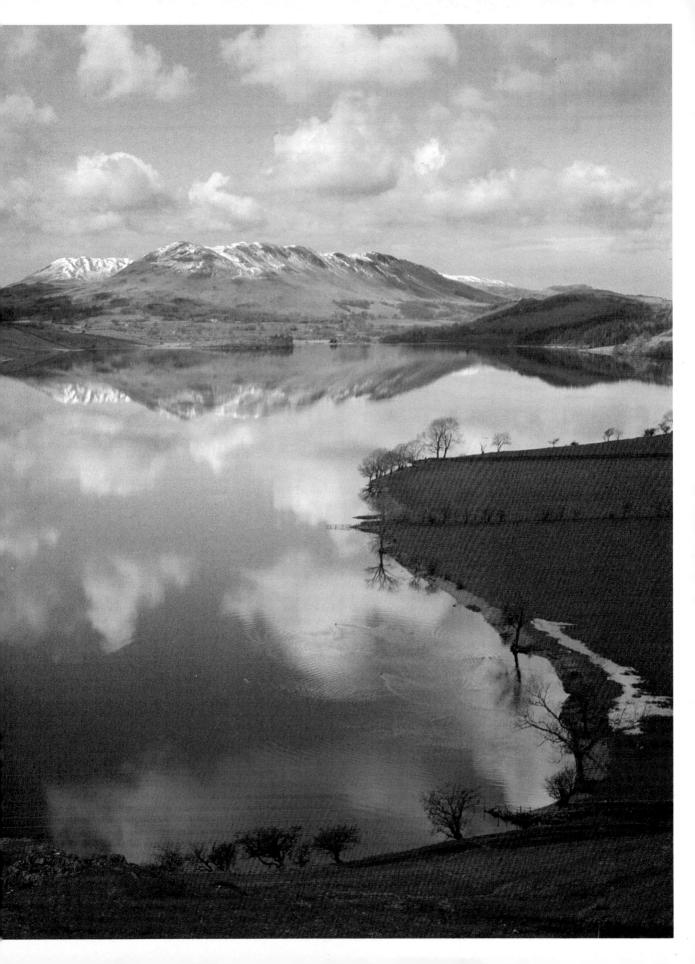

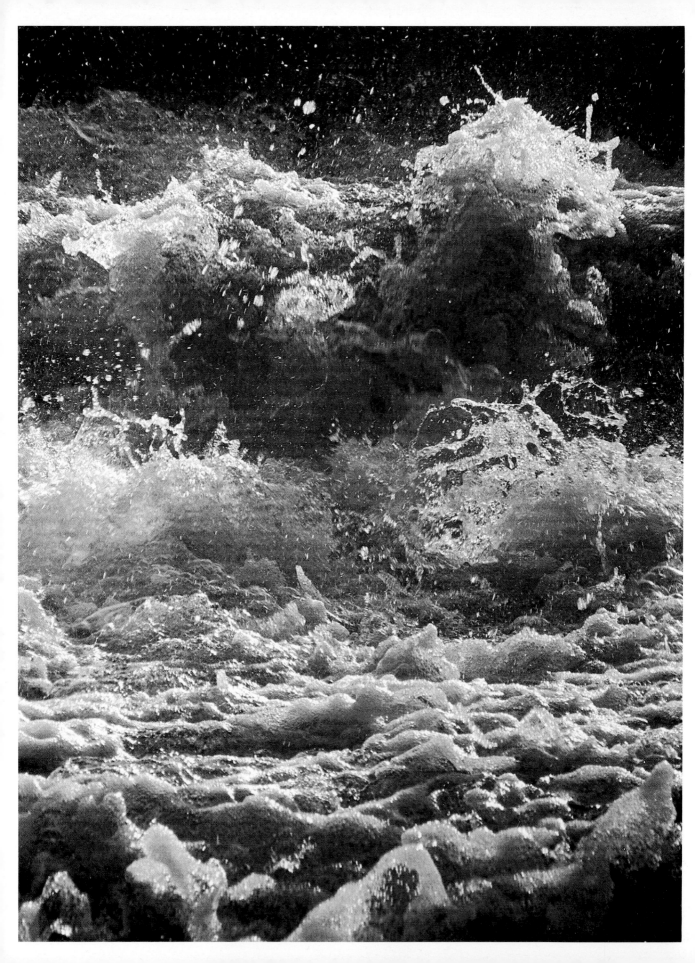

from the Lake District feature both elements, although the emphasis on each can vary. The mountainous surroundings also allow one to work not only from the shore and vicinity of the lake, but also to capture quite different effects from an inexhaustible selection of elevated vantage points, including Derwent Water from Cat Bells, Grasmere from Loughrigg Fell, Buttermere from Haystacks, Crummock Water from Scale Knott, or Wast Water from Great Gable. Normally, one will be working with a wide-angle lens, but the telephoto should not be scorned. It can be used to frame distant details – like the beautiful fell formations visible beyond Loweswater when looking across the lake towards the southeast.

The juxtaposition of flat lustrous water and surging, jagged mountain is pictorially unbeatable. The lakes mirror the qualities of the weather and sky, so that on a grim and turbulent day the waves on the leaden, rippled waters will complement and emphasize the surging clouds and the dark, grim mountains. However, some of my own best Lakeland pictures were taken on a still, clear and frosty April morning, when the lakes were absolutely motionless, allowing the slopes, peaks and cloud patterns to be mirrored perfectly in the water. Stillness or wind, one's position relative to the sun, the choice of vantage points, the season and the time of day will each transform the qualities of the lake scenery, so that you could spend a year photographing a lake such as Wast Water, Loch Shiel or Lough Neagh and still only have scratched the surface of the pictorial possibilities.

The most notable English wetlands are the East Anglian Fens, the Norfolk Broads and the Somerset Levels. All are victims of a merciless campaign of drainage and ecological destruction by the local farming interests, so you will have to seek out such fragments of loveliness as survive amongst the scenic carnage. The Fens and the Levels are peat-carpeted plains which were subject to periodic inundations when floodwaters from the adjacent areas of higher ground were ponded back by tidal surges rolling up the broad, tortuous river courses. Drainage was accomplished in the seventeenth, eighteenth and nineteenth centuries. The Norfolk Broads have a quite different origin, being vast riverside medieval peat diggings which were inundated in the latter part of the Middle Ages.

In all these places the horizon is level and low (though Burrow Mump, Glastonbury Tor and the Polden Hills feature prominently in some views of the Levels). Consequently, the sky will be a feature of any panoramic view. It is essential to decide on the proper emphasis between landscape and cloudscape, for the attention of the viewer needs to be drawn to a focus of interest and will wander if presented with an image which does not discriminate between the two, no matter how attractive each component may be. To avoid such competing emphases the horizon line should generally be set well above or well below the horizontal centre line of the photograph, not along or close to it.

Another potential problem derives from the flatness of the setting, which compresses the more distant landscape into a very narrow horizontal strip. This difficulty can be partly alleviated by seeking a higher vantage point. In the Fens, for example, the view obtained from the train on the Ely–Peterborough railway line is far more comprehensive than that enjoyed by the farmer in the fields just a few metres below. Even the difference between the view of the motorist and motor coach traveller is quite striking. Similarly, Burrow Mump, a few miles south of Bridgewater, is a superb vantage point for the Levels, while some windmills in the Broads allow a broader view. Once photographers would exploit the advantage of photography from a stance on the roofs of their cars – but proud owners of modern cars may make the costly discovery that they are built differently today. One other response to the problem of the extensive and featureless foregrounds encountered when using wide-angle lenses in flat country is to include some attractive foreground feature – like reeds silhouetted against a water course – while the heavy horizontal emphasis of the horizon can be countered by a stream or drainage

LEFT Surprisingly, perhaps, the area covered by this picture is just over a square metre. It was taken at a waterfall where the river was in spate and the camera was pointing into the sun. The strong backlighting allowed an exposure of only $^1/_{2000}$ sec, which has 'frozen' the flying spray. A 300 mm telephoto was used in conjunction with Ilford HP5 film rated at the normal ISO 400.

95

A fragment of old Fenland conserved at Wicken Fen, in Cambridgeshire. The crisp colours, well recorded on Kodak Ektachrome 64 film, result from a combination of clear air and low afternoon sunlight.

ditch running obliquely or directly towards the skyline, or by trees which interrupt the skyline.

Techniques and equipment

Some relevant photographic techniques have already been mentioned, but two valuable ones concern the treatment of moving water and the use of polarizing filters. A shutter speed as slow as $^1/_{125}$ sec will apparently freeze most moving water, but the effect of motion is more effectively conveyed by the use of a slow shutter setting, such as $^1/_4$ sec, which allows the white water to blur. This technique is commonly used at waterfalls, and is so effective that it should not be regarded as a hackneyed approach. The slow shutter speed is achieved by reducing the aperture until the desired speed is reached. If a minimum aperture of f/16 or f/22 does not yield this speed, then slower settings can be achieved by the use of neutral density filters. But since most waterfalls are found at the heads of gorges or in shady places, you can generally obtain a setting of something like $^1/_4$ sec at f/16 using medium-speed film. The slower the shutter speed, the more the falling water will appear as a soft white veil, and you can experiment with different settings on either side of $^1/_4$ sec.

Although this is a standard treatment for waterfalls, one seldom sees it applied to other forms of moving water. Even so, it can be very effective when used in a close-up mode to trace swirling eddies around pebbles and boulders, or the bucking motions of water at rapids. Drifting spray can be a problem when

working close to waterfalls, particularly in windy conditions. The only remedy is to keep the lens shielded until the last possible moment.

A polarizing filter is a useful adjunct to lake and river photography, allowing you to control reflected glare from water as well as other less obvious reflections, such as the sheen of foliage or rocks. Ordinary unpolarized light comprises waves which vibrate in all planes parallel to the direction the light is travelling. When light is reflected from non-metallic surfaces, waves and their components vibrating in one given direction are reflected more strongly than those in the others, which are absorbed to a greater or lesser extent. The reflected light has become partially 'polarized' in one plane. The angle of reflection at which the effect is most marked varies with the material.

The polarizing filter can be likened – very crudely – to a system of parallel slats on a sub-microscopic scale which tends to let light-waves vibrating parallel to the slats through, absorbing to a varying degree those vibrating at other angles. Polarizing filters are mounted in rotating holders so that you can turn them to the angle you want. By rotating the filter you can see how at one particular orientation it cuts down reflections and at others lets part or all of the reflection through.

Use of this filter allows the camera to 'see into' rivers and rock pools, but it should be used with discretion. Sometimes you will of course want to exclude glare, but at others the silvery sheen and highlights on a body of water are an important part of the picture. Rather than using this valuable filter as a matter of course, you should compare visual effects with and without the polarizer and at different orientations. It's always worth taking the 'control' picture without the filter as well.

Another interesting use of the filter is in controlling sky tone with colour films. The light from a blue cloudless sky is partially polarized, the effect being strongest at 90° to the direction of the sun. By rotating the filter you can darken the blue sky to the degree you want: note, though, that the steely blue colour does not always look pleasing on colour film. The same phenomenon, incidentally, combined with the polarizing effects of reflection at water surfaces, is the cause of the peculiar indigo colour of lakes and the sea under certain conditions. Using the polarizing filter can produce a similar effect on water colour.

Because it absorbs at least half the light, the polarizing filter needs about $1\frac{1}{2}$ f-stops of extra exposure which may preclude its use when you need to use high shutter speeds, or small stops for depth of field.

Project: **An unusual riverside photograph**

The various techniques described above can be applied to the different waterside settings which one encounters, but this project is an unusual, subtle and demanding one: to capture the sensual qualities of the riverside world in just a square metre or a few square centimetres of the water's surface. The equipment consists of a camera loaded with colour film, a telephoto lens of around 135 mm to 200 mm with polarizing filter, and a tripod or monopod.

Any convenient river can be exploited, but success depends upon the ability to 'think telephoto'. We are not, at present, concerned with panoramic views, but with seeking tiny pictorial cameos within the general scene. This not only tests the ability to recognize the field of view of the telephoto lens, but also powers of observation and creativity – after all, success in landscape photography revolves around the ability to 'see' pictures within the landscape, and to recognize how the different elements of the scene will be rendered by the camera. All manner of subjects could be tackled: a trout lurking just beneath the surface; fronds of weed swaying with the current; leaves reflected in a limpid pool, and so on. Alternatively, one could attempt a more impressionistic approach, concentrating on the colour or texture of moving water. Try walking along the east bank of a

A small patch of water may contain more photographic potential than the broad vista in which it lies. Here autumn foliage is reflected in the slightly rippled waters of a clear Pennine river.

river around sunset, hoping to catch the golden reflections of a sinking sun or to capture the circles of ripples produced by raindrops. Another possibility is to explore a river in spate, using the telephoto lens to capture the crested rapids and strong eddies. First attempts may produce only disappointment, but at the very least the aspiring photographer can gain an appreciation of the possibilities and recognize the potential of the telephoto lens and its ability to discover scenes within a scene. Thought is required at every stage: whether to use a polarizing filter; what shutter speed will best capture the pattern in the current; how much depth of field should be sought, and whether a tripod or monopod should be used. Seeing and thinking are the keys to success.

7
MOUNTAINS AND CAVES

Britain is no Nepal, and Ireland no Peru. Those unfamiliar with these islands might easily sneer at our endowment of mountains, the highest scarcely ranking as a foothill by Alpine standards, let alone those of the Himalayas. So it is interesting to recall how many of the conquerors of the world's most daunting peaks acquired their skills and preparation on the crags around Llanberis, Ben Nevis and Langdale. Most photographs tell one little about the real dimensions of a mountain. From the right vantage point, one of the Lake District's modest peaks can seem quite big enough (too big for some) – so that this is a good time to consider the two most important practical aspects of mountain photography: portability of equipment and safety.

Carrying equipment and choice of clothing

The need to select and pack one's burden of equipment with care is more important in mountain photography than in any other branch. Gear that can comfortably be carried for five miles across easy terrain may prove to be an unbearable load in an ascent of just 150 metres. The challenge is met partly by the judicious selection of just the items that will be needed, and partly by choosing the most convenient method of carrying them. The aluminium photography case comes bottom of the list. These are fine for moving delicate equipment from home to studio, for bump-proof transport in the boot of a car, or for announcing 'I am a serious photographer' to an indifferent world. In difficult terrain such cases are extremely un-portable and can be relied upon to unbalance the bearer, while the hard corners gouge bruises in his or her thigh. The conventional camera bag comes next in the order of dispensability. Normally slung over one shoulder, they also tend to unbalance you, destroying the rhythm of scrambling, and pulling you out towards nasty drops, or, if on the other shoulder, pushing you outwards from crags flanking narrow paths. Some of the more sophisticated bags have optional belt fittings. Access to a front-slung bag is easier, but the bag tends to slap against the thighs on ascents and to pull the body forward and downward.

Two other carrying systems deserve much more serious attention. Those who have struggled with camera bags may be amazed at the apparent lightening of the load and ease of movement which results when the paraphernalia is transferred into sets of padded pouches slung on a photographer's belt, with the pouches arranged to balance the load. The pouches come in a number of forms, including holsters of different sizes to accommodate cameras fitted with various lenses. Some are rigid and give a high degree of protection against drops and falls, others are soft and padded. (Personal experience suggests that lenses and the like can

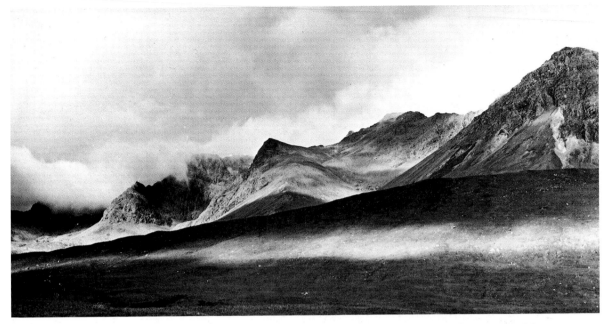

ABOVE AND RIGHT Both the wide-angle and the telephoto lens have a vital role to play in mountain photography. This is the same scene in the Cuillins on Skye photographed with a wide-angle lens (above) and a telephoto (right), showing how the telephoto was used to isolate the most attractive detail.

drop from the type with simple Velcro fastenings.) Other valuable assets are photographers' jackets and waistcoats, which also distribute the load in the desirable way and are packed with useful pockets. The jackets, being stuffed with gear, cannot easily be taken off and carried when one warms up, and so the waistcoat, worn over dispensable sweaters, is a better option. The one that I favour, made by Quest Vest (see p. 233), has numerous pockets, two of them large and thickly padded, and – most important – shoulder tabs which hold camera straps, keeping the cameras ready for use but safe from slips.

Here it is convenient to consider garments generally, as well as the clothing you need for mountain photography. Pockets and comfort are the watchwords: one always wants plenty of both. Leather jackets tend to leave one rather clammy after arduous exercise, but, being windproof, they are very good for general use in the spring months when sharp breezes blow. At the time of writing there is a fashion for denim and light cotton waistcoats, most with lots of pockets. These are absolutely ideal for summer wear, while some photographers favour the more specialized waistcoats made for fishermen, which have many useful pockets. Denim jeans are convenient garb for all but the coldest conditions, but the tighter kinds should be avoided for mountain work as they tug against the leg muscles on each upward step. Light, waterproof anoraks can be worn over a photographer's belt or waistcoat, thick flannel shirts are popular with climbers and a woolly jumper should always be carried if you are going into hills or mountains, even when it seems quite warm down on the plain.

Each year more ramblers than rock climbers are likely to die in our mountains. A few may be victims of unforeseeable bad luck, but most perish on the altar of their own carelessness. Proper clothing and thoughtful preparations are essential. Before venturing into mountains you should always be satisfied that you would be able to return safely in the worst conceivable conditions – remembering that while ice and blizzards may be unlikely in summer, low cloud and heavy mists can be encountered at any time. A map and the ability to read it are vital for long forays in unfamiliar terrain and a compass may also be advisable.

Clothing should similarly be equal to the worst of Nature's moods – and better to bear the burden of an extra sweater or anorak than to shiver on a windswept ridge. The high-street tailor's outdoor clothing tends to be inferior in all but sartorial aspects to military gear, which is usually made to the highest standards of

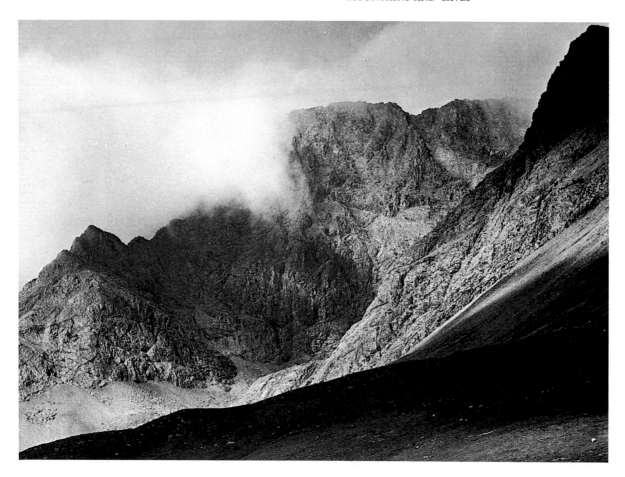

durability and design. Consequently the dedicated photographer can become a connoisseur of the army surplus stores. Though derided by more fastidious relatives, pride of place in my wardrobe is enjoyed by pairs of Canadian army trousers (massive pockets and double reinforcements), Spanish army wool shirts, and a black US army anorak with quilted lining. All such garments are also suitable for mud-wallowing in nature photography, when camouflage net scarves can double up as concealment for a hidden, remotely-triggered camera.

While specialist rock climbers favour a type of lightweight boot, heavier fell boots with good ankle reinforcement and top quality cleated soles are best for rough walking. (The wise fell-walker will regard the widely-read Lakeland guide which recommends wellington boots as an invitation to disaster, and also remember that the more expensive treads grip rock better than some cheaper soles.) My own closest call came when, having been wearing heavy fell boots all week, I was scampering across a dewy slope above a steep gorge, forgetting that I was now wearing canvas camping boots.

Equipment for work in mountains

Here the aim is to carry as light a load as possible – while bearing in mind that one cannot easily return for items which are suddenly found to be essential. Those primarily concerned with rock climbing or fell-walking may settle for a 35 mm compact camera, while others wishing only to take one SLR camera lens should consider a wide-to-standard zoom. However, mountain subjects tend to offer exciting possibilities in both colour and monochrome, so two bodies should be

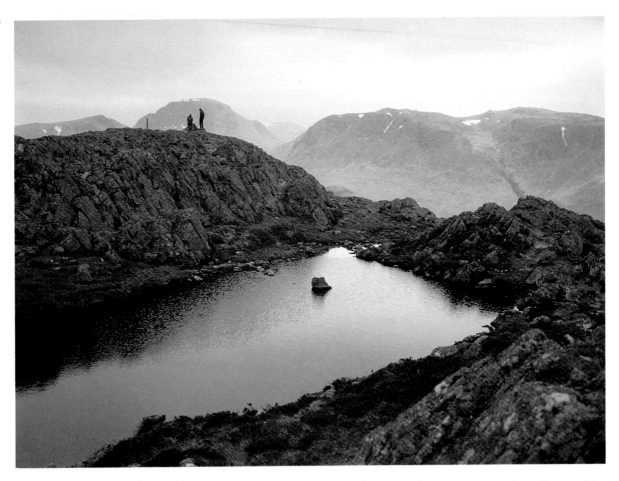

Unnamed tarn on the summit of Haystacks, one of a string that grace the summit of this lovely Lakeland fell. Here the figures of the two climbers are an essential indicator of scale and are well positioned against the mass of distant Great Gable.

carried, if possible. If only two fixed focal length lenses can be taken, then a wide-angle of around 28 mm will be found essential for wide panoramas, while a telephoto lens of 150–200 mm length allows one to pull in the details of the distant scene or isolate a dramatic rock formation. A third lens choice could be the standard lens or a medium wide-angle of around 35 mm, while a compact teleconverter might be carried to double the power of the telephoto, avoiding the need to take a cumbersome, long, conventional telephoto or a delicate mirror lens.

Be optimistic in packing film: conditions could be surprisingly good and there will be no shops on the mountain! The strong possibility of haze and the importance of including cloud formations in the vistas argue for the use of an orange filter in monochrome work, while a red filter can be used more selectively to give stronger haze penetration and heavier atmospheric effects. In colour work, a skylight filter will slightly reduce haze, a polarizing filter will cut reflections and glare and strengthen skies in snow scenes, while a warming filter will help to cut the excessive blueness often seen in the shadows. When working above the snow line, automatic meters may lead to slight overexposure and it is wise to 'bracket' shots, taking one on the auto setting, and subsequent ones with the lens stopped down by $^1/_2$ stop and 1 stop. Only the most devoted of stalwarts will accept the burden of a tripod, even though work in mist around dark rock faces and details of shaded gorges may demand a camera support. Fortunately, makeshift tripods can generally be created from rucksacks, boulders and scree, while a telescopic monopod slung on the belt may earn its keep. Finally, a set of extension tubes can easily be carried to permit close-ups of alpine flora and mosses and lichens – but bear in mind that a proper macro lens, although heavier, is scarcely more bulky.

Photography in high places

In mountain photography, as in driving, it is unwise to become captivated by the scenery to the exclusion of all else. The approaches to vantage points should be made in a deliberate manner, forgetting, for the moment, the splendours of the awaiting scene. On difficult ground it is a good idea to plan each little stage of the ascent or traverse carefully, with maximum concentration. Many readers will, like the author, be afflicted with that phobia of high, exposed situations commonly known as 'vertigo'. There does not seem to be a cure, and occurrences are unpredictable: you may do an ascent requiring hands as well as feet one day without ill effects, yet be assailed in a completely safe situation on the next. Yet this should not lead you to shun the incomparable world of mountains; perhaps the best advice is to recognize the problem and avoid situations that you cannot retreat from – even with a spinning head and legs of jelly.

Most people seen rambling in mountains are occasional visitors from the lowlands, many of them discovering their lack of physical fitness. The combination of steep slopes and a modest burden of gear can be surprisingly demanding on the physique – yet it is also surprising how quickly a reasonable level of fitness can be achieved. And so it is prudent to begin a trip on the less rigorous routes, saving the hardest work for the later stages of a holiday.

The main opportunities in mountain work are as follows:

1 Panoramas of the ranges seen from lowland valleys, lakeside or sea-shore.
2 Panoramas of upland and lowland seen from a mountain vantage point.
3 Details of pinnacles, crags, mist patterns and fragments of a distant view isolated by the telephoto lens.
4 Close-ups of mountain flora.

Interesting mountain pictures can be taken from plains and valleys by those unable to climb. This is the Sgurr an Lochain range in the Western Highlands taken from Glenshiel. The appeal derives from the turmoil in the clouds around the summit and I exposed for the sky, thus darkening the mountain mass.

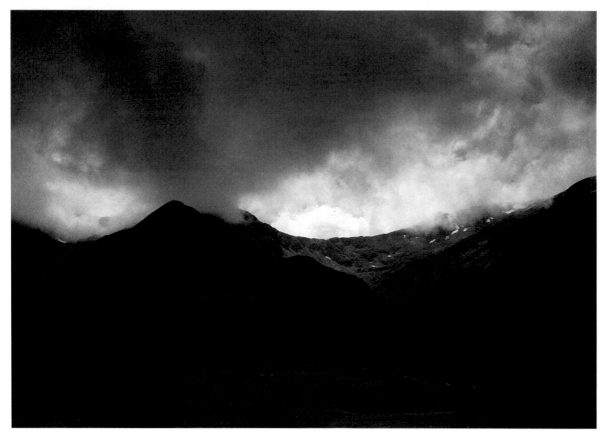

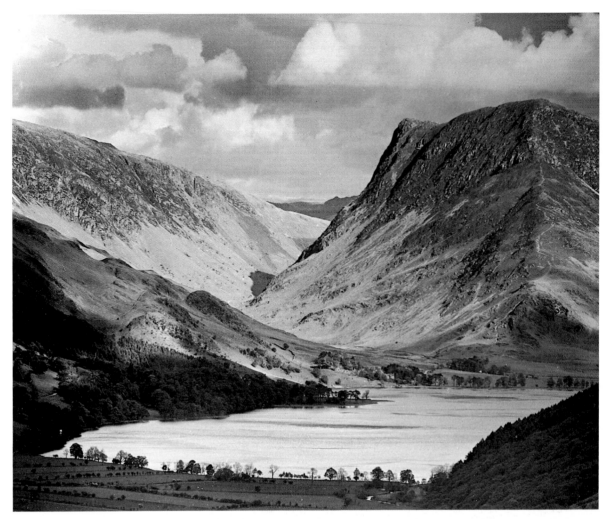

This picture was taken from the same high vantage point as the photograph on p. 59, but using a telephoto lens, monochrome film, a red filter and printing on hard paper. It shows Fleetwith Pike looming above Buttermere in the Lake District. The summit of the Pike was about 5 miles from the vantage point, though the near lake shore was only about 2 miles away, showing how the telephoto lens gives the illusion of compressing perspective.

Readers of less-than-perfect fitness should take heart from the fact that views do not necessarily improve with altitude. At 1000 metres, or higher, panoramas of the valleys and plains below tend to lack immediacy and impact. In Britain some of the finest views can be enjoyed at heights of 150 to 500 metres, while even in the Alps many of the most stunning photographs are taken from positions just above the tree-line.

Some mountain photographs derive their success from the detailed rendition of lake, ridge and valley. Others succeed with a starkly simple juxtaposition of black crags and wisps of mist, or lowering clouds and daunting slopes. High up and ringed by imposing panoramas, it is easy to overlook the cameos *within* the broader scene – light glancing off the wet stones of the track, cloud shadows on a distant valley, or the shapely form of a far-off peak. So remember to 'see' with telephoto eyes as well as with wide-angle vision.

Understanding the mountain scene

As most experienced fell-walkers will know, the mountain landscape of Cumbria is quite different from that of, say, the Cuillins or the Brecon Beacons. Even within the Lake District there are striking differences between the smoothly sculptured slopes of the Skiddaw Slates in the north and the rugged knolls and jutting crags of the Borrowdale Volcanic Series of rocks in the central area. The

enthusiast will soon learn that hill and mountain scenery varies greatly from range to range. If you wish to photograph craggy pinnacles and soaring rock faces it is wise to go to Skye and the Western Highlands rather than to the more rounded mountains of the Grampians, or the tabular plateau country of the Brecon Beacons or Pennines.

Long ago an American geomorphologist, W. M. Davis, pointed out that landforms were the creations of structure (the composition, stratification and faulting of rocks), process (the forces which have moulded the landscape, such as uplift, glaciation, river, wind or sea erosion) and time (the stage reached in the erosion of the landscape). These three factors are found in an infinite range of variation and combination, ensuring that each vista of scenery is unique. In the Western Highlands, for example, there is an intensely glaciated landscape founded on tough, ancient rocks, which have been baked in the furnace of geological trauma, gashed by volcanic dykes, iced in places with basalt lava flows and injected with great granitic intrusions, which, millions of years later, may be exposed to form noble summits. In the Pennines, in contrast, there are the brooding landscapes formed on Millstone Grit, the plateaus, gorges and silvery scars of the Carboniferous limestone country, and areas of more detailed, step-like scenery where selective erosion has exploited the weaker strata in the narrow beds of sandstone, shale and limestone in the Yoredale Series. The differences in geology evoke a visible response in the vegetation cover, with the dry limestone tending to support bright pasture, while the damp, acidic Millstone Grit soils may be carpeted in moorland. These latter soils also support the thicker tree cover seen in valleys in Millstone Grit. In such ways the mountain photographer will find an elementary understanding of geology and geomorphology most useful. Thus, if you wish to photograph details of jagged crags and crested ridges, it is best to explore the brutally glaciated slates and volcanic rocks of Snowdonia and the central Lake District. Similarly, potholes, caverns and cliff-flanked gorges are features of upland limestone country, while the grotesque rock stacks known as 'tors' are features of the southwestern granite moors and a few unusual grit outcrops in the Pennines.

Drifting mist is attractive, but deceptively difficult to capture in monochrome work as the levels of contrast are less than one might imagine. The only solution is to exploit whatever sunlight may appear and print on a hard paper. This is the Old Man of Storr formation on Skye.

Foregrounds are often a problem in mountain photography, but here the jagged foreground rocks are the crucial element in the photograph. This is taken in the raggle-taggle country of the Borrowdale Volcanics, near Watendlath in Cumbria.

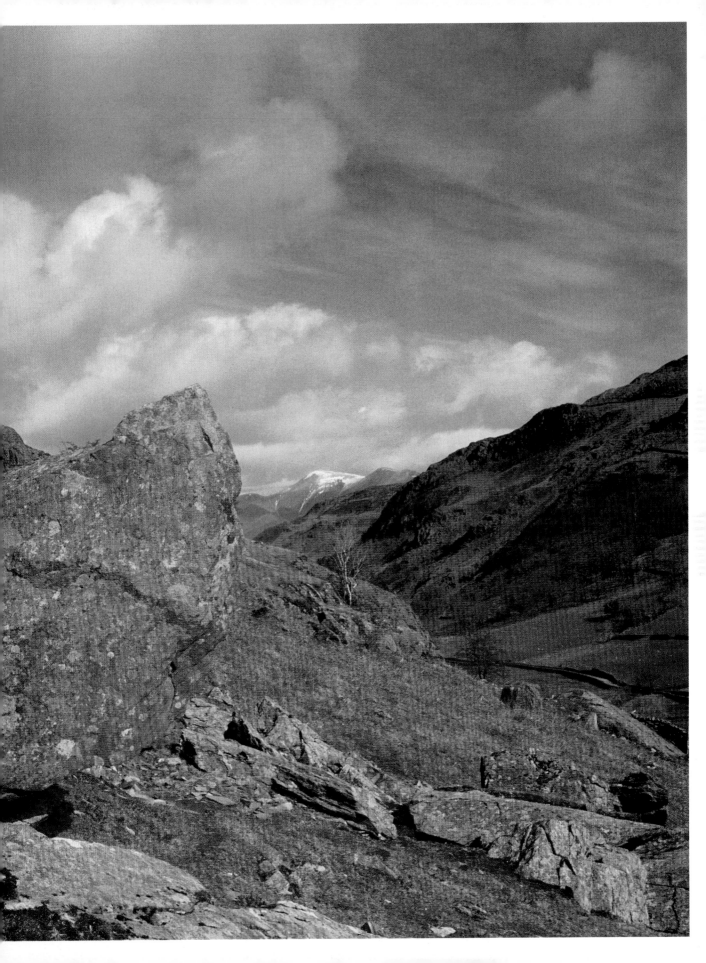

RIGHT This is a technically rather complicated picture of one of the outlets of the Thor's Cave complex in Staffordshire. An exposure reading was taken from a well-lit section of the cave wall, avoiding the direct light of the cave mouth, and during the long exposure a little electronic flash was thrown into the foreground area.

Work in caves

This may be as good a place as any to introduce the possibilities of underground work. A few sea caves apart, caverns are only found in limestone areas, and are largely confined to uplands marked on geological maps as being composed of Carboniferous limestone, including the Pennines, the Mendips and the Peak District. Here the caverns are the courses and former courses of streams which have trickled down the fissure networks and enlarged their subterranean passages by the solution of the calcareous rocks.

Only idiots will venture into a non-commercial and unknown cavern network without sound potholing experience or an accomplished guide. Apart from the problem of becoming lost or trapped in the dark labyrinths, there is also the threat that, following a sharp deluge, the passages may rapidly become the channel of a tumultuous river. Most of the dramatic photographs displayed in caving publications are taken with 35 mm cameras and compact but powerful flash guns, or, less frequently, are time exposures taken using the light from helmet lamps. These can be very effective when silhouetted figures and their cyclops-like lamps are shown. Since experienced potholers wriggle through narrow passages and may swim underwater through sinks, the equipment must obviously be compact, well cushioned and carried in waterproof packaging.

Work using a single flash inside caves will generally produce rather unattractive sharply-defined black shadows and bleached-out highlights. In the more accessible caves, with space to move around, the technique of 'multiple flashing' will permit much more polished results. Firstly the camera is mounted on a tripod, while its wide-angle lens is set to a small stop, allowing a generous coverage and great depth of field. On the older types of camera a 'T' or 'time' setting was often provided, allowing the shutter to be opened and then closed by successive pressures on the release. The modern 35 mm camera offers only a 'B' or 'bulb' setting, making multiple flashing more difficult. The shutter must be opened and kept open, either with the help of a companion or by using a strong elastic band or some other form of pressure on the release. An electronic flash gun is then switched on and kept in the 'on' position as the photographer proceeds through the cavern, illuminating different rock faces with successive flashes. This method produces very effective results, although it is essential, firstly, that the gun is never pointed toward the camera, secondly, that the flash is always directed away from the photographer (who will otherwise appear as a 'ghost' in the photograph), and thirdly, that the 'on' or 'ready' light on the back of the gun is covered or kept out of the view of the lens (or it will register as a trail of light). By beginning flashing at the end of the visible cavern and creeping back toward the camera, lighting different rock faces from different angles and being sure that no expanses go unlit, you can illuminate areas that you previously occupied. So long as you remember the three points given above, the cavern will be beautifully illuminated and reveal no sign of the 'flasher'. When the flashing is complete, the shutter is then closed. Different factors apply in cave-mouth settings where there is a strong leakage of natural light from the world outside. Here you can use the necessary long exposure with the camera mounted on a tripod, say $^1/_{15}$ to 4 secs, while using the flash gun as fill-in to illuminate shaded areas receiving little or no natural light.

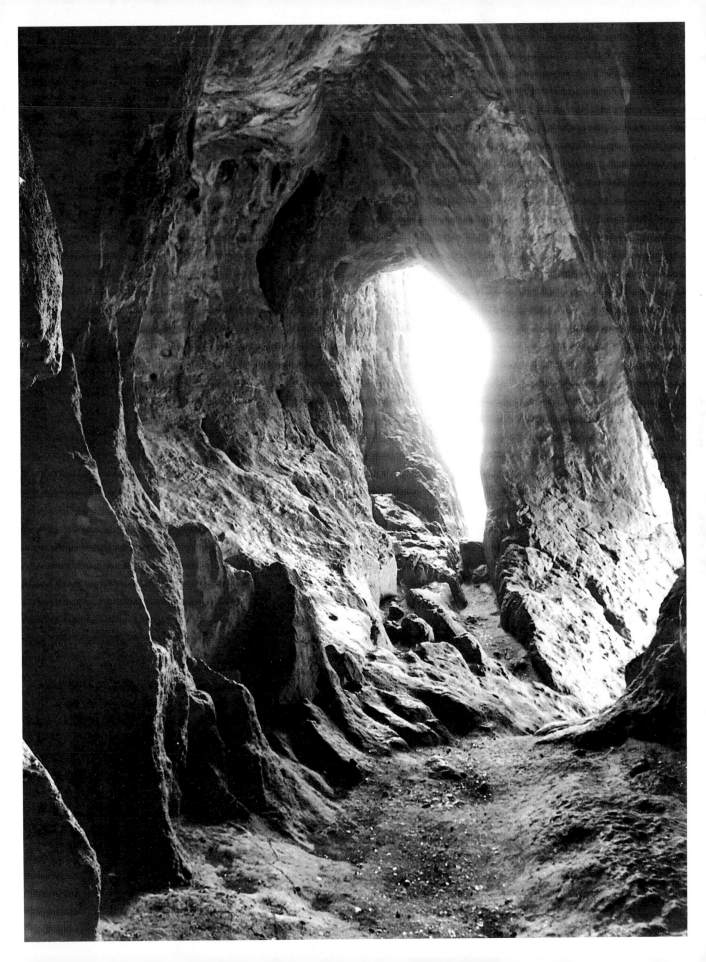

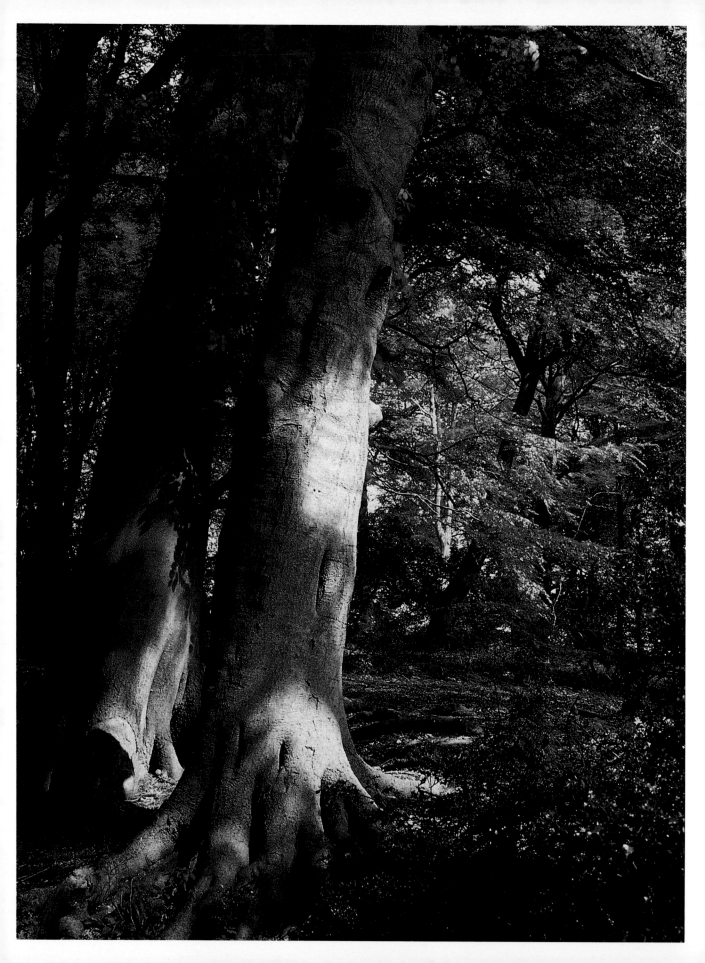

8
WOODLANDS

Woodlands provide the landscape photographer with a wealth of opportunities. They contain innumerable challenging, beautiful and, sometimes, even dramatic subjects – or rather, some woods do. As ever in landscape photography, a knowledge and an understanding of the subject can only enhance the quality of the results, an appreciation of the opportunities and the pleasures of the quest. The character of a wood is much more than simply a function of the species of trees which it contains, but is also produced by the history of human management and, as is now so often the case, neglect.

Understanding the woodland scene

The best woods contain gnarled and venerable giants, mossy dells and secret nooks, but it is quite wrong to imagine that woods are the last fragments of the primeval wilderness. Patches of semi-natural wildwood may be represented by some small, rather scrubby oak woods in Cumbria's Borrowdale, and by stands of Scots pine in the Scottish Highlands, threatened relics of the old Caledonian forest. But the overwhelming majority of woods clearly display the handiwork of man. During the Middle Ages woods were carefully managed to meet the enormous demand for hardwood timber. They were commonly guarded by 'wood banks' and divided into sections which were cut in rotation. Some areas produced light 'coppiced' timber. Here the trees were felled at ground level every decade or so to yield poles for tool handles, wattle for building and hazel sways for thatching, and also for charcoal and fuel. Soon after coppicing, a new crop of poles would spring from the coppiced stools. Frequently, trees such as oak, ash and elm were allowed to grow tall amongst the coppiced underwood and were eventually felled to yield heavy timber for ship-building or house-building: this created a woodland landscape of 'coppice with standards'. Where the cultivation of timber was combined with grazing by livestock, the trees were often beheaded or 'coppiced' above the reach of cattle or horses, which would otherwise browse on the soft new growth; this method of management is known as 'pollarding' and the trees cropped in this way are 'pollards'.

In many woods these methods of woodmanship were continued well beyond the close of the Middle Ages. During the nineteenth century, the increasing availability of imported softwood timber was paralleled by a general neglect of the traditional practices, and there are only a few woods where one can still see the old crafts in operation. In the post-medieval period the fashion for landscaping and agricultural improvements led to the planting of ornamental woods and shelter belts, sometimes to enhance the countryside, sometimes to protect crops and

LEFT Massive beeches in Ashridge Park, near Berkhamsted, Hertfordshire. The heavy shade cast by beech woodland suppresses undergrowth.

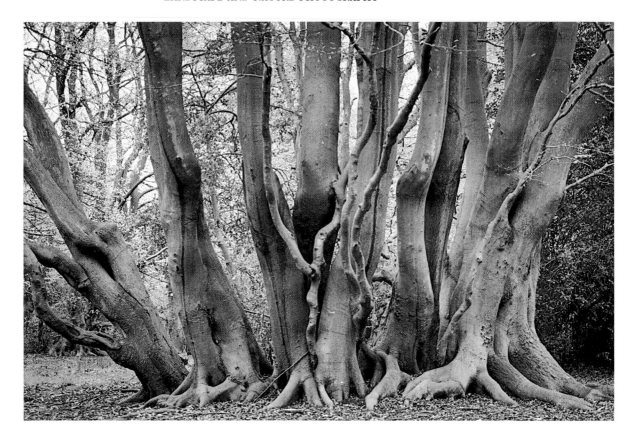

This coppice in Epping Forest, Essex, may be a thousand years old. Envigorated by regular coppicing, trees survived far longer than they could as standards or pollards.

livestock from the wind and provide game cover. Beech and Scots pine were popular choices and larch was sometimes planted as an ornamental-cum-timber tree. In the Victorian era there was a vogue amongst the owners of stately homes for the establishment of collections of exotic trees, which were frequently introduced at the expense of landscaped plantations of indigenous hardwoods established during the previous century.

The range of opportunities

Each particular woodland environment offers its own range of photographic opportunities and limitations. In many cases the limitations greatly exceed the possibilities. Now the most common type of deciduous wood is one which proclaims decades of neglect. It still provides an invaluable refuge for a myriad of plants and wildlife, but it presents few really enticing vistas. There will be a number of attractive 200-, 300-, or 400-year-old standards, but the view is likely to be obscured by rank undergrowth and the scores of weedy saplings which spring unchecked from the woodland floor. The most widespread feature is likely to be the abandoned coppice, with the clusters of poles rising from the old 'stools' and growing thigh-thick, crooked and ungainly. The neglect of woodmanship in many such woods was followed by 'elm invasion', with the displacement of other deciduous trees. Now the ravages of Dutch elm disease are producing another kind of woodland carnage.

In this very common type of British wood one must search hard to find the more photogenic facets of the general scene, but in the commercial conifer plantations beauty of the picturesque kind is scarcely to be found. In the older plantations of the eighteenth and nineteenth centuries, where Scots pine and larch were favoured, pleasing groups of attractive trees may be found, but normally you will

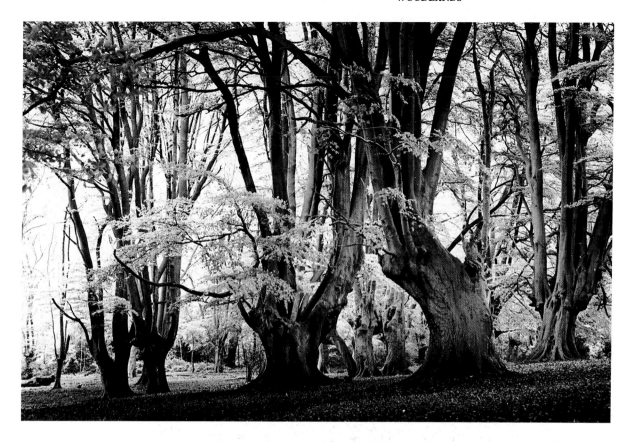

see marshalled rows of unhappy aliens, all of the same species, age and size, equally spaced and drab as can be. Here there is little point in trying to grope for beauty and it is better to seek to capture the unnatural starkness of the scene.

Hornbeam pollards growing in Epping Forest, Essex. The prolonged neglect of pollarding has created the top-heavy appearance.

Turning now to the more inviting opportunities, coppice-with-standards woodland provides possibilities, with the standards towering like stately parasols over the bristling young coppice beneath. However one must search hard to find woods – like Bradfield, or Wolves Wood, both in Suffolk – where the ancient woodland practices are still extant.

The most exciting possibilities are found in woods of old pollards. Here the individual trees are often up to 500 years old and may stand in ground kept clear of an understorey of hazel, holly, hawthorn or bramble by grazing. Although the practice of pollarding may have been abandoned for centuries, the gnarled trees will still display the typical pollard form, with most branches rising from the crown of the trunk like the tentacles of a giant squid. Parts of Sherwood Forest, Windsor Great Park and the New Forest contain some magnificent collections of venerable oak pollards, though these may be interspersed with birch thickets, less attractive areas of abandoned coppicing and depressing conifer plantations. Beeches were also sometimes pollarded, and some very beautiful beech pollards can be found, as near Knightwood Oak (a splendid oak pollard) in the New Forest, which has given its name to an area of trees, or Burnham Beeches in the Chilterns. Epping Forest has expanses of small beech and hornbeam pollards – and some interesting lollipop-like, newly pollarded trees. Popular in many old landscaping schemes, particularly in the chalk country, the beech produces a heavy shade which suppresses the undergrowth, and a mature plantation of well-spaced standard or pollarded beeches will not fail to provide material for an attractive series of photographs. Wandlebury Wood near Cambridge, and Berkhamsted Common, Herts, are particularly inviting.

113

Working in woods: opportunities and equipment

The more obvious photographic opportunities are as follows:

1 The wood as a feature of the landscape, viewed from a vantage point beyond the woodland margins.
2 A woodland vista as seen from within the wood.
3 Details of the woodland scene – a stump, a fern and boulder cluster etc.
4 Close-up views of members of the woodland plant, fungi and animal communities (as discussed in the chapters on nature photography).

Autumn has its special attractions for the nature photographer. Here are two less conventional approaches. In the picture far right the woodland floor is omitted to concentrate attention on the juxtaposition of golden beech leeves and pale blue sky, while to the right the woodland floor itself is the subject. Here a wide-angle lens has been stopped down to f/16 and the tripod-mounted camera exploits its great depth of field. Yellow horse chestnut leaves are the main colour source.

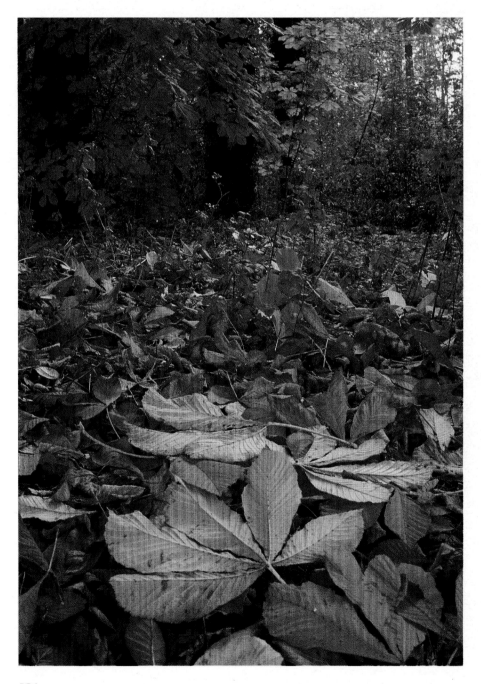

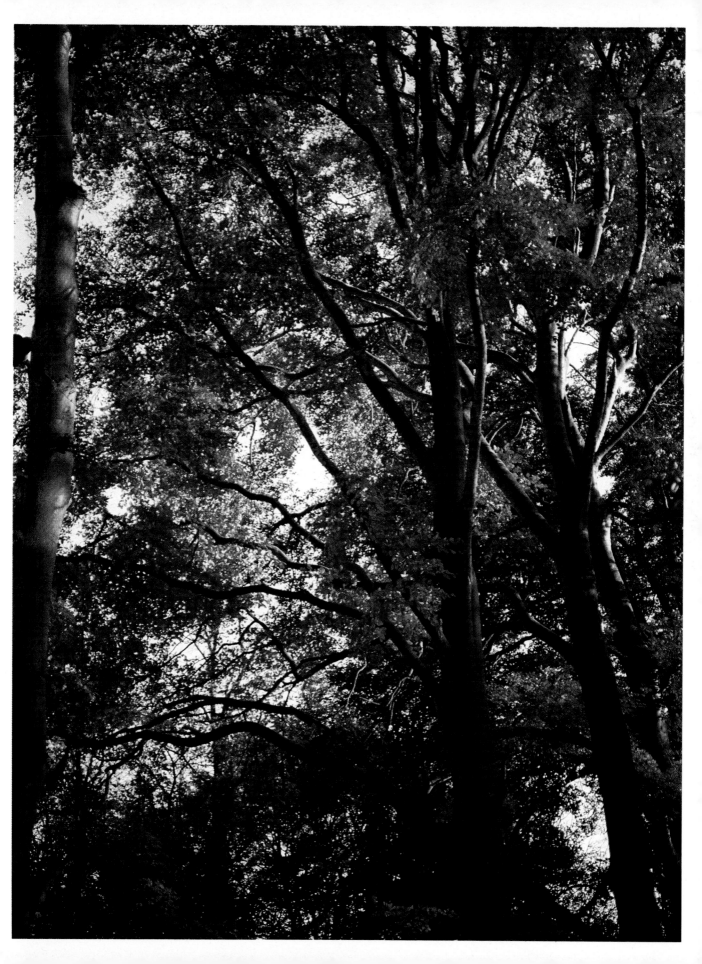

RIGHT Massive beech pollards at Knightwood Oak in the New Forest. In photography such as this the choice of camera position is crucial, and shifts of just a few centimetres can have profound effects.

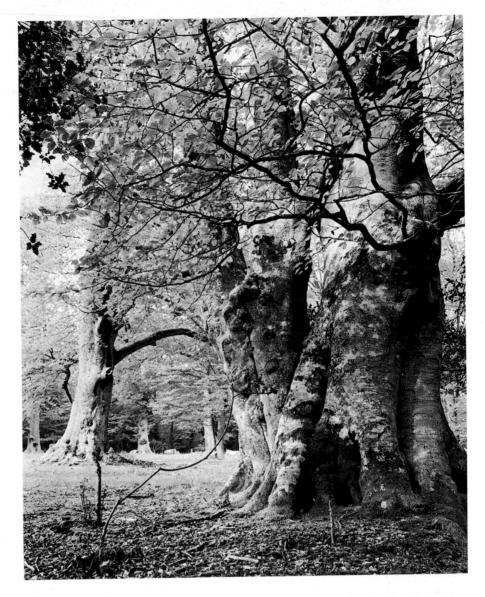

FAR RIGHT When you have developed a good woodland technique, try experimenting with infra-red film. Its effects are summarized in this picture from a small oak wood.

As you begin to work in woodland settings, two important and rather surprising factors become clear: firstly, the shade beneath the leafy canopy is much deeper than at first imagined and, secondly, within the heavy shade the levels of contrast can be remarkably high.

The equipment needed for general woodland projects is as follows:

1 Preferably two camera bodies, for woodland subjects work well in both colour and monochrome. (If you hope to photograph deer or larger birds flying in the canopy then a third body, loaded with a fast film and carrying a long telephoto, may be needed.)
2 A sturdy tripod. This is essential, bearing in mind the low levels of light.
3 A wide-angle lens (around 28 mm) and a telephoto lens (135 to 200 mm).
4 Additional close-up equipment and flash guns, if fungi, plant and insect life are to be tackled.

In tackling the deceptively simple subject of a woodland vista, the beginner is likely to fall into the trap of failing to see the trees for the wood! This is to say that a

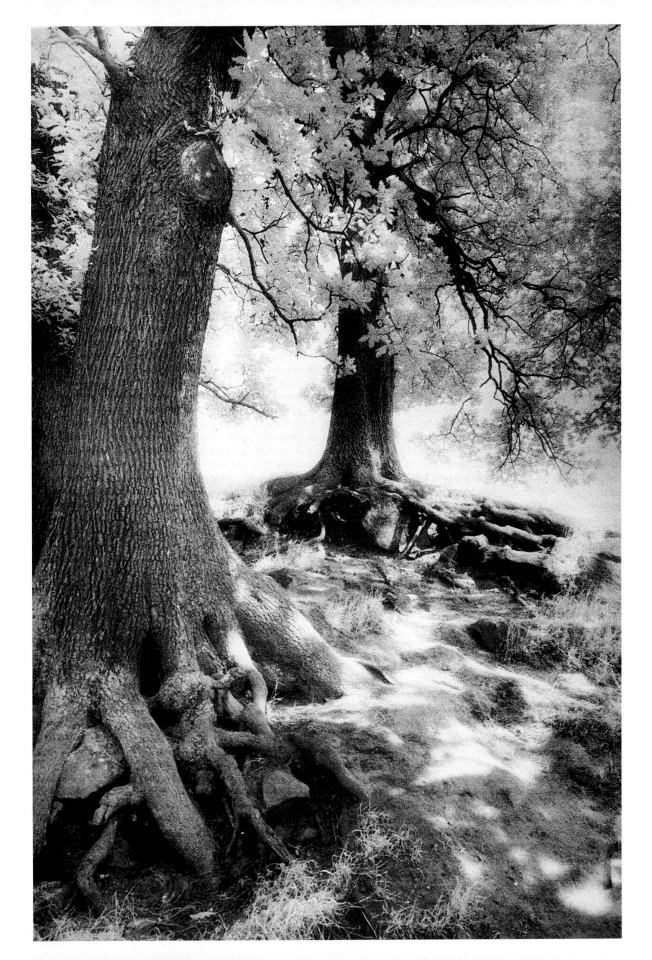

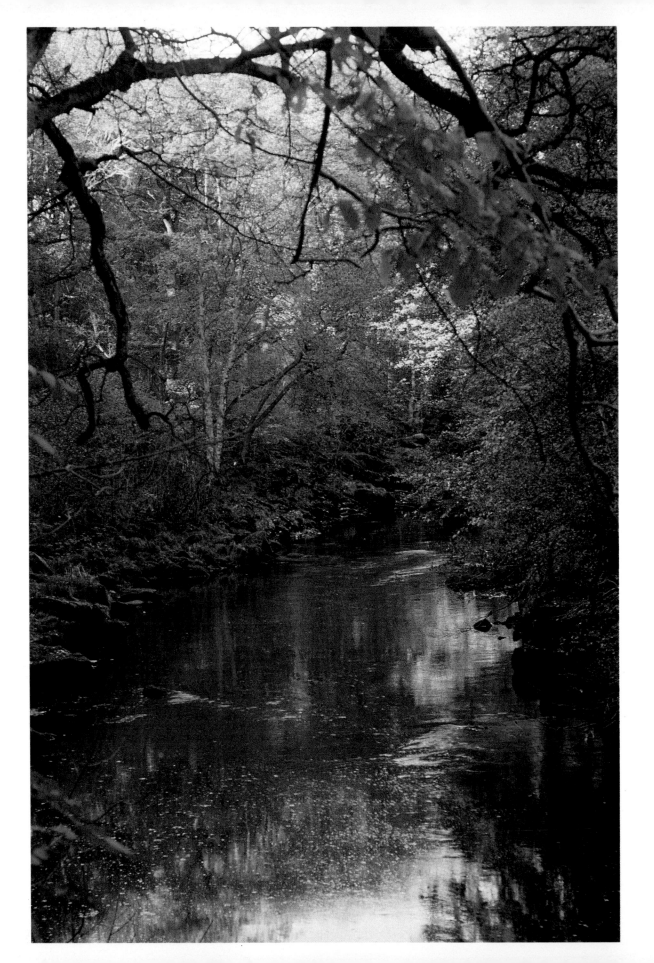

picture is likely to lack impact if it is unselective and shows a large number of trees rather than concentrating the attention on one tree or an attractive grouping of individuals. And so one should use the wood itself as a general background, while isolating particularly pleasing trees as the main subjects. This technique will normally involve the use of a wide-angle lens, allowing you to stand quite close to the trees concerned, while still including a section of the woodland floor and most of the trunk and foliage within the frame. The strong 'perspective' characteristics of the wide-angle lens will help to separate the subject from the woodland backdrop.

The theme of the wood as a dense assemblage of trees can be most effectively accomplished using a telephoto lens. By apparently compressing the perspective, the lens seems to reduce the space surrounding each tree, so that if you photograph a collection of trees in an area (say) 50 to 150 metres away, then you may achieve the attractive effect of a wall of writhing trunks and branches. Here a small aperture of around f/22 will be needed to obtain a sufficient depth of field, with the associated long shutter speed, so that you will need a tripod and still conditions which do not stir and blur the foliage.

In moving through a wood and seeking out the most attractive vistas, keep one eye open for the little specks of colour which could be a beautiful orchid or a delightful collection of fungi. One should also try to recognize the attractive details in the scene. A frond of foliage which seems to glow when backlit by the sun, a gnarled old stump, or a yellow and bronze jigsaw of fallen leaves can be as effective as any broader view and particularly evocative of the woodland ethos.

The character of the woodland scene changes with the seasons, with leaves which were soft and fresh in April turning to shades of ochre and rust in autumn. May brings the bluebells – and also a number of disappointed photographers. What seemed like an azure carpet may be recorded as a greyish smear. Blue filters improve the close-ups of these flowers and a graduated blue filter, inverted, may obviously strengthen the effect in general views. (The cause of the problem lies in the fact that flowers reflect infra-red radiation in order to stay cool, and some of this radiation is recorded on some colour slide films as a pink which partly kills the blue. Recent films such as Ektachrome 100 are much better in this respect.) Beech woods again provide the most tempting invitations when it comes to autumn colour; oak may also turn to a rich amber, while chestnuts and sycamores add notes of yellow. In the glades of chalklands the little guelder-rose beckons with red leaves and redder berries. Snow adds a new dimension of loveliness to the setting – but to get the best results one must reach the chosen wood while the freshly fallen snow is still standing on the smallest twigs. After a breeze or a slight thaw the wonderland qualities are lost, with the trunks standing black against the white carpet and the branches merging into the darkness beyond.

Other conditions can be equally inviting to the photographer. Backlighting can be exploited to great effect when the morning mist is still not risen and shafts of sunlight stream through gaps in the canopy. Fog also creates appealing conditions, which are best exploited when shooting into the low winter sun, whose rays are diffused by the fog to give the mists a luminescent quality. Successively distant trees increasingly merge into the mist. Those closest to the camera are a slate grey, with the trunks and branches becoming paler and paler shades of grey with distance, until eventually the wood disappears into the pearly glow.

Project: **Portraying an attractive woodland vista**

There are two components to the problem: firstly to find a suitable wood, and secondly to do pictorial justice to the loveliness of the scene.

You will be looking for an attractive wood, with public right of access. Ordnance Surveys maps show the distribution of woods and some of the public footpaths, but at best they only discriminate between deciduous woods and

LEFT Photographs of a wood from the outside looking in can be difficult. Often the foreground is dull, while the shrubs which thrive in the light 'woodland edge' environment tend to mask the view of the wood's interior. Here, at Strid Woods in Wharfedale, North Yorkshire, the river forms an avenue of interest leading into the wood. The delicate autumn colours were obtained by exposing for the shaded trees rather than the brighter water.

119

coniferous plantations. You will find the best opportunities in a mature deciduous wood with photogenic species like beech, oak, hornbeam and lime – preferably old standards and pollards. Information on the nature and composition of woods can be gained by membership of a county Naturalists' Trust and by consulting books like the *Macmillan Guide to Britain's Nature Reserves*. Membership of a Naturalists' Trust will also give the privilege of entrance to some woods which lack more general rights of access, while membership of the Woodland Trust will produce a wealth of additional information. Another setting to be considered is an old shelter belt of Scots pine, for these indigenous trees produce dramatic silhouettes, with the tufts of blue-green foliage carried like banners on their gauntly contorted branches. Having discovered a promising wood, you can now explore for subjects within it.

Though most people will agree about which woodland photographs are good, bad or indifferent, the compositional guidelines seem indefinable. In essence, one walks through a wood until a particular combination of trunk, branch, texture, light and shade demands to be captured. Try to see the wood both through the eyes of the wide-angle and the telephoto lenses – which offer quite different possibilities. Be prepared to follow the wooded tracks for quite some distance, for even in attractive woods, like Epping Forest, the New Forest or Burnham Beeches, one can spend much time in finding just the vista which will fit in a rectangular frame and encapsulate the aura of the general setting. Having chosen a view and vantage point, decide whether foreground or distant detail should be sharp, or whether a nearby branch or twig can be used to frame the main subject or fill an uninteresting void: set the depth of field accordingly. Exposure can be a problem. The camera will normally provide a centre-weighted reading, but correct exposure can be confirmed by moving in close to take individual readings from the brightest and most shadowy areas. If in doubt, average them or bracket the exposure. If the main attractions are nearby sunlit trunks or foliage, these can be metered, but to register detail in less accessible, shady areas the aperture should be set a stop or so wider than the general meter reading suggests (though this could result in wishy-washy highlights if colour is used). Useful experience can be gained by photographing the vistas from slightly different positions. In comparing the results, you will be surprised at how much a small change of vantage point can affect the character of the composition.

Some notes on the more photogenic tree species

Alder Not particularly attractive as an individual tree, but a familiar facet of the riverside landscape.

Ash Most attractive as field and hedgerow trees, or in small isolated groups. The downward sweep of the branches gives the tree its characteristic form.

Beech A supremely photogenic tree, most frequently found in post-medieval plantations associated with landscaping, game cover or the cultivation of timber for use in the old chair-making industry. The dense canopy shades out undergrowth and the amber tones of autumn are particularly strong.

Birch The silver birch is mainly a tree of the more acid soils and can be found in neglected heathland, in stands within deciduous woods or in commercial forests where this tree may be used to shelter young conifers. The quite similar downy birch prefers moister and mountainous situations. The foliage is light and wispy and the trunks, very erect in the younger trees, are beautifully patterned with flaking silver, red and black bark.

Bird-cherry Found in some moist lowland woods but mainly on the margins of upland woods. In spring it produces beautiful clusters of white flowers in long, loose, pendant racemes – perhaps the most beautiful blossom of any native shrub.

Blackthorn or sloe A common hedgerow shrub, most notable for the clouds of pure white blossom produced in some springs. It flowers a few weeks before the hawthorn.

Elder A shrub of hedgerows and woodland clearings notable for its white blossom and purplish-black berries.

Elm The disappearance of the elm is removing one of the most distinctive facets of the English rural scene. Relatively uninteresting (photographically) as a woodland tree, but invaluable as a field and hedgerow tree, where the silhouette, with its graceful tiers of foliage stacked like clouds, was a traditional feature of the agricultural landscape.

Field maple A small and pretty tree of English hedgerows, woodlands and abandoned downland pastures. Though often overlooked, it is quite common and in autumn the foliage turns a rich yellow and orange.

Guelder-rose A shrub of the moister soils which is of particular appeal to photographers for the striking red coloration of its autumn leaves and berries. Usually a shrub of the woodland margins in the southern chalklands.

Hawthorn Like the earlier flowering blackthorn, very common as a hedgerow shrub, but gnarled and wind-battered individuals can complement the fell and moorland scene.

Hornbeam Despite its fluted bark and serrated leaves, there is a very superficial resemblance to the beech, though this tree is commonly associated with old woodlands. Found in old coppices and also as an attractive pollard, notably in Epping Forest.

Horse chestnut An imposing tree, popular in the earlier of the landscaped parks. The flower spikes and conkers are both attractive subjects.

Larch The most attractive alien conifer with tattered mists of light green foliage. Used for landscaping and commercial planting in the nineteenth century and for relieving the dark green expanses in more recent 'landscaped' plantations. Planted with dramatic effect on rocky knolls in some parts of the Lake District.

Lime The small-leaved lime may have been the most numerous tree in the ancient wildwood and may be found as a standard, pollard or coppice tree in woods on richer soils. In such woods it produces a heavy shade, while free-standing individuals display their stately outlines.

Oak Noble as a field or woodland tree. In some autumns a very russet coloration is produced.

Poplar Alien poplars are often seen in shelter belts and damp plantations. Such trees are a key facet of some continental countrysides, but never seem at home in the British scene. The native black poplar, however, is a majestic tree, towering to 30 metres in height, and black poplars were formerly planted beside lowland ponds, ditches and rivers, but now this is a rarely-seen tree.

Rowan or mountain-ash A dainty tree with attractive foliage and a rich crop of red berries in autumn. Rowan is often seen as a solitary tree of the northern uplands and can present a very effective silhouette in craggy areas.

Scots pine The native pine, with billows of dark foliage carried on tortured branches to produce a striking silhouette. These qualities are perhaps best seen in the old Scots pine plantations and shelter belts of the Brecklands around Thetford in Norfolk.

Willow The willow comes in several different species and is commonly seen as a riverside pollard; pollarding often continues today, particularly where anglers need space to cast their lines. The silvery foliage shimmers in the sunlight and breezes, while fluffy catkins decorate the trees in early spring.

Yew Most commonly seen as a churchyard tree, sometimes found in the woodland understorey, and, very occasionally, in pure woodland stands. Twisted and time-worn, the most venerable yews make particularly attractive subjects.

9 VILLAGES

Village scenes are very popular choices for aspiring photographers and, particularly since no cross-country walking or specialist equipment is involved, one might think that villages are easy subjects. However, those who want their pictures to be as near-perfect as possible may agree with my view that the village is one of the more difficult pictorial targets. Of course, one can always drive off to one of the sure-fire certainties in the well-known hit parade of picture postcard villages – like Lacock in Wiltshire or Finchingfield in Essex – and come away with a pretty picture of a cottage. But a cottage is not a village, and there should be more than just prettiness in a picture of real quality. In explaining why villages are tricky subjects it can be said that there are two aspects to the problem. The first is concerned with the impedimenta of modern life, the second is of a deeper nature and invites one to ask what a village is and was and how it should be photographed.

Problems and opportunities in village photography

Here we can remind ourselves that, rather than reacting like the eye or a mobile movie camera, the still camera produces images which can be compared to framed paintings. As one wanders through a village, the odd car or telephone wire may not seem to detract very much from the pleasures of the scene and successive blemishes are forgotten as the vistas unfold. Yet take a still from any part of the scene and place it in a frame and the eye will instantly be drawn to that 'For Sale' sign, those dustbins or the wires which slice across the sky. Even the more attractive villages seem to act like magnets to the paraphernalia of modern life. Some, like Barnack in Cambridgeshire, are so festooned with wires as to be almost impossible to photograph successfully. Most have their High Streets lined with parked cars (these being most numerous at weekends, when the commuting wage-earners are at home). If there are no cars, this will undoubtedly be because the kerbs are marked by double yellow lines, which look ghastly in colour photographs – and are a prominent feature of villages such as Castle Combe in Wiltshire. Meanwhile, in the sugary show-piece villages, their charms proclaimed in a legion of glossy guide books, other photographers, all jostling to capture a famous vista for the ten thousandth time, form another type of hazard. As one who has spent dozens of hours waiting for cars and people to move in places such as Lower Slaughter, Okeford Fitzpaine, Kersey and Weobley, I can affirm that there is no easy answer to such problems, apart from patience and optimism.

Soon the eager village photographer will wish that a time machine were on hand for a trip to the not-so-distant days of great village and landscape photographers

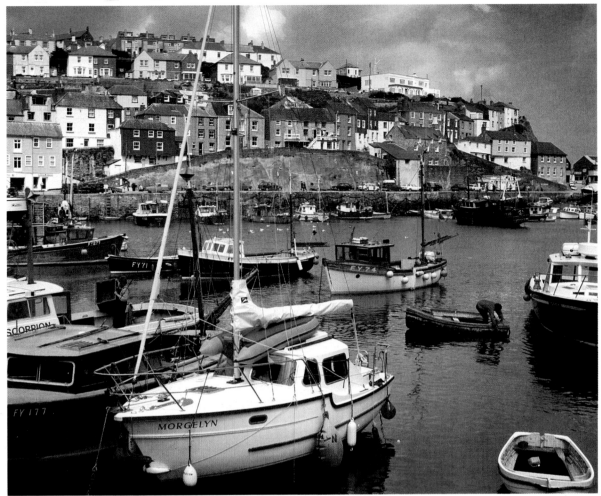

such as Edwin Smith. Then many roads were unmetalled as well as unpainted, the telephone was just a rich man's plaything, cars were few and comely, while village dwellings, not 'restored', gentrified and made spick, span and twee, still displayed the patina of age and dust and the textures of crumbling daub and unkempt thatch.

The photographic prospects may improve if one deserts the film stars of the village world for the starlets and unknown extras. After all, Broadway and Bourton-on-the-Water are not the only villages in the Cotswolds and, with all the clutter of tourism, a million miles from being the most attractive. Show-piece villages are best tackled out of season. After various fairly fruitless attempts to work in Finchingfield, Thaxted and Lavenham, I eventually succeeded on winter days when the village and townlets were virtually cut off by snow.

Some readers will be quite content to achieve some pleasing shots of pretty villages which are fit to grace any chocolate box and are sure to impress friends. Others may feel that, since an immaculate folio of pictures of fashion models may tell one next to nothing about womankind, the 'film-set' places are an unlikely introduction to the real world of the village. There is much to commend this point of view, for while settlements like Cerne Abbas or Finchingfield may seem to evoke the days of 'Merrie Olde England', one can be pretty sure that villagers of these bygone times did not exist as keepers of antique shops, tea-shop proprietors or affluent commuters! Neither did the old village look remotely like the places in the glossy picture books. Real 'Olde Worlde' villages stank of sewage, rat runs ran

Cornish fishing villages are usually sure-fire pictorial successes. Here at Mevagissey the soft grey and buff tones of the distant buildings are particularly appealing and harmonize with the cool harbour colours.

123

The unplanned layout of Middlesmoor in Nidderdale, North Yorkshire, a village which grew from a monastic grange and became, in the eighteenth and nineteenth centuries, a small settlement for miners, smallholders and quarrymen.

from end to end of the rows of shabby hovels and, periodically, whole streets would burn down. If photography is about truth, then the truth of a thousand book jackets, chocolate boxes and picture postcards reflects the Victorian whimsy which then provided the twentieth-century inspiration for the gentrification of selected villages. The old village folk were displaced by affluent commuters and retired people, who built the quaint porches, planted the roses which now garland them, exposed the timber framing, mended the thatch and bought the curtains at Laura Ashley.

Off the beaten track there are scores of other villages which are relatively undiscovered, un-gentrified, unspoilt, and know not the marshalled clamour of the coach party. Middlesmoor and Arncliffe are two from the Yorkshire Dales

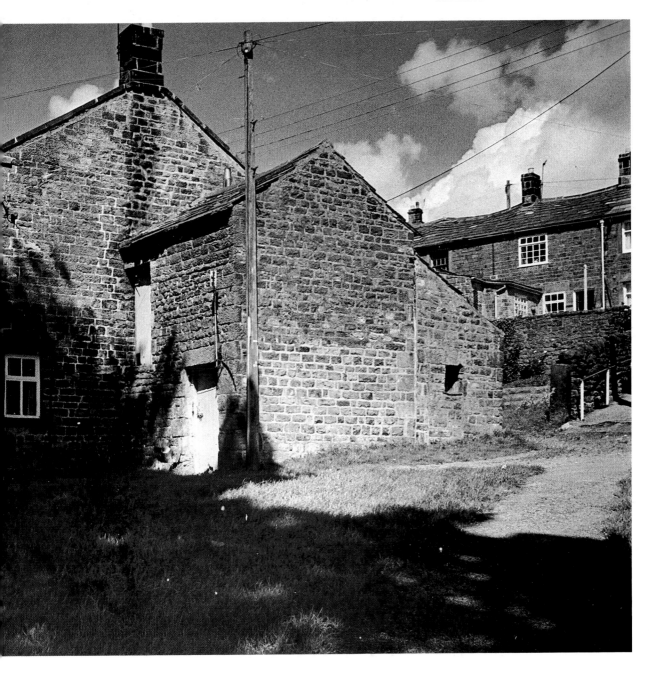

which still spring to mind. They also represent two different forms of village landscape, the former unplanned and full of curves and angles, the latter, like thousands of others, the creation of medieval village planning which, in this case, organized the dwellings around a central rectangular green. My own special interest in village photography has concerned attempts to portray the ways in which planning, shrinkage, growth around different nuclei, the insertion of greens, and other facets of village history are preserved in the living landscape. (The topic is a fascinating but complicated one, and so I must pass on, referring the reader to books such as Christopher Taylor's magnificent *Village and Farmstead*, Trevor Rowley's *Villages in the Landscape* and my own *Shell Guide to Reading the Landscape*.)

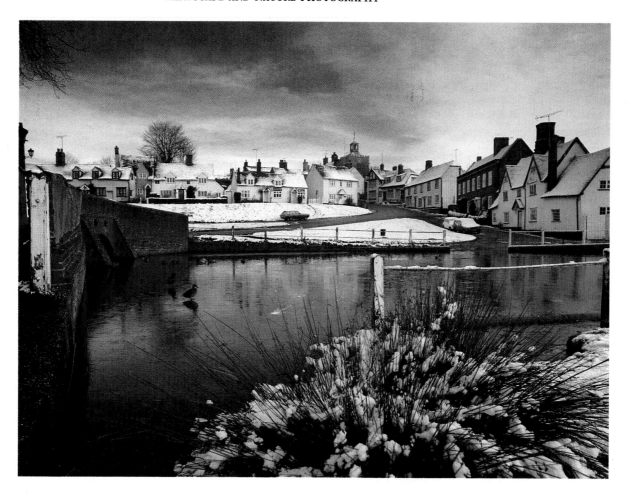

The showpiece village of Finchingfield, Essex, is seldom seen in its winter glory. Virtually cut off by snow in this photograph, there were none of the impedimenta of tourism which would normally make good work impossible in this popular centre.

Another fascinating and also very picturesque facet of the subject concerns the way that local building materials are displayed in the village scene. Readers could begin a collection of village photographs, each one representing a cluster of houses built in the true vernacular style of their regions. This project involves much more than travel, for it is not easy to find a group of dwellings unmarred by recent window alterations or alien intrusions like synthetic tiles, glass door panels, factory-made bricks and so on. Were we similarly to outlaw television aerials, the project would be virtually impossible! Each part of Britain has its own particular vernacular tradition: limestone and red pantiles in parts of Lincolnshire and east Yorkshire; flint, brick or timber-framing and thatch in East Anglia; a more open and heavier type of timber-framing in the West Midlands; golden limestone and stone or thatch roofing in the Cotswolds; Millstone Grit in the Pennines and so on.

Approaches to village photography

Only from the air can the whole of a village be photographed, while a picture of a single dwelling belongs more to the realm of architectural photography. And so it follows that village photography involves pictures of selected streets, lanes and groups of houses. The basic possibilities are as follows:

1 The village as seen from a distant vantage point.
2 A portion of the settlement as seen from street level.
3 Parts of the village seen from an elevated vantage point within it.

126

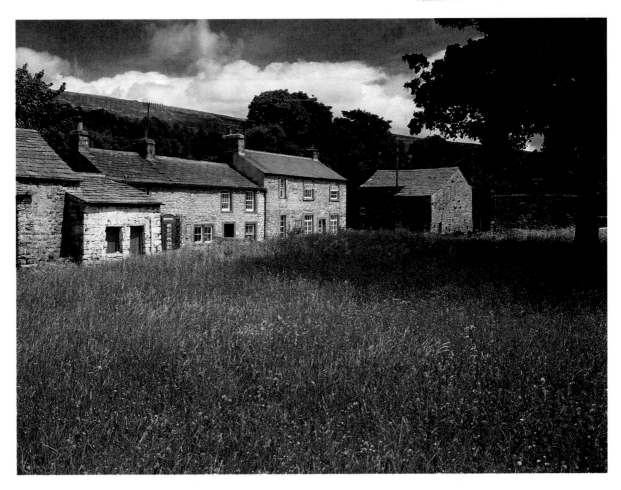

The first approach enables one to portray the village in its rural setting, thus displaying the traditional context of village life. One might either look down into the settlement from some convenient hill, or else show the village buildings outlined against the skyline. Clearly, this approach is likely to be most effective in areas of undulating terrain. Novice photographers are likely to overlook the possibilities of this potentially valuable approach in favour of the more obvious opportunities presented by the second suggestion listed. Here success depends on composition, perspective and lighting – and also on avoiding the eye-grabbing hazards of telegraph wires, parked cars and so on. But since no two villages are the same, the photographer must improvise.

Most villages contain one public building which serves as a superb vantage point: the church. But one should never ascend the church tower without obtaining prior permission from the vicar, or rector. In practice, the door to the tower is likely to be locked, with the key in the keeping of the vicar, churchwarden or caretaker. Towers can be very dangerous places. Many years may have passed since the steps or ladders submitted to a safety inspection; parapets are usually lower than one may expect and their stonework could be unstable; also the walkway inside the parapet may be very narrow. (Having once been caught hanging in space by my elbows negotiating a trap door when the church clock saw fit to strike eleven and, on another occasion, been obliged to organize the descent of the village drunk, who unexpectedly joined me on a narrow parapet, I always treat church towers with a healthy respect!) Still, the views from such unconventional vantage points can be exceptionally rewarding.

Part of the rectangular planned medieval green at Arncliffe in the Yorkshire Dales. How discerning of the villagers to allow the buttercups to grow, and the success of this picture derives from the lovely green and gold foreground.

127

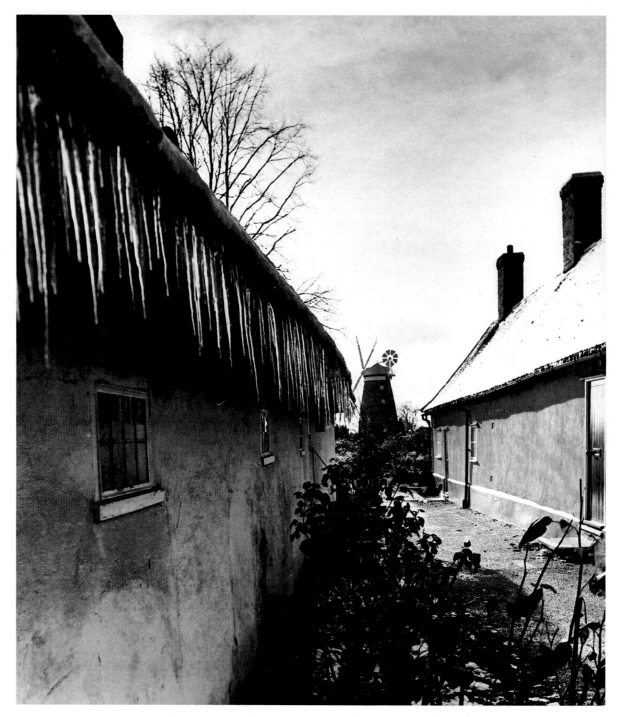

An unconventional picture from the failed medieval town of Thaxted in Essex. The icicles hanging from the thatch provide an unusual keynote and underline the value of working at all seasons.

Project: **Creating a village mosaic**

Serious-minded photographers may disparage the conventional village postcard – but here is the chance to show what you can do. The object of the exercise is to create a mosaic of a selected village, consisting of a postcard-shaped rectangle which is quartered and has a fifth picture inserted as a centre panel. Each of the five pictures should be attractive in its own right, but each must be quite different. They should combine to produce an impression of the chosen settlement which is

greater than the sum of the parts. One might provide an impression of the characteristic vernacular architecture of the area, while the cottage, church and High Street components can be balanced by greener, more rural vistas. Do not attempt to take all the pictures on the same day. Each scene will have its own best lighting conditions, while the inclusion of a snow or autumn scene will add extra notes of diversity.

Having obtained the desired pictures, work carefully to achieve the best arrangement for the mosaic. Remember that the centre picture will obscure the lower left corner of the upper right photograph and so on, so seek to arrange things so that the overlaps obscure uninteresting areas. If you are pleased with your efforts, it is possible to have an actual postcard made, which might be sold to support a worthwhile local cause. In my own village of Birstwith in the Yorkshire Dales, a local amateur, Tom Wright, has produced an admirable village mosaic which has sold hundreds of copies for charity (printed by The Thought Factory, see p. 233).

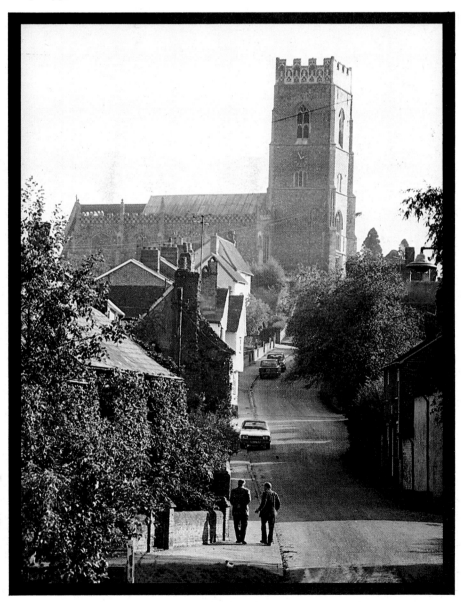

The High Street at Kersey, Suffolk, photographed at mid-week in autumn after the bustle of tourism has subsided. A short telephoto lens was used to compress perspective. The church is about 200 metres from the camera position.

The village in its landscape is a rather neglected theme. This is Castleton in Derbyshire, glimpsed from the steep slopes of Cave Dale.

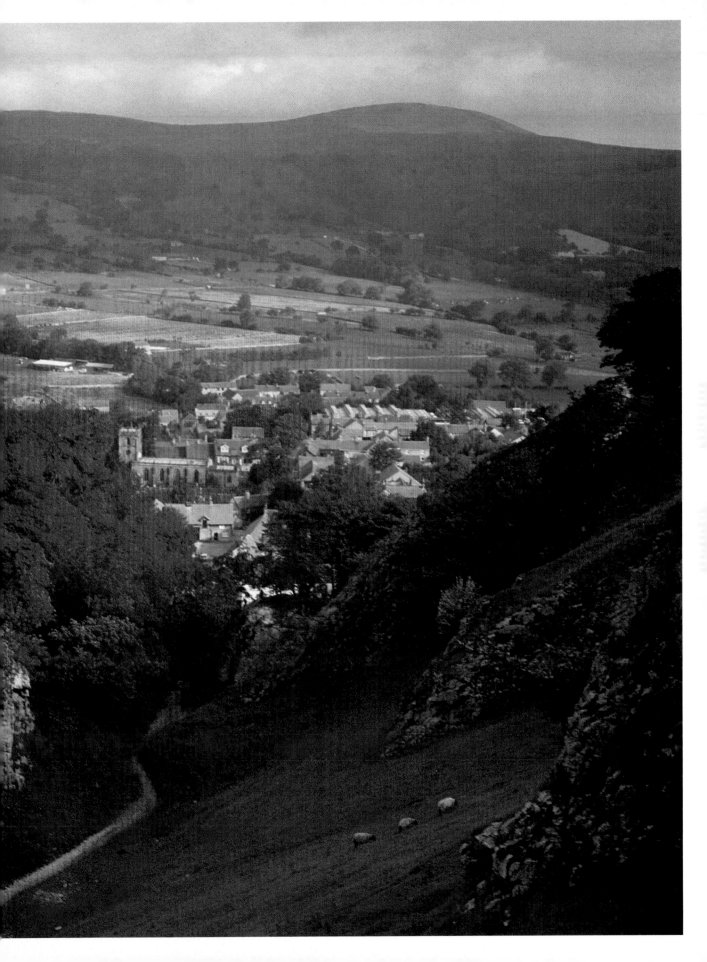

10
AIR PHOTOGRAPHY

The last decade has witnessed a spate of books of aerial photographs and there is no doubt that the public interest has been aroused by these collections of unfamiliar views. One might assume that aerial photography is a realm reserved for experts with specialist equipment, yet the conventional camera will work as well in the air as from the ground. The main problem is how to get it airborne.

Equipment and techniques

Air photography operators tend to work with two types of camera. The bulky floor-mounted survey camera points directly downwards and produces strikingly detailed images on large negatives, sometimes presented as 255 mm square contact prints. On commissioned survey work the aircraft flies at an exactly determined height and speed, producing a map-like mosaic of pictures, these being taken at regular intervals. (Stunningly detailed landscapes can be obtained with this camera if used in an impromptu diving or climbing mode.) In aesthetic terms the vertical photographs tend to seem rather flat and bland. Visually the most exciting pictures are 'obliques', taken at a low altitude of less than 900 metres using a hand-held camera which is directed out of the side window of the cockpit. Standard medium-format cameras are usually used for such work, though 35 mm cameras are also used. Popular refinements include special camera backs which can carry film in bulk, motordrives and skylight filters (to reduce the haze).

Much air survey work is of a scientific nature, concerned with mapping vegetation, counting individuals in a seabird colony, assessing the progress of crops, or discovering and mapping archaeological sites. In the last named field, hidden features are shown up by 'crop marks'. These are revealed as shadows cast by taller plants (perhaps growing in former ditches), or by normal plants on shorter ones (which might be growing on wall footings). Shadow marks can also be cast by tiny ridges representing buried walls or former field boundaries. Soil marks resulting from disturbed ground present rather fuzzier clues, while parch marks appear in dry weather, when crops on old walls parch out in contrast to those on ditches and trenches which remain more lush. Other pictures taken from the air are primarily of an aesthetic nature, exploiting the appeal of the hedgerow tracery, scalloped cliff line, stately home and so on when seen from an unusual vantage point.

The conventional 35 mm camera will give excellent service in air photography. If used from an aircraft one should set a fast shutter speed of at least $^1/_{500}$ sec, to

LEFT Interesting pictures can be taken from commercial airliners. These cotton-wool cloud patterns over the Midlands were photographed in the course of a scheduled Heathrow–Dyce flight.

BELOW LEFT This Cessna Skymaster is the aeroplane used by the Cambridge University air photography team. Note the essential high-wing monoplane design which allows good downward vision. The floor-mounted survey camera is seen through the open door, and oblique pictures in 120 or 35 mm format are taken through the opened side windows.

counteract the vibration of the aeroplane. A zoom lens of, say, 50 to 150 mm range will save time wasted in changing lenses, and since the focus remains on infinity one is left free to concentrate on zooming. The landscape will pass by very quickly, so an autowinder is an asset. Normal filters can be used, those which reduce haze being particularly useful. The best results are likely to be obtained under conditions of unusual clarity and with the sun fairly low in the sky. The slowest possible film should be used to retain fine details, and fortunately light-levels a little higher than their equivalents as measured from the ground. A tip given to me by a full-time aerial photographer is to set an aperture $\frac{1}{2}$ stop smaller than that which the meter suggests – this can be done by adjusting the compensation or the film-speed dial on the camera.

Getting the camera airborne

A variety of different platforms can be used – pictures can be taken from commercial airliners, though these normally work at operating heights too high for anything except cloud patterns, apart from the moments around take-off and landing. Private light aircraft are excellent platforms, but in order to avoid the obstruction of the view by the wing of the craft one *must* use a high-wing monoplane – like the Cessna Skymaster. Private pilots are not allowed to take fare-

The western mainland of Scotland; the white stipple at the foot of the picture is pleasure craft.

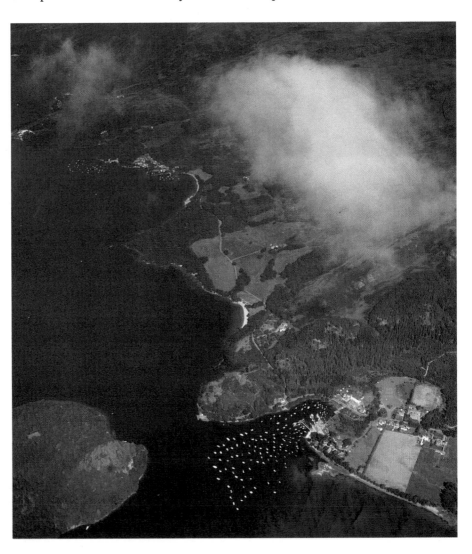

paying passengers, though on a visit to a local flying club one might be able to organize a flight by meeting the fuel bill. Photographs can be taken through the cockpit windows. Better results are obtained when shooting through the opened side panels – but the resultant blast of air is formidable. Pictures are normally taken as the plane banks around the target – but be warned, attempting to combine navigating by map and taking photographs from a banking and bucking light aircraft may produce sickness even in those with a strong constitution. (Following a very rough flight for the BBC, I have painful memories of sitting on an airfield too sick to stand, while the movie cameraman went off to bathe an eye that had received the full weight of his camera, blown back when the cockpit window was opened.)

Helicopters consume much more fuel than conventional aircraft, but their more stately progress and ability to hover over a target make them a superior form of platform. The view from the 'goldfish bowl' type is amazing, with the landscape unrolling in the space between one's feet. Reasonable pictures can be taken through the Perspex, providing that the planes of the film and the Perspex are roughly parallel. Hot-air balloons are superb camera platforms, their drawback being the fact that their course across the countryside is largely determined by the prevailing wind rather than the pilot.

Next we come to the unconventional platforms. Since remote triggers of various kinds are available, the photographer can remain on the ground and the problem is how to get a camera airborne. Good results have been obtained using kites, and the kite-minded reader could experiment – perhaps using a sequence of progressively larger kites to tow each other skywards, with the last and heaviest kite carrying the remotely-triggered camera.

Another possibility involves the use of a light-weight 35 mm camera mounted in a radio-controlled model aircraft. This technique has been developed by professional aviation modeller Peter Miller (see p. 233). The compact camera needs a fairly high shutter speed and is mounted in a padded chamber to reduce vibration. Cameras tried include the Ricoh 500RF combined with a clockwork winder, the Canon Sureshot, the old clockwork Robot Star and the Konica FS-1, with its shutter-priority automatic exposure and a built-in motor wind. Plainly one needs to gain some expertise in flying radio-controlled aircraft, and, as the maker describes, 'It is remarkable how much improvement is noticed in your landings with £200 worth of camera in the model.' One must also learn to judge just where the camera is pointing at any time and be able to position the craft properly before triggering the camera. Peter Miller can build complete radio-controlled aircraft and camera outfits for any readers seeking to explore this promising field, while others with experience in model-building and a knowledge of aircraft radio-control mechanisms might carry out their own experiments – remembering the legal aspects relating to radio transmitters. The aircraft should naturally be capable of slow and stable flight and landing and be endowed with the power to lift the camera equipment.

A final possibility involves the hire of a captive helium-filled balloon and camera set-up from Skyscan (see p. 233). The costs of hiring the expertise and equipment are considerable, but for those who can afford the rates the results should be excellent. Precise picture composition is achieved from the ground using a TV camera monitor and the vibration-free pictures are taken with a 6 cm square-format Rolleiflex SLX. The balloon can operate at heights up to 150 metres and is brought to the chosen site packed in a long wheelbase Land Rover.

Aerial photography provides a vast spectrum of scientific and aesthetic interest; some adventurous readers may like to explore the existing possibilities suggested, while others may hope for a day when there is a system available that is cheap, safe and entirely predictable. Perhaps the development of lighter cameras, remote triggers and smaller, cheaper platforms will bring the unfamiliar view to the realm of the non-specialist photographer-operator before too long.

RIGHT A high-powered enlargement of a floret of an early purple orchid photographed in the field using a macro lens on extension tubes and ring flash. The actual floret is smaller than a little finger nail.

This is a branch of nature photography which could easily form a lifelong hobby, one which will take the enthusiast to scores of entrancing natural habitats. The possibilities and opportunities are inexhaustible, the resulting images often exceptionally beautiful, and, as in other fields of the craft, success depends partly on photographic technique and creativity and partly upon the research, fieldwork and understanding needed to locate and appreciate the chosen subjects.

Possibilities and techniques in wild-flower photography

We can begin by considering the different categories of wild-flower photographs. Set out in the order of increasing magnification they are as follows:

1 Pictures of the habitats in which the plants grow: old meadows, fens, cliffs, sand dunes and so on.
2 Pictures of the subject shown growing in its habitat, such as dog-roses in a hedgerow, coltsfoot on a roadside verge, early marsh orchids in a wet meadow.
3 Pictures of an entire plant showing its flowers, foliage and form.
4 Close-ups of the flower head or 'inflorescence'.
5 Extreme close-ups of details of the inflorescence, showing the structure of stamens, petals, style and so on.

The 90 mm macro lens is ideal for categories 1 to 4, although effective results in 1 can also be obtained with a close-focusing wide-angle lens used with a small aperture to maximize depth of field. In 2 an illusion of extreme depth of field can be gained by using a split-field filter. This is half a close-up lens, and, when mounted on a camera lens which is focused at infinity, it will give close focus over half the field covered by the camera lens. Thus it allows both a foreground plant and a background setting to be in focus, so that one could, for example, show a bed of thrift or sea-pink growing against a sharp background of cliffs. In practice these filters only work well in very favourable conditions; patches of blurred middle distance are likely to be included, while there is often an obvious soft zone corresponding to the edge of the half filter. With its limited depth of field, a telephoto lens can be used to isolate a chosen flower from its surroundings, and the soft, blurred forms of the other plants in the community can form a very attractive foreground and background. Telephotos are also useful for pulling in plants growing in inaccessible places, like scentless mayweed on a sea cliff. Subjects in category 5 generally require a more specialized treatment, involving bellows and microscope objectives.

136

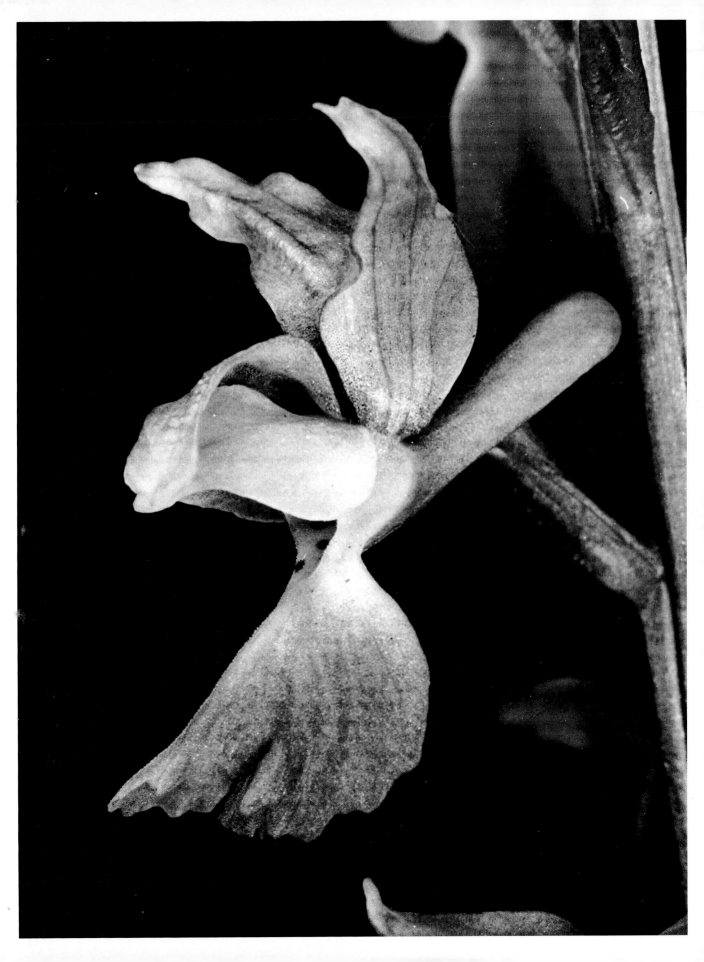

RIGHT Any collection of wild-flower photographs should include some pictures of the plants growing in their habitat. These early purple orchids were flowering in May in a Wealden wood alongside bluebells.

Studio lighting arrangements apart, there are two effective forms of illumination in wild-flower photography: natural lighting and ring flash (other forms of flash being unacceptably harsh). In general the ideal conditions for wild-flower work are a bright but hazy light: one of the worst forms of illumination for landscape photography thus creating excellent working conditions in the plant world. With depth of field as a crucial factor, one often finds that light-levels are too low to allow the use of a suitably small aperture while hand-holding the camera. Given ISO 50 colour film and a well-extended macro lens, exposure readings will frequently be in the region of $^1/_{15}$ sec, at f/11 to f/16 – so that the use of a tripod becomes essential. But while the tripod will counter camera movement, it can do nothing to control movements of the subject. Look closely at a typical wild flower and you will see that even in the lightest of breezes it is almost constantly atwitch, and in this windy country totally still conditions are unusual. To some extent subject movement can be reduced by the construction of makeshift wind breaks, or by improvised lightweight clamps to steady the stem of the plant. Otherwise one must wait patiently for a brief interlude when the breeze dies and the flower stops nodding or swaying.

The untrained eye may not be a reliable judge of the quality of lighting in wild-flower work. Plants which seem to look delightful in brilliant sunlight will appear brassy, bleached-out and lacking in detail or subtlety when photographed. Equally, in dull conditions flowers may seem unacceptably drab, yet emerge as delicately colourful in the portrait. Inadequacies in the natural illumination may be countered by the use of a reflector which will gently bounce some light into shaded areas. The reflector could be a sheet of cooking foil stuck to some stiff card, or a more sophisticated disc of white fabric stretched around a collapsible wire frame; Multiblitz manufacture such a reflector. It fits snugly into a 190 mm diameter carrying bag and expands into a 457 mm diameter disc. In emergency, the back of an Ordnance Survey map or even a newspaper can be pressed into service.

FAR RIGHT This rare green-winged orchid was photographed in soft spring sunlight. The f-stop on the macro lens was chosen to show the foremost florets sharply focused against a background of softer ones.

138

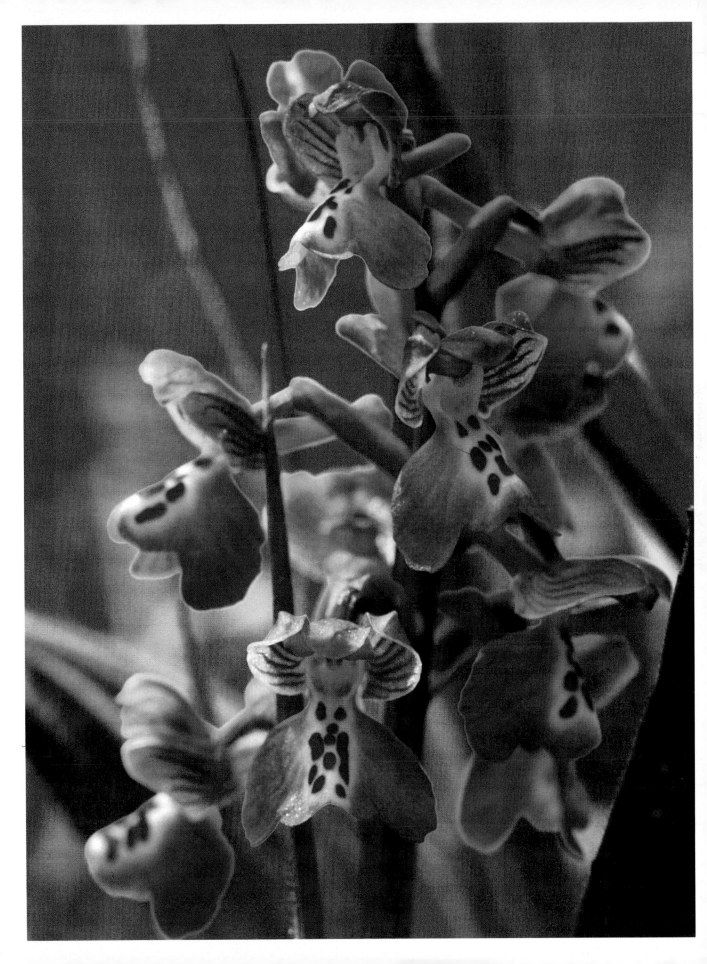

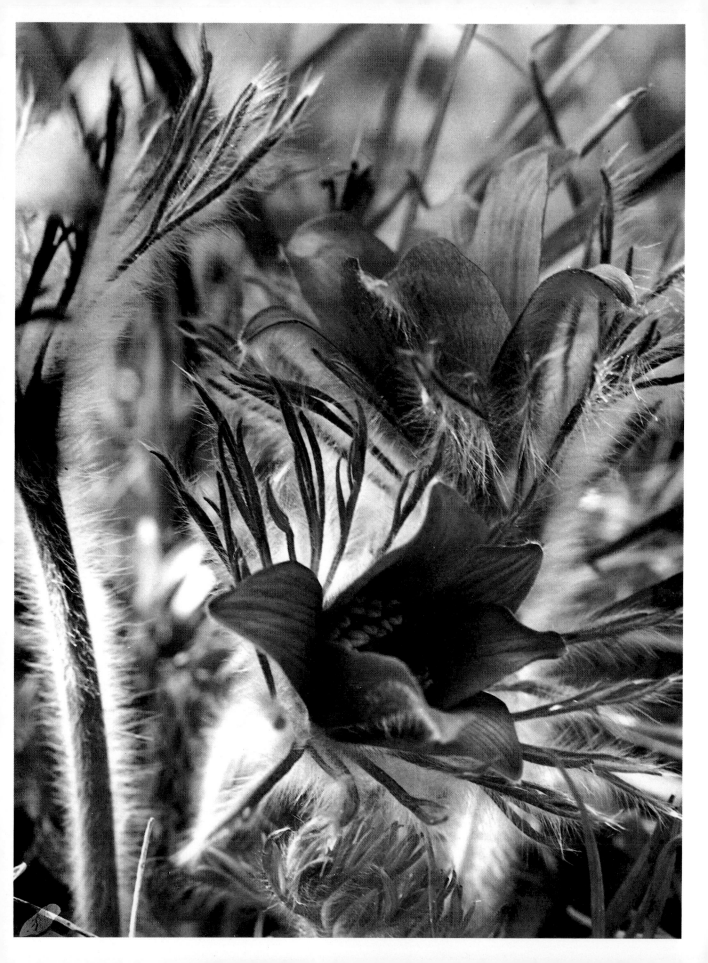

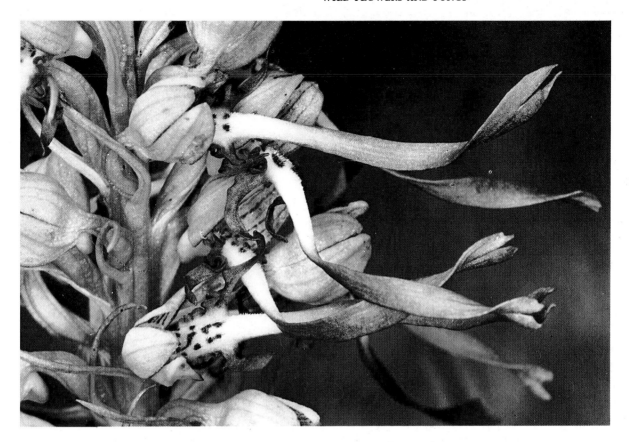

Ring flash is the next best alternative to natural lighting. Coming from many different directions the light merges to illuminate most recesses of the subject, and the relatively soft but bright shadowless light is well suited to various plants. A distinct practical advantage of ring flash is that it allows one to freeze the movement of wind-blown subjects. Its disadvantage is that the rapid fall off in the intensity of the light can often result in black or muddy backgrounds. Sometimes this effectively isolates the plant, while in other cases the night-like effect is not attractive. With careful planning ring flash can be combined with natural light or background flash, while the sky itself can often provide an appealing background for flowers lit by ring flash.

Correct exposure also requires some thought, whether or not flash is being used. For example, the rare fen violet is a very pale blue with fine mauve veining on its delicate petals. It grows low down amongst the fen vegetation and any automatic exposure which properly exposes the surrounding stems will leave the light flower looking bleached and featureless – so an exposure of about two thirds of a stop less than the automatic reading is required. Similarly, and especially in strong sunlight, bright yellow flowers tend to appear as blobs of melted butter unless the aperture is reduced to allow a rendering of detail. The accurate rendition of colour can also pose problems. Flowers reflect invisible infra-red radiation, with the result that blue flowers, like bluebells, forget-me-nots or harebells, tend to be rendered with unacceptable pinkish tones on some colour film. Film manufacturers obviously know about this and some of the latest films – such as Ektachrome 100 – have much improved rendering. Otherwise one remedy is to fit a pale blue (82A) filter to compensate and restore the true blue coloration.

In general, most wild flowers will photograph very well in colour, while only a few work as well in monochrome. Those that do include ones with strong simple

The lizard orchid, shown here in extreme close-up, is very rare and one of the many plants which will only be found as a result of careful research.

LEFT Backlighting by sunlight has been exploited in this photograph of the rare pasque flower. This is in no way a 'botanical' type photograph, rather a little essay in light and texture.

141

RIGHT A combination of natural lighting and ring flash was used in this picture of a wild strawberry. This will stand as a 'botanical' photograph since it shows setting, flower, leaf and fruit forms. (While Fujichrome 50 is noted for its handling of greens, note how well it has also handled the reds.)

FAR RIGHT A bee orchid photographed with diffused natural light and a macro lens. A small f-stop was needed to provide adequate depth of field and the slow shutter speed made the use of a tripod essential. The flower is about the size of an old sixpence.

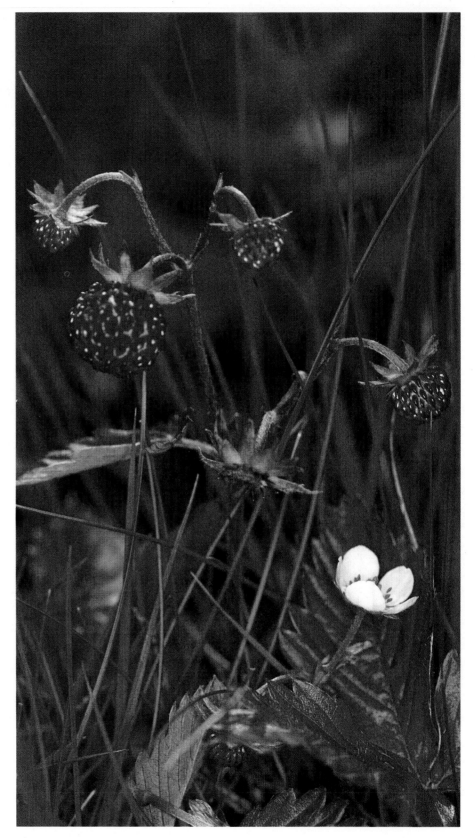

142

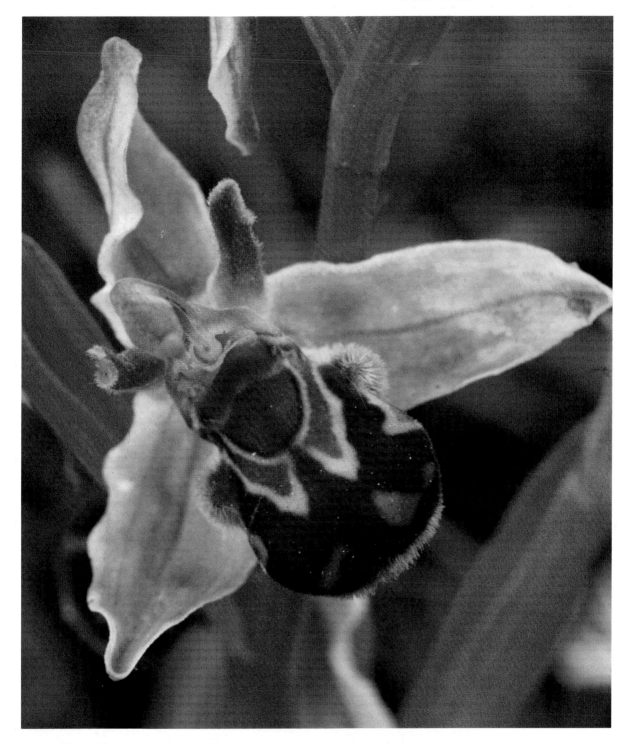

forms, like wild roses, the pasque-flower, giant bell-flower and sprays of chestnut or hawthorn blossom. Without colour to isolate the inflorescences from the foliage, small and intricate flowers tend only to work in monochrome in extreme close-up.

The choice of an aperture is conditioned by the depth of field question. From time to time one may deliberately set a wide aperture in order to isolate a plant

143

against a fuzzy background. More commonly one is struggling to include as much of the flower as possible in sharp focus. Much depends upon the shape of the subject concerned. Some flowers, like daffodils with their trumpets in one plane and the surrounding sunburst of petals in another, are particularly awkward, while others, like the flattish blossoms of the wild roses, are much more cooperative. Often one needs to include a number of blooms in the photograph, and the camera must be carefully manoeuvred until the plane which comes closest to linking the individual flowers in the group is parallel to the film plane.

Normally one has a choice of subjects, and some rare plants grow profusely within the few habitats in which they survive. The best specimen for photography need not be the largest and most colourful of those available. It could be the one with the most attractive juxtaposition of flower and foliage, a member of an appealingly set-out group, the example most favoured by the natural lighting, the one standing against the best background, or a plant growing at the edge of a community and accessible without the need to trample on its neighbours. With a little practice the eye will be able to spot the most photogenic floral starlet.

To summarize, wild-flower photography is an easier branch of nature photography in the sense that the subjects will not skulk away at the sound of your approach, but the success of each picture involves a sequence of correct decisions. As well as conventional compositional problems, they concern the choice of a shutter speed sufficient to counteract movement on either side of the lens, the selection of the right aperture/speed combination to expose the flower properly,

This group of toadstools was photographed in natural diffused light using a macro lens and tripod. Unlike wild flowers, fungi do not tend to sway in the wind – and in this respect they are easier subjects.

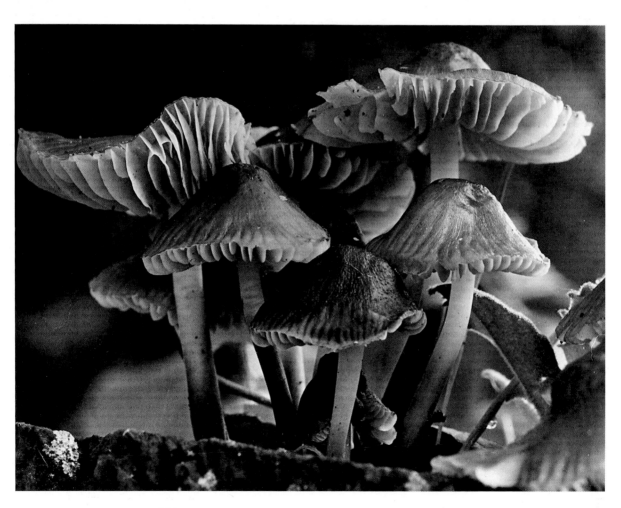

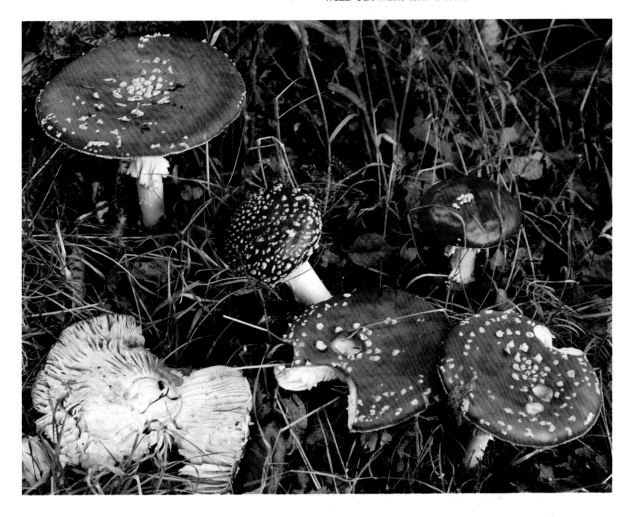

the possible use of colour correction filters and the use of an aperture which will provide the desired depth of field.

Fly agaric toadstools are highly photogenic subjects.

Work in extreme close-up is best accomplished in the home studio, where lighting arrangements can be carefully controlled. There is no harm in picking one or two specimens of *common* wild flowers, though the rarer plants should never be picked. Never dig up a wild flower, and when working in the field be very careful never to trample or flatten a bed of surrounding plants in the attempt to photograph one.

Fungi

In the world of fungi the division between extremes of beauty and ugliness can be a fine one. Most fungi grow in the dim depths of woodland, where the use of available light may not be practical. Unlike most wild flowers, with their bolder forms most fungi lend themselves to photography using main and fill-in flash guns mounted in the conventional manner on opposite sides of the camera lens. This form of lighting accentuates the sculptured form and texture of the subjects, and one may be surprised just how colourful many fungi seen in murky woods are

when exposed to bright light. Autumn is the best season for this work – always try to reserve a day in early October for fungi-hunting. It will also provide you with a chance to check on the development of the autumn foliage. Try to avoid the more popular woodland paths, where the more promising subjects are likely to have been kicked over.

Picking a path to the flowers

Technical expertise is of no help if one is unable to discover a succession of attractive subjects. The majority of our wild flowers are rare, localized or inconspicuous and most only grow in special, favourable habitats. Some beautiful, photogenic wild flowers, like rose-bay willow-herb and bluebells, are very common, but most others are much scarcer. You are unlikely to discover gems like the threatened green-winged orchid or the oxlip without a deliberate search and a measure of travel. Timing the search is also crucial – there is no point in seeking early purple orchids outside the flowering season in April and May. Join the hunt too late and you must wait almost a year for another chance to photograph a chosen species.

This point underlines the importance of prior planning in this branch of nature photography: 'Know your subjects' are again the watchwords. The keen wild-flower photographer will anticipate the flowering of the chosen plants and know just where to find them. Late April and early May of last year found me photographing oxlips and early purple orchids in Cambridgeshire woods, snakeshead fritillaries in a Suffolk meadow, early spider orchids in an old pasture in Kent, wild pear blossom in Epping Forest and green-winged orchids in a Fenland meadow. From time to time one will stumble across an interesting rarity, and one should always be on the look out for such happy encounters. More often, though, the rendezvous has been arranged in advance by careful research. An understanding of the plant and its setting is still important, for while the books and pamphlets may tell one that, for example, marsh violets grow in a particular wood, one must be able to recognize the damp habitats within the wood where a close search is likely to be rewarded.

Some research in plant identification is also essential. Is that lovely rose a common dog-rose or field rose or could it be a downy rose, sweet briar, or one of the rarer varieties? Artists' impressions do not always provide a definitive answer. It is as well to compare illustrations in several good books and examine the diagnostic botanical details of the problem plant. A systematic identification guide, which demands a reasonable botanical vocabulary of its user but is widely used by serious students, is *Excursion Flora of the British Isles* by A. R. Clapham, T. G. Tutin and E. F. Warburg.

Plants which were once very common, like the ragged-robin, the bee orchid or the corncockle, are becoming rare. While the idiot who digs up a single wild orchid from a protected site quite rightly faces prosecution, modern agriculture destroys thousands of entire habitats each year and is rewarded by subsidies which make the state support for the nationalized industries look like small change. Wetlands are drained, hedgerows and woodlands grubbed up, old herb- and flower-rich meadows are reseeded, while herbicides destroy the flowers which spangled the grainfields and verges. In consequence, the wild-flower photographer tends to island-hop across the barren areas, moving from one tiny nature reserve to the next. He or she can do no better than to join the appropriate county Naturalists' Trust, while membership of nature organizations, like the RSPB or Woodland Trust, will also give access to a range of interesting habitats. By joining the county Naturalists' Trust, one gains both access to protected sites and information about the occurrence of particular plant species within the home area.

RIGHT When a large colony of plants is found, seek carefully for the most photogenic specimen. This snakeshead fritillary was selected from hundreds of neighbours because a petal had naturally curled back to reveal the anthers.

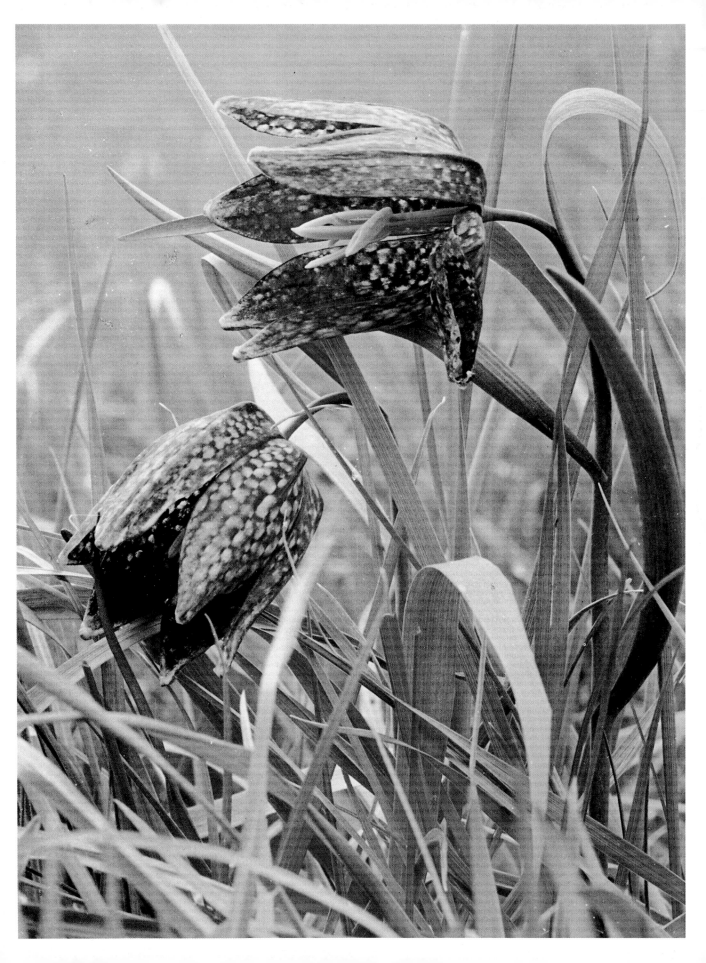

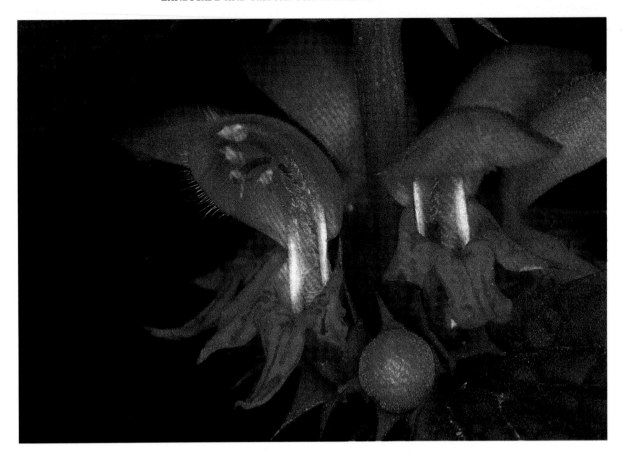

Some highly photogenic plants, like yellow dead nettle or archangel (above) and members of the dandelion family (right), are quite common. Both photographs exploit ring flash.

Often, however, a plant which particularly appeals grows only far beyond the range of a convenient trip. The practical answer to this dilemma is to grow the plant at home – a packet of seed usually costs less than a gallon of petrol. Many native plants produce seed which grows more vigorously and freely than that of the alien common garden plants, though some seed, like that of the cowslip, could take years to germinate unless a very fresh supply is obtained. Once grown, many of our native plants prove to be more beautiful and manageable than the popular garden imports. Photography apart, the conservational value of wild flowers relates to their role as food plants for a large range of birds and insects. They should not be introduced into the wild without the sanction of the conservational authorities, for they could disrupt delicate ecosystems or invalidate surveys and research. The local garden centre will sell the seed of a number of native plants, but in the form of selected cultivated varieties. Authentic seed can be obtained from a number of suppliers – see p. 233.

Projects in wild-flower photography

Obtaining a collection of photographs of all our native wild flowers represents a lifetime's task. Even so, our collecting instincts seem to compel us to accumulate sets. Some sets – like a complete wild-orchid set – could only be completed with difficulty and, in at least one case, with the risk of being a less than welcome intruder. A spectrum of opportunities remains. One could try to obtain a pictorial record of each species found in a selected habitat, a collection of all the native cranesbills, roses, or members of the Primula family. Before any serious work begins, you will need to learn how to find and photograph a selected plant. Choose

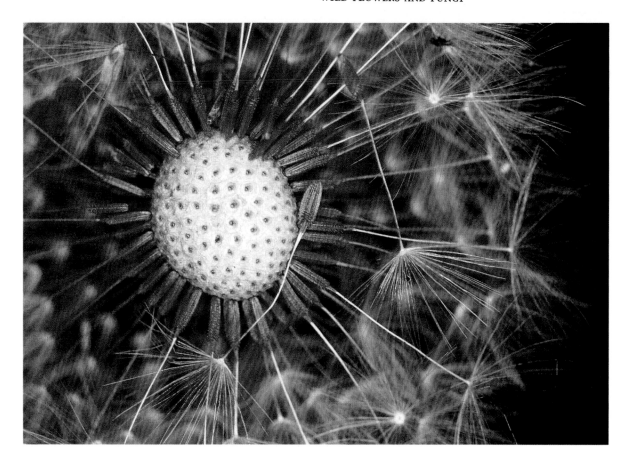

any of the attractive and less common flowers growing in your region. If you live in the East Midlands you might choose the lovely oxlip, northerners might select the meadow or the bloody cranesbill, and most could do worse than target the common heath spotted or the early marsh orchid. Then refer to a good botanical guide and discover the time of year when it flowers (allowing for factors like a late spring or a mild winter) and the sort of habitat in which it flourishes. Then consult local botanists, societies of naturalists and conservationalist brochures to pinpoint precise locations. Go early, if only to check the progress of the plants – be able to identify the characteristics of the leaves – and choose the right time to return. In the case of some very rare plants, like snakeshead fritillaries and lizard orchids, the local conservation society may provide details on wardened sites or open days.

When the plants are in flower choose the best possible methods of photography – hazy light, backlighting, ring flash and so on. Experiment with different lens and light combinations and remember that nothing sets off a plant more fetchingly than the right background tones and textures. Take a sequence of at least six *different* photographs and in due course determine which has been most effective. (It is a cheap lesson in photography that costs only six exposures, yet you can have no better master than your own discriminating judgement.)

12
BUTTERFLIES, MOTHS AND OTHER INSECTS

The insect world tempts the nature photographer with an inexhaustible array of fascinating and challenging subjects. Some, like swallow-tails or peacock-butterflies, are gorgeously colourful. Others, like grasshoppers or mayflies, have intriguing forms, while many, like stag-beetles or puss-moth larvae, are captivatingly grotesque. Though the larger butterflies and moths can be photographed effectively at only half life-size in field conditions using a macro lens or, less suitably, a standard lens with extension tubes, much of the more exciting and innovative work must be done at considerably higher magnifications and in a studio setting.

Techniques and equipment for butterfly photography

This is a popular field of activity, the subjects being highly visible and brightly coloured. Different enthusiasts use contrasting field techniques. Some favour relatively long telephoto lenses, relatively fast film and natural illumination, others a variety of different flash techniques. I prefer to stalk butterflies using a 90 mm macro lens. As often as not the subject will flit away before it can be framed and focused, but with persistence even lively and jittery types – like the wall brown or the orange tip – can be photographed in this way. However, if a 50 mm macro lens is used you will seldom be able to approach sufficiently closely. Butterfly stalking is best performed in solitude, for there is nothing more likely to bring howls of laughter from an audience than the sight of the photographer stooping and scurrying in pursuit of his elusive quarry. Try to move smoothly but not too slowly, since the insects normally alight for just a few seconds. Periodically butterflies spread their wings to absorb the warmth of the sunlight, and this is the moment to shoot – but if you allow your shadow to fall on the outspread wings then the butterfly will be off, and the chase must be renewed.

Some butterfly photographers advocate the use of a pair of flash guns of differing power mounted on either side of the lens. Such a set-up emphasizes the moulded form of a subject, as I have described. In butterfly photography one normally maximizes the quality of the portrait and evades the depth of field problem by having the plane of the open or folded wings parallel to the film plane – in which case moulding is neither apparent nor sought. Where the natural light is inadequate then ring flash is superior to any other form of flash, and most closely approaches the effect of bright but diffused daylight.

A more difficult technique of lighting, which I am always keen to exploit, involves a combination of daylight and ring flash, and aims to show the perched

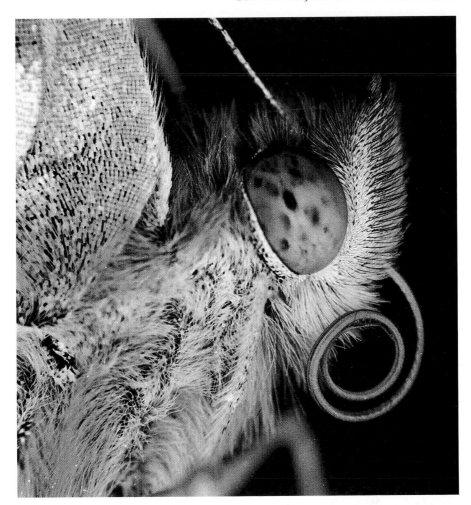

This silver-washed fritillary was photographed after emergence with TTL ring flash and a standard lens reversed on extension tubes. The high magnification reveals details as small as the wing scales. (The butterfly was then released.)

subject brightly lit against the background of a rich blue sky. Firstly, having found a spot where butterflies are perched and feeding, take a light-reading from the sky. Using ISO 50 colour film this is likely to be about f/11 to f/16 at the flash-synchronization speed. Your camera instruction book probably gives advice on flash-synchronization speed, and it is also likely to be marked on the shutter speed dial with a special colour or with an extra symbol. Then set the lens at one stop less than the indicated reading – f/16 to f/22. The focus is pre-set to produce an image a third to a half life-size and the flash is adjusted in accordance with the chosen focus. (On the more powerful ring flashes the full power manual setting will be about right.) The results – exemplified by the picture of the peacock butterfly (see p. 156) – can display a richness of background colour not obtainable under natural lighting conditions.

Discovering butterflies

In this field of nature photography, as much as in any other, a knowledge and affection for the subjects is invaluable. Fortunately for the beginner, some of the largest and most colourful butterflies – the peacock, small tortoiseshell and red admiral – are extremely widespread and common. Other attractive subjects – like the painted lady or clouded yellow – are migrants whose numbers fluctuate considerably from one year to the next. A butterfly enthusiast could live a lifetime and never see a rare visitor like the spectacular Camberwell beauty, while the

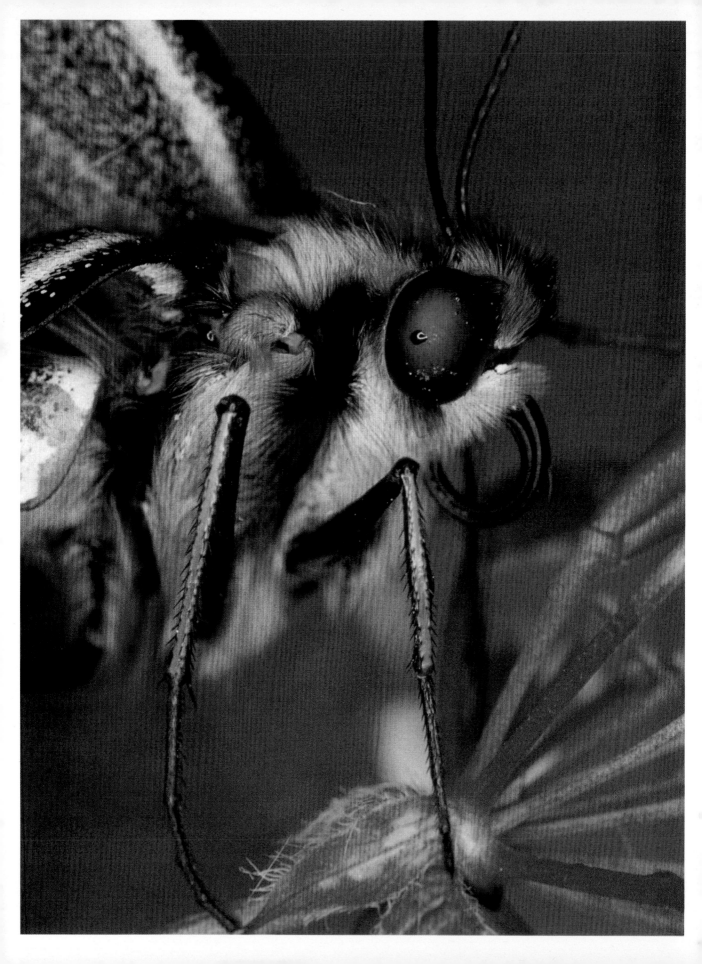

incomparable swallow-tail and the lovely large copper are now confined to a small handful of protected wetland sites. Many other butterflies on the British list are seldom glimpsed by the casual rambler but are quite numerous in their favoured habitats. Consequently, it is folly to hope to find a chalk-hill blue far away from old pasture in chalk country, or a Glanville fritillary away from the Isle of Wight. Equally, there are a few butterflies, like the gorgeous purple emperor and, to a lesser extent, the white admiral, which are not commonly seen because they frequent wooded areas. The purple emperor lives amongst the oak canopy and the white admiral in neglected coppices where honeysuckle thrives. And so, to discover the rarer butterflies, one must be aware of their habits and habitats. (The old butterfly collectors would bait purple emperors from the tree tops with offerings of decomposing animals.)

Photographers based in the warmer southern counties enjoy a wider range of subjects, both native and migrants, than those in the north, but fortunately all enthusiasts can easily obtain specimens of a large selection of British and exotic butterflies and moths from established suppliers (see p. 233). These normally arrive in the post as pupae, though some eggs or larvae may also be obtained. Pupae can be placed in a 'cage' of fine black netting and imminent emergence is often signalled by a darkening of the chrysalis. Pupae should be sprayed daily with a mist of water, otherwise they will become too dry and the wings of the insect may not unfold properly. After emerging the butterfly will slowly 'pump up' its wings and for some time it will remain stationary and obliging. This is the best time for photography and one should have arranged to have suitable props in the form of appropriate plant material to hand to construct a background. If you then wish to keep the insect, a supply of the correct food plant should be obtained. I prefer to release the butterflies as soon as they are ready to fly – and one must choose a habitat in which they may feed and, hopefully, find a mate. In these ways the well-being of the subject is protected – but one does fear for the entomologist who

LEFT A rare swallow-tail butterfly photographed with ring flash and a standard lens reversed on extension tubes.

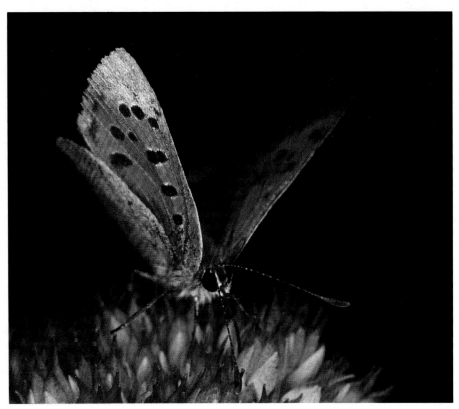

The small copper butterfly, an unusual visitor to the wildlife garden. The iceplant proves irresistible to butterflies and is one of the best choices for the butterfly section of the garden.

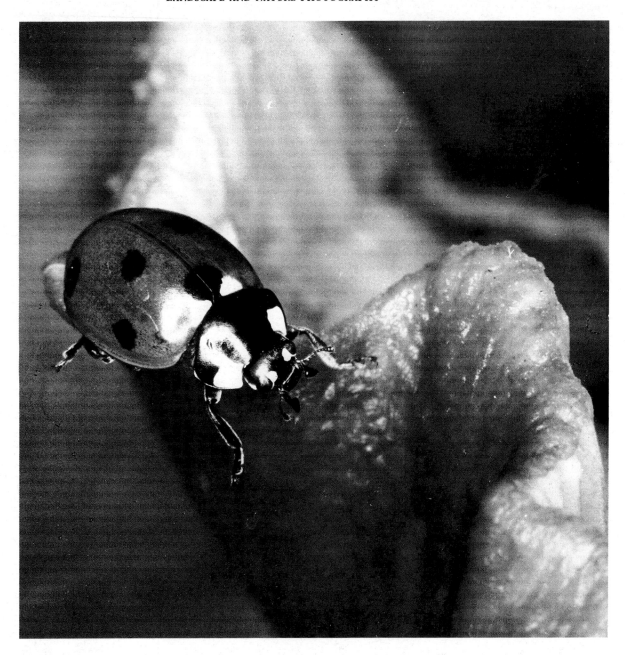

Most insects make attractive subjects. The ladybird (above) is negotiating the summit ridge of a fungus and grasshoppers (right) can be photographed by careful stalking. Ring flash and a fully extended macro lens were used in each case.

might be dumbstruck or worse to see a recently released Camberwell beauty or long-tailed blue flitting across his patch. Some forethought is required in the introduction of any new plants or animals into the natural environment.

Conservation and photography should be happy partners and the relationship can be developed by planting a nature garden. Throw out those gaudy alien plants (but keep the Michaelmas daisies and the buddleia, which is well-named the 'butterfly bush') and introduce native plants in a wild corner to attract and sustain a community of butterflies and moths. Honeysuckle, primroses, bedstraws, willow-herbs, knapweed, bugle, heather, thyme and kidney-vetch are amongst the many attractive native food plants. It is a poor nature garden which fails to attract a range of whites, orange-tip, small tortoiseshell, brimstone, peacock and red admiral butterflies. Gardens in the southern half of the country should attract

154

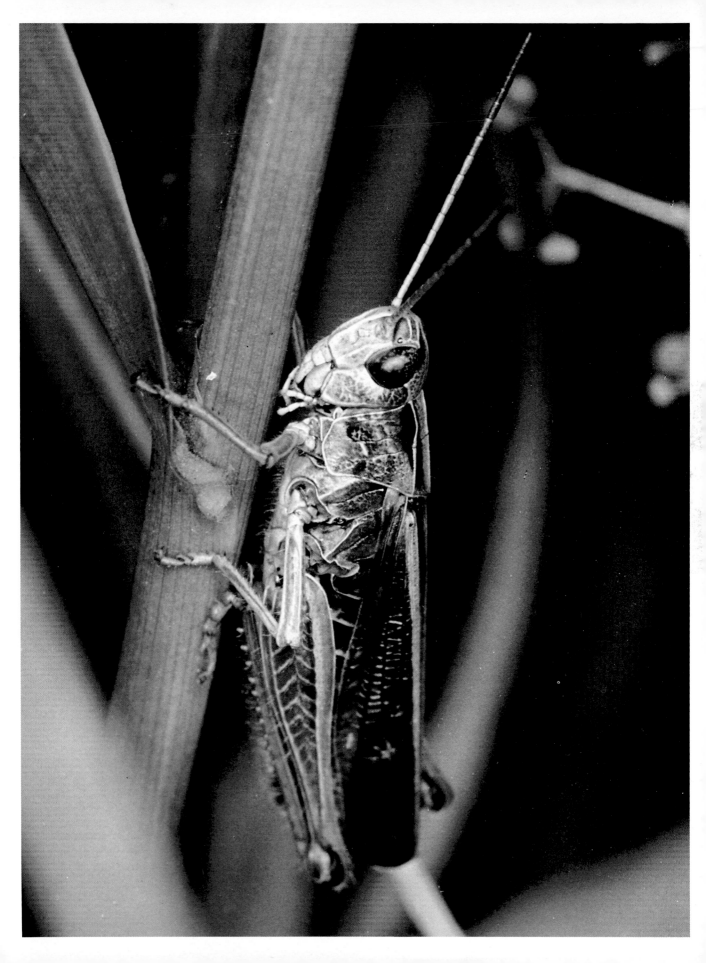

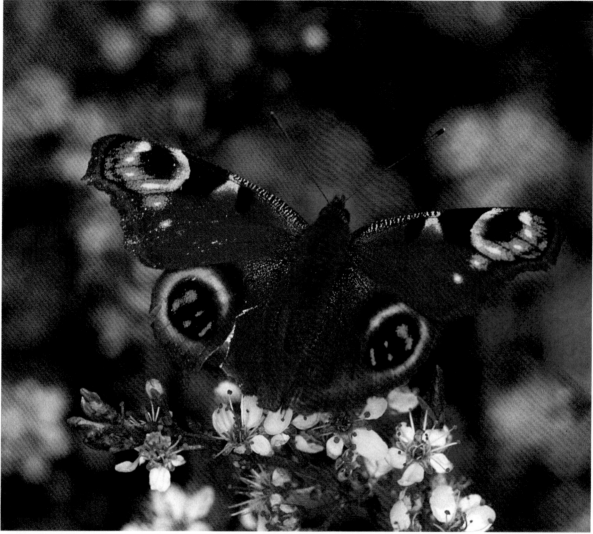

A peacock butterfly photographed with a carefully adjusted combination of ring flash and natural light.

the holly blue and gatekeeper, and the pretty comma, now more common, which could be enticed by the buddleia, asters and daisies.

Some caterpillars are specific to certain food plants, but the following plants support the caterpillars of at least one type of garden butterfly: broom, cocksfoot grass, holly, ivy, hop, honesty, stinging nettle, annual meadow grass, dock, lady's-smock, birdsfoot trefoil.

Project: **To obtain your first good butterfly photograph**

This is a project for novices, who may be heartened to find that a top-class butterfly photograph is not too difficult to obtain. The peacock is a spectacular butterfly, found throughout most of Britain from July to the autumn, some wintering in sheds to emerge and fly in April and May. In summer the butterflies will be found in orchards and gardens or breeding around nettle beds. They are relatively approachable and can best be photographed while basking with wings outspread. Ideally, one should fit a 90 mm macro lens and a ring flash. Otherwise a 100 mm or 135 mm telephoto and extension tubes (or a zoom lens with a built-in lens 'macro' facility) can be used with an automatic flash gun mounted on the

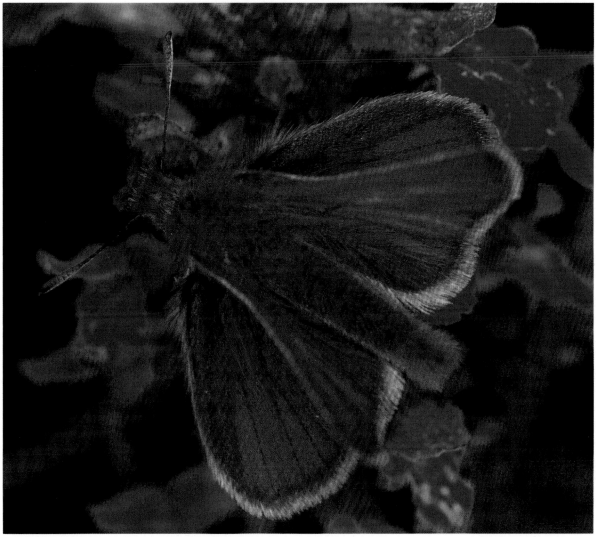

camera hot shoe.

Having found a habitat with peacock butterflies, set the lens to produce a one third life-size image on the film. This will allow the insect to fill the frame well, while still leaving room to include some of the food plant or basking site. Remember to put the camera on the appropriate flash setting. If TTL flash is used, set a smallish aperture for depth of field. With automatic flash set the smallest aperture offered and compensate to allow for extra lens extension. With manual flash, check the flash-to-subject distance (about 30 cm with ring flash and around 42 cm with hot-shoe flash, using a 90 mm lens), allowing $\frac{1}{3}$ stop extra exposure to compensate for the darkish colour of the insect. Having now set all the camera and flash controls in advance, you can concentrate on the butterfly. Do not attempt any more adjustment of the lens; approach the peacock swiftly but stealthily and press the shutter as soon as a sharp image appears in the viewfinder. Having thus hopefully secured a good image, you should then have the confidence to attempt more carefully composed and interesting studies.

Most flash units have a 'test' button. With shy subjects this can be fired before the insect is framed and in focus. The flash of light may baffle the butterfly, keeping it motionless for long enough to allow a closer approach – but be sure that the batteries are fresh enough to give a rapid recharge.

When photographing butterflies in the wild, attempt to portray them on a characteristic nectar plant. This large skipper is visiting betony.

157

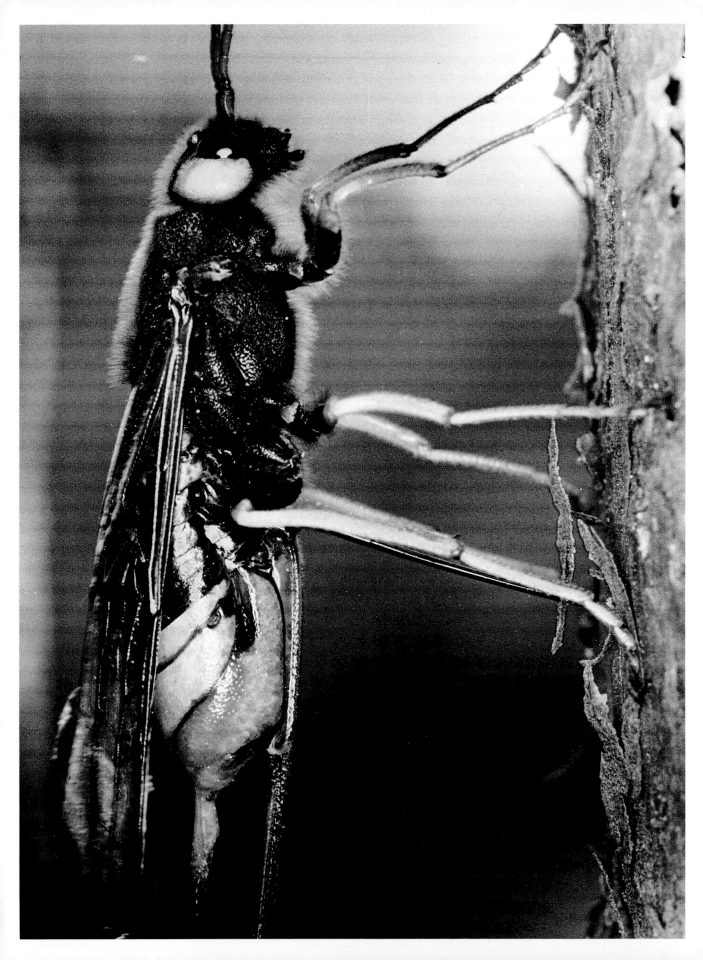

Moths and other insects

Many of the techniques used in butterfly photography can be applied to moths, remembering that most moths are on the wing at night. As a result, these insects are difficult to see and accurate focusing in the gloom is generally impossible. As compensation, moths are easily captured, and can then be taken carefully to the studio. The simplest method is to attract subjects by shining a torch on a suspended white sheet and then to catch them in a jam jar. A more sophisticated apparatus consists of a funnel set in the top of a box. A strong light is lit above the mouth of the funnel and the box is lined with papier-mâché egg boxes which cushion the fluttering of the captives. A third method described by Gerald Durrell in *The Amateur Naturalist* involves painting planks with a mixture of treacle, pear-drop essence and alcohol, which attracts the insects in the evening, making them dopey and manageable.

While butterflies have captured the interest of many nature photographers, moths, because they are generally drab and ungainly by comparison, have received far less attention. Even so there are some spectacular examples, such as the stunning pink and green elephant hawkmoth, the ghostly white silk moth, or the beautifully-marked, cream, grey and buff emperor moth. In extreme close-up the fluffy heads and feathery antennae of many moths also make excellent photographs. Several moths produce bizarre caterpillars as well: the green and black dragon-like puss-moth larva which spits formic acid, the vapourer caterpillar, tufted like a worn-out tooth brush, or the familiar 'woolly bear' offspring of the garden tiger-moth.

Project: **To record the life-cycle of a moth**

The camera can be used to compile a pictorial biography of any creature. Butterflies and moths, with their transitions from egg to caterpillar, chrysalis and adult, make particularly inviting subjects. The brown-tail tussock-moth is an excellent choice for the beginner, the insects being numerous, widespread and attractive, while the larvae are not too particular in their choice of food plant so that it is easy to arrange a supply of fodder. In the course of a May or June country walk one will often see a hedgerow which seems to be covered by patches of cobweb. These patches are tents of silk spun by the hordes of little caterpillars lodged within. Carefully cut the two or three twigs supporting the tent and take the delicate structure and its inmates back to the studio. At first the caterpillars are rather undistinguished little wrigglers, impressive mainly for their numbers and vitality. A regular food supply of hawthorn, dog-rose, bramble or apple leaves should be provided – indeed the larvae will feed on the foliage of most hedgerow or fruit trees. Quite swiftly the caterpillars grow and take on a more striking appearance with black bodies spotted with red, striped in white and covered in detachable hairs (which can cause rashes on sensitive skins). Later in June each caterpillar forms a small silken cocoon amongst the foliage provided, while mid July witnesses the emergence of fluffy satin-white moths with distinctive brown tips to the abdomen. Cylindrical plastic emergence cages can be bought from specialist dealers, while Living World (see p. 233) supply sheets of fine black netting which can be hung on the wire or wooden framework of a home-made cage.

Other subjects

The techniques employed in insect photography very much depend on the nature of the subjects. Many can be photographed in field conditions using a macro lens. Mayflies, dragonflies, grasshoppers and the larger beetles are all inviting quarry. Small insects and details from larger insects are more conveniently portrayed in

LEFT This giant wood wasp is laying its eggs in a dead pine trunk. Note how the needle-like ovipositor has pierced and lifted a flake of bark. This is a technically complicated picture; ring flash provided the main light source, while natural backlighting lightened the 'body fluff' of the insect, thus defining it against the background.

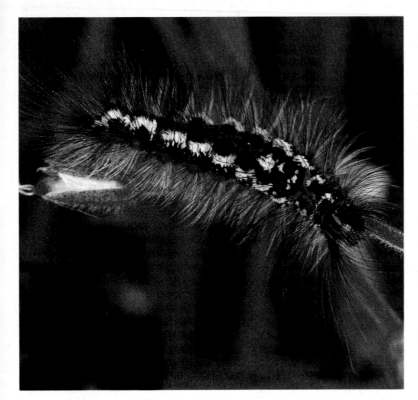

ABOVE Tussock-moth caterpillars are among the several bizarre and photogenic moth larvae that can be found.

ABOVE RIGHT A puss-moth caterpillar, displaying the powerful jaws which devour willow leaves at an amazing rate.

FAR RIGHT The mayfly was photographed with ring flash against the blue sky, which was intensified by using an f-stop of f/16 with ISO 50 film.

the home studio. With the standard lens reversed and mounted on three extension tubes, one can obtain impressive pictures of the head and thorax of insects like grasshoppers and butterflies. With a wide-angle lens similarly mounted, the heads of such insects can be photographed, while, with a microscope lens mounted on bellows with a Luminar adaptor, extreme close-ups of subjects like the scales on a butterfly wing or the amazingly colourful eye of the horsefly can be obtained.

In close-ups the ideal method of illumination is provided by a powerful ring flash with a TTL setting. As I have explained, automatic flash with an external sensor is unable to compensate for the enormous loss of light engendered by the reversing of lenses or the use of extension tubes, bellows or microscope lenses. On the other hand, manual flash is tricky to use in extreme close-up work: one must accurately measure the flash-to-subject distance, calculate the aperture setting and then work out compensating factors for the lightness or darkness of the subject, and for the use of tubes, bellows, reversing rings and so on. This is made much simpler by standardizing your conditions – flash-to-subject distance, magnifications, film type – as far as possible and making some test calibration pictures. It's also worth 'bracketing' exposures. Consequently, all serious insect photographers should aspire to obtain a relatively costly TTL camera and ring flash combination which will remove most of the time-consuming arithmetic and error and allow one to concentrate freely on the framing of subjects in the viewfinder. I favour a Contax camera with a Sunpak auto DX 8R ring flash, but there are other possible set-ups. When working at high magnifications it is hard to hand-hold the camera in focus, so that even though employing flash it is best to use the tripod. With combinations of photofloods it is possible to dispense with flash in the studio and to generate sufficient illumination to work in close-up with a camera's TTL metering system using artificial light film, or daylight film and a pale blue correction filter. However, the heat from the bulbs is likely to be so great that at best the subjects are distressed or, at worst, lightly grilled. In most cases flash is the kinder option.

160

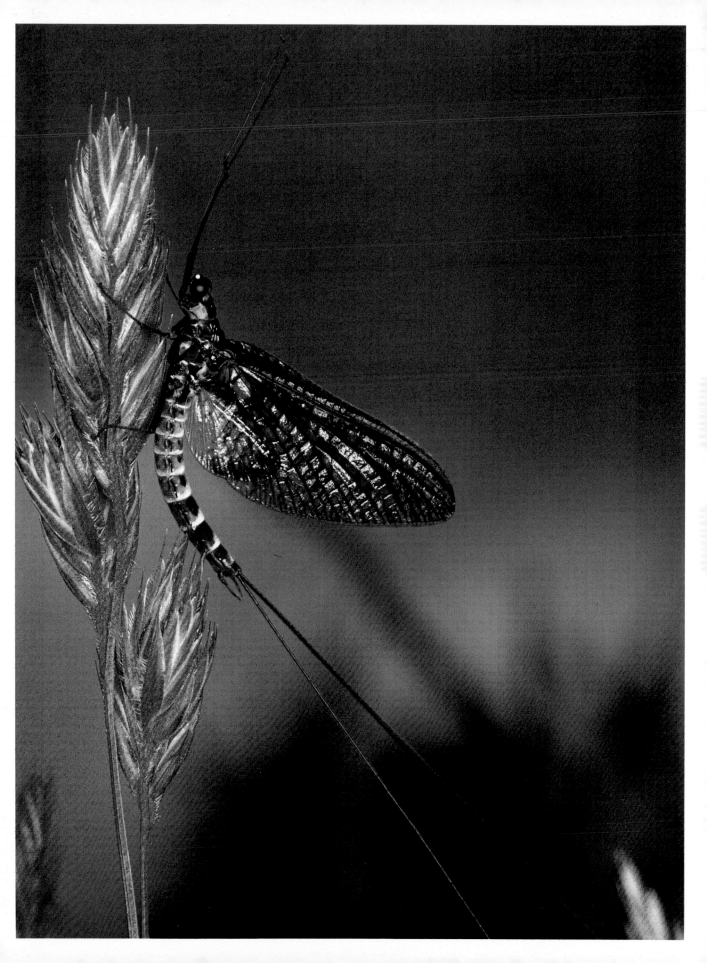

13
AMPHIBIANS AND REPTILES

Tropical frogs, with their brilliant colours and glistening skins, have probably graced more magazine covers than any single film star. Amphibians might have been created for the photographer, while reptiles can also be excellent subjects: snakes with their scales, flickering tongues and cold sinister eyes and lizards with their angular dinosaur-like forms.

Photographic opportunities

Britain contains a fair range of amphibians, all of them attractive subjects. There are two types of toad: the common lives up to its name, but the natterjack is rare and extremely localized. The common frog is fast becoming uncommon as a result of the destruction of its habitats and the effects of agricultural chemicals which stem the growth of tadpoles, while a few localities support alien frogs, the dark green edible frog and the elegant and beautifully-marked marsh frog. There are three species of newt. The smooth newt is relatively widespread; the little palmate newt is encountered mainly in the northern uplands and recognized by its webbed feet and the thread-like tip to its tail, while the larger great crested newt with its brilliant orange and black belly is becoming quite rare.

Amphibians are mainly seen during the spring breeding season when they adopt an aquatic lifestyle. It is also at this time that newts take on their most spectacular coloration, best shown by the male smooth newt, with its crest, fiery belly and blue tail mark, and by the male great crested with its black crest and vivid undersurface. Newts are best photographed in water, though they will be unhappy if placed in a tank outside their aquatic season. However, though no harm may come from 'borrowing' a smooth newt from its habitat for a brief photographic session, the rarer types are best left undisturbed. The best and the most conservation-conscious approach to photography is to provide a chemical-free garden pond where a little colony may establish itself. When borrowed from a garden pond newts can be photographed in a small aquarium, using the same methods as described for fish (see Chapter 14) and taking care to include the right water-weed accompaniments. At the time of writing I have an aquarium containing a smooth newt which is shortly destined for its return to the pond and I am once again captivated by these charming little creatures. Though rather ungainly and comical when walking on the land, when in the water they are graceful swimmers and voracious hunters. Perhaps their most photogenic pose is the 'slow downward glide', accomplished with toes spread and limbs outstretched, looking for all the world as though the animal were descending gently by parachute.

Frogs and toads are scarcely less inviting subjects. They have a moist,

glistening skin, warty in texture in the case of the toad, and those wonderful headlamp-like eyes. When handled there is not really the slimy feeling which some people expect, though one may be surprised by the rather prickly feeling of their 'claws'. Frogs and toads are excellent subjects, whether photographed on land or in the aquarium. It is also possible to photograph them underwater, from the pond-side, using a lens of around 300 mm, a polarizing filter and waiting for a moment when the surface is free of distorting ripples. One form of photograph which is striking, if now rather hackneyed, is 'the jumping frog'. This is set up quite simply, using one of the infra-red break-beam triggers described in Chapter 1 and an electronic flash. The frog is invited (by prodding it) to jump through the beam, which is positioned (hopefully) to intercept the frog in mid leap. When the beam is broken, the camera and flash are fired and the airborne animal is frozen. A conventional flash may freeze all motion, a high-speed one is certain to do so. This method of photography may not be cruel, but I am sure that the frog concerned would prefer to be somewhere else.

Britain contains three types of snake: the grass, the adder or viper, and the smooth. The smooth snake is uncommon and localized in places in the sandy southern heathlands. It is harmless, but best not disturbed and photographed only in a natural habitat. The adder is best left alone by the inexperienced naturalist for other, more selfish reasons. Its bite is seldom fatal, though dangerous to people with poor heart conditions and to dogs or other pets. Careful stalking in an area known to be frequented by adders may produce a picture of a reptile basking in the sun. A telephoto lens and monopod can be employed, and, if disturbed, the snake will be only too happy to beat its retreat. Grass snakes are still sufficiently common to be borrowed, briefly, for photography under more controlled conditions. Though quite harmless they will often deliver a display of unrestrained aggression which will delight the experienced photographer but be very alarming for the unprepared. (Just to avoid accidents I might add that grass snakes have a grey-green colour, a cream and black belly and yellowish patches on the sides of the head, while adders have brownish coloration and distinctive dark zigzag stripes running along their spines.) Grass snakes are expert escape artists, but can be confined in a dry aquarium furnished with turf, stones or other stage props. Electronic flash can be used to freeze the quick-fire stabbing motions of the

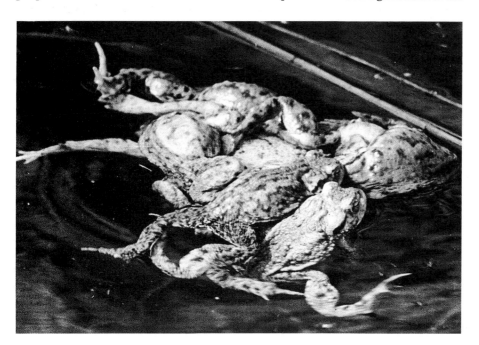

Amorous male toads perform a seething water ballet around a female. Photographed in the wild using a 300 mm telephoto lens.

163

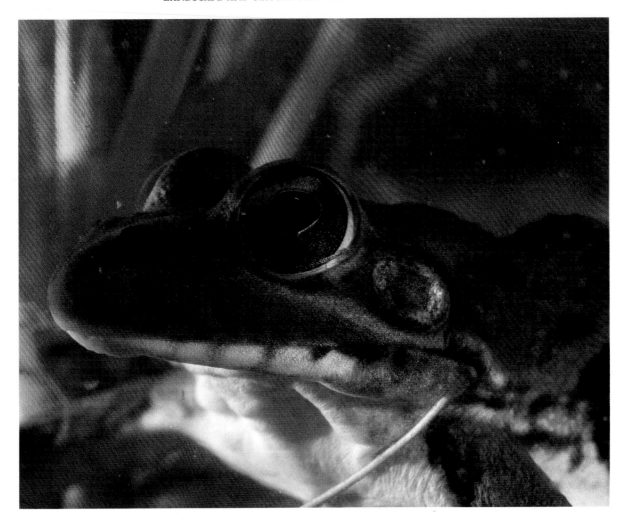

The beautiful marsh frog is an alien amphibian which has become established in a few British wetlands. This specimen was photographed in an aquarium using a macro lens and a sidelighting and fill-in flash combination.

forked black tongue. The most effective shot may be one which shows the head outlined against the scaly coils, the darting tongue frozen by the flash. As with all vivarium photography, the glass of the tank must be spotlessly clean and the flash guns positioned to right and left of the camera lens, sufficiently far apart to avoid reflections from the glass (see next chapter).

Lizards are more elusive than the grass snake. Their tribe includes the snake-like slow worm – not a particularly compelling subject – and two dainty, more conventional lizards, the common lizard of warm dry heath, moor and dune habitats, and the rare sand lizard, the prey of the smooth snake and similarly mainly confined to the southern strip of England. Sand lizards should not be disturbed, and both forms of lizard are likely to shed their tails if captured, not a fatal accident for the animal concerned, but one best avoided. Careful stalking by a photographer equipped with a fairly powerful telephoto lens may produce pictures of these appealing reptiles basking on stones, walls or sandbanks during a hot summer's day. The easiest opportunities are provided by lizard colonies established in stone garden walls.

Project: **Photographing toads**

Several of our amphibians and reptiles are now rare, and all are to some degree threatened by the poisoning and destruction of habitats – but the toad is still very

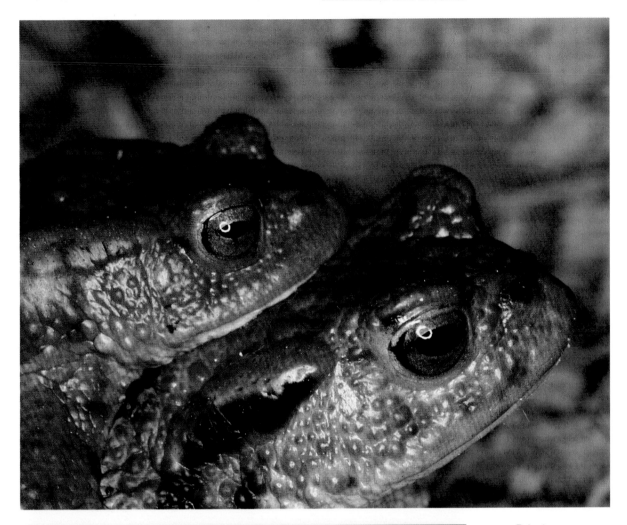

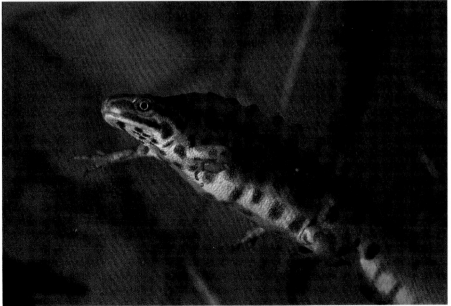

ABOVE Paired common
toads photographed in the
wild using a macro lens
and ring flash. The grey
of the damp chalk path on
which the toads were
found harmonizes well
with the brown and amber
colourings of the animals.

LEFT A male smooth newt
performing the 'downward
glide'.

common. Most readers will live within a few miles of a breeding ground and some will know of the local 'toad patrols' which have sprung up to assist the amphibian armies where their routes cross busy roads. The post-hibernation breeding activities provide a fascinating and, photographically, not too demanding opportunity for an essay in natural history photo-journalism.

The toads emerge from their hibernation burrows during warm, moist weather around the start of April, or earlier if the season is mild. Success here depends on prior knowledge of a favoured breeding ground and on not missing the crucial few days when the animals head for water. The essay can begin with pictures of the animals heading towards their breeding ponds. The most favoured wetlands are amazing places at this time of the year, the toads so numerous that one must tread with caution, while there is a continuous soundtrack of chirruping croaks. On the land the slow-moving animals can easily be captured using a macro lens and ring flash set-up, while the toads which throng the water can be photographed with a telephoto lens and polarizing filter – a tripod may be needed here. During the breeding season the males develop clasping pads on their feet and become attached to the (larger) females. Sometimes great swirling masses of toads gather in the water around some particularly favoured female. The next stages in the annual saga – from spawn streamers through tadpoles to juvenile toads – can most easily be portrayed in a home aquarium. Remember to release the youngsters in a moist and sheltered area where the chances of survival are good. A macro lens extended to provide a 1:1 magnification is adequate for the photography of tadpoles, which could be photographed in the tank or in a shallow glass dish containing water from the tank.

An irate grass snake. Note how electronic flash has frozen the motion of the flickering forked tongue.

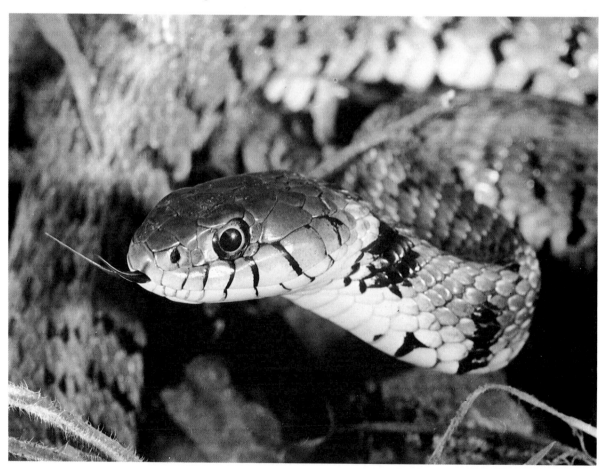

14 FISH

Fish photography might be thought of as one of the most difficult branches of nature photography. In reality a simple and fairly standardized procedure can be adopted where the actual photography is concerned, with the greater effort and ingenuity being concentrated on the creation of authentic sets and the capture of subjects. All readers will have seen the spectacular results of underwater photography around sun-bathed coral reefs or tropical rivers. Here, however, the sea is too silt-laden and murky and the rivers too dark, shallow and swift for underwater work to offer many attractions. Instead, fish are photographed in artificial environments created in glass tanks.

Techniques

Because of the pane of glass separating the subject from the camera, special care must be taken in the positioning of the flash guns which are most conveniently used to provide the illumination. The use of ring flash or camera-mounted guns is quite impractical because the glare from the flash tube would be reflected in the glass. Therefore two flash guns should be set up to the right and left of the camera. In holding the camera, the film plane should be kept roughly parallel to the plane of the glass and guns can be positioned each to bisect the angle between lens barrel and glass. One gun provides the main illumination, and the second, weaker gun is used to fill in the shadow area. An extension cable links one gun to the camera flash socket or hot shoe, while the second gun can be triggered by a cheap slave unit. I prefer to use a TTL flash gun of guide number 20 or 30 as the main source of illumination, using a little manual gun with a guide number of 14 for fill-in. A small aperture of around f/16 is needed to provide sufficient depth of field to keep the plants and other props of the tank habitat in focus, and if manual guns are used then they should be positioned sufficiently closely as to permit the use of a small aperture. Automatic guns can be used where there is no extreme extension of the lens and consequent reduction in light reaching the film – as would occur with close-ups of a small fish like a stickleback.

Setting the stage

The key to attractive work in fish photography is the effort devoted to creating an authentic setting. Here, as ever, a knowledge of fish and their habitats is vital. Some, like the delightful paddle-finned tench, feed amongst the muddy bottoms of deep, still or slow-moving water bodies, while others, like the beautiful

167

grayling, are generally associated with swift, stony rivers. The fish of upland streams flourish in environments where the current is too swift to permit much weed growth, while those of lowland chalk streams thrive in alkaline conditions which favour rich varied plant growth. The more that one seeks to recreate an appropriate river environment in the tank, the more convincing the photography will seem. Thus the roach lives in a lowland lake and slow river environment, feeding mainly near the muddy or sandy bottom. It is a shoaling fish and can also be photographed in a mixed group with the similar but more vividly coloured rudd, which often shoals with roach. In contrast, the much rarer barbel is a fish of clear deep rivers where there are alternating beds of shingle and sand, while carp favour the bottom of slow, weed-choked waters. The surest way to create an authentic setting is to visit a river or pond where the chosen fish subjects are indigenous and to make a collection of rocks, sand or mud and associated algae and weeds. The tank can then be prepared and allowed to stabilize some time before the fish are introduced.

Obtaining the fish themselves is a different problem, and those who regard the rod and line method as cruel – as it may well be – should consider commercial outlets. It may be worth visiting large garden and pond supply centres, for native fish are sometimes introduced amongst large consignments of water-weed. Small fish are much more manageable than fully-grown adults, and since most assume an adult form when just a few inches long, the actual size of a specimen will not be too apparent in a photograph. Pike, however, are strongly striped when young, but faintly blotched and mottled when adult. If handled in the manner described below, most fish will endure a brief journey from river or pond to tank, though bream should be avoided as they are poor travellers.

All fish make good photographic subjects, and some are outstanding. These include the voracious pike and zander, which have all the sinister grace of jet fighter aircraft; the pugnacious but appealing perch; the dark tench, plump yet stylish like a dame of the opera, or the mirror carp with its plated sides flashing like an armoured knight.

The tank used in fish photography need only be large enough to house the subjects in comfort and provide an adequate supply of oxygenated water. I use a tank approximately $46 \times 20 \times 20$ cm for small subjects and one approximately $61 \times 30 \times 43$ cm for larger ones. Some photographers confine the fish to the front area of the tank with an internal sheet of glass to ease focusing. But sooner or later the fish will move into the chosen portion of the tank, and it seems unfair to inconvenience them further. The most obvious shot shows the fish in profile, but a more striking image is obtained in a three quarters shot of a fish in the act of turning, showing the curvature of the body and the powerful thrust of the tail. Careful observation and fast reflexes are needed to capture this instant. Naturally, all the techniques described in this chapter can be applied to portraits of pet goldfish or tropical fish. Very small subjects – like freshwater shrimps – can be photographed in miniature tanks made by gluing strips of plastic 125 mm thick to two small panes of glass to form the tank ends; backlighting will produce a dark background and emphasize the translucent qualities of the subjects. Alternatively, one can easily make a miniature tank, gluing small panes of glass with silicone rubber aquarium repair sealant. With such tiny tanks, flash sidelighting is used, and masks are needed to keep stray flash light out of the camera lens. Sea fish are best avoided by those without access to fresh seawater or experience in managing marine aquaria.

Project: **Your first fish photograph**

Two common and colourful little fish, the minnow and the three-spined stickleback, make excellent subjects. The minnow is found in clear, stony rivers, streams and lakes and is best photographed from April to June, when the male

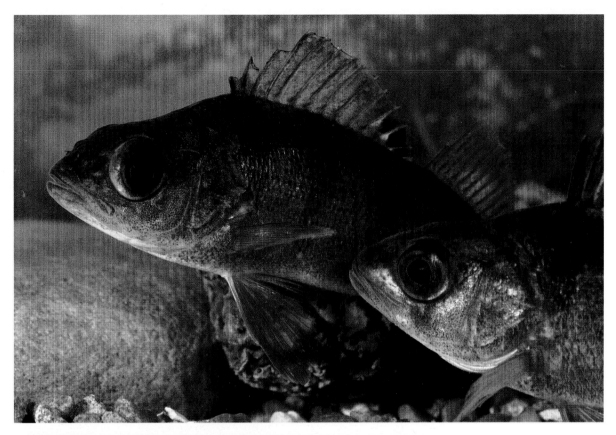

ABOVE The perch is a delightful and photogenic fish which reminds me of a pugnacious little bulldog. These young specimens were photographed with the twin flash gun method described in the text.

LEFT A ten-spined stickleback – much less colourful than the three-spined – guards its territory. The greenish cast, resulting from daylight reflected from the pond weed, gives a naturalistic effect.

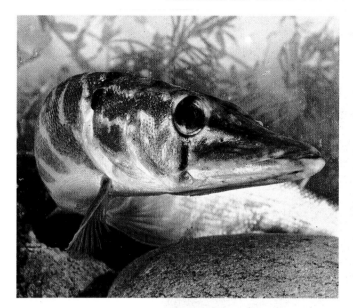

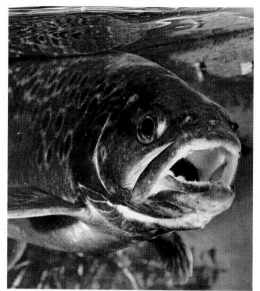

ABOVE The pike has a sinister kind of grace. This is a young specimen, and later the barred markings will become blotches and spots.

ABOVE RIGHT The brown trout is a voracious carnivore and this picture attempted to capture a prey's eye view of a largish specimen.

RIGHT In order to suggest powerful motion, try to capture your fish subject at the instant of turning, as shown in this portrait of a small dace.

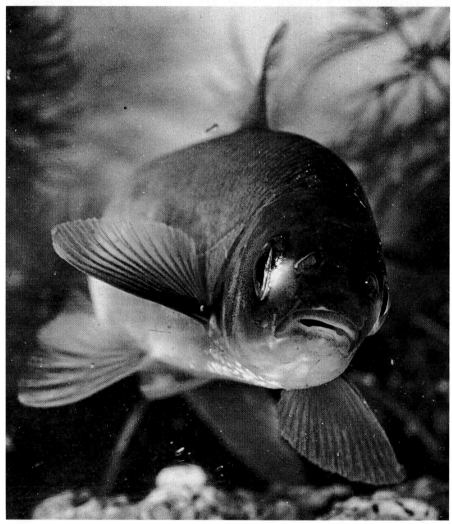

Small subjects can be
photographed in home-
made miniature aquaria.
Flash backlighting has
captured the translucent
qualities of these tiny
freshwater shrimps.

develops a crimson belly and white tubercles on its head. The three-spined stickleback is found in most waters which are not too muddy or weedy, and in the May and June spawning season the male has a red belly even brighter than that of the minnow. Since sticklebacks are intensely territorial, do not confine several males in a small tank. Water containing either minnows or sticklebacks will easily be found, and materials from the habitat can be used to create the tank setting. A few days later the fish can be caught using the old glass jam jar method. For uninitiated 'townies' all that is needed is a jam jar and a length of string. The string is tied around the neck of the jar, which is then placed in a likely spot in the stream bed. As the fish swims in, a sharp yank on the string brings out the jar and its captives, and each fish caught is transferred to a plastic bucket filled with the river or pond water. Returning home, the fish and some of their water are poured into a polythene bag which is floated in the tank for about 20 minutes to allow water temperatures to equalize, so that the shock to the fish is minimized. Then they can be released into the tank. Allow them a few hours of settling-in time, during which the tank should be shaded and undisturbed. Fit a macro lens or its equivalent to the camera and set up the flash guns, as described. The back of the tank should be masked with a background card tinted in river-like colours, perhaps grading from dark brown at the bottom to yellow-green or pale blue at the top. Observe the fish carefully, firing the shutter when they are seen sharply defined and in suitable positions. The photo session over, the fish should be returned to their home in the same water and using the polythene bag method already described. If kept for more than a few days the fish can be fed on bloodworms or daphnia, bought from the aquarium shop; larger garden worms may stick in their throats.

15
BIRDS

Bird photography is a popular pursuit. Visit any reserve and one species that you are almost certain to see is the long-lensed bird-snapper. Though popular, this is one of the most difficult, perhaps the most challenging, of all branches of nature photography. A small avian minority – like robins and mallards – can be relied upon to surrender their charms to the camera without too much persuasion. But most types of wild bird are scarce, timid and unobtrusive. Have you ever seen a nightjar or Dartford warbler? How would you rate your chances if you were given a year in which to obtain a good picture of a rarity like a hen-harrier or a firecrest? Serious bird photography is for those who are prepared to discard a handful of films in return for one exquisite frame – so film misers beware!

Problems and opportunities

One can just begin to appreciate why bird photography is so challenging by watching a common garden bird like the blue tit. With its perky manner and blue and yellow plumage it is a real attention-grabber and so one tends to imagine that it is larger than it really is. In fact, its body is about the size of a small matchbox. Stick a 200 mm lens on your camera and focus on a matchbox: how close must you get before it fills up half the viewfinder? The answer is about a metre, and no wild bird will let you approach this close. To obtain a reasonably detailed picture of the bird with this lens you need to be within 3 metres, but even with the most familiar garden birds the threshold approach distance which they will tolerate is somewhere between 4 and 30 metres. Now look very carefully at the blue tit and you will see that it not only constantly hops and darts from perch to perch, but also that its life consists of a rapid sequence of jerky movements, the bobbing and head-twitching happening at speeds fast enough to blur the conventional photograph. Finally, consider the fact that while you may see dozens of blue tits each day, you are unlikely ever to see some other equally colourful birds – like bluethroats or golden orioles – in your entire life. And you will certainly not see real photogenic characters like puffins, green woodpeckers, or gannets without a special effort and a measure of pre-planning.

In a lifetime of observation, a tolerably keen birdwatcher might expect to see about 200 different species of British birds (though the official list of birds believed to have reached these islands unaided on at least one occasion is far, far larger). The average citizen may never glimpse more than 30 or 40 kinds of birds in a lifetime (and may only recognize half a dozen different types). All of which goes to show that the aspiring bird photographer will do better to begin his or her

hobby with sparrows, thrushes and other common garden birds than head for the hills and marshes in search of rare but glamorous quarry such as ospreys or avocets, which test the fieldcraft and expertise of the most experienced worker.

Chance plays an important part in bird photography, but even so not a great deal will be achieved without a hefty investment of patience, planning and concentration. Only when these assets have been spent can chance really begin to play its part. It is always a good idea to begin a little photographic campaign with a particular picture in mind. Pictures of the chosen bird within its habitat are essential in any bird-life portfolio, and in such cases the creature need only be shown large enough to be recognizable. Bird portraits can be of many kinds. The type of picture suitable for an identification guide could show the subject in profile, with all its diagnostic features of plumage and form well displayed. Alternatively, one might concentrate on a particular facet of behaviour. Some specialists try to distinguish between scientific work, intended to illuminate a feature of behaviour, and 'pictorialism', where the objective is a beautifully composed portrait. The distinction is often blurred despite the differences in emphasis, but in general a bird portrait will be much more engaging if the bird is alert and active rather than dozing on its perch. Given a little patience, any bird is likely to engage in some activity, such as preening, singing, nest-building, squabbling and so on. The scientific and the pictorial approaches merge in the very specialized field of high-speed in-flight photography – which merits a special section at the end of this chapter.

Lenses for bird photography

The central problem in bird photography is how to get a camera sufficiently close to a wary and easily-distressed subject. Though the problem is straightforward, there are many possible responses – but whichever option is chosen the rule that the welfare of the subject comes first *must invariably be remembered*. No simple

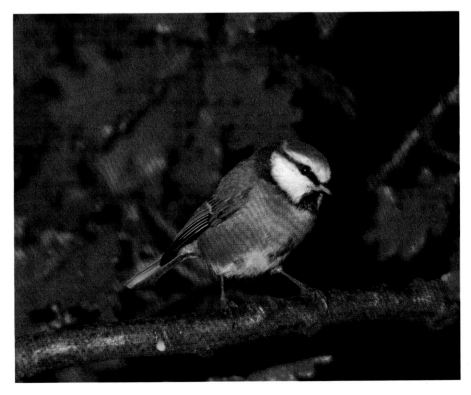

The deceptively small size of a bird like this blue tit demands close working distances. Here a 300 mm telephoto, remote trigger and TTL flash on an extension lead were employed.

173

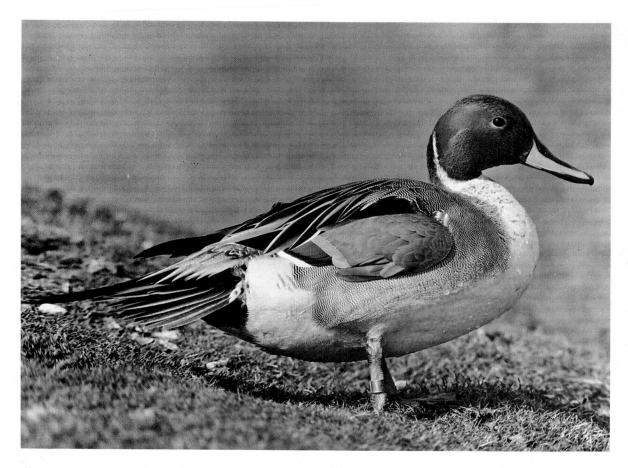

ABOVE An 'identification guide' type of picture, like this one of a pintail, should show the various diagnostic features of form and plumage in precise detail.

solution is found by sticking a whopping lens on the camera and expecting to take exquisite bird portraits from 100 metres away from the subject. There are several top photographers who do not choose to own a 1000 mm lens – the reasons becoming apparent to those who have tried to use them. Most serious workers prefer the quality of rendition which is only available with slow colour films of ISO 25 to 64, and are therefore forced to accept the trials and tribulations associated with slow shutter speeds. Look through a really long lens and two features will instantly become apparent – the extremely shallow depth of field (which makes sharp focusing both critical and difficult) and the fact that the viewed world seems to be undergoing an earthquake. Even when the camera is mounted on a fairly substantial tripod, the 1000 mm lens is still prone to the jitters, while it is seldom feasible to work in light sufficient to allow one to hand-hold at the minimum necessary speed of $^1/_{1000}$ sec. In the event, either the big lens or the slow film has to go, so in general we say goodbye to the long lens.

It is helpful to know what gear some talented bird photographers prefer. Michael W. Richards recommends relatively short telephotos of 135 to 200 mm; John Karmali, whose *Birds of Africa* is the finest collection of bird photographs that I have seen, did most of his work with a 280 mm lens, while Heather Angel is quoted in *Camera Weekly* (17 March 1984) as finding a 200 mm the most generally useful telephoto and a 400 mm especially valuable for birds. There certainly seems to be a consensus that *one should seek to use the shortest lens suitable for the job in hand.* A 200 mm telephoto is an easy and delightful lens to use and a 300 mm conventional lens is perfectly manageable. A 400 mm conventional lens is a fairly bulky beast, while although a 500 mm mirror lens is light and wieldy, at this focal length real operational difficulties are becoming apparent. Many manufacturers

RIGHT These Bewick's swans were photographed with a 200 mm lens stopped down to provide a good depth of field, while using ISO 400 film to allow a fastish $^1/_{250}$ sec shutter speed. In situations such as this you must shoot at the instant when the subjects adopt a vigorous pose.

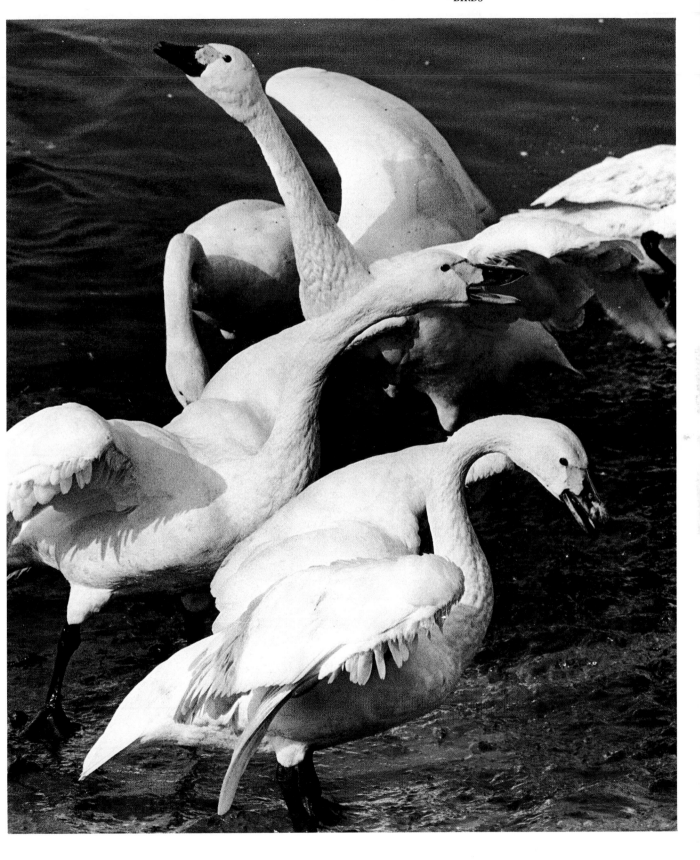

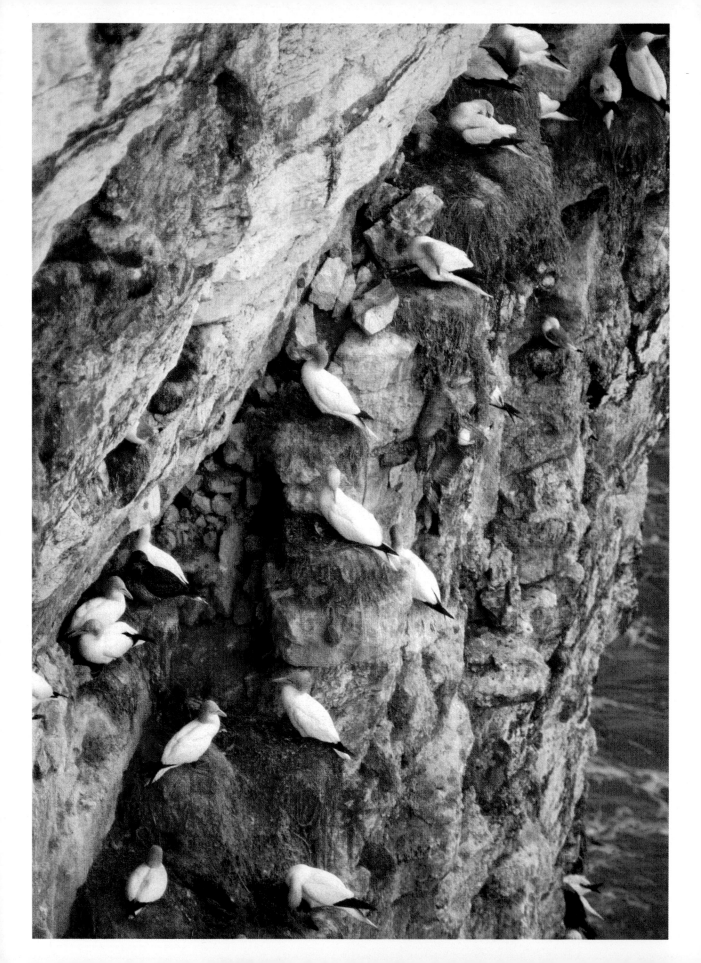

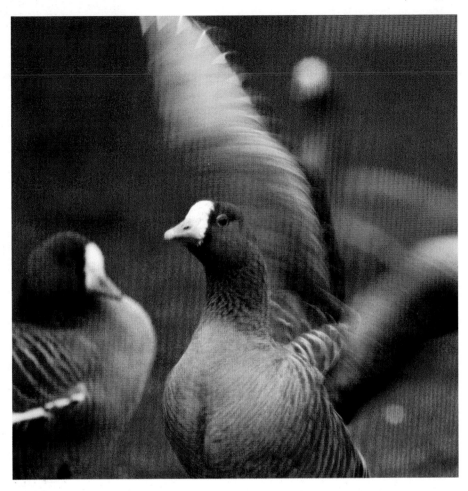

Bird portraits are always more interesting if the subject is doing something, rather than slumbering glumly on its perch. This lesser whitefront goose is exercising its wings and the relatively slow shutter speed conveys the motion and reveals the wings as a blurred background to the sharply focused head. Because the other geese are out of focus, they do not distract from the main subject.

do different ranges of lenses; those in the 'fast' range have big apertures and bigger prices. It is better to buy from the cheaper range, with lenses that are lighter and which do not turn frightening, bulging eyes on the subjects. The depth of field with, say, a 400 mm lens set at f/2.8 is anyway too small to be of much use. A modest refinement, available on many telephoto lenses, is the facility for close focusing. If your lens does not focus down to about 1.25 metres you may be forced to accept the inconvenience of fitting an extension tube for close work. In certain circumstances, like photographing puffins or gannets nesting on an inaccessible sea cliff, one may have to resort to a long lens. A 500 mm mirror lens would be a sensible choice. Most such lenses have a fixed aperture of f/8, which produces a rather dim viewfinder image. Precise focusing is essential with such a lens, but when one fits a ×2 magnifying aid to the viewfinder the image seen becomes dimmer still, so that much peering and fine tuning may be needed to achieve sharpness. A 1000 mm mirror lens, probably with an f/13.5 aperture, is an expensive lens demanding spot-on focusing of a murky image. Far cheaper to fit a ×2 converter to a 500 mm lens; with a good lens and a well-matched converter sharp $6^1/_2 \times 8^1/_2$ inch (165 × 216 mm) enlargements should be attainable.

Project: **To master the telephoto lens**

Having obtained a suitable lens for bird photography – and do not begin with anything longer than a 300 mm lens – you must now become really familiar with its use. This requires an ability to hold a moving creature in sharp focus by smooth

LEFT A pictorial essay on a bird species should always include shots of the birds in their natural habitats, such as this gannetry on chalk cliffs at Bempton near Bridlington, Humberside.

Powerful fixed aperture mirror lenses provide a fixed and shallow depth of field, as exemplified in this picture of nesting kittiwakes, taken with a 500 mm f/8 mirror lens. Note how the central nest site is sharply defined, while the birds perching just to left and right are blurred. Shallow depth of field can help to concentrate attention on a main subject.

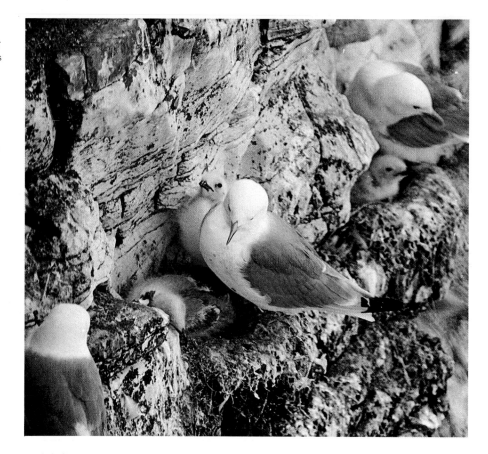

and deft movements of the focusing ring and quick enough reactions to press the shutter at the critical instant when the bird has adopted an attractive pose, or is moving across an appealing background. Not far away there is sure to be a canal, river, or park lake with mallard and their cross-bred comrades. Go to the shore taking the telephoto mounted on an unloaded camera. Select a paddling duck and follow its movements through the viewfinder, holding the bird in focus until your arms ache. Then repeat the practice till, as if by instinct, you can coordinate your focusing with the movements of the duck. Next, continue with the exercise, but say 'click' each time that a sharply-focused and nicely-lit bird adopts a photogenic pose. Finally, load the camera, set the mode control to 'automatic' (with whatever compensation the situation requires) and a shutter speed at least equal to the focal length of the lens, and shoot off a few frames, accepting only top-class compositions, but being ready to gamble away shots in the hope of catching an interesting pose and movement. In due course you will be able to inspect the resultant film: award yourself a pat on the back for every truly sharp picture and a slap-up meal if there is one really first-class portrait. But be honest with yourself: portraits and snapshots are not the same thing!

More equipment and techniques

Focusing and the selection of an adequate shutter speed are a sufficient challenge for most situations in bird photography, so that it is tempting and often convenient to use automatic metering. On shutter-priority cameras this will normally amount to selecting the slowest shutter speed still compatible with the lens in use ($c.$ $\frac{1}{250}$ sec for the 200 mm lens, and so on). With aperture-priority cameras one effectively does the same thing, choosing the aperture which sets the

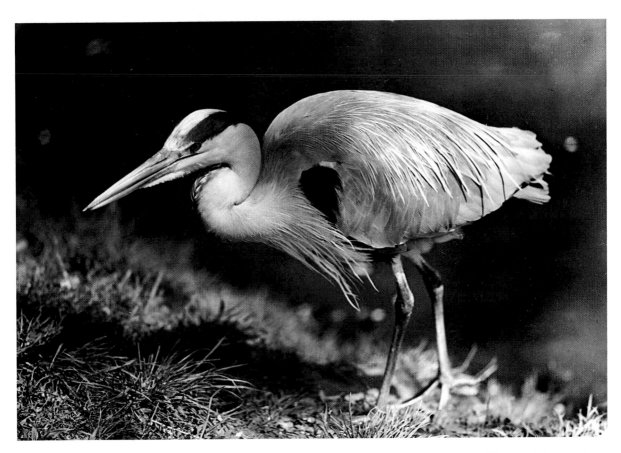

appropriate shutter speed. But further adjustments may be needed: a sunlit swan amongst the darker reeds or a similarly sunlit gull flying against a blue sky background may require $\frac{1}{2}$ to 1 stop less exposure than the background. Similarly, a grey heron in a bright sky may need a stop more exposure than the meter suggests. In practice it is best to judge all such settings in advance, leaving the hands and concentration free for the task of focusing and supporting the camera.

I began with the problem of distance; either you must get close to the bird or it must come close to you. While detailed portraits of very large birds like swans or herons can be obtained from distances of around 50 metres, with the finches, tits, warblers, larks and other small birds the critical distance may be 3 metres or less. Stalking is one possibility. Experienced stalkers with an expert knowledge of bird habits and environments can achieve quite striking results. You could attempt stalking with a 300 mm optical lens or a 500 mm mirror lens, the camera being mounted on a shoulder support or a monopod. Even so, it is very unlikely that stalking will get you sufficiently close to many small birds. If they are to come to you then they must be unaware of your presence, and a hide is the obvious answer.

Hides come in many forms: the sitting room and the car can be as useful as the conventional construction of canvas and poles. Many of the best photographs of garden birds have been taken from sitting room, kitchen and shed windows and the family car is a very effective mobile hide, especially when a bean bag on the sill of the open window is used as a camera rest and a blind is added to hide the photographer within. For work at estuaries, an old boat covered in a canvas hood can prove ideal. The photographer enters the hide at low tide and waits for the water to rise. Eventually the estuarine waders are concentrated in the diminishing shoreline around the boat, quite unaware of the cameraman in their midst.

The pictorial approach to bird photography is very demanding and photographs should be well composed with the subjects shown in interesting poses under attractive illumination. The menace and single-mindedness evident in this portrait of a heron always remind me of a certain lady Prime Minister. Sidelighting reveals the delicacy of the plumage and the blurring of the foot conveys a sense of motion.

179

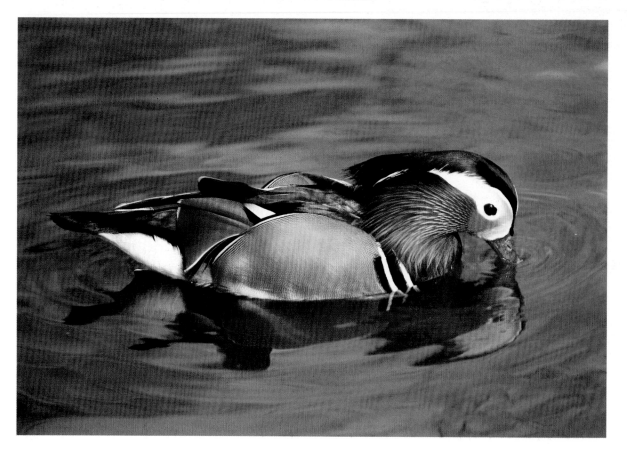

Some birds are so colourful as to demand colour photography. The mandarin duck is an alien, now established on a few British waterways.

RIGHT With light coloured birds, like this mute swan, exposure compensation is needed if feather detail is to be preserved. Here the resultant darkening of the background enhances the result.

Conventional hides include the fixed kinds installed for visitors at many bird reserves and portable hides which are erected in likely places, either to observe a particular bird or pair, or as part of a wait-and-see strategy. Purpose-built hides are available from Jamie Wood Products Ltd (see p. 233), while cheap examples include the camping lavatory tents which can be modified simply by cutting a slit for the lens. Whichever kind of hide is chosen, careful siting and, perhaps, the addition of camouflage netting will increase the chances of success. Inside the hide a tripod will steady the camera and a folding stool will do the same for its operator. Other hide variants include the tree house or platform and more bizarre creations – like the imitation tree trunks pioneered by the famous Kearton brothers.

Two good rules to remember when working with a hide are, firstly, that birds are far from being stupid, and, secondly, that most have learned to fear humans intensely. They have memories but do not count very well, so that if one person is seen entering a hide the birds will stay away, but if two people approach the hide and one departs, the birds are likely to assume that the hide is now empty. The use of assistants is strongly advised when working the rarer species. Waiting in the cramped confines of a hide can be trying for restless souls. The secret is partly psychological: if you expect that something interesting is about to happen you can wait contentedly for hours, but if you doubt the chances of success then time drags and discomforts are magnified. Hides will often be set up in gloomy, bushy places where flash will be essential. Birds may well shy away from the prominent silver face of the flash gun if it is too close to the perching site. Therefore one needs to keep the gun as far as possible from the subject – and this requires the use of a powerful gun. The Metz 45CT3 gun is quite expensive but it offers TTL dedication with compatible cameras and has a muscular guide number of 45. Also, a telephoto attachment is available which has the effect of almost doubling the

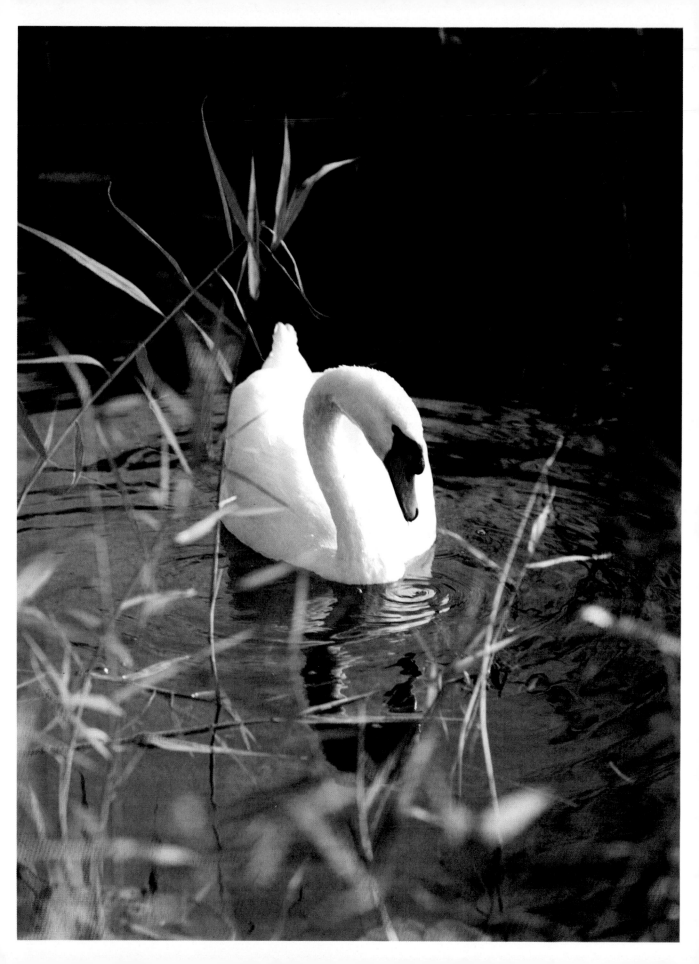

guide number. Similar telephoto attachments can be made to concentrate light from any flash gun, using a fresnel lens similar to those found on powerful lamps and torches. One would need to manufacture a fairly light-tight and stable housing and experiment with a flash meter to find the optimum distance in front of the flash head for mounting the fresnel lens.

Hides are positioned in the places most likely to be visited by the target bird. Of these places the most obvious is one close to the nest. However, I am sure that if I can discourage readers from working nest sites then many budding bird careers will be saved. An exception can be made for those birds, mainly the cliff-nesting species, who feel so secure on their inaccessible ledges that they will happily tolerate photographers on an adjacent cliff top. Under some circumstances of familiarity and security, water birds like moorhens or swans will also tolerate the presence of man. With most birds the response to a severe disturbance by an intruder at the nest is to desert, and no photographer is so experienced as to be able to say with *absolute certainty* that desertion will not be a sad consequence of the photographic operations. It is an offence to work at the nests of birds on the Nature Conservancy protected birds list without obtaining permission from that organization – see Chapter 19. Thousands of remarkable pictures of birds at their nests have been published, and there is no doubt that their powerful visual appeal has encouraged public awareness of the case for conservation to an immeasurable degree. Even so, the observer will see that while nests spotted in the course of country rambles are usually well masked by twigs and foliage, the photographs show an unimpeded view of the nest and its contents. This is generally the result of 'gardening', the photographer having cut or tied back the intruding vegetation. Such gardening may cause the birds to desert and is also likely to expose the nest to predators.

If a reader is determined to work a nest site from a hide, then it is best to choose the nest of a relatively bold and common bird, like a robin or blackbird, and to do the job as expertly as possible. Either the hide should be erected at a considerable distance from the nest and moved forward in stages over the course of several days or, alternatively, it can be erected a bit at a time to rise gradually at its intended site over a similar period. In either case one aims to minimize the intrusion of an unfamiliar and potentially frightening object in the sensitive vicinity of the nest.

I have said that the key problem is one of getting a camera close to a small and wary subject, and also mentioned that wild creatures are far more frightened of humans than they are of bits of machinery. The use of remote triggering devices provides the opportunity for the photographer to remain tolerably distant from his or her subject, while the camera is sufficiently close to produce top-class results. The only disadvantage with such techniques could arise from a lack of awareness of whether the equipment might be disturbing and distressing the subject. At first the use of such remote triggers takes one into unfamiliar territory, but with a little outlay, practice and patience some outstanding pictures can be obtained, while the range of opportunities is inexhaustible. The following project provides a straightforward introduction to the techniques involved.

Project: **To obtain an excellent portrait of a garden bird**

This project is most easily accomplished during the winter months, when hunger encourages birds to set aside their inhibitions. Begin by providing a constant supply of bait in the form of wild-bird food, placing the bird-table a few metres from a convenient window. Care should be exercised in the choice of foods, for while unsalted peanuts are welcome in the winter they can cause spring fledglings to choke. Remember too that while tits, finches, sparrows and starlings will flock to the bird-table, thrushes and blackbirds prefer to feed on the ground. (Having encouraged birds to feed in your garden, you are then morally bound to maintain

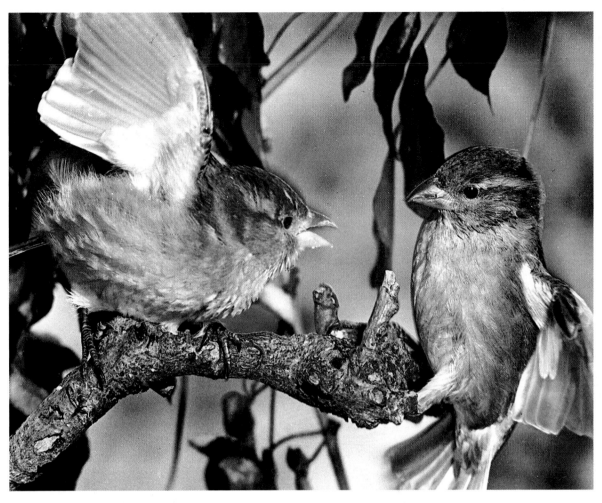

the food supply throughout the cold season.) Gradually familiarize the birds with the paraphernalia of photography. Artificial constructions like bird-tables are not very photogenic, so place a twiggy branch a metre or so to one side of the bird-table. You will be focusing the camera on the most tempting twig perch, so arrange the branch so that it will be in line with a suitable background – either the sky or a harmonious bush. The setting could be enhanced by draping ivy around the twigs: the glossy evergreen leaves will produce attractive highlights. If aerials, sheds or fences spoil all the available backgrounds, then manufacture a naturalistic backdrop and screen from dead branches and leaves.

Next make a set of dummy equipment – polystyrene boxes can be painted black to mimic camera bodies, round perspex cartons can duplicate the lens and mock flash guns can be created from oblong plastic cartons stuck on cardboard rolls. Set the dummies in position around the bird-table and wait for a few days until the birds ignore their presence before substituting the real things. Fit a short or medium telephoto lens of 135–200 mm length and an autowinder on the camera and mount the camera on the tripod, focusing on the selected twig. Link one flash gun to the camera and place it above and to one side of the perch, about 2 metres from the twig. Fit a slave unit to the second gun and place it at a similar distance from the twig but to the other side of the camera. One gun, the most powerful, will provide the main illumination, the other fills in the shaded areas. Set the smallest aperture that the power of the guns will allow (if you own a flash meter, then calculations and guesswork can be avoided and correct exposure is assured). Now

Do not scorn the common garden birds. These squabbling female house sparrows were photographed on an artificial set placed above a bird-table using twin flash guns and an infra-red remote trigger of the push-button type. Such a picture would be very difficult to obtain with uncommon birds in field conditions.

183

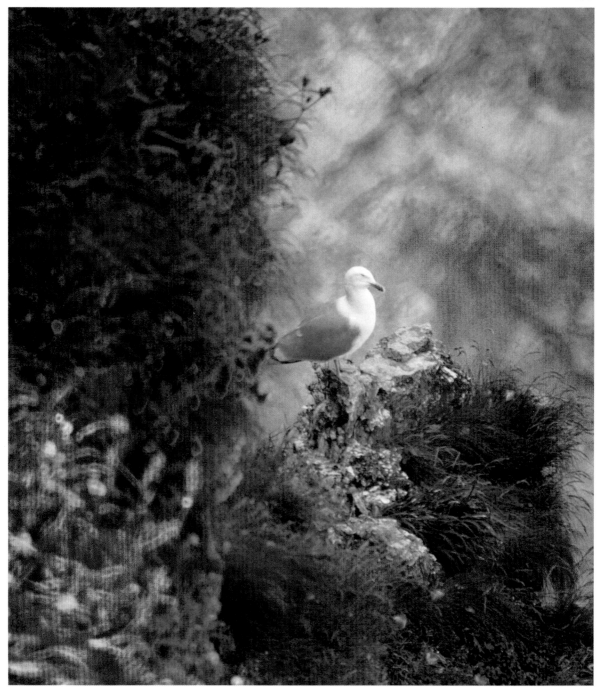

Another approach to pictorial bird photography (see p. 179). The shallow depth of field provided by the powerful telephoto lens has isolated the sharply-focused herring gull and adjacent grasses against the soft foreground flowers and cliff backdrop.

link the camera to the remote trigger. These are of different types. The break-beam type will trigger the camera whenever a bird is landing on the perch, but conventional flash will not be fast enough to prevent an unattractive blurring of the wings. More useful here is the push-button type, fired by a remote hand-held infra-red trigger – and by the flash of light from a flash gun at greater distances still. With all the gear set up you can then retire to the comfort of your window seat, triggering the camera whenever a bird on the target twig adopts an interesting pose. But before retiring to wait, it is important to memorize the exact area covered by the camera.

This exercise demands more equipment than the average reader may yet possess. In addition to the camera, you need an autowinder, two fairly powerful flash guns and their supports, ones of guide numbers 30 to 45 being preferred, and a set of infra-red triggers. How can one cut down on the equipment bill? It is better to dispense with flash entirely rather than to use weak flash guns. With powerful guns you will be able to use a smallish aperture of f/11 or f/16. In weak winter lighting a flash-synchronization speed of $^1/_{60}$ or $^1/_{125}$ sec combined with a small aperture and a slow film will eliminate 'ghosting', in which the ghost image outline exposed by daylight spoils the main image illuminated by the flash. (The only certain way to eliminate ghosting is to work in near dark conditions, in total darkness with the shutter blind kept open, or to use a medium-format camera, like the Bronica models, with shutters incorporated in the lenses to allow faster flash-synchronization speeds.) If you want to discard flash and retain the smallish aperture necessary to provide adequate depth of field, a fast film of about ISO 400 will be needed. You can dispense with the autowinder, though you will be obliged to disturb the bird by going out to advance the film after each exposure. A long air-bulb release can be substituted for the infra-red trigger, the tube passing up through a slightly open window. However, since there is a slight delay between squeezing the bulb and triggering the camera, some momentary poses will be lost.

An alternative technique involves the use of a tiny electrical micro-switch, cheaply obtained at any of the shops which serve electronics buffs. A selection should be available and those with a light action and a fine wire trigger are best. The trigger is linked by cable to the camera's shutter release socket and placed in a spot where it is out of sight of the lens and can be triggered by the walking, perching or pecking action of the birds. For example, it could be hidden beneath a dusting of snow, fixed to the back of a perch or concealed under grains of bird food. Be sure, however, that it cannot snag the feet of the birds. Whichever triggering method is adopted, once the craft has been perfected in the garden it can be applied in the wild, remembering to avoid the sensitive nest site. As your fieldcraft increases, the remotely-triggered camera can be targeted on tree trunks frequented by tree-creepers, perches used by hedgerow birds, riverside stones frequented by dippers and wagtails and a host of other promising situations.

In-flight photography

Eventually the enthusiast will want to photograph birds in flight. With large birds with a slow wing-beat, like herons, geese and swans, this will present no problem and a shutter speed of only $^1/_{250}$ sec should suffice. Birds like gulls, which have a gliding mode, can also be photographed with relative ease. But whereas herons and swans follow fairly straight flight paths, gulls wheel around the cliffs. Here the easiest method is to pre-focus the camera at a suitable distance and then to follow the bird through the viewfinder, pressing the shutter when it is seen sharply focused. With a shutter speed of $^1/_{500}$ sec and a 400 mm or 500 mm lens and the aid of a shoulder support, success should be quite easily achieved. Motor drives will take a rapid sequence of perhaps five frames per second – one of which should be sharply focused (you hope!). The sense of movement can be enhanced by using a slower shutter speed and 'panning' the camera, keeping the bird's head in the same part of the finder through a flight sequence. Remember, though, that panning will stop all forward motion and show the bird sharply against a blurred background, but it will not stop the wing-beats – so it is best used with gliding birds.

Once you have mastered the pre-focusing technique of in-flight photography and are thoroughly familiar with your equipment, you can then attempt 'follow focusing'. Focus on a promising subject and gently rotate the focusing ring to maintain a sharp viewfinder image as the bird flies towards or past you. You can

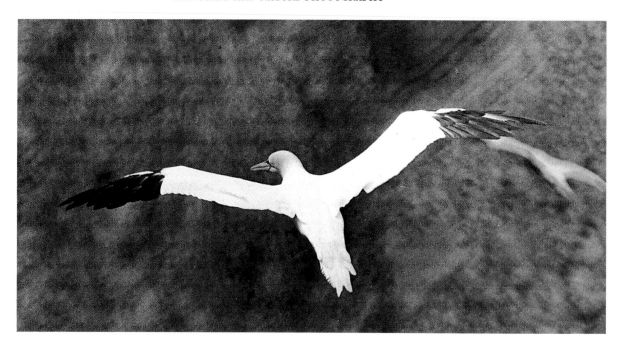

A gannet in flight photographed with a mirror lens using the 'panning' method. This technique is most suitable for birds with a gliding mode.

then release the shutter at the closest approach or most attractive instant. This technique can be practised from cliff-top vantage points, where gulls or gannets successively exploit the same air currents. After hours of practice you should be able to hold focus, even with a 500 mm lens, which can give very impressive results.

Small birds with very rapid wing movements are altogether a different proposition. The typical 35 mm camera has a minimum shutter speed of $^1/_{1000}$ sec. A few very expensive models have faster shutters, with special Nikon and Contax models offering $^1/_{4000}$ sec, but none provide the speeds of around $^1/_{6000}$ sec or faster needed to freeze the wing tips of a small bird like a blue tit (while in-flight insect photography may demand flash speeds shorter than $^1/_{20,000}$ sec). High-speed flash and a large measure of ingenuity are now needed. Any modifications to flash guns should be left to competent experts, for the guns can be lethal. The conventional electronic flash gun at full power has a speed of around $^1/_{500}$ to $^1/_{1000}$ sec – fast, but far from being fast enough. It increases its apparent brightness not by intensifying the light output, but by prolonging it. Thus, to obtain a very short flash, one must accept a very 'weak' output of light. Some of the more expensive guns have settings which allow the use of the gun at fractions of its full power, and thus at a similar fraction of its slowest speed. A large hammerhead flash gun set in this way may just provide a sufficient light output, a cluster of three such guns may, in effect, produce half as much light again. My own high-speed kit is a powerful but outmoded Braun 800 outfit with a paper capacitor modification – an adaptation which should only be attempted by competent electronics specialists. (The electrolytic capacitors of commercial flash units cannot tolerate the high voltages associated with low resistance tubes.)

Any high-speed flash gun should be linked to a camera which is triggered by an infra-red break-beam system. Even then chance plays a massive role in the process. A brief instant passes between the breaking of the beam and the reaction of the camera: the delay on mechanical cameras which use a solenoid device to open the shutter is between 10 and 30 milliseconds. With electronic cameras, which have internal operating systems rather than solenoids, the delay may be even longer. The result of this is that a camera directed at the infra-red beam itself is likely to show no bird at all, or just the tail of the disappearing subject. So one

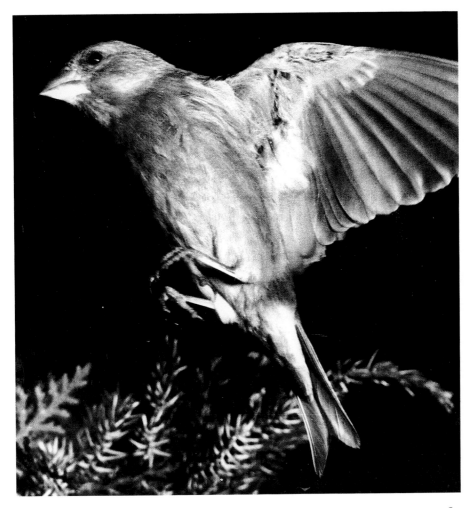

must anticipate the delay in the camera response and relate it to the presumed forward flying speed of the target. Even then a whole film may be used without obtaining a single worthwhile frame (three films were used before obtaining the greenfinch shot below). If the camera is positioned with its film plane parallel to the beam, it will tend to take head-on shots and rear views, while if the film plane is at right-angles to the beam most pictures will be in profile – but in either case care is needed to ensure that the triggers and flash gun do not appear in shot. It is also necessary to work in a gloomy situation, otherwise the fairly slow flash-synchronization shutter speeds will allow ghost images. Experimenters in high-speed photography have tried several devices – including dynamite – in attempts to overcome the minute but crucial delay in the opening of a shutter. The best so far developed involves keeping the integral focal plane shutter open and fitting a leaf-type shutter to the front of the lens. At the time of writing, Mazof, manufacturers of remote triggers and high-speed flash equipment, are reported to be planning to market a front shutter device early in 1986.

One theory holds that birds mistake flash for lightning and are therefore largely oblivious to it. Flash guns placed too close to a bird may cause a little distress: some birds are unconcerned by flash; others fly away when the gun is fired, but usually swiftly return. They will also realize quite quickly that a particular flight path produces a flash and the whir of an autowind and will learn to avoid the space spanned by the beam.

This photograph of a greenfinch in flight was taken using high-speed flash and a break-beam trigger.

The interest of high-speed flash is not confined to the world of birds. It can be applied to mammals, like flying bats, and to jumping frogs. Remarkable applications in the insect world are displayed in the book *Caught in Motion* by Stephen Dalton. The author used a very fast flash speed of at least $^1/_{20,000}$ sec and a highly sensitive beam trigger set inside a box, or 'flight tunnel'. The greatest problem he faced was getting the shutter to open sufficiently quickly. Experiments using elastic bands and even a small charge of dynamite were superseded by the development of an electronic shutter with an opening time of only $^1/_{400}$ sec.

Readers who would like to attempt photography of small garden birds in flight without investing in specialist equipment and electronic know-how could try the following procedure. It is a hit-and-miss method which will certainly score many more misses than hits. Firstly, study the flight path of a garden bird very closely: where does it slow its flight in the instant before perching? Use your largest available flash gun, preferably with a guide number of at least 30, set it in the 'auto' rather than the TTL mode (if it has one), as this will reduce ghosting, and place it as close to the targeted flight path as is possible without disrupting it. Mount the camera on a tripod, fit a telephoto lens to the camera and link the flash to the camera by an extension lead. Connect an air-bulb release to the shutter socket and retire out of sight. You are now gambling on triggering the camera when the bird flies into the space covered by the lens and flash (shoot early to allow for the reaction times of yourself and the camera), and are hoping that the auto flash sensor will detect the bird at close proximity and deliver a suitably short burst of illumination. Crisp in-flight images can be obtained in this way, but keep a litter-bin handy for the many dud pictures.

A song thrush in winter. The technique and set are the ones used in the photograph on p. 183, while the snow is genuine.

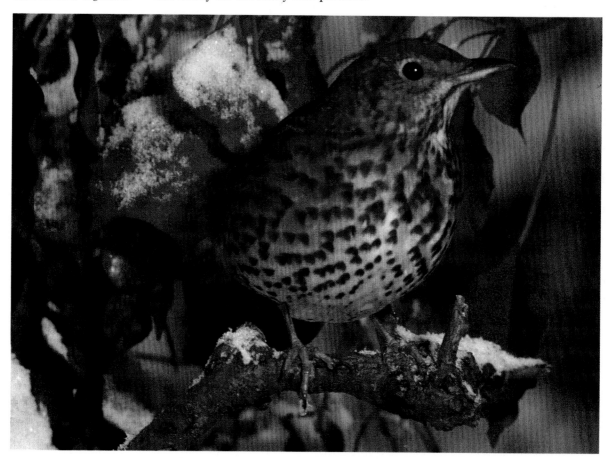

16
MAMMALS

When compared to the wild animals of the veldt or rain forest, those of Britain might seem to be a rather drab and innocuous assortment. Still, it is not easy to imagine anything more delightful than a red deer or a fallow deer fawn, or more personable than an otter, while on closer acquaintance the diminutive woodmouse emerges as a fascinating little character. The assemblage of British mammals is a modest one. It includes only one member – the red deer – which is reasonably large and in numerical terms it is dominated by small and difficult subjects: fifteen types of bat, the shrews, voles, mice and rats. Plainly, the techniques which are effective in attempts to photograph deer cannot be applied to tiny subjects like bats or shrews. Equally, the lifestyle and habitat of any particular animal condition the photographic strategy. Hares are difficult subjects because they occupy very open country, moles are obviously a greater challenge still, while good cover is usually found near the earths and sets of foxes and badgers. The movements of rabbits are predictable and a camera can be set to cover a run; free-flying bats, however, pose insuperable challenges to all but the most dedicated workers.

Techniques and equipment for animal photography

The novice, influenced by films of African photographic safaris, probably has an unbalanced impression of what is involved in animal photography. Where elephant, wildebeest and zebras abound, one can expect to achieve a string of successes by wandering stealthily about the bush with a powerful telephoto lens fitted to the camera. In Britain, however, the intensity of light is much lower, the animal subjects usually much scarcer, smaller and more elusive, and the inhabited cover is generally thicker. As a result, the emphasis shifts from stalking methods to the careful pre-planning of a particular campaign. One can fit a powerful lens and ramble hopefully around an unfamiliar piece of countryside – but the chances of stumbling across a fox, badger or otter are slim. Even if such animals are glimpsed it is highly probable that the view will be obstructed, that the light will be too dim, and that the animal will sense your presence and slip away long before it becomes much more than a dot in the viewfinder.

Stalking is, however, a suitable technique when photographing deer in fairly open country. The animals should be approached from downwind, zig-zagging via the stepping-stones of whatever patches of cover may be available. Having studied the terrain and planned an approach route, one should move smoothly but swiftly from one patch of cover to the next in a stooping or crawling position,

With their inquisitive, playful characters otters are superb subjects for the dedicated nature photographer. They can sometimes be found basking in this position, like cats at the fireside.

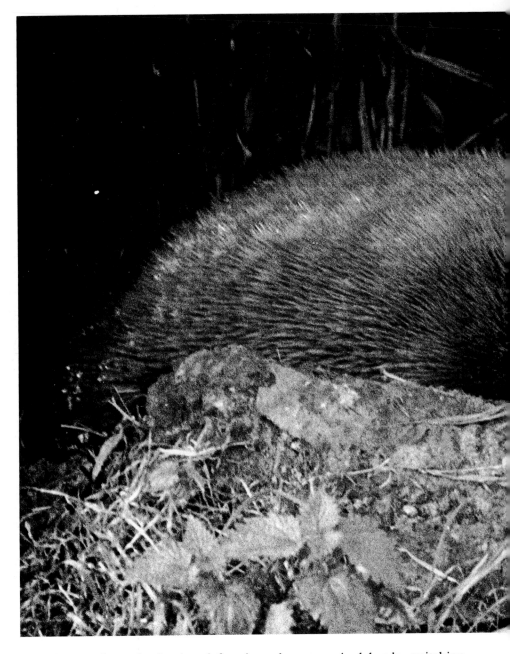

turning away from the herd and freezing whenever raised heads, twitching nostrils and pricked ears show that the curiosity of the quarry has been aroused. Deer have good eyesight and excellent senses of smell and hearing. If the herd is grazing and poorly posed, the faint click of the shutter from a well-concealed camera may alert them, providing the opportunity for a more interesting shot during the seconds when the animals are scouring the countryside, ears pricked and eyes wide for the source of danger.

Red deer are mainly creatures of the open mountain and moor, but in Scotland they may wander down through the conifer plantations to seek for food close to the valley hamlets when the winters are hard. Fallow deer are woodland and parkland animals which are sometimes encountered in open country on their migrations between such havens, while the diminutive roe deer is a shy nocturnal forest

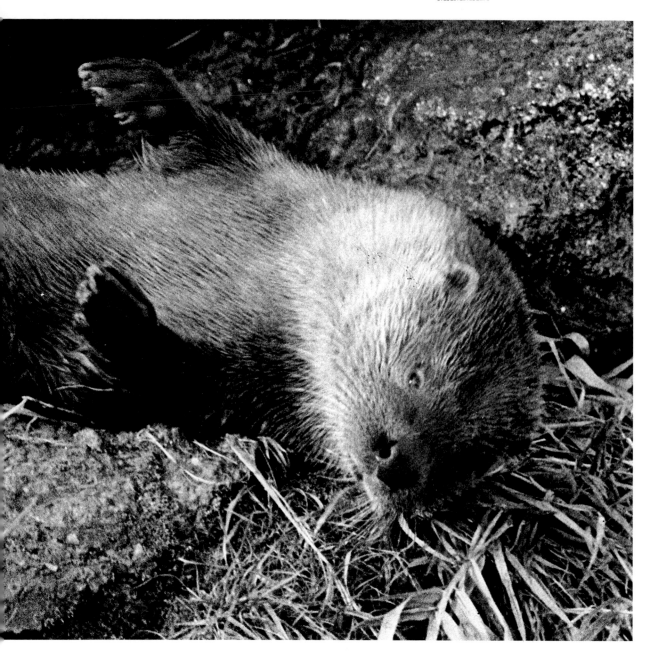

animal. It is seldom seen and any small deer glimpsed is more likely to be either a muntjac or a Chinese water-deer, both of which have escaped from zoos or parks and become established in the wild. While none of the British wild mammals can be regarded as dangerous, deer – particularly the little roe – can be aggressive during the breeding season.

While stalking can be effective in some types of terrain, in wooded environments the light levels are usually too low to allow the hand-holding of the long (400 mm conventional or 500 mm mirror) lenses which are best suited for this kind of work. Working from a well-sited and well-camouflaged hide offers several advantages. The more controlled conditions allow the use of tripods, or flash and shorter lenses, and also give one a measure of freedom to choose a background. Any beginner who manages to frame and focus a wild deer has done very well, but

When stalking, you are constrained by the available cover, and if you are using fixed focal length long lenses (as opposed to zooms) framing may present problems. In this picture of a suckling red deer fawn, taken with a 400 mm conventional lens, I decided to frame in a way that cropped the rump of the mother and the legs of the fawn, but preserved the head of the hind.

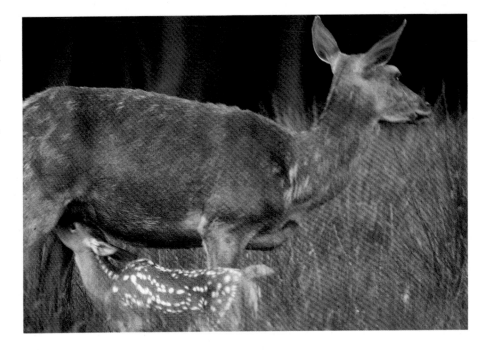

the most dedicated enthusiast will also try to capture the sort of background texture which will enhance the pictorial qualities of the photograph. He or she will also seek to use an aperture which will either reveal the animal within its habitat, with foliage sharply defined, or else outline the creature against an undistractingly fuzzy backdrop. (Where long lenses are used at distances of less than a few hundred metres, their shallow depth of field characteristics will virtually ensure a fuzzy background.) Hides are also effective in the photography of animals in the middle size range, like foxes, badgers, otters and polecats. With fieldcraft and, perhaps, some informed local advice, you may discover where foxes and badgers have their abodes, the whereabouts of otter 'slides', or even the boulders used by polecats in crossing streams. One can also invoke the fairly safe principle that animals of all kinds are more frightened of humans than machinery. Therefore you may often be able to place a hidden camera closer to the frequented area than you could position a hide (remembering that a number of rarer animals enjoy legal protection within their abodes and their immediate surroundings – see Chapter 19). Such a camera (and if necessary, the attendant flash gear) should be erected quite quickly, avoiding unnecessary disturbance, trampling and scent traces. It can be set on a low tripod, focused and covered in camouflage netting. For more controlled pictures, the photographer is concealed at a safer distance from the anticipated action, triggering the camera either by an air-bulb release or via an infra-red sensor. Alternatively, the camera can be linked to a break-beam type of infra-red trigger and you can then retire completely from the arena.

Project: The use of remote triggers in animal photography

The novice will need to build up a reservoir of fieldcraft before attempting to work with shy and, in some places, scarce animals like badgers, foxes, otters and deer. Despite the grim onslaught of myxamatosis, the rabbit is again relatively common and it is an easy subject. Given the right equipment, the following tactics will almost ensure an interesting photograph. Firstly, select a burrow, looking for

fresh tracks and droppings which show that the burrow is still in use. You will see from the firmed earth and short vegetation just outside the burrow opening that there is a distinct entrance and exit path. Fit a telephoto lens of around 100 mm to 200 mm and an autowinder to the camera and mount the camera on a low tripod. Position the camera to one side of the rabbit run, just high enough to give a view that is unobstructed by vegetation. Remember that a rabbit is about the size of a small cat and that it has a low profile when running, but one twice as high when sitting up and using its ears and nose to sense for danger. Remember too that rain is usually a possibility so, before leaving gear in the open, check the weather forecast and also cover vulnerable equipment with polythene bags as added insurance.

Seek to frame the impending animal fairly tightly, but allow for unpredictable variations in its posture. Place the infra-red transmitter and receiver on either side of the run, out of shot but exactly bracketing the section covered by the lens. Check that they are not apparent in the viewfinder but that the view between them is unobstructed. Set the smallest aperture that the power of your main flash gun will allow and link the triggering apparatus to the camera. Now add two flash guns in unobtrusive positions, one above and a little to one side of the camera for main illumination, the other to provide fill-in and background illumination. One will be linked to the camera by an extension cable, the other is linked to a slave unit. Check that everything still looks fine in the viewfinder, switch the flash, winder and trigger 'on' and drape camouflage netting over the gear, being sure to leave the lens and flash heads unmasked, though clear polythene bags over the flash heads will not really impede the passage of the flash. Since rabbits are mainly nocturnal animals, while naughty little boys are largely creatures of the day, it is wise to erect the gear at dusk, before the rabbits emerge, and to return late at night or early in the morning, before the vandals are about. With any luck the system should have recorded a sequence of shots – though half of them are likely to show the rear view of a homeward-bound coney. The choice of a location near the burrow entrance helps to ensure that the rabbits will not normally be passing through the sensors at speed.

This project requires some fairly costly accessories: the autowinder and the infra-red sensors. A cut-price version is possible, using a cheap cable and air-bulb release in place of the sensors. Set up the remainder of the gear in the manner described, carefully memorize the details of the camera's field of vision and retire to a concealed spot near the limit of the cable release, peering through the cover and triggering the camera when the rabbit is in shot. This allows some selection of images and saves film that would otherwise be wasted on tail-end shots, but the absence of an autowinder means that you will be obliged to emerge from cover to wind on each frame. The rabbits will only tolerate a few disturbances and there will be long waits between each appearance, though patience in choosing the most attractive pose will be rewarded. A piece of carrot placed at the crucial spot could produce suitable pause and pose. Having gained some sound practical experience around the warren, one may then turn to more challenging subjects like hares and foxes, or perhaps even stoats and weasels. Readers who are unsure of their fieldcraft could wait for a fall of snow and then discover the paths frequented by different animals by studying the pattern of tracks.

Other possibilities and the vivarium

While some animals demand considerable guile and planning beforehand of the photographer, there are a few which are easy game. Hedgehogs are delightful subjects, while being both common and relatively tame. No special fieldcraft is required, for sooner or later one will be found suicidally oblivious on a road, rummaging noisily in the garden at night, or be met in the course of a country walk. The yelp of a dog in undergrowth usually signals a nose pricked on

hedgehog spines. Grey squirrels are also easily photographed. In the wild they are rather shy and will frustrate the photographer with their canny trick of moving round a tree so that they are always hidden from view. In most urban parks, however, the squirrels are often so tame and dependent on human charity that they will take titbits from the hand. Their shyness diminishes along with the natural food supply, while attractive pictures can be taken in autumn when the squirrels are hard at work burying fruit and nuts amongst the turf. Red squirrels (like otters) enjoy special protection, and must not be disturbed in or near their drays.

Moving down the scale of size, we come to the bats and small rodents. Roosting bats might seem to be easy subjects, but the novice should be warned that it is illegal to disturb roosting or hibernating bats with flash photography – a fine of £2000 could be imposed. The most advanced photographers might attempt to photograph free-flying bats in flight using infra-red beam triggers and high-speed flash. Such photos lie near the limits of possibility and should only be attempted with optimism by those with a detailed knowledge of the movement of the local bat population and a reservoir of experience in the use of the triggers. Mice, voles and shrews are too small and elusive to be photographed successfully in the wild by any but the most dedicated enthusiasts. If you are so dedicated, a macro lens, autowinder, twin flash gun and infra-red trigger set-up arranged around a known run offers the best prospects of success.

For carefully-focused and well-composed pictures the vivarium is the safest bet. This can be a small glass fish tank, and the skill involved largely concerns the creation of a naturalistic micro-world within the vivarium. Of course, one must also obtain a subject – remembering that bats and shrews are protected species and must not be removed from the wild for photography. (I must confess that some of my own mouse and vole subjects were rescued unharmed but distinctly discommoded from a former cat, lamented by us, but not by the local rodent population.) The use of a Longworth trap is a civilized alternative and does not require one to arrive, like the US cavalry, in the nick of time. These traps, obtainable from Penlon Ltd (see p. 233), have a compartment in which the potential subject can curl up amongst some bedding until the arrival of its captor. Naturally, the traps should be inspected regularly.

A suitable vivarium environment should already have been prepared with the stage decked in natural materials with attractive colours and textures. Here it is useful to look closely at hedge bottoms, stream banks and the woodland floor,

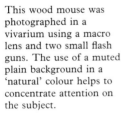

This wood mouse was photographed in a vivarium using a macro lens and two small flash guns. The use of a muted plain background in a 'natural' colour helps to concentrate attention on the subject.

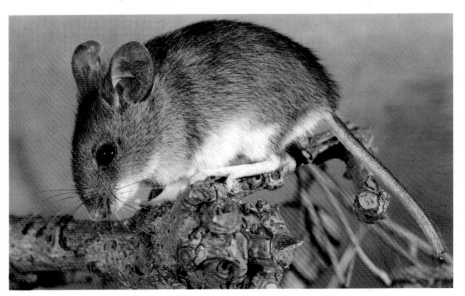

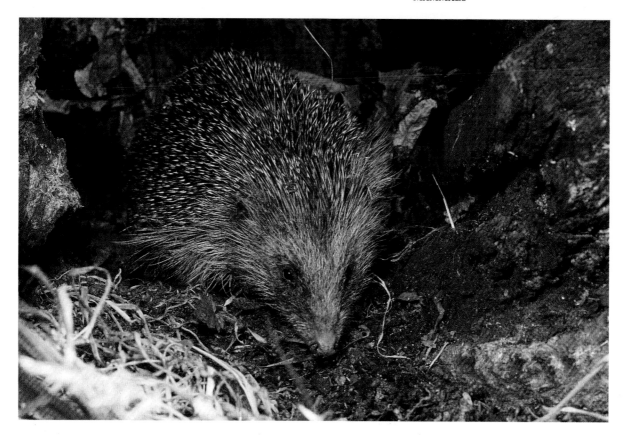

taking notes or pictures and bringing back a selection of dead materials. It is well to keep a handy store of dead leaves, living moss, gnarled twigs, lichen-encrusted stones and dried sand for the unexpected capture. Earth should be avoided or there will soon be muddy little pawprints over the vivarium glass. After the subject has been introduced into the vivarium, work can proceed, using a twin flash gun and macro lens set-up, much the same as that used in fish photography. A powerful macro lens will allow 'head and shoulders' portraits as well as full-length shots.

There seem to be different schools of thought concerning the best procedure. One recommends allowing the captive to settle into its new home for a few days, during which its fears and inhibitions will melt away. An alternative strategy is to take advantage of the fact that a newly-captured and confused animal will indulge in 'displacement behaviour'. Just as we might behave strangely in tense situations, a frightened mouse will start gnawing some nuts or grooming itself, adopting a range of photogenic poses. In any event, the exercise should culminate in the release of the animal in a sheltered environment where it can hope to prosper, even though wood mice and bank voles do make entertaining and likeable (if rather smelly) guests. Shrews and moles are voracious feeders and should never be detained for long, and a special Nature Conservancy Licence is needed before shrews can be trapped.

The subject of captivity leads to the question of work in zoos. From the point of view of the nature photographer (rather than the holiday snapper) these are not particularly inviting places. Even in the open collections, the surrounding habitats are completely artificial (lions and English elm trees are quite incongruous), while the animals are often unrepresentative of their unconfined brothers and sisters, being portly or neurotic and lacking the bright-eyed vibrancy of the wild beast. To the photographer the wildlife park does have at least two

As your fieldcraft develops, you will learn the most promising locations for remote triggers. Twin flash guns were used in this hedgehog portrait. Remember to allow for the colour of an animal in pre-setting exposures – hedgehogs are rather dark subjects.

RIGHT Pose is vital in any animal portrait. I saw this mother grey squirrel burying nuts in the autumn and noticed that she would periodically sit up to look for danger. The alert pose was captured with a 200 mm lens. The dim light demanded a wide aperture, resulting in an attractively blurred background which helps to outline the subject.

BELOW RIGHT Background can play a crucial role in wildlife photography, and if there is a choice of subject it is best to seek the one in the most attractive setting. A pair of old oaks provide the background for this picture of a fallow hind licking her fawn, but the soft dark form of the deer behind is the crucial compositional element. Here a 500 mm f/8 mirror lens was employed.

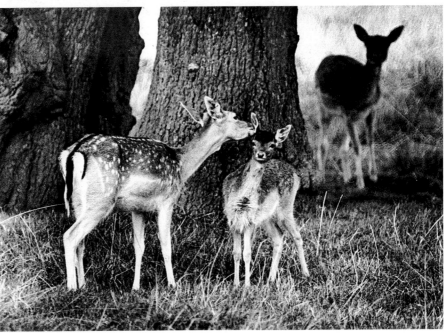

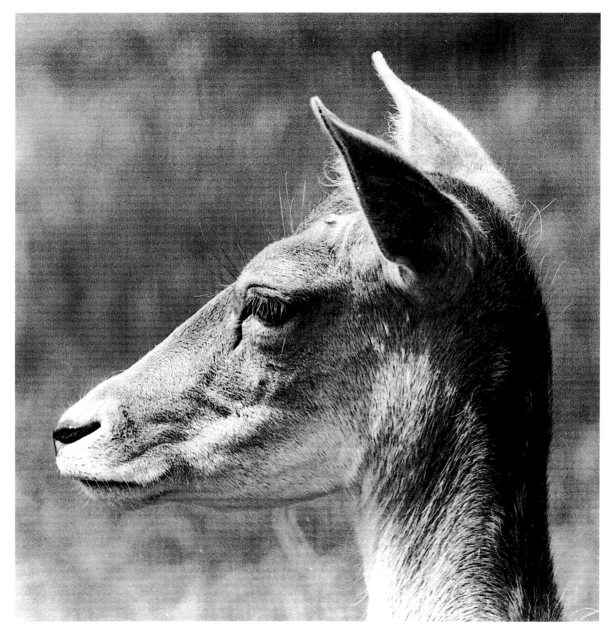

uses: firstly, it allows the capture of close-up details – the head and lovely eyes of the fawn, the texture of an otter's fur, and so on – which would be extremely difficult to obtain otherwise. Secondly, it enables one to study the colour, form and movements of animal types which could be subjects for photography in the field, making it easier to select backgrounds or behaviour patterns for future work.

We can end the chapter with the subject of backgrounds. Most competent exponents will realize that pose, colour and composition are hallmarks of appealing photographs. But as experience increases, one appreciates more and more the contribution that the context, its textures and tones, make to a first-class picture. To the beginner, who thinks that getting a squirrel in the viewfinder is a major achievement, such remarks may seem to heap difficulty on difficulty, but the joy of nature photography is that one will never run out of stimuli and challenges. The perfect picture is really a thing of dreams, yet a constant goal.

Wildlife parks provide opportunities for close-up portraits which might be unattainable in the wild. There can be little in nature more beautiful than the head of a red deer hind.

17
IN THE DARKROOM

The creative process need not end when you release the shutter, and while there are no special advantages in the home processing of colour slide films, with black and white materials darkroom work is virtually essential. It is in the darkroom that you can manipulate your negative to recover or underline the qualities of light and atmosphere which were sensed in the field.

The home processing of monochrome material is a two-stage process: *developing*, a mechanical and, to be honest, boring process, and *printing*, where skill, sensitivity and creativity can be applied.

Developing

The advantages of home developing are several, including speed, economy and the ability to give your films the personal treatment. To begin with you can adopt the following sequence of operations.

Firstly, you need a place – not necessarily any more than an understairs cupboard or darkroom 'tent' – which is *absolutely* dark. This serves as an area where film is transferred from cassette or spool to the developing tank. Before darkening the loading area, dismantle the tank and memorize the location of the spiral which will hold the film, the tank body and its lid. Use your thumb nail or a special opening tool to prise off the ends of the cassette (or, with roll film, remove the paper tab sealing the roll and separate the leading end of the film from the backing paper). Snip off the narrower film leader on the 35 mm roll, leaving a square end on the exposed film – some photographers also snip the corners of this squared end, though this is not easy in the dark. Carefully insert the end of the film into the spiral, which you will drop into the developing tank, and load the film into the spiral. This is one of those tasks which is only very easy when you know how, but it can be rehearsed in daylight using a cut-price out-dated film as a dummy until you have gained the knack. When you are sure that the film is properly loaded and the lid of the tank secure, the developing process is completed in the light. It is also possible to buy a photographic 'changing bag': this is a light-tight zipped bag with armholes. The inside of the bag makes a miniature darkroom in which you can load film into a developing tank. Only your hands – which go through the armholes – and the tank etc. are in darkness. Such a bag is also useful if you have to un-jam a camera out of doors.

Select a developer which is appropriate to your film and follow the manufacturer's instructions. For example, when developing FP4 in Acutol you dilute the solution in water in the ratio of one part developer to ten parts water at a temperature of exactly 20°C. The developer is poured into the tank and the film

develops for 6 minutes, with 10-second rotations of the reel at the end of each minute. One may opt for the easy-to-use liquid concentrate developer, like Aculux, Acutol or Ilfsol, or for powder developer, like ID-11 or Microphen.

Then the developer is poured out of the tank and a solution of stop-bath can be poured in to terminate development instantly. (I prefer just to flush the tank with water which should be at about the same temperature as the developer was.) The stop-bath or water is poured out of the tank and a solution of fixer, such as Acufix, Hypam or Amfix, is poured in. With a fast-working fixer the process is completed in a couple of minutes or so. Next the fixer is removed and the film, still in its tank but now safe in bright light, is washed in clean running water for at least 20 minutes. It can then be removed from its spiral and hung up in a dust free area to dry. Either add a few drops of wetting agent to the last rinse or wipe the film with one stroke of a soft and newly rinsed squeegee to prevent the formation of 'drying marks'. If such marks do appear, re-wash and dry and extend the washing period next time around.

If carefully standardized, this procedure will produce exactly the same results each time. It is possible, however, to exert special controls. Negative contrast can be increased by extending the development time, though, if there is too much extension, quality will fall and graininess will increase. Denser, more contrasty negatives are more easily printed by novices and it is sometimes a good idea to overdevelop films taken on murky days. There will be no significant drop in quality by developing FP4 in Acutol for 6 minutes 45 seconds, instead of the 6 minutes recommended for the 35 mm FP4.

Developing procedures can be adjusted in other ways to change the speed of a film. For example, FP4 is rated at its 'normal' speed of ISO 125 when given a standard development in the developer ID-11; Acutol claims to provide $^1/_2$ stop increase in the speed of the film, but Perceptol, which offers a very fine grain, lowers the effective speed of FP4 to ISO 80, while Microphen raises it to ISO 200. The use of unconventional development or 'push processing' can allow a film to be used in very low light levels. For example, HP5 is normally rated at ISO 400, but a prolonged development in ID-11 of 18 minutes produces an effective speed of ISO 1600 and 16 minutes development in Microphen at 20°C allows an extremely fast film speed of ISO 3200, but with rather contrasty and grainy results.

It is useful to be aware of the characteristics and possibilities offered by different film/developer combinations, especially for the occasions when you need to boost contrast or work in very dark conditions without a tripod. In general, however, it is as well to find a combination which works well and gives predictably good results. As it happens, almost all the monochrome photographs in this book were taken on Ilford FP4 and HP5 films, developed in the standard way in Paterson Acutol and Aculux respectively. None received more than a very slight push processing.

Printing

While some experts have a fascination with developers, printing is a far more creative process. In order to print you will need a darkroom – though this can be any room which can be blacked out. Excellent roll-up darkroom blinds can be tailor-made to order by the photographic superstore, Jessops of Leicester (see p. 233). If attempting your first print, the following procedure can be followed: place the enlarger on a suitable surface with the printing paper and negatives on one side of the masking frame, which sits on the baseboard of the enlarger. To the other side of the enlarger erect a splash-board made out of a plank of wood or piece of Formica and in its shelter set out trays of paper developer, stop-bath or water,

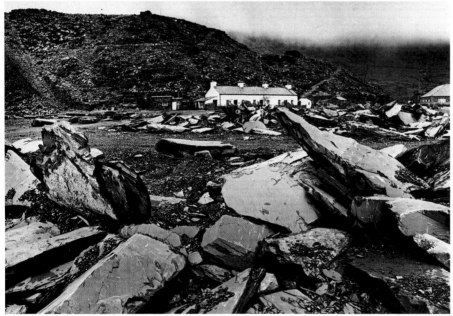

Hard printing papers increase contrast and 'bite'. In these pictures of mountains overlooking Llanberis Pass (above) and a Welsh slate quarrying landscape (left), the contrasty papers underline the hardness and bleakness of the scenery.

FAR LEFT In this picture of fungi and flaking bark, a soft grade 1 paper was used to increase the tonal range in a contrasty subject.

and fixer in that order. Replace the conventional light bulb with a suitable darkroom bulb to produce an orange or brownish safelight and then load a selected negative into the carrier on the enlarger. Open up the aperture on the enlarging lens, focus the image carefully on the white masking frame and then switch off the enlarger or swing its red filter into operation.

Place a sheet of grade 2 or grade 3 printing paper in the masking frame,

201

adjusting the margins of the frame to produce narrow white borders on the print, close down the aperture on the enlarging lens a couple of stops and expose the paper for a trial period of 10 seconds. Then place the paper in the developer, seeking to immerse it all completely in one swift motion. Keep it in the developer for the time recommended by the manufacturer, rocking the dish gently all the time. With the developer being very fresh, this first sheet may develop too swiftly and go quite black. If the results appear acceptable, wash the print in the stop-bath and transfer it to the fixer. Grip the paper in tongs, touching only the masked edges which will be the white margins of the print. If the second print attempted also darkens too quickly, reduce the exposure by 2 seconds. If it does not develop fully, increase the exposure by 2 seconds. Continue in this way until you have produced an acceptable print. Alternatively, you can work out the correct exposure with a stepped doubling-up series of test exposures by moving a card across the paper to give 1, 2, 4, 8, 16 and 32 second exposed steps on the same sheet. This is done by giving a first exposure of 1 second to the whole sheet, covering one sixth of it and giving the rest 1 second, covering another sixth and giving 2 seconds to the remainder, repeating the process with successive 4, 8 and 16 second exposures. From the stepped test print you can easily see between which two steps the correct exposure lies. Remember, however, that the dark working conditions make prints seem heavier than they really are – so allow them to go a little darker than appears to be desirable. You can only really judge in white light. After a few minutes in the fixer the prints can be exposed to the light, washed and dried.

When you have mastered this basic printing technique you can progress into the creative arena. Most books advise one to make a sheet of contact prints from a set of negatives and to make test strip exposures on sheets of printing paper. Light-sensitive meters and timers are also available for darkroom work. Actually, with experience one can judge exposures and the respective quality of negatives by eye and bypass the more boring procedures. Each batch of printing paper has its own exposure time, resulting from factors such as slight variations in manufacture and age.

To produce a first-class print from a negative one must choose the right grade of paper. Multigrade or Polycontrast type papers have their contrast levels determined by different filters inserted into the enlarger, but other types of paper are available in different grades. These vary according to the brands, but may run from the very soft grade 0, through 'normal' grade 2 to the very hard or contrasty grade 4. These grades are not standardized, so that, for example a Barfen grade 2 is slightly harder than an Ilford grade 2. For top-quality prints I prefer the non-Multigrade, non resin-coated papers – this is to say papers of the 'old fashioned' fibre-based types in a range of different grades. Papers also have different surfaces – matt, semi-matt, stipple, glossy and so on. A fine tradition in landscape photography favours the glossy finish, though matt can sometimes be effective. (Glossy prints on fibre-based paper can be glazed on a hot bed glazer after washing.) Papers also vary in terms of the inky qualities of their blacks and the white or ivory nature of their whites. Exhibition quality papers are a little more expensive, but one should at least be aware of the beautiful results produced by papers like Ilford Galerie, or Kodak Elite.

In general one will tend to print a negative of modest contrast on a hard – grade 3 or grade 4 – paper, and reduce the contrast in a dense negative by using a softer – grade 1 or grade 2 – paper. Soft papers will reduce the 'bite' in an image but give a more extended range of tones. In practice you will probably need a good stock of papers of grades 2 and 3 and a smaller, but at times essential, supply of grades 1 and 4.

The best choice of paper is not always obvious, even though scenes taken in brilliant sunlight with heavy shadows favour a soft paper, and a hard paper may be needed to intensify detail and contrast after work in overcast conditions.

Mountain scenery printed on a hard, grade 4 paper takes on a heavier, starker quality, while the softness and subtle gradations in a misty scene can be accentuated by using grade 1 paper. There may be times when one is not sure whether fine detail will best be represented by the extended tonal gradations of soft paper or by the biting contrast of a hard one. Also, while some very expert printers prefer to work with thin negatives, beginners will find it much easier to work with a denser negative, even though it will be more grainy and offer a less subtle tonal range than an equivalent thinner one.

Creativity in the darkroom

Creativity begins with the right choice of paper, but it goes much further. If you can study a set of village landscapes by the superb photographer, Edwin Smith, you will see that the skies are often heavy, the dark roof lines and steeples standing out against the clouds, with the scenes seeming to suggest a sense of intensity and foreboding. This is achieved by 'burning in', the sky and the skyline being given a longer exposure under the enlarger than the other parts of the picture. Any portion of a print can be darkened and intensified by burning in, or lightened by 'holding back' or partly shielding an area from the light. Thus, by holding back one could preserve details of bark texture in a tree trunk silhouetted against a bright sky, and by burning in one could strengthen a cloud pattern or reduce the obtrusive qualities of a patch of brightly-sunlit foliage. Some photographers use masks and 'dodgers': little discs of opaque material held on thin wires to burn in or hold back portions of a photograph. I prefer to use my hands, much in the way that the old 'shadow artists' would create foxes, ducks and rabbits in shadows on an illuminated screen. With practice one can adjust the fingers to create illuminated 'holes' for burning in or form masks to cut off the light from a quite irregular area.

The novice printer should begin by acquiring a basic printing technique that works, next learn something of the craft of burning in and holding back. Then one can adopt a different, less orthodox printing technique, 'water bathing'. Get rid of the tray containing the stop-bath (and the awful smell that comes with it), and replace it with a tray of lukewarm water. Expose a piece of paper in the normal way, but immerse it in the water bath before it has fully developed. The dark areas will continue to develop only slightly and briefly, while development continues in the highlighted areas, where a good tonal gradation will be established. Parts of the print still needing development can be dipped back into the developer more than once until just the right degree of development is achieved. Refill the water bath with clean water for the next print. Assuming that the paper was adequately exposed in the first place, with this printing technique you can exert precise control over the final result. Thus holding back and burning in can be used to rough out a desired effect and water bathing is the fine-tuning control which may create a perfect print.

While prints are conventionally made with the narrow white margins which are effortlessly produced by the masking frame, some landscapes, whether in monochrome or colour, are more effective with black borders which seem to 'hold in' the scene. Such borders are less easily created. You need a mask with a straight edge. This is used to cover all but one margin of the print, and you successively expose each of the four margins to the unimpeded illumination of the enlarger for intervals sufficient to blacken the exposed borders completely.

With these and other darkroom manipulations available, we come to the question of what is 'fair play' and what is cheating. Each thinking photographer will have his or her own opinion. The printing in of a cloud pattern from another negative to replace a featureless sky is a rather pointless stretching of the rules. At the same time much of the aura or drama of a landscape is likely to be lost in the clinical machinations of the camera – and it seems reasonable to attempt to re-establish the true impact of a scene in the darkroom. Certainly the burning in of

RIGHT In this scene of a winter sunset at Castlerigg stone circle in Cumbria, the sky and standing stones have been slightly burned in, while the foreground was slightly held back to increase the perspective effect. The use of a softish grade 1 paper reveals the tonal range in the sky.

BELOW RIGHT A different effect was sought in this picture of Swinside stone circle in Cumbria. A hard paper was used to maximize the contrast between the stones and their setting, while the sky was heavily burned in.

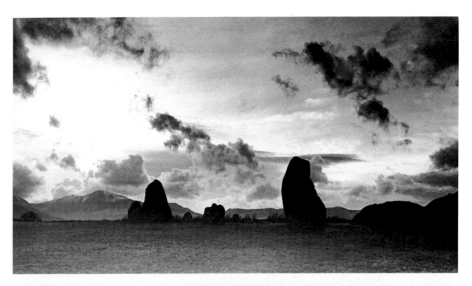

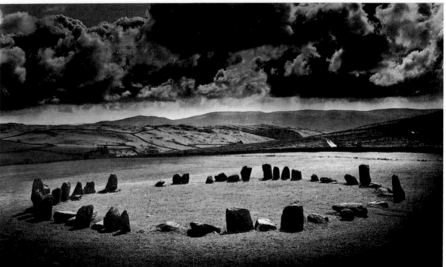

skies is usually essential, even when a filter is used, if the full effect of the cloudscape is to be recovered – the reason is that the contrast in brightness, between, particularly, skies, ground and foliage, is much higher than the eye appreciates. The absolute purist might never use filters, never push a film or burn in, and use only normal grade paper – but how often would his or her photographs truly represent the powerful qualities of the landscapes seen through the viewfinder?

With many prints the final stage of processing is retouching. Generally, this only involves the use of specks of dye to mask little white marks caused by dust on the negative – and time is saved if the negatives are kept in a dust-free environment. With too much retouching, a print starts to become a painting rather than a photograph. In landscape photography there should not really be any need for retouching, but in nature work it may be necessary to strengthen the outline of a slender antenna which is merging into a background, to define the bill of a distant bird or to attempt other tiny but helpful alterations. Subtle single strokes with a very fine paintbrush will achieve these, but where larger marks need retouching, do not attempt a 'painting' technique, but apply tiny spots of carefully diluted dye with a 'pricking' motion until the flaw disappears.

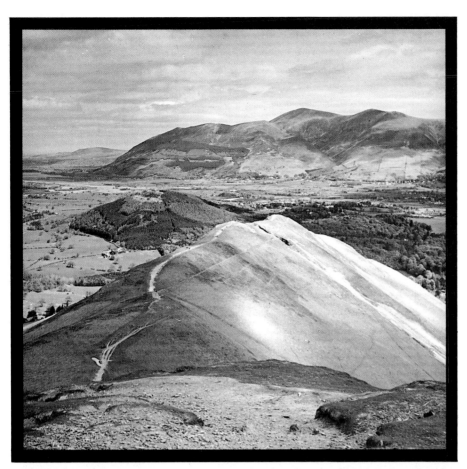

LEFT Black borders can be very effective, particularly where a sky is not strong or the composition is unusual. This is Skiddaw in the Lake District from high on the Cat Bells ridge.

BELOW LEFT This picture of a scene at the foot of the Cliffs of Moher on the west coast of Ireland was a printing challenge. If printed in the normal way, the foreground sea stack would have blacked in before the foam pattern on the breakers developed. A 'hand and finger' shadow pattern was used to mask the foreground, which received just a quarter of the exposure under the enlarger which was given to the sea.

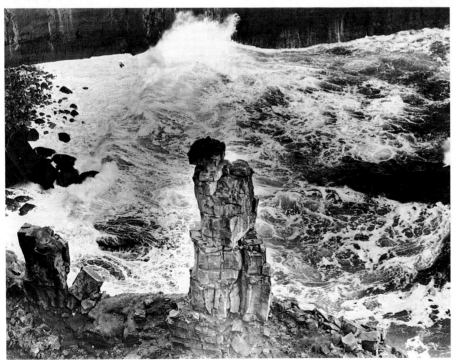

18
PUTTING SOMETHING BACK: THE NATURE GARDEN

An interest in nature photography implies a love of wildlife. As with other activities, there are a few 'cowboys', people who have no real interest in the natural world and care only to sell a few pictures or grab snapshots at the expense of a frightened or injured creature. Their paths are marked by trampled orchids, deserted nests, open field gates and discarded film cartons. At its best nature photography can be a splendid symbiosis between the cameraman and the living world, for the opportunities to repay for the pleasures of the hobby are many and significant. The craft of putting something back focuses on the nature garden. To give just one example, the 'common' frog would be virtually extinct in many areas as a result of the drainage of farm ponds and the spraying of agricultural chemicals were it not for the havens provided by garden ponds.

The essence of wildlife gardening involves the cultivation of native species of plants and the provision of ecological niches which are fast disappearing as agribusiness devastates the countryside. The native plants are not grown primarily in the hope that they will spread to recolonize the rural landscape, but because they provide food and shelter for a plethora of insects and those creatures that prey on them. Giving just a couple of examples, research has shown that the oak supports some 284 species of insect, while amongst our other native deciduous trees the hawthorn turns in an 'average performance', being host to 149 species. Today one will find an incomparably richer assemblage of wildlife in a patch of suburbia than in an expanse of prairie fields a hundred times as large. Even some larger animals, like badgers and foxes, are finding town life less stressful than the rural struggle to survive.

Any garden can be modified to enhance its wildlife potential, and the effort will be rewarded with an inexhaustible stream of photographic opportunities. This is written with some feeling, for having recently moved house, leaving behind one nature garden and having a new one still in the process of creation, the opportunity for a few minutes photographic break is sorely missed. As with other aspects of conservation, nature gardening may have an 'image' problem, for many readers may imagine the wildlife garden to be a rank and un-neighbourly jungle of nettles and thistles. However, if the objective is gradually to substitute the alien garden plants, which are generally of little or no interest to our wildlife, with native species which will provide support for insects, birds and animals, then the reader is obviously free to draw the line at any point: some could indulge in a complete re-landscaping and planting plan, others might just plant a birch tree (home to 229 insect species), grow a clump of teasel as winter bird food, or cultivate old-fashioned shrub roses to produce a supply of edible hips.

Like any other pursuit, wildlife gardening has its purists and special interest

RIGHT This red admiral has been attracted to the Michaelmas daisies, a valuable source of nectar in the early autumn.

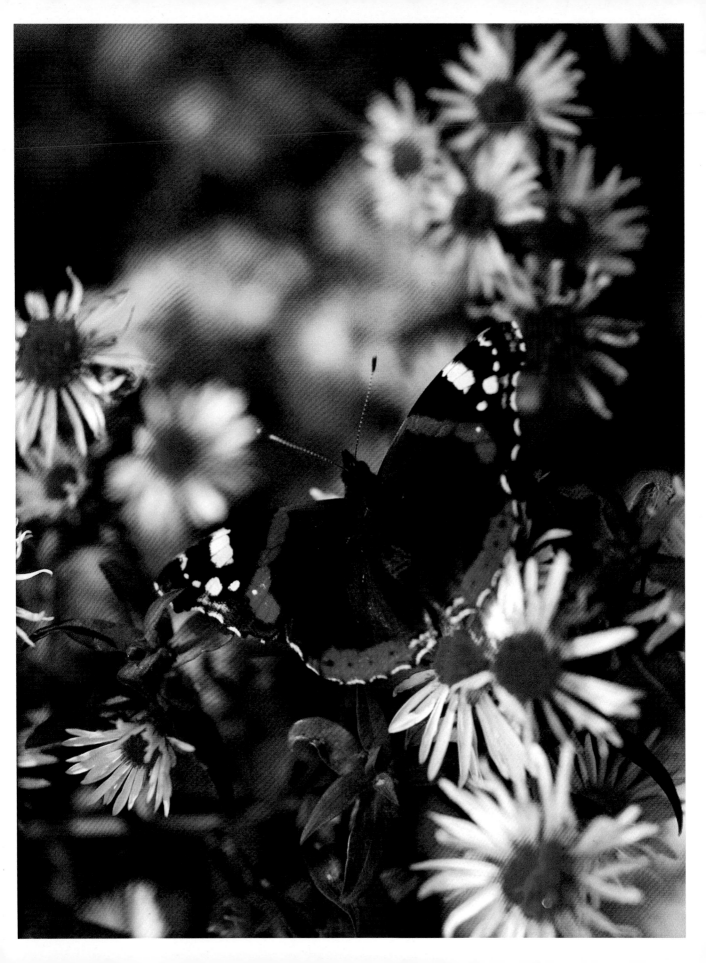

This young grey squirrel was encouraged to visit the garden by providing acorns in a cranny on the rail of my garden fence.

RIGHT Even the canny starling overcomes its alert and crafty nature in winter to visit bird-tables, but food and water supplies must be maintained. (Dark coloured birds are always difficult subjects, but here the slanting winter sunlight has picked out the lovely speckled plumage.)

groups. For example, the excellent RSPB publication *Gardening with Wildlife* suggests keeping a cat is incompatible with encouraging birds to settle in the garden. Yet the garden of a catless household will certainly be assimilated into the territory of a neighbouring cat, while in the wild nests are prey to stoats, weasels, rats, squirrels and some larger birds. The ideal would be a highly territorial cat (as the domestic cat usually is), which shows only a passing interest in hunting and which could be confined during the critical weeks when fledglings are hopping around. Similarly, some texts suggest keeping a garden pond free of goldfish, which will prey on tadpoles and insect larvae. I stocked my pond with harmless rudd – and then saw a neighbour's goldfish pond seething with well developed toad, frog and newt tadpoles. To be on the safe side, one could partition off an arm of a pond to keep fish away from the young tadpoles. Far better to go as far along the wildlife gardening road as one can comfortably travel than see the activity as a reserve for purists.

With a little forethought, the nature garden can be visually more attractive than its predecessor. For example, there are few alien shrubs and small trees as appealing as the native birches, rowan, field maple and wayfaring-tree, and surely none better in a moist limey soil than our own guelder-rose. The most useful general strategy may be to create the sort of diversity associated with a woodland edge environment, while also providing other ecological niches such as those of the pond, the hedgerow, the wild-flower meadow and the stone wall. The garden could perhaps also include a patch of ground for the lovely 'weeds of cultivation' –

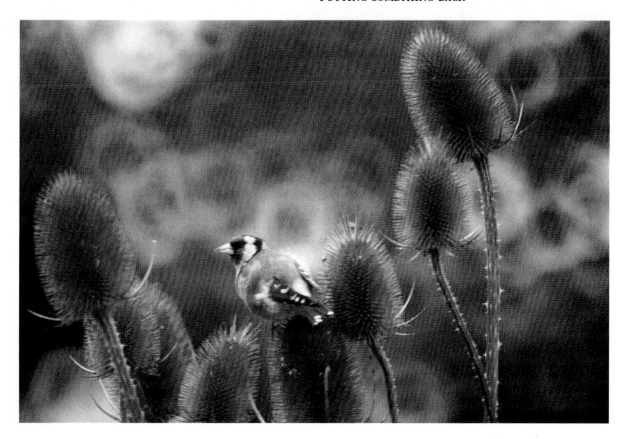

corncockle, cornflower, poppy, scentless mayweed – which have frequently been exterminated from the ploughlands by the spraying of herbicides. The wildlife garden does not need to be exclusive – I keep a bed of my favourite old roses, delphiniums and irises – while several alien plants, like the ubiquitous buddleia, and some gaudy occupants of the flower border, such as the wallflower, cosmos, polyanthus, iceplant and tobacco-plant, produce a useful supply of nectar or seed. Many an immaculate lawn could be shown off to greater advantage if an edging of native grasses is left unmown in spring and summer and cultivated as a wild-flower meadow.

Thought is needed in planning such a garden, and one should take account of the potential customers. In an urban environment a patchwork of native plantings and seed or nectar producers will be welcomed, while in a (sadly) typical rural setting one could augment the diminishing supply of local wood, wetland and hedgerow species. In an area of largely unspoilt countryside it could be useful to increase the supply of scarcer resources. For example, in my corner of the Dales there is an abundant supply of alder and oak and any that I might grow would amount to a very minor contribution. Similarly, there is little point in my growing food plants for southern English butterflies or hoping to attract an Orkney vole. Trees like birch, field maple and rowan are present in the area, but in modest numbers, so those that I grow make a significant contribution to the local pool of resources. So before devising a planting plan it is worth making an inventory of the scarcer and most threatened local resources – as well as including the native plants which you will enjoy or wish to photograph. Using a cheap soil-test kit you can assess the acidity of your soil and adjust the conditions to suit the chosen plants. My own soil is neutral, but I have a bed treated with garden lime and a limestone rockery for plants like meadow clary, bloody cranesbill, wild thyme and wild strawberry, which enjoy little alkalinity, and also some ground that is made

Wildlife gardening gives one many opportunities to plan a photographic campaign. The story of this photograph of a goldfinch began more than a year before the picture was taken, with the planting of wild teasel seed for the specific purpose of attracting goldfinches into the garden.

LEFT The corncockle is a 'weed of cultivation' virtually exterminated by herbicides. It is an annual which is worth its place in any garden for its looks alone. Here a dense planting provides a carpet of colour.

211

more acid for the heathers with additions of peat and sulphate of ammonia. Most native plants are fairly adaptable, but any plant book will describe the variously favoured habitats, and these can be created in the garden.

Any nature garden should have a permanent water supply throughout the year. Ponds are invaluable to the bird, mammal, insect and amphibian life of a neighbourhood, but should be built with sloping sides and without projecting lips of stonework. This enables birds to bathe at their margins, allows creatures which

BELOW The nature garden can provide interest and subjects throughout the year – sunflowers are more beautiful when dead and frosted than when in full bloom.

FAR RIGHT The author's nature garden seen two months after work began. The pond receives soft water from the house roof and overflows to flood the foreground bog garden. Old roses growing on the trellises will help to shade out excessive sunlight and provide winter hips for the wild birds. The drystone wall flanking the pond is in gritstone to harmonize with the house and setting, but a back-packing of limestone chips allows lime-loving rock plants to grow. The background area will be planted with buddleias and other good butterfly plants. There is no steep edge to the pond, reducing the risk of ice damage and allowing animals like hedgehogs to escape. Access for visiting wildlife from the adjacent damp meadow is provided.

tumble in, such as hedgehogs, to climb out, as well as easing the departure of developing amphibians. A deeper section with a depth of about one metre will harbour life when the surface is frozen and allow plants like water-lilies to be grown, while marginal shelves favour the cultivation of yellow iris, kingcups, water mint and many other native plants.

In stocking a wildlife garden it is essential to avoid the temptation to remove living plants from the wild. Many can be purchased from garden centres or specialist nurseries – but you should try to insist on indigenous rather than specially cultivated strains. Many more can be grown from seed from specialist dealers like those given on p. 233. It is illegal to take seed (or flowers) from many plants, as listed in Chapter 19.

The list of plants which can be grown to please the eye and increase the wildlife potential of the garden is a very long one, but here is a shortlist of ideas:

Hedges Mixed species hedgerows give the greatest range of opportunities. Consider combinations of hawthorn, sloe, field maple, elder, dogwood, privet (wild), ash, oak, elm, hornbeam, hazel, holly, wayfaring-tree, yew, dog-rose and field rose. Most traditional hedges were 'layed'. If one grows a mixture of hawthorn and blackthorn or sloe, then trees such as ash or oak can be planted at intervals of one or two metres. These trees will then serve as posts when the hedging shrubs are layed. This involves cutting the shrubs almost through, bending the trunks over diagonally and tying them into the posts. The result is a robust stock-proof hedge with thick cover for nesting birds.

Specimen trees Any on the list of native species, but the following make appealing compact trees: birch (silver or downy), field maple, rowan, guelder-rose, cherry (wild or bird), crab-apple, holly, juniper, wild service-tree, grey willow, wayfaring-tree, aspen.

Ponds Yellow iris, water forget-me-not, water plantain, water mint, flowering rush, burr-reed.

Bog garden Ragged Robin, purple loosestrife, meadow-sweet, hairy willow-herb, marsh-marigold (kingcup), marsh woundwort, brooklime.

Wild-flower meadow Ox-eye daisy, harebell, meadow clary, field scabious, devil's bit scabious, knapweed, cowslip, snakeshead fritillary, meadow cranesbill.

Weeds of cultivation Common poppy, scentless mayweed, corncockle, corn-marigold, cornflower, red dead-nettle.

Woodland edge environment (dappled shade) Foxglove, hedge woundwort, nettle-leaved bellflower, violet (dog or sweet), primrose, red campion, yellow archangel, snowdrop, green alkanet, stinking iris and stinking hellebore.

The native guelder-rose is surely superior to any exotic garden shrub – and of much more value to wildlife.

19

PHOTOGRAPHY, CONSERVATION AND THE LAW

One needs only to glance at the newsagent's or bookseller's shelves, or to check the TV programme ratings, to see that natural history has captured the imagination of the nation. Much of the credit for this can be claimed by photographers, not only the resourceful movie cameramen who have created the host of successful TV nature films, but also still photographers, such as Eric Hoskings and Heather Angel, whose work has brought the marvels of wildlife into countless homes. Without the popular support won by film, and book and magazine illustrations, the conservation movement would be incomparably less robust and more emaciated. At the same time one cannot deny the existence of a small minority of callous, stupid or ill-informed photographers, whose destructive activities discredit the craft. Callousness and stupidity tend to be innate, but this chapter attempts to inform the ill-informed and guide the novice. Quite severe penalties can be imposed against illicit activities in nature photography, and while it is as well to be aware of legal restraints and professional advice, common sense and a concern for the well-being of the countryside and its plants and wildlife should always guide one's actions.

It is a simple rule of nature photography that the welfare of a creature – or a rare plant – *always* comes first.

Nature photography can and should produce benefits for conservation. Your pictures will help to remind others of the wonders of the fragile natural world; injured, trapped or exhausted creatures may be rescued in the course of photographic rambles, while a growing interest in the subject matter can lead to wildlife gardening or membership of various worthwhile organizations, such as the RSPB, the Woodland Trust, Friends of the Earth, Greenpeace, the League Against Cruel Sports or a score of other societies, not least your county Naturalists' Trust.

Any damage inflicted upon the natural world or landscape by photographers will be minute in comparison with the changes wrought by modern agriculture. A recent Nature Conservancy Council report catalogues the following catastrophic losses of traditional countryside since 1947: 95 per cent of herb and wild-flower meadows; 80 per cent of chalk and limestone pasture; 30–50 per cent of ancient woods; 50 per cent of fens, and 30 per cent of upland grassland and heath. In the face of destruction on such a rapid and massive scale, the photographer might consider his or her actions inconsequential. But this would be wrong: the greater the devastation of the countryside and its wildlife, the greater the responsibility to protect what remains.

Notes on bird photography and protected species

Certain birds enjoy special protection in Britain under Acts of 1954–67, 1975 and 1981. The current list embraces the following species, which are protected with special penalties, although the photographer should avoid disturbing any nesting bird, particularly those which may be missing from this list but which are breeding for the first time in Britain, or nesting here after an absence of several years.

Wild birds specially protected at all times

Avocet	Golden eagle	Red kite
Barn owl	Golden oriole	Red-necked phalarope
Bearded tit	Goshawk	Redwing
Bee-eater	Green sandpiper	Roseate tern
Bewick's swan	Greenshank	Ruff
Bittern	Gyr falcon	Savi's warbler
Black-necked grebe	Harriers (all species)	Scarlet rosefinch
Black redstart	Hobby	Scaup
Black-tailed godwit	Honey buzzard	Serin
Black tern	Hoopoe	Shorelark
Black-winged stilt	Kentish plover	Short-toed tree-creeper
Bluethroat	Kingfisher	Slavonian grebe
Brambling	Lapland bunting	Snow bunting
Cetti's warbler	Leech's petrel	Snowy owl
Chough	Little bittern	Spoonbill
Cirl bunting	Little gull	Spotted crake
Common quail	Little ringed plover	Stone curlew
Common scoter	Little tern	Temminck's stint
Corncrake	Long-tailed duck	Velvet scoter
Crested tit	Marsh warbler	Whimbrel
Crossbills (all species)	Mediterranean gull	White-tailed eagle
Dartford warbler	Merlin	Whooper swan
Divers (all species)	Osprey	Woodlark
Dotterel	Peregrine	Wood sandpiper
Fieldfare	Purple heron	Wryneck
Firecrest	Purple sandpiper	
Garganey	Red-backed shrike	

Wild birds specially protected during the closed season

Goldeneye
Greylag goose (in Outer Hebrides, Caithness, Sutherland and Western Ross only)
Pintail

Under the existing legislation a special licence from the Nature Conservancy Council is needed before one may attempt to photograph a specially protected bird near or on its nest (or any specially protected animal in its place of shelter). The first-time applicant should submit three photographs to demonstrate technical competence. This reflects the sensible principle that inexperienced workers should gain their experience with the more common species.

In photographing any nesting bird, protected or otherwise, the following points should be observed:

● Never erect a hide in a position where it might attract to the nest the attentions of less scrupulous members of the public or predators.
● Restrict movement, particularly movements of the hide, to a minimum.
● Never proceed with the next step in a project until you are certain that the bird(s) accept(s) all the apparatus introduced.
● If intruding vegetation must be removed, do not cut it, but tie it back temporarily. Remember that camouflage is essential to the security of nesting birds and do not expose the nest to human or animal attack.

● Use at least one assistant to cover your movements to and from the hide, and keep such movements to a minimum.
● When using remote cameras always fit a (quiet) autowinder to avoid repeated trips to advance the film.
● Preferably only work near nests where young are at least a few days old, and never work at a nest where incubation has only just begun or where the clutch is incomplete: the likelihood of desertion diminishes as nesting progresses.
● Avoid the nests of birds which are settling in unfamiliar territory or nesting at the limits of their range.
● When work is finished, remove the hide and any camouflaging materials completely.

Notes on animal photography and protected species

A number of mammals, reptiles, amphibians, insects and other animals also enjoy special protection, and are listed as follows:

Specially protected wild animals

Mammals
Bats (all fifteen species)
Bottle-nosed dolphin
Common dolphin
Common otter
Harbour (or common) porpoise
Red squirrel

Reptiles
Sand lizard
Smooth snake

Amphibians
Great crested (or warty) newt
Natterjack toad

Fish
Burbot

Butterflies
Chequered skipper
Heath fritillary
Large blue
Swallowtail

Moths
Barberry carpet
Black-veined
Essex emerald
New Forest burnet
Reddish buff

Other insects
Field cricket
Mole cricket
Norfolk aeshna dragonfly
Rainbow leaf beetle
Wart-biter grasshopper

Spiders
Fen raft spider
Ladybird spider

Snails
Carthusian snail
Glutinous snail
Sandbowl snail

In general the photography of mammals in their wild state and away from their abodes should not cause problems, but one should never disturb an animal in its roost or lair, or obstruct its access to such a place. Bats and their roosts are particularly vulnerable and all species are protected and may not be disturbed – the maximum penalty for such an offence is now £2000. Shrews also enjoy a measure of protection and may not be trapped unless a special licence is obtained, the animals subsequently being released into the wild. As with bird photography, the ability to be tight-lipped is a distinct advantage. During World War II people were warned that 'careless talk costs lives', and if you talk about your discoveries and achievements, then a colony of great crested newts could end up in aquariums, raptor nests could be robbed for falconry, while badgers could be dug out for the subhuman activity of badger-baiting.

Notes on wild-flower photography and protected species

There are no special restrictions on the photography of rare wild flowers, but one should not uproot any wild plant without the permission of the landowner and it is illegal to pick, uproot or take the seeds of the following specially-protected plants when they are growing in the wild:

Specially protected wild plants

Adder's-tongue spearwort
Alpine catchfly
Alpine gentian
Alpine sow-thistle
Alpine woodsia
Bedstraw broomrape
Blue heath
Brown galingale
Cheddar pink
Childling pink
Diapensia
Dickie's bladder-fern
Downy woundwort
Drooping saxifrage
Early spider orchid
Fen orchid
Fen violet
Field cow-wheat
Field eryngo
Field wormwood
Ghost orchid

Greater yellow-rattle
Jersey cudweed
Killarney fern
Lady's-slipper
Late spider orchid
Least lettuce
Limestone woundwort
Lizard orchid
Military orchid
Monkey orchid
Norwegian sandwort
Oblong woodsia
Oxtongue broomrape
Perennial knawel
Plymouth pear
Purple spurge
Red helleborine
Ribbon-leaved water-plantain
Rock cinquefoil
Rock sea-lavender (two
 rare species)

Rough marsh-mallow
Round-headed leek
Sea knotgrass
Sickle-leaved hare's-ear
Small Alison
Small hare's-ear
Snowdon lily
Spiked speedwell
Spring gentian
Starfruit
Starved wood-sedge
Teesdale sandwort
Thistle broomrape
Triangular club-rush
Tufted saxifrage
Water germander
Whorled Solomon's-seal
Wild cotoneaster
Wild gladiolus
Wood calamint

The photography of all wild plants demands special care. The chosen subjects seldom flourish in isolation and the trampling of adjacent vegetation can disfigure and damage a habitat. Low-growing species demand a similarly low viewpoint and it is often essential to work from a prone position. No damage is likely to be done by lying in the grass, but amongst, say, a colony of wild orchids, it is all too easy to flatten the rare plants by accident. So it is better to select subjects at the edge of a group rather than near the centre. Also, bearing in mind the threats from rogue plant collectors, it may be as well to be deliberately vague when discussing the whereabouts of threatened plants, particularly the 'desirable' wild orchids.

Introductions

An interest in nature photography could lead one into the purchase and portrayal of exotic species of animals. Afterwards these should be kept as pets rather than being released into the wild. Most probably they would not survive for long in the wild, though the examples of the mink (a homicidal maniac in numerous riverside areas), the voracious zander, the coypu and, on a much smaller scale, the Mongolian gerbil show that introductions can severely disrupt a habitat. The principle also applies in the plant world. Himalayan balsam and the monkey-flower are extremely attractive garden escapees, but in many places they now completely carpet river banks, at the expense of native plants and the wildlife which depended on them. In time introductions, like the horse chestnut, become an accepted part of the British scene (though sycamore and rhododendron are a blessed nuisance in several woods). Nature gardening is an enormous boon to the conservation movement and, when seed is bought from reputable dealers, rare plants can be grown for studio photography of a quality not always possible or practical in the wild. Even so, not even native plants should be indiscriminately introduced into the countryside. They might not be of the true native or regional stock, genetic changes could result from interbreeding with established communities, while other plants could be displaced. If some seeds from my authentic bloody cranesbills or burnet roses should be naturally dispersed and germinate in a limestone pavement, all well and good, but it would be wrong to attempt unauthorized plantings.

Landscape and nature photography offer an inexhaustible source of pleasure to the photographer and his audience – it is just as easy to return the favours as it is to destroy the sources of enjoyment and beauty.

20
WEATHER AND SEASONS

No one can live in Britain for very long without becoming aware of the distinct seasonality of our climate. Equally, nobody can explore the field of landscape and nature photography in any depth without learning about the subtleties of light, weather and the annual cycle of changes in the environment.

In planning any photographic trip one ignores the season, weather and forecast at one's peril. The nature photographer must know exactly when the mayfly will hatch or the fly orchid bloom. Similarly, the landscape photographer will find that he or she is always at the mercy of the natural lighting and may find an arduous trip rendered worthless by unfriendly conditions.

There is no single 'best' set of conditions for outdoor photography. The wild-flower photographer seeks very still, slightly overcast conditions, the people on the holiday beaches want a high sun burning in a cloudless sky – but both these weather situations are usually anathema to the landscape photographer. More often than not he or she will hope for clear air, low sun and a fresh breeze to roll billowing clouds across the sky.

Each particular scene has its own ideal lighting conditions, but here we must generalize a little and cut a few corners. Usually one dreams of working in late spring or early autumn, with the low sun of late afternoon in conditions of exceptional clarity – such as often signify the approach of a strong weather front and a rainstorm. At such times even the most run-of-the-mill countryside can seem idyllic. The only qualification to this 'ideal' stereotype is the fact that, as the sun sinks, so the light takes on a reddish, seemingly golden tone. As a result, a very pale blue 'morning-evening' colour correction filter may be needed.

Heavy cloud need not necessarily be a bad thing, for a leaden, threatening sky will add drama to a mountain scene, while rain adds a sparkle to rock formations, roads and walls. Clear blue skies have an unwelcome emptiness in both colour and monochrome work. They are often associated with heat haze and with high pressure conditions, with descending air currents which hold down dust and smoke in a murky fuzz. In the arable eastern counties the combination of high pressure and stubble-burning produces a dull haze which is sure to kill the beauty of the distant scene – though later in the day vivid sunsets can be expected as a result of the impurities in the air. Even outside the eastern fiefdoms of the barley barons, August is often a month of heat hazes – and a good time to clean and service equipment for the superb months which follow. The high sun of midsummer casts heavy black shadows in the hours around midday and good results may not be obtained until the sun has sunk and lights trees, terrain and buildings from a shallower angle – such sidelighting is usually very attractive. Mist and fog are obviously generally unwelcome but can be exploited to great

It really pays to get about in winter. Here the hard contrast in the lower, sunlit part of the picture complements the soft tones of the smoke rising from the household fires in Grassington, North Yorkshire, and of the shaded slopes beyond.

OVERLEAF Two different approaches to photography at sunset. The conventional treatment (left) shows a sunset which owes its colours largely to airborne impurities from August stubble burning. The unconventional sunset (right) was taken in midwinter and the sun is simply used to provide a centre of colour and interest in a picture which is really about silhouettes.

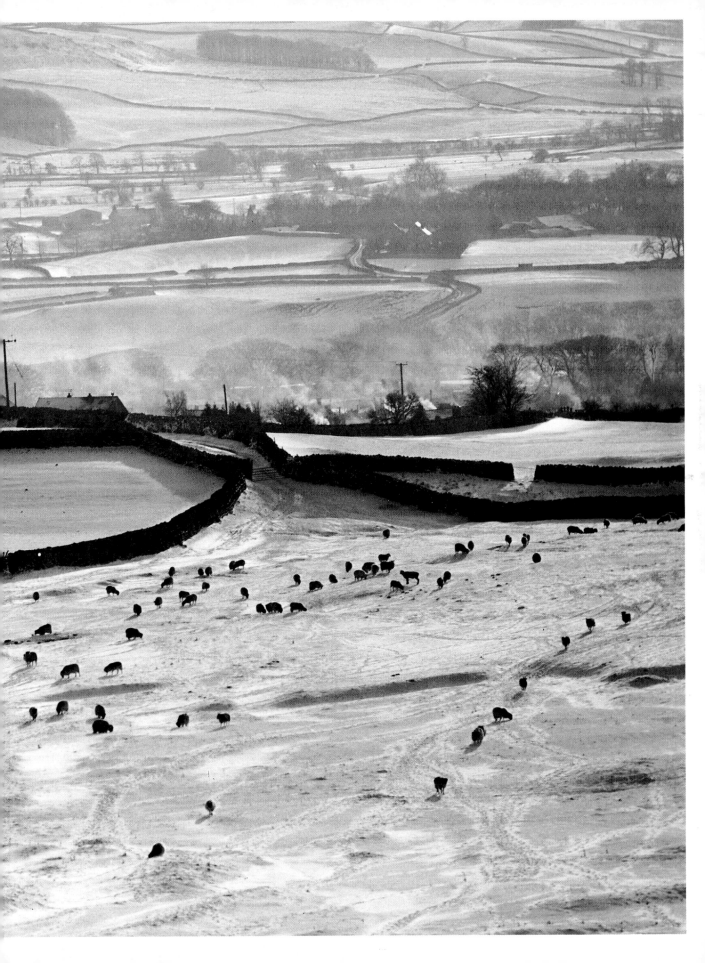

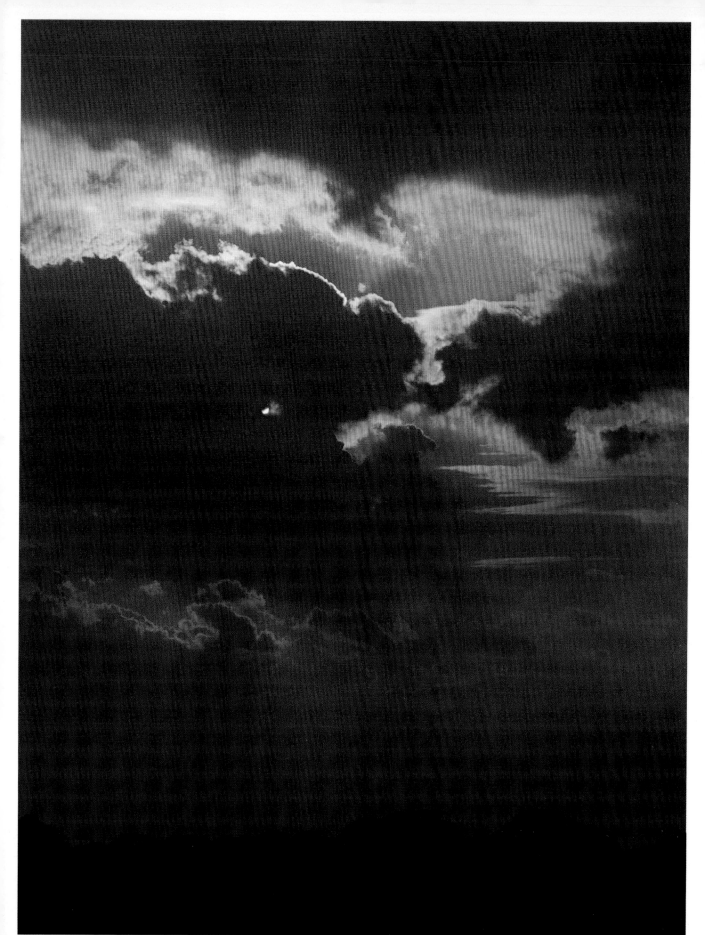

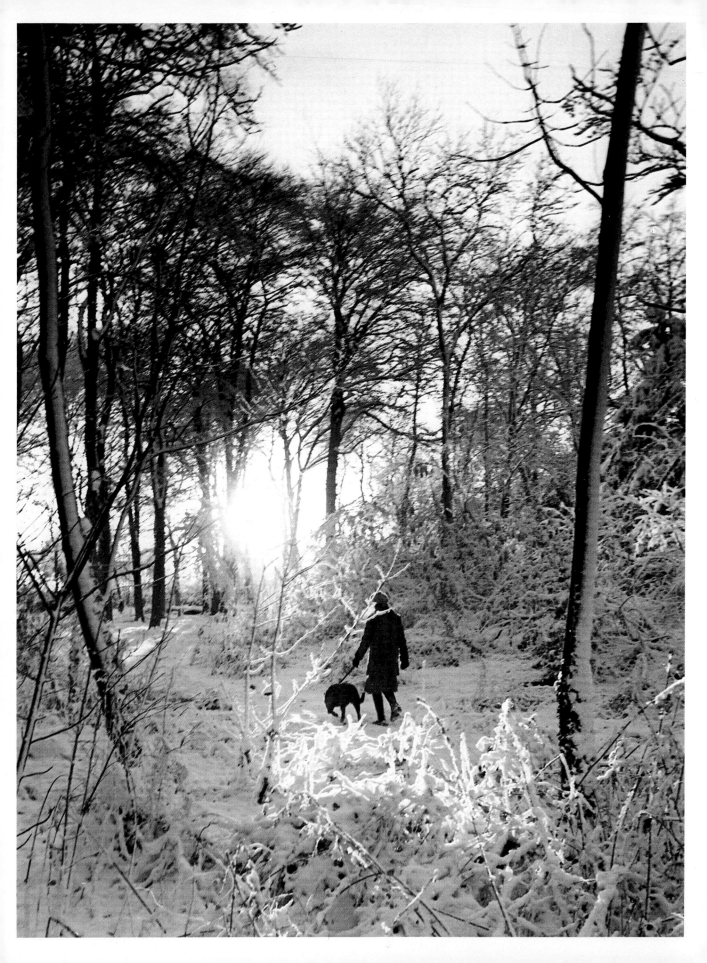

effect, either to inject a dream-like note of mystery in woodland or wetland photographs, or when one is working above the morning or evening mist, looking down on the soft grey veils which mark the valleys and hollows.

For the reasons given, spring and autumn have a stronger appeal than high summer – though the widely denounced summer of 1985 rewarded the landscape photographer (but not the holiday maker) with a continuous sequence of vigorous cloud patterns as the cyclones queued up to assault us. The charms of late autumn, with multi-coloured foliage, soft light, vivid eruptions of fungi and a general ethos of sweet melancholy, are well known. Spring is less favourable in landscape terms; the light is still cold and thin, the countryside colours still deathly pale and algae gives an unattractive yellow-green hue to bare trunks and branches. The dawn of spring is a time of hard frosts, and while the broad vistas may seem lifeless or anaemic, close-ups of frost encrusted foliage should be seized early in the morning, well before the thaw. This is also the time when birds are starving and when a regular supply of food *and* water on the bird-table will both save lives and reward the photographer with shots of birds which become shy and discerning as the season wears on. Winter is a challenge. One must work hard to discover possibilities and force oneself out into a chill and clammy countryside. But perseverance can be rewarded, and I find that proportionally I take better pictures in winter than in the favoured seasons. This reflects the fact that, by trying harder and by dredging the depths of imagination and concentration in generally unfavourable settings, one tends to tap the best of one's potential.

A fall of snow brings countless cameras out from their winter roosts. Do not delay, for soon the brilliant icing on the details of the scene will disappear and trees and buildings will stand black and dismal on the white carpet. A sunlit snow

ABOVE Autumn brings its own special attractions for the landscape and nature photographer – but do not delay, for sharp frosts and strong winds can drastically reduce the length of the amber season. As the bright leaves carpet the woodland floor, foregrounds take on an extra appeal; here, at Strid Woods in the Yorkshire Dales, birch and beech are the main contributors to the autumn carpet.

LEFT Winter in Wandlebury Woods, Cambridgeshire. Soon this magical quality will fade as the freshly driven snow falls from the twigs. Though small, the figure walking into the setting sun is crucial to the composition.

scene has just three hues: black, white and blue. Shadow areas, which seem quite natural to the human eye, may appear to be excessively blue in colour photographs – so that it may be wise to adopt a pale pink 'warming' colour correction filter if you wish to match the eye's impression. However, when you look closely at the original scene, you'll see that the shadows really *are* blue.

It is easy to be intoxicated by the winter wonderland. After weeks of gloom and drizzle the sunlit snowscene will seem quite magical. Yet it is one thing to be standing in a suddenly wondrous setting and another to see perfect pictures composed in the viewfinder. In a few months time the joys of the snowscape will be forgotten, so be sure that your pictures really capture the ephemeral delights. Blue, black and white alone need not create a telling image and there could be more power in a close-up of a snow-blasted wall or branch than in a panorama.

Too few people realize that outdoor photography is a year-round pursuit. Weather forecasts are still imperfect and the detail given may be too coarse for our needs. Yet time spent in catching a forecast or in learning to read a pressure chart is, for the photographer, time well spent. Like anyone else, he or she will want to maximize opportunities and avoid disappointments. The diagram below provides a simple reminder that 'for everything, there is a season', and shows that there is no season which is completely devoid of interest and challenges.

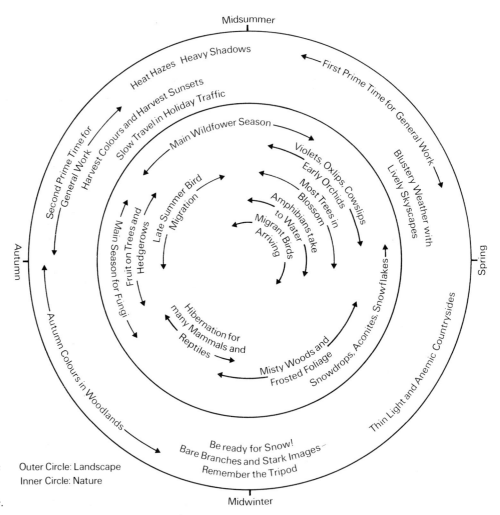

Some of the photographic opportunities and problems encountered at different times of the year.

226

21
PLANNING
A TRIP

When buying a first camera we never quite know how deeply we will dip into the bran tub of photography. Some remain holiday snappers, others find a passing interest developing into a hobby. The hobby can become a serious enthusiasm as the photographer begins to specialize in portraiture, sport, architecture – or landscape, or nature. Eventually the enthusiast will start thinking about photographic projects and holidays, and will want to consider set courses, specialist package holidays or personally chosen projects. This chapter is about the last-named adventure, and if much of the content seems mundane or banal then I can only remind the reader that faults in the transport arrangements, film shortages, or any other hitches lose time and could cost one the picture of a lifetime. Better not to mar a holiday by learning about the nuts and bolts of the working photographer's lifestyle the hard way. Serious photography demands care and motivation. Indeed, one could say that the quality of work is generally proportional to the concentration and creativity expended. For those reasons it does not readily combine with a family jaunt or a sociable ramble. I am lucky to have worked with expert authors and have learned a great deal from photographic field trips with archaeologists and landscape historians such as Jack Ravensdale, Christopher Taylor and Tom Williamson. In general, however, while it is always nice to have an agreeable companion (who can be burdened with the heavy tripod or flash outfit), it is almost impossible to be both an interesting and talkative rambler *and* still recognize all the subtle photographic opportunities which arise. Top-class photography is a solitary pursuit, and few comrades will readily tolerate the enthusiasm of a cameraman who is prepared to sit out a storm behind a wall in the hope of enjoying a moment of scenic drama as the black clouds break, or lurk in the bushes in the hope that a nightingale may settle nearby.

In planning a trip away from home, transport is the main consideration. The mode adopted determines the amount of gear which can be carried. Unless one is prepared to pay excess baggage charges, then air travel is the most restrictive. With rail or coach travel one is limited by the amount of luggage that can be manhandled around a station – or between distant stations in the case of London. Cycling has its obvious distance restrictions, while the use of a car allows the greatest freedom. However, it is best to arrive in the chosen location feeling fresh and raring to go, feelings seldom apparent after an arduous cross-country drive. For these sorts of reasons I choose air travel and hire cars for work on islands and in the most distant parts of Britain, rail and hire cars for fairly distant but more accessible areas, and drive to places within about a hundred miles of home. For shorter trips, which involve narrow country roads, the cyclist has the distinct advantage of being able to stop at will. The motorist, in contrast, will sacrifice

many unexpected opportunities for want of safe parking places.

Travel arrangements should be planned carefully in advance: for example, one cannot be certain of obtaining a hire car during the height of the holiday season. On the other hand, I have always been able, eventually, to find accommodation, even if this sometimes proves more expensive than intended. Booking in advance gives the security of a place to sleep at the end of the day, but it does restrict one's movements. For example, one might be at Tintagel in Cornwall around 6 pm and decide that Rough Tor or Land's End might be found at their best in the evening light. If you have reserved dinner in Port Isaac at 7 pm, then something must be sacrificed. Bearing in mind the considerable costs of travel, I prefer to work until dusk if the conditions for photography are excellent – and then worry about where to spend the night.

When travelling alone a small hire car will be sufficient. Fiestas and Novas are popular choices. I have found them willing little beasts, and their small dimensions are suited to the narrow back roads of the least spoilt countrysides. Local garages and agencies often have lower hire charges than do the big hire firms, but these cheaper cars should be checked carefully – useful bits like door locks or even rear-view mirrors are often broken and there may be a stop on the accelerator. Proper locks and a jacket or blanket for camouflage are essential if one is to leave bits of gear in a parked car, even in the most out-of-the-way places. Some family cars are more suited to photographic outings than others. A good choice is a hatchback or small estate, not too wide and with front-wheel drive. Unless the car is being used as a trackside hide it is *not* a good idea to tempt fate – in the form of a bump in the rear – by having cameras in the passenger seat. The urge to stop without warning to photograph a spectacular view can be tempered by keeping the gear out of reach in the back of the car. On narrow roads the three- or five-door vehicle with its rising tail-gate facilitates the extraction of equipment.

Gear may have to be hauled between stations and around airports – and the less that one resembles a tottering Christmas tree, the greater the comfort. Awkward items, like tripods, can be packed with clothing in a sizeable bag or suitcase, along with film and the bits of gear which will not jam into the camera bag, and then extracted at the destination. In packing the aim is to have the lightest load, while checking carefully that most possible photographic opportunities can be covered. Never underestimate the amount of film you will need. Given excellent conditions and a bit of luck it is quite possible to shoot off six 36-exposure rolls in a day. Remember, too, that small town chemists nowadays may only stock colour print film. Workers in the medium format particularly should prepare for the worst and take copious supplies of 120 stock.

Clothing should also be packed with forethought, allowing for the possibility of a cold wind, soaked jeans, sodden shoes or boots, and so on. Lots of socks and a *real* waterproof are the rule! Bear in mind, too, that you may be appearing at a hotel reception desk at the end of the day. And so it may be politic to have a clean pair of shoes, jacket or windcheater ready for the rendezvous with the worst kind of receptionist that fate may have in store.

Having chosen an area for work in landscape or nature photography, the opportunities can be maximized by the careful planning of sites and itineraries. How many places can be photographed in one day? Given a car, an area of operation about the size of an average county district and a readiness to forego lunch and refreshments, the answer is about twenty. If one really wants to explore all the possibilities of each place properly, then the number falls to about four or five. But to obtain the definitive picture of a selected place or creature requires various reconnaissance trips, long periods of sitting and waiting, plus the deserved measure of good fortune. Time spent travelling between locations is, in the narrow photographic sense, time wasted. Before embarking on an expedition I study the lists of nature reserves to find out what can be seen, when, and where, and also glance at other listings of archaeological sites, churches, deserted

medieval villages, and so on. I study the Ordnance Survey 1:50,000 or 1:25,000 maps, looking for promising patches of countryside, vantage points, footpaths and possible parking places. I then transfer the information on to a road map, with dots marking the chosen sites and notes about their contents and access. Finally, I work out the swiftest and most economical route between the places, linking them together, like beads on a string. But remember, country back roads are likely to be more tortuous than the maps can show and so a seemingly longer link via a trunk road can prove swifter. As a hardened geographer I can navigate within a locality using a 1:50,000 map. Others may find it easier to dispense with the big map and use the road map and signposts. One soon discovers that in some places, such as

Marking up a road map is very useful when planning a trip. The most economical route between the selected sites is prominently superimposed on the road map and the intended sites are clearly marked, along with relevant notes.

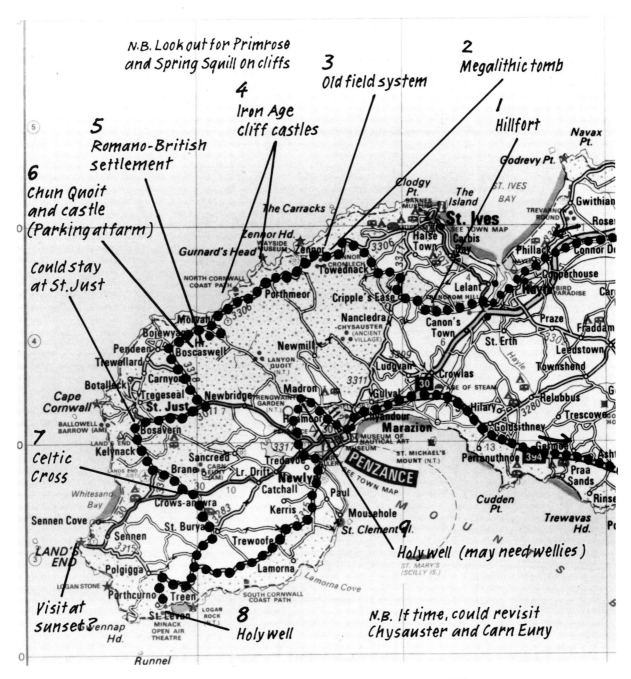

When working in the field a map can quickly be marked up in this (exaggerated) way. The photographic stand-point lies at the point of each 'V' and the arms of the 'V' show the direction of view. The angle of the arms relates to the angle of view of the selected lens. The 'V's are numbered in sequence, allowing a proper record to be written up later and allowing 'mystery shots' to be identified from the negative strip numbers.

deepest Kent or Norfolk, the provision of road signs is more eccentric than in others, such as Cornwall or Essex. It is as well to have the 1:50,000 map somewhere to hand – perhaps a compass too – for the subtleties of direction and to pin-point rights of way, which may not be signposted.

A route plan should be an aid rather than a straight-jacket, for some of the best pictures will not be anticipated. Given perfect conditions – say very clear air and dawn or evening sunlight – an area may seem a fairyland of delights. It is easy to flap and fail on all fronts through the inability to sacrifice some beckoning opportunities in order to concentrate on others.

Finally, it is easy to forget how remote some of the wilder countrysides really are. If disasters do strike, then they are likely to occur on a Sunday when one is as far as possible from a dentist, mechanic or surgery. Useful additions to the first-aid box include a few antibiotics, tummy medicine, stopping for tooth cavities that have lost their fillings and salt tablets. On various trips I have needed one or other of these aids. I can also testify that heat exhaustion is extremely unpleasant, and photographers working with heavy loads in hot, dry and rugged conditions are

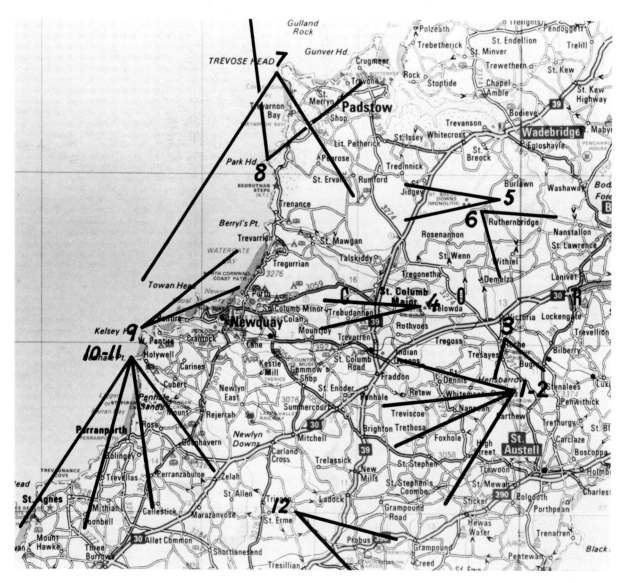

Scots pines in a shelter-belt on a nature reserve in the Brecklands of East Anglia.

particularly vulnerable – you should always carry a good supply of liquid, for the affliction arrives without warning.

It is important always to keep a record of what one has photographed. The purist can carry a notepad and record every single detail of location, direction and exposure. In practice these meticulous methods can be distracting and time-consuming. I use a shorthand method, drawing V-shaped symbols on a road map. The point of the 'V' marks my position, while the limbs of the symbol define the area framed in the viewfinder – thus an acute 'V' signifies a telephoto shot and a broad 'V' one taken with a wide-angle. In the evening this information can be transferred into a proper log. Keeping such records is tedious and may seem unnecessary. However, in five years time, when you have thousands of negatives and transparencies, a proper chronological log will allow you to find and identify a picture in minutes rather than hours.

Most little problems can be avoided by a little advance planning, and the extended photographic trip can provide enormous fun. By using one's gear continuously over a period of days one becomes a much more effective practitioner.

Why not give it a try? At the end of the day you sit exhausted in a strange little hotel room with only the Gideon Bible for company. After a late meal and an early bath you are too tired to do much but clean the lenses, write up the log and check the next day's itinerary. This may seem a soulful existence, but the enthusiast will doze off savouring the delights of the day and happy in anticipation of the exciting images which will soon emerge through the developer. Did you catch that deer before it melted into the thicket? Was that butterfly a small pearl bordered fritillary – and was it in focus? Did you do justice to that stunning cloudscape? Perhaps not. Perhaps tomorrow.

OVERLEAF If you can begin your travels before dawn you may be rewarded for your dedication. In winter the lateness of the sunrise leaves one with few excuses to linger.

231

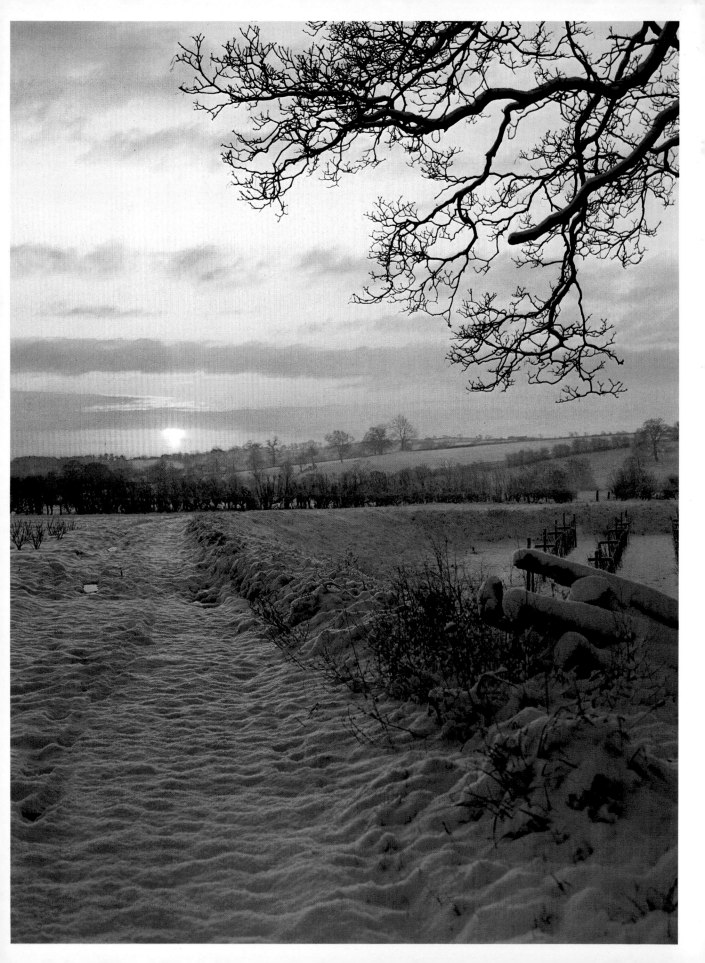

USEFUL SOURCES AND ADDRESSES

Equipment services

Air photography – from model aircraft: Miller Aviation Models, Red Cot, New Street, Glemsford, Sudbury, Suffolk, CO10 7PY.

– from tethered balloon: Skyscan, Stanway Grounds Farm, Stanway, Cheltenham, Glos, GL54 5DR.

Close-up equipment and Novoflex power-focusing long lenses: Fotoadvise (MEW) Ltd, 22 Aylmer Court, Aylmer Road, London, N2 0BU.

Darkroom materials: Phototec Mail Order, 82A Clifden Road, London, E5 0LJ; Jessops, Jessop House, Sandamore Road, Leicester, LE3 1T2.

DIY remote triggers: Camtronic, 19 Kelsey Close, Fareham, Hants, PO14 4NW.

Elicar macro lenses and ring flash: Luxfoto Ltd, 384 Barkham Road, Wokingham, Berks, RG11 4DL.

Equipment test report reprints: AP Test Report Reprint Service, *Amateur Photographer*, Surrey House, 1 Throwley Way, Sutton, Surrey, SM1 4QQ.

Filters and other accessories: Janet Green Photographic, 1 Market Arcade, Halifax, West Yorks, HX1 1NX.

Hides: Jamie Wood Products Ltd, Cross Street, Polegate, Sussex, BN26 6BN.

Large-format cameras: Teamwork, 11 Shelton Street, London, WC2H 9JN.

Longworth traps for capturing small rodents alive: Penlon Ltd, Abingdon, Oxon, OX14 3PH.

Microscopes: Rheinbergs Sciences Ltd, Sovereign Way, Tonbridge, Kent; Revor Optical and Technical, 44 Oakwood Road, Hampstead, London NW11.

Moth traps and insect nets: Watkins and Doncaster, Park View Road, Welling, Kent.

Optical components, microscope components: H. W. English, 469 Rayleigh Road, Hutton, Essex, CM13 1SU.

Photographers' jackets: Quest Vest, Box 99, Bozeman, MT59715, USA.

Photographic chemicals: Rayco (UK) Ltd, Ash Road, Aldershot, Hants.

Posso tripods: Luxfoto Ltd, 384 Barkham Road, Wokingham, Berks, RG11 4DL.

Postcard printers: The Thought Factory, Unit 8, Hastings Road, Leicester.

Remote triggers: Natron, 15a High Street, Alcester, Warwicks, B49 5AE; Mazof Studios, 61 Tytherton Road, London, N19 4P7.

Special lens mounts, microscope mounts and filters: SRB Film Service Instruments, 286 Leagrave Road, Luton, Beds, LU3 1RB.

Licences for photographing protected species

The Licensing Officer, Nature Conservancy Council, Northminster House, Peterborough, PE1 1UA.

Amphibian and reptile suppliers

Philip Harris Biological Ltd, Oldmixon Industrial Estate, Weston-super-Mare, Somerset.

Suppliers of butterflies and moths

Entomological Livestock Supplies, 109 Fairmile Road, Halesowen, West Midlands, B63 3PZ.

The Living World, Seven Sisters Country Park, Exceat, Seaford, East Sussex, BN25 4AD.

Suppliers of wild-flower seeds

John Chambers, 15 Westleigh Road, Barton Seagrave, Kettering, Northants, NN15 5AJ.

Chiltern Seeds, Bortree Stile, Ulverston, Cumbria, LA12 7PB.

Emorsgate Seeds, Emorsgate, Terrington St Clement, Norfolk.

W. W. Johnson and Son Ltd, Boston, Lincs, PE2 8AD.

Naturescape, Little Orchard, Main Street, Whatton in the Vale, Notts.

The Seed Exchange, 44 Albion Road, Sutton, Surrey.

Suffolk Herbs, Sawyers Farm, Little Cornard, Sudbury, Suffolk.

USEFUL BOOKS

Understanding the landscape and nature books

BOOT (ed), *Macmillan Guide to Britain's Nature Reserves*, Macmillan, 1984.

BROWN, E. H., and CLAYTON, K. (eds), *The Geomorphology of the British Isles* series, Methuen, 1976–.

CLAPHAM, A. R., TUTIN, T. G., and WARBURG, E. F., *Excursion Flora of the British Isles*, CUP, 1959.

DURRELL, G., *The Amateur Naturalist*, Hamish Hamilton, 1982; Penguin, 1985.

MUIR, R., and DUFFEY, E., *Shell Countryside Book*, Dent, 1984.

MUIR, R., *Shell Guide to Reading the Landscape*, Michael Joseph, 1982 (2nd ed).

MUIR, R., *Shell Guide to Reading the Celtic Landscape*, Michael Joseph, 1985.

RACKHAM, O., *Trees and Woodland in the Landscape*, Dent, 1976.

ROWLEY, T., *Villages in the Landscape*, Dent, 1978.

TAYLOR, C., *Fields in the English Landscape*, Dent, 1975.

TAYLOR, C., *Village and Farmstead*, George Philip, 1984.

WALTHAM, T., *Caves, Crags and Gorges*, Constable, 1984.

Air photography

BERESFORD, M. W., and ST JOSEPH, J. K., *Medieval England, An Aerial Survey*, CUP, 1979 (2nd ed).

MUIR, R., *History from the Air*, Michael Joseph, 1983.

ST JOSEPH, J. K. (ed), *The Uses of Air Photography*, John Baker, 1966.

Photography

ANGEL, H., *Photographing Nature: Insects*, Fountain Press, 1975.

ANGEL, H., *The Book of Nature Photography*, Ebury Press, 1982.

ANGEL, H., *The Book of Close-up Photography*, Ebury Press, 1983.

BRUCK, A., *Close-up Photography in Practice*, David and Charles, 1984.

DALTON, S., *Caught in Motion, High-Speed Nature Photography*, Fountain Press, 1982.

FREEMAN, M., *The Wildlife and Nature Photographer's Field Guide*, Croom Helm, 1984.

HAZELHOFF, F., *Four Seasons of Nature Photography*, Fountain Press, 1982.

HOSKINGS, E., with FLEGG, J., *Eric Hoskings' Owls*, Pelham Books, 1982.

HUGHES, T., and GODWIN, F., *The Remains of Elmet*, Faber, 1979.

KARMALI, J., *Birds of Africa*, Collins, 1980.

KERFF, G., *Photographing Landscape*, Focal Press, 1978.

MILNESS, D., *The Photoguide to Mountains*, Focal Press, 1977.

RICHARDS, M.W., *The Focal Guide to Bird Photography*, Focal Press, 1980.

SPILLMAN, R., *The Complete Photobook*, Fountain Press, 1983 (3rd ed). Recommended as a general introduction to photography.

THOMPSON, G., and OXFORD SCIENTIFIC FILMS, *Focus on Nature*, Faber, 1981.

WARHAM, J., *The Technique of Bird Photography*, Focal Press, 1983 (4th ed).

WILSON, A., *Creative Techniques in Nature Photography*, Batsford, 1979.

WILSON, A., *Close-up Photography and Photo-micrography*, Batsford, 1985.

WOODS, G., and WILLIAMS, J., *Creative Techniques in Landscape Photography*, Harper and Row, 1980.

Gardening with wildlife

BAINES, C., *How to Make a Wildlife Garden*, Elm Tree Books, 1985.

RSPB, *Gardening with Wildlife*, 1982.

CONSERVATION ORGANIZATIONS

THE BRITISH BUTTERFLY CONSERVATION SOCIETY, Tudor House, Quorn, Loughborough, Leics, LE12 8AD.

BRITISH HEDGEHOG PRESERVATION SOCIETY, Knowbury House, Knowbury, Ludlow, Shropshire.

FIELD STUDIES COUNCIL, 62 Wilson Street, London, EC2A 2BU.

FRIENDS OF THE EARTH, 377 City Road, London, EC1V 1NA.

GREENPEACE, 36 Graham Street, London, W1 2JX.

ROYAL SOCIETY FOR NATURE CONSERVATION, The Green, Nettleham, Lincoln, LN2 2NR. (This organization will provide the address of your own local Nature Conservation Trust.)

ROYAL SOCIETY FOR THE PROTECTION OF BIRDS (RSPB), The Lodge, Sandy, Beds, SG19 2DL.

SCOTTISH WILDLIFE TRUST, 25 Johnstone Terrace, Edinburgh, EH1 2NH.

URBAN WILDLIFE GROUP, 11 Albert Street, Birmingham, B4 7UA.

WILD FLOWER SOCIETY, 69 Outwoods Road, Loughborough, Leics.

THE WOODLAND TRUST, Westgate, Grantham, Lincs, NG31 6LL.

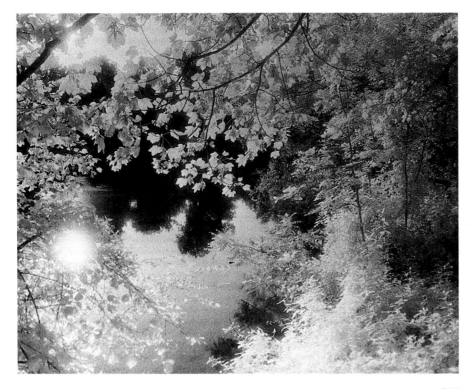

Sycamore and ash trees overhanging a Buckinghamshire pond, photographed looking into the sun using infra-red film.

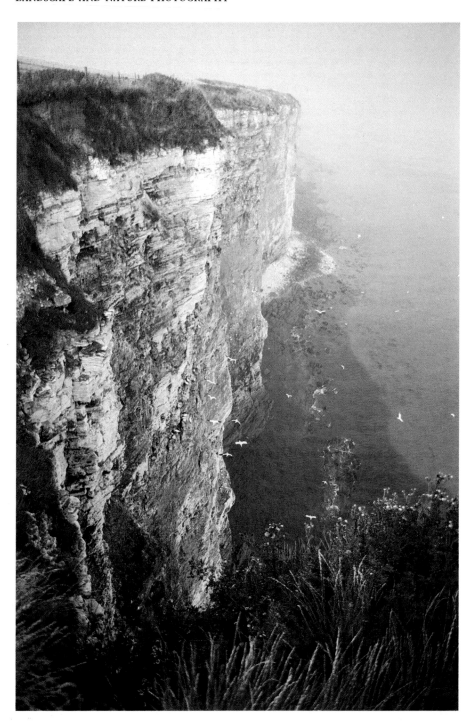

Gannets wheeling around chalk cliffs at the RSPB reserve at Bempton, Humberside.

INDEX

Page references in italic refer to illustration captions.

air photography 132ff, *133, 134*
Airn Force, Cumbria *90*
amphibians 162ff, *52, 163, 164, 165, 166*
 protected 217
aquarium, *see* vivarium
Arncliffe, Yorkshire *127*
Ashridge Park, Hertfordshire *111*
autowinder, *see* camera
autumn 119, 146, 225, *23, 98, 114, 119, 129, 206, 225*
archangel *148*

backgrounds (*see also* pictorial composition) 36, 48,
 167–8, 183, 187, 192, 194, 197, *183, 194, 196*
birds 172ff, *11, 32, 36, 39, 50, 86, 173, 174, 176, 178,*
 179, 183, 184, 188, 208
 attracting 183, 225, *211*
 in flight 185ff, *186, 187*
 protected 216
blue tit *173*
'botanical' photography *142*
Brimham Rocks, Yorkshire *36*
buildings, *see* village photography
Burrow Mump, Somerset *29*
butterflies 150ff
 gatekeeper *51*
 habitats 152–6
 large skipper *157*
 painted lady *35*
 peacock *156*
 red admiral *206*
 silver-washed fritillary *151*
 small copper *153*
 swallowtail *153*
Buttermere, Cumbria *58*

camera 24ff, 38, 55
 air photography 132
 aperture priority 36–8, 179
 automatic exposure 36

autowinder 38, 132, 183, 185, 193, 194
bags 99–100
contamination by sea water 75
electronic shutter 38
field camera 27–8
landscape photography 24ff
large-format 27–8, 31, 81
medium-format 25–7, 28, 32, 51, 132, *25*
microscope-mounted 42, 44
nature photography 38ff
positioning 116
rangefinder 24
shoulder straps 38
shutter-priority 36, 178
single lens reflex (SLR) 24ff, 36, 38, 42, 101
solenoid device 38, 186
35 mm format 24ff, 36, 38, 42, 101, 108, 132,
 135, 186
through-the-lens facilities (TTL) (*see also*
 flash) 34, 38, 42, 45, 160
twin lens reflex (TLR) 27
camouflage (*see also* hides) 193
Castleton, Derbyshire *130*
caves 108–9, *108*
Cessna skymaster 134, *133*
cliffs 75–9, *75, 77, 78*
Cliffs of Moher *205*
close-up (*see also* insects, wild flowers etc.) 22, 30,
 38–44, *21*
 lighting 44–5, 48–50
 magnification 42–4, *40*
 microscope 42–4, 50, *40*
clothing 99–101, 228
cloud patterns 33, 85, 90, 95, 203–4, *61, 103, 133*
cockerel *50*
composition, *see* pictorial composition
conservation, *see* nature conservation
'control' picture 97
corncockle *211*
coypu *52*
crop marks 132

cross-section, geographical 58–9, *59*
Crummock Water, Cumbria *58, 59, 92*
Cuillins, Skye *78, 100*

dace *170*
darkroom, equipment and techniques 198ff
deer 190–1, 192, 196, 197, *31, 192*
depth of field 15, 19, 36, 39, 42, 69, 72, 84, 108, 136,
 138, 143–4, 145, 150, 157, 174, 175, 177, *28, 31,*
 72, 86, 114, 142, 174, 177, 178
Derwent Water, Cumbria *12*
developing, *see* film
diatoms *40*
duck, mandarin *179*

Epping Forest, Essex *112, 113*
equipment, general 24ff
exposure 16–21, 174–5, 186–8, *35, 36, 39, 85, 86,*
 103, 119, 174, 180, 195
 automatic 36–8, 102
 bracketing 84, 102, 120, 160
 for air photography 132–3
 for bird photography 174–5, 178–9, 185, 186–8,
 174, 180
 for close-up nature photography 42, 45, 47, 138,
 141, 144, 160, 167, *138, 142*
 for mountain photography 102, *103*
 for waterfalls 96–7, *90, 95*
 for woodland 120
 with flash 45, 47, 150–1, 167, 185, 186–8, *160*
 with infra-red film 81, 84

Fenland 95–6, *20, 37, 96*
fieldscape 64ff, *17, 61*
 cameo 69, *68*
 earthworks 64ff, *64*
 field patterns 65–9, *65, 66, 70*
 flowers of the field 69, 208–11, *15, 68, 70, 211*
Film 23, 50ff
 colour fidelity 52–4, 119, 141, *23, 27, 31, 50, 51,*
 96, 142
 counteracting infra-red radiation 119, 141
 developing 198–9
 infra-red 81–4, *81, 82, 83, 117*
 ISO coding 51
 particular effect of fast film 51, *31, 51, 94, 175*
 particular effect of monochrome 50, 51, 141–3,
 52
 particular effect of slow film 51, 56, 134, 174, *39*
 plane 144, 150, 167
filters 20, 33–4, 50, *35*
 80B 34, 48
 82A 34, 141, 160
 graduated 21, 34, 61, 75, 119
 green 33, 50
 morning-evening 34, 219
 orange 33, 50, 57, 61, 75, 102, *28, 57, 61*
 polarizing 33, 34, 61, 72, 74, 97, 102, 163, 166,
 62, 70, 75
 red 33, 50, 61, 75, 81, 84, 102, *104*
 skylight 34, 61, 102, 132
 split-field 136

star-burst 34, *35*
yellow 33, 75
yellow-green 50, 61
warming/cloudy 34, 102
Finchingfield, Essex *126*
fish 167ff, *169, 170*
 protected 217
fishing net *25*
flash 34ff, 44ff, 138, 157, 188
 boosting natural light 44, 138, 141, *156*
 exposure compensations 47
 fill-in 44, 108, 145, 167, *46, 164*
 guns 16, 44–5, 46, 108, 145, 164, 167, 180–2,
 183, 185, 186, 193, 195, *46, 194, 195*
 high-speed 163, 186–8, *187*
 hot-shoe 157
 macro 44, 45, 47, *46, 47*
 'multiple' 108
 ring 22, 44–5, 72, 141, 150–1, 156, 158, 160, *46,*
 47, 136, 142, 148, 151, 153, 154, 156, 159,
 160, 165
 slave unit 183
 sychronization 151, 185, 187
 through-the-lens (TTL) 34, 38, 42, 45, 50, 55,
 157, 160, 167, *35, 46, 151, 173*
 to freeze motion 157, 163, *166*
flat terrain, problems of 95
focusing 15, 36, 42, 44, 84, 177–8, 185–6, *32*
fog, *see* mist
fossil *48*
framing 22, 58, 69, 129, 143–4, 193
 to strengthen image *92*
frogs 162ff
 'jumping' 163, 188
 marsh *164*
frost 225, *212*
fruits and seeds 23, *52, 142*
fungi 116, 145–6, *53, 144, 145, 201*

gannet *186*
gardening, *see* nature gardening
geomorphology
 coastal 78–9
 upland 88, 104–8
 water bodies 86
giant wood wasp *159*
Glen Nevis *19*
goldfinch *211*
goose, whitefront *177*
Gordale Beck, Yorkshire *9*
Grantchester Meadows, Cambridgeshire *83*
grasshopper *154*
Grassington, Yorkshire *65, 220*
greenfinch *187*
guelder-rose *214*
gull, herring *184*

hedgehog *53*
hedgerows 45–8, 68–9, 120, 121, 143, *47*
heron *179*
hides 179–80, 182, 192
housing animals, *see* insects, vivarium

'identification' photo *174*
illumination, *see* lighting
infra-red photography 80ff, *81, 82, 83, 116*
insects 116, 150ff, 159–60, 207, *35, 40, 46, 51, 151, 153, 154, 156, 157, 159, 160*
 protected 217

Kersey, Suffolk *129*
kestrel *32*
Kilnsey Crag, Yorkshire *26*
kittiwake *178*

ladybird *154*
law, the 147–8, 194, 195, 215ff
leaves 119–21, 225, *23, 48, 98, 114, 225*
lenses 28–31, 32, 38–44, 54–5
 bellows 39, 42–4, 136, 160, *40*
 close-up attachment 39, 43
 enlarging 202
 extension tubes 39, 42, 43, 47, 102, 150, 156, 160, *35, 136, 151, 153*
 for bird photography 172ff
 for close-up nature photography 38–44, 136, 150, 156–7, 160
 for details in landscape 58, 72, 97, 136, *61, 100*
 macro 22, 39–44, 72, 102, 136, 150, 156, 159, 160, 166, 171, 194, 195, *40, 136, 138, 142, 144, 154, 164, 165, 194*
 microscope 42, 44, 50, 160, *40*
 mirror 30, 102, 174, 177, 179, 191, *31, 32, 178, 186, 196*
 optical 179
 rendition of colour film 54
 reversed 39, 42, 44, 160, *35, 151, 153*
 standard 28, 38, 39, 44, 102, 150, 160, *35, 151, 153*
 teleconverters 30, 102, 177
 telephoto 22, 28–30, 31, 33, 58, 69, 72, 95, 97, 101, 103, 116, 120, 136, 150, 156, 163, 166, 174–7, 183, 193, *11, 21, 61, 77, 86, 95, 100, 104, 163, 173, 184*
 wide-angle 28, 39, 42, 56, 57, 69, 72, 73, 84, 90, 95, 101, 104, 108, 119, 120, 136, 160, *12, 27, 28, 72, 77, 100, 114*
 zoom 30–1, 42, 57, 84, 101, 134, 156
lichen *53*
lighting (*see also* exposure, flash) 15–16, 41, 46
 backlighting 16, 44, 119, 168, *15, 17, 48, 95, 141, 159, 171*
 dark field illumination 50
 diffused/overcast 16, 150, *46, 82, 142, 144*
 eliminate 'ghosting' 185
 for birds 179, 183–5
 for close-up 44–50, 141, 149, 150–1, 156–7, *142, 148, 154, 156, 159*
 for insects 150–1
 for landscapes 19–21, 68, 219–26, *14, 16, 17, 66, 75*
 for mammals 192–3
 for wild flowers 138–41, *141*
 for woodland 119
 improvised 45, 50, 138

natural 44, 138, 219–26, *9, 40, 46, 96, 142, 144, 156, 159*
 reflectors 138, *48*
 sidelighting 16, 50, 168, 219, *16, 40, 164, 179*
 studio 45–50, 138, 160, *48*
 with vivarium 164, 167, *164, 169, 171*
light-tent 48
lizards 165
Llanberis Pass, Wales *201*
Loweswater, Cumbria *88*

mammals 189ff, *31, 52, 190, 192, 194, 195, 196, 197*
 protected 192, 194, 217
maps, use of 58–60, 78, 79, 119, 229–30, *230*
mayfly *160*
Meal Cumhann *19*
metering (*see also* exposure) 19–20, 38, 42, 45, 47, 81, 120, 134, 178, *36*
meters 19, 38, 42, 44, 47, 102, 160, 202
Mevagissey, Cornwall *123*
Middlesmoor, Yorkshire *124*
mist 119, 219–25, *85, 105*
monopod 32–3, 97, 102, 163, 179
moss *40*
moths 159ff
 eggs *40*
 elephant hawk *46*
 emperor *46*
 protected 217
 puss *160*
 recording life cycle 159
 tussock *160*
 white *47*
motion 96, 157, 163, 185–8, *170, 177*
mountain photography 56–9, 88–9, 90–5, 99ff, *19, 27, 100, 102, 103, 104, 105, 106*
 cameos 104, *104*
 problem of foreground 106–7, *106*

nature conservation 12, 146–7, 154–6, 162, 166, 173, 206ff, 215ff
nature gardening 146, 154–6, 162, 206ff, *153, 212*
negatives 25–8, 42, 51, 198ff
newts 162ff
 smooth *165*

orchids
 bee *142*
 early marsh *9*
 early purple *136, 138*
 green-winged *138*
 lizard *141*
otter *190*

panoramas (*see also* fieldscapes, mountain photography) 28, 56ff, 72, 90, 95, 98, 102, 103–4, *20, 57, 58, 59, 61, 62*
pasque flower *140*
peacock *11*
perch *169*
perspective, *see* vantage point

pictorial composition 20–22, *86*
 amphibians and reptiles 162–4, *165, 166*
 birds 173, 183, *177, 179, 184*
 fish 167–8, *170*
 infra-red photography 84
 insects 150, 156–7
 landscapes (and seascapes) 20, 57–8, 61, 69, 72,
 89–95, 104, *21, 61, 86, 106*
 mammals 192, 194–5, 197, *192, 194, 196*
 villages 122, 126–7, *123*
 wild flowers 21, 144, 147, *147*
 woodland 119, 120, *114, 116*
pike *170*
pintail *174*
planning 78–9, 146, 219, 227ff
plant clamp 138
printing 199–203
 'burning in'/'holding back' 203–4, *204*
 paper 84, 202–3, *201, 204*
props
 natural 183, 188, 194–5
 studio 48, 138, 171

Ranworth Broad, Norfolk *86*
record keeping 228–31
reflectors, *see* lighting
remote triggering 38, 135, 163, 182, 183–5, 187–8,
 192–3, 194, *173, 183, 187, 188, 195*
reversing rings 39, 42, 160
rock pools 72, 75, 97, *75*

safety 78, 100–101, 103, 127
scale 69, 77, *102*
seascapes 72ff, *72, 75, 205*
seasons (*see also* autumn, spring etc.) 219ff
shrimps *171*
shutter release mechanisms 108
silhouette effect 16, 108, 120, *17, 36, 61, 81, 86, 222*
Skye 70, 78, *100, 105*
skyscapes 132, 203–4, 219, *36, 61, 62*
snakes 163, *166*
snakeshead fritillary 147
snow 102, 119, 129, 224–5, *66, 188, 225*
song thrush *188*
sparrows *183*
spider's web *40*
spring 162, 225
squirrels *196, 208*
stalking
 birds 179
 butterflies 150
 fish 171
 mammals 189–91
starling *208*
stickleback *169*
strawberry, wild *142*
Strid Woods, Yorkshire *225*
studio
 animals in 159, 194–5
 flora in 138, *145*

lighting 45–50, 138, 160, *48*
 planning a 45
summer 225, 226
sunflowers *212*
sunsets 219, *14, 16, 36, 68, 86, 222*
swans
 Bewick's *39, 174*
 mute *180*
synchronization, *see* flash

teleconverters, *see* lenses
texture 22, 90, 97–8, *52, 141*
Thaxted, Essex *128*
Thor Cave complex *109*
toads 162ff, *52, 163, 164, 165*
trapping
 fish 171
 moths 159
 small mammals 194
travel 228ff
trees
 in nature gardening 211
 photogenic 120–121
triggers, *see* remote triggering
trip device, electrical microswitch 185
tripod 31–3, 97, 102, 116, 119, 138, 160, 166, 191,
 193, *86, 90, 114, 142, 144*
 improvised 102
trout *170*

underground, *see* caves
Ure, River *85*

Vale of Aylesbury *62*
Vale of York *57*
vantage points 58–9, 69, 72, 78, 79, 90, 95, 103, 120,
 126–7, *18, 59, 65, 89, 92, 104*
village photography 122ff, *123, 124, 126, 127, 128,*
 129, 130
vivarium 159, 162, 163–4, 167, 168, 171, 194–5, *164,*
 171, 194

walnut *52*
Wandlebury Woods, Cambridgeshire *225*
water 85ff, *21*
 elimination of reflection *74*
 estuaries 90, *179, 89*
 lakes 90–5, 97, *58, 88, 92*
 photographing into 97, 163
 rivers, streams, canals 19–20, 85ff, 97, *83, 85, 86,*
 100, 118
 waterfalls 19–20, 86, 89, 96–7, *21, 90, 95*
 wetlands 95–6, 166, *96, 164*
Wicken Fen, Cambridgeshire *96*
wild flowers 136ff, *9, 136, 138, 141, 142, 146, 148*
wind
 flower photography 138
 ruffling foliage *35*
winter 119, 182–3, 225–6, *20, 85, 86, 128, 188, 204,*
 208, 220, 222
woodland 111ff, *23, 111, 112, 113, 114, 116, 119*

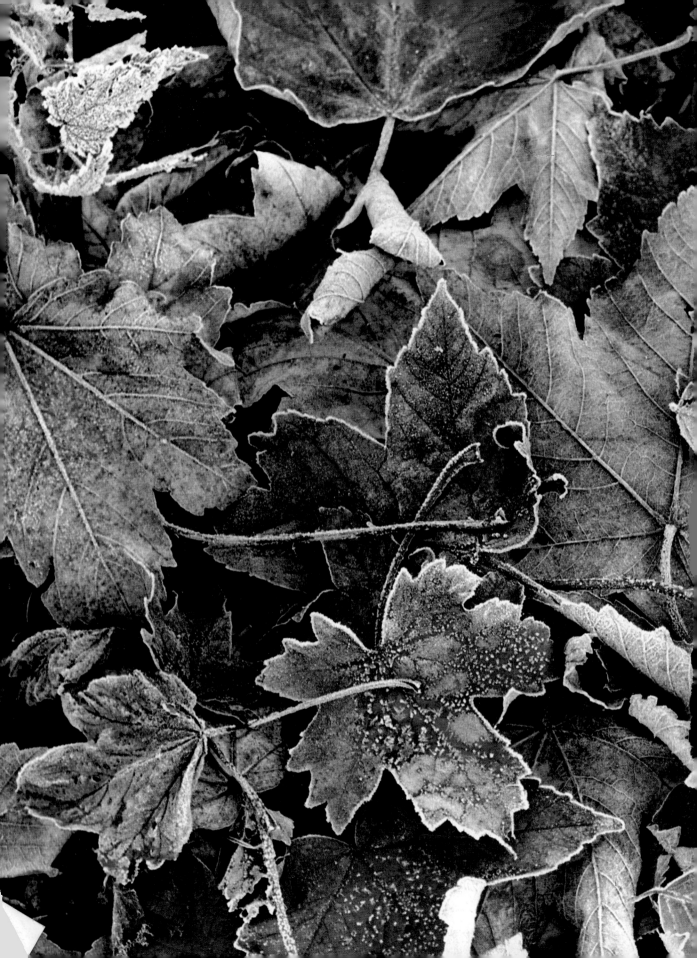